HOW TO PHOTOGRAPH
BUILDINGS AND INTERIORS

HOW TO PHOTOGRAPH BUILDINGS AND INTERIORS

GERRY KOPELOW

PRINCETON ARCHITECTURAL PRESS

To Ven. Namgyal Rinpoche, for his clarity and generosity. And to Doug Duncan, Mark Webber, Jeff Olsen, Terry Hagan, and Karma Chime Wongmo, who carry on the work.

Published by
Princeton Architectural Press
37 East Seventh Street
New York, New York 10003

For a free catalog of books, call 1.800.722.6657.
Visit our web site at www.papress.com.

© 2002 Princeton Architectural Press
All rights reserved
Printed in Hong Kong
05 04 03 02 5 4 3 2 1

Editing and layout: Clare Jacobson and Nicola Bednarek
Book design: 2ᵇ Group

Special thanks to: Nettie Aljian, Ann Alter, Janet Behning, Megan Carey, Penny Chu, Jan Cigliano, Mark Lamster, Nancy Eklund Later, Linda Lee, Jane Sheinman, Lottchen Shivers, Katharine Smalley, Scott Tennent, Jennifer Thompson, and Deb Wood of Princeton Architectural Press—Kevin C. Lippert, publisher

Library of Congress Cataloging-in-Publication Data
Kopelow, Gerry, 1949–
 How to photograph buildings and interiors / Gerry Kopelow.—
3rd updated and expanded ed.
 p. cm.
Includes index.
 ISBN 1-56898-323-9
1. Architectural photography 2. Photography of interiors I. Title.
TR659 .K66 2003
778.9/4 21
 2002003393

Technical Notes

The architectural images in chapters 1–8 were made with a Toyo G 4x5in view camera and several Fujinon lenses. Since films have improved substantially in the past few years, I have been able to do more work with medium format. For this I generally use Fuji GX680II and Fuji 680III cameras. I use Canon equipment for 35mm work. The images in chapters 1–8 were made on Kodak color negative films, processed and printed in my own darkroom on Kodak RA papers. Most of the images in chapters 9–16 were made with Kodak and Fuji transparency materials, generally Kodak EPP and Fuji Velvia, and processed in my own darkroom.

The digital revolution has changed my working methods. Now, I shoot mostly on color negative material and make high-resolution scans with a Minolta Dimage Scan Multi II 6x9cm scanner. Prints, when required, are made on an Epson Photo Stylus 1270. It is interesting to note that no film whatever went to the publisher in the preparation of chapters 17, 18, and 19; all images were submitted on compact disks or by email. The cover image was shot on location at Daly Plaza in Chicago with a Better Light scan back mounted on my Fuji GX680III camera.

Acknowledgments

I would like to thank Better Light, Horseman, Phase One, Vistek (Toronto), and B&H Photo (New York) for their technical support and the loan of equipment for testing and review. Many other equipment manufacturers, including Canon, Nikon, Minolta, Hasselblad, Mamiya, Kodak, Lee Filters, and Applied Science Fiction were also instrumental in providing technical information and illustrations. Architectura and Arthur Erickson generously supported this project by allowing me to document several of their interesting projects with a variety of photographic equipment—Christina Symons at Architectura very kindly organized these efforts. And finally, a heartfelt thank you to editors Clare Jacobsen and Nicola Bednarek for their subtle and intelligent modifications to my work.

Photo Credits

Cheryl Albuquerque: 14, 15, 59b, 62b, 99.
Calumet Photographic: 136.
Dbox: 190.
Fuji Photo Film Company: 125.
Michael Holder: 8, 30, 31, 54, 59t, 62t, 63, 98, 172.
Kodak Canada: 185.
Lee Filters: color plates 54–61, 165.
Albert Normandin: 137.
Rescom Interactive: 189.
V-PAN: 139.
All other photographs by Gerry Kopelow, except where otherwise noted.

CONTENTS

INTRODUCTION

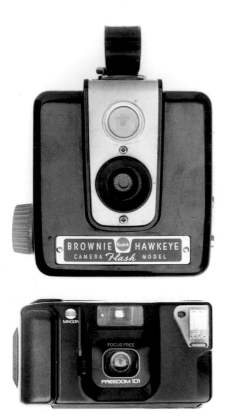

Two versions of "you push the button, we do the rest" cameras—a 1950s vintage Kodak Brownie Hawkeye and a 1990s Minolta Freedom 101.

INTRODUCTION

In the early days of photography, when everyone used simple box cameras to take black-and-white family snapshots, Kodak advertised their services with the motto "you push the button, we do the rest." Today, with an abundance of sophisticated tools available for both professional and amateur photographers, the implied message remains the same: technology will make the picture.

Unfortunately, auto-everything cameras do not and cannot make "good" pictures all the time. Some human intervention is required to elevate what would otherwise be an ordinary, if technically adequate, snapshot. A little investigation into the process of producing photographs that transcend the mechanical reveals that even in today's microchip environment, the aesthetic sensitivities and technical judgment of human beings are paramount.

This book is intended to help those people who require excellent photographs of buildings, inside and out. Regardless of whether those photographs are obtained through the services of a professional or an amateur photographer, the process will be facilitated with a basic understanding of photographic technique. Acquiring such knowledge need not be an intimidating proposition. Keep in mind that despite the complicated bells and whistles that are flogged so insistently at the camera store, photography's 150-year-old mystery—how best to make two dimensional representations of three dimensional objects—is not so much a technological problem as an intellectual one. Architects, interior designers, heritage preservers, and city planners are, likely, already well-prepared for the task. Anyone with some knowledge and appreciation of the design and structural elements of buildings has potential as an architectural photographer or an informed purchaser of architectural photographs.

THE CURRENT STATE OF ARCHITECTURAL PHOTOGRAPHY
People who need good photographs of buildings are plagued with the same frustrating paradox that confounds consumers of many other goods and services: they are propagandized by the media. Because of its effectiveness as a selling tool, excellent photography is now commonplace. Well-produced magazines, in particular, condition us to very high visual expectations. National and international architectural journals regularly publish wonderful color photographs and we readily absorb these images, assuming unconsciously that what we see so often must be easily accessible. When the time comes to buy or make such photographs on our own, however, there is inevitably a certain "reality gap" between what we want and what we get. The current state of affairs finds most practitioners caught somewhere between the slick work of first-class professional architectural photographers and the fuzzy, off-color efforts of the office novice. The discrepancy between what is seen in the glossy trade journals and what is possible in real life can be narrowed by commonsense practices that can be learned with a little effort. The first step is a study of results obtained by the published professionals.

Any respectable journal will include a range of images, most made by paid professional photographers working on assignment for the magazine or on behalf of the contributors. The best work will be distinguished by natural color, an abundance of detail, pleasing lighting, controlled representation of vertical and horizontal lines, and a suitably graphic composition that affords the viewer an exciting and/or informed look at the building.

Much goes into making such extremely effective images. The photographer and client must be able to understand one another, the photographer must be sufficiently skilled so that all the technical variables will be well-managed, and the production values of the printing process must be high enough to accurately reproduce the original photographs. That this occurs often and consistently in the well-known publications means that at least some users of architectural photography are well served.

However, what is in the magazines is not necessarily typical of general conditions, because what the media does best is reproduce many copies of few pictures. These pictures then become visual icons and the object of photographic envy. In reality, most "working" architectural images do not get industry-wide exposure. Instead, they are made and used locally as documentation for ongoing projects, as samples for practitioners' portfolios, as support material for proposals, and more. These pictures are made by all sorts of people, the majority of whom are not professional photographers, usually because of budget

restrictions. Most users of these images would prefer that they reflect the highest industry standards but, for a number of reasons, accept work of substantially inferior quality.

THE PURPOSE OF THIS GUIDE It is my intention to provide a compact and informative handbook of architectural photography that will serve as a reliable reference to professional users of architectural photographs.

First, the special problems and advantages of working with a professional photographer will be examined with a view to making the collaboration of end user and producer as efficient and enjoyable as possible. In this scenario, a knowledge of photographic technique is not required. However, an appropriate vocabulary for discussing such specialized work will be provided and thoroughly explained.

Next, the production of in-house photography will be extensively discussed and analyzed. Here familiarity with the technology as well as the vocabulary of photographic practice is a necessity. A little patience will be required as, step by step, a working knowledge of both the basics and the subtleties of photographic architectural documentation is acquired.

Finally, I will offer advice to aspiring or established professional photographers who would like to excel at architectural work.

EXPECTATIONS AND BENEFITS By discovering and appreciating how professional photographers think and work, you can direct them more effectively as well as evaluate the work they do for you more competently. You will save time, money, and frayed nerves. By going further into the process and learning how to do some of what the professionals do yourself, you will save even more time and money, but there will be an added bonus: personal satisfaction.

People with an interest in improving their visual skills can expect to produce pictures that will be acceptable for publication, and more than acceptable for many less glamorous purposes. The difference between "acceptable" and "inspired" is something you must provide yourself. However, the difference between "acceptable" and "unacceptable" can be learned. Likely you or your photographically minded associates already own a 35mm camera, so aside from a little time, film, and processing, the lessons will be relatively inexpensive.

The final benefit, and perhaps the most significant, is a qualitative improvement in your ability to communicate. All photographs are evidence, visual proof of some situation or condition. To whatever purpose a photograph is put, there is a transfer of a unique kind of information that cannot be conveyed by words. Making better photographs means this highly subjective and rather tenuous process will be much more straightforward.

I **WORKING WITH A PROFESSIONAL**

WHAT A PROFESSIONAL PHOTOGRAPHER DOES

DEFINING THE JOB Anyone can take a picture, and these days, with wonderful films and cameras so easy to obtain, the average picture is not half-bad. Even so, "not half-bad" is not good enough for most commercial purposes. (By "commercial" I mean any application where the photograph is used to support or sell some activity, or any service associated with doing business.) When reliable results of very high quality are required, when the picture must come out every time, the first and often the best resource is a professional commercial photographer, someone who makes a living by selling photographs produced according to clients' specifications.

Unless you are living in a very large urban center, or unless you have the money to import a specialist from out of town, it is unlikely that a professional photographer who specializes in architectural photography will be found close at hand. In virtually every community, however, there will be one or more individuals who are reasonably competent at a number of photographic disciplines. I have already defined a professional photographer as someone who produces photographs as a business for other businesses. In all but the most sophisticated markets, such people must of necessity be competent generalists, and they do a credible job shooting in a wide range of situations. The difference between the generalist and the specialist will be the experience they each bring to the task and, consequently, the efficiency with which the job is completed. Both varieties of photographer must approach architectural photography with a specific arsenal of technical skills and equipment, supplemented with an intellectual and aesthetic gestalt similar to, or at least compatible with, that of an architectural designer.

All commercial photography requires the production of photographs that are technically excellent and aesthetically appropriate. However, dealing with buildings and interiors introduces a number of variables that are not necessarily common to other types of photography. First, buildings and rooms are larger in scale than most objects the typical commercial photographer has to deal with. Outsized subjects require special wide-angle lenses and a substantial investment in powerful lighting equipment. Second, architectural

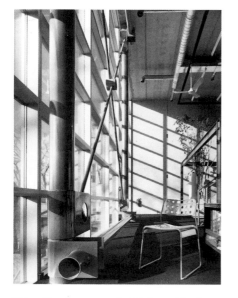

This office is a cement slab box with glass ends. The chair provides a sense of scale. The wind-stress support is clearly delineated just inside the glass curtain wall. This image shows the dramatic effects of the mid-morning sunlight. The grid pattern on the far wall echoes the pattern of the window mullions. Camera: Toyo 4x5in, lens: 90mm (moderate wide-angle), film: Kodak Vericolor III Type S. Perspective controls were required.

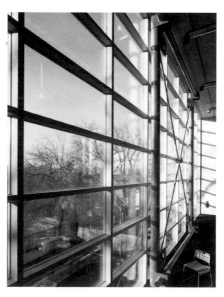

This is a simplified version of the first image. The composition was streamlined by moving to a higher camera position and angling the camera to eliminate everything except the window and chair. Camera: Toyo 4x5in, lens: 75mm (extreme wide-angle), film: Kodak Vericolor III Type S. Perspective controls were required.

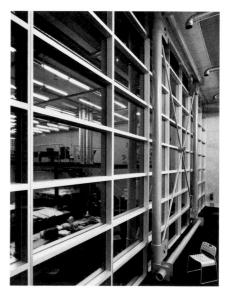

Similar nighttime view of the office back wall. The dark window makes a dramatic backdrop for the structural elements while the diminishing reflections add depth and a sense of the room. Camera: Toyo 4x5in, lens: 90mm (moderate wide-angle), film: Kodak Vericolor III Type S. Perspective controls were required.

subjects (except for renderings and scale models) are situated in their own unique (and immutable) settings. That is to say, variables such as camera position and color balance are to a large degree predetermined by existing conditions and not totally controllable as they are in a studio. Third, there is formidable physical effort associated with architectural work: the equipment is heavy, bulky, and delicate, and consequently difficult to transport to, from, and around the job site. Since much of the work is done outdoors, the work is compounded by the vagaries of weather and seasonal conditions.

The foregoing is not intended to discourage those who would like to retain a commercial photographer, but rather to point out that first-class architectural work involves some effort, and anyone who can make a living (or part of a living) at it is probably sensitive, intelligent, and physically fit.

I will discuss the specifics of selecting a professional photographer shortly, but it makes sense to provide a job description first. I believe the following criteria define quality architectural photography:

1. The image must be clear, with an abundance of detail and consistent focus.
2. The color must appear natural and appropriate for the scene.
3. Perspective and point-of-view should be natural and pleasing.
4. Sun angle, sky conditions, and seasonal variations should be appropriate.
5. The subject must be portrayed in its proper context relative to the site.
6. The scale of the subject must be properly established.
7. Location photos must be made discretely, with consideration for the occupants.
8. Deadlines and other professional obligations should be scrupulously observed.

The superior photographer will fulfill these requirements and still display a degree of individuality. Clients are required to be realistic about the potential of specific projects.

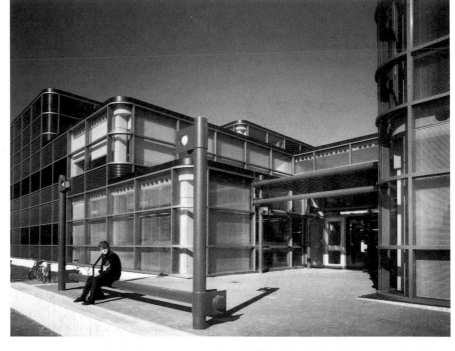

IKOY Architects' Earth Sciences Building at the University of Manitoba. I included a curious student to give a feeling for the scale of the project, but also to show how the structure and its embellishments are put to use. Camera: Toyo 4x5in, lens: 90mm (moderate wide-angle), film: Kodak Vericolor III Type S printed on B&W Kodak Panalure paper. Perspective controls were required.

THE LARGE-FORMAT ADVANTAGE In this chapter I will point out those factors that distinguish one professional from another. There is, however, one notable factor that distinguishes the professional from all but the most sophisticated amateur: large-format view cameras.

Most people are familiar with miniature-format cameras that use 35mm film. The term "35mm" refers to the actual width of the film stock, but, because of the area lost to the double row of perforations, the image area is only 24x36mm. Still, many modern films do a very good job of holding detail, considering that a standard 8x10in enlargement involves a magnification of about seven—more if the image is cropped.

As both an amateur and professional format, 35mm is popular because the cameras and lenses are small, light, and easy to operate as well as relatively inexpensive to buy and run. Despite these obvious advantages, the prolific midgets are not the favored tool of the professional architectural photographer. In fact, most published photographs of buildings and interiors have been made with picture-taking machines that look very much as they did in the nineteenth century. Just like their ancestors, today's view cameras are equipped with an accordion-type bellows and a ground-glass focusing screen that is typically viewed from underneath a dark cloth. The modern large-format camera is in fact a genetically accurate descendant of the earliest view-cameras, and can only be used mounted securely on a tripod.

Although the basic physical configuration has endured for over a hundred years, some things have changed. First, the original cameras were made of hand-crafted tropical woods, while the modern view-camera is wrought from exotic alloys and space-age plastics that have been finely machined for precise fit and repeated adjustment. Second, advances in

14

film technology have allowed the cameras to be sized down to a degree, thus making them much more manageable; today the most common size uses 4x5in film, as opposed to the 5x7in, 8x10in, 11x14in (and beyond) in vogue years ago. Nevertheless, some die-hard perfectionists still use gigantic view cameras for special projects.

Regardless of twentieth-century refinements, the view camera is a clumsy giant compared to the slick "35," so it must have some impressive advantages to retain such a loyal following among pragmatic professionals. There are two big pluses: image quality and image control. The quality factor is a simple function of size. An 8x10in enlargement from a 4x5in negative is a magnification of only two, so every aspect of image integrity is easily preserved and mechanical faults minimized. Detail and tonal gradation are excellent. Color saturation is spectacularly rich. And, as an added bonus, the large images are easy to view without a loupe or magnifier at the editing stage.

None of the elements of image quality are difficult for the nonprofessional to appreciate. The degree of image control that the view camera offers the competent professional is not so easy to understand without some theoretical background.

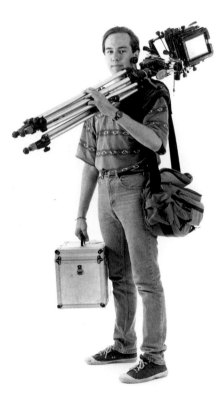

Photographer apprentice Leo Kopelow demonstrates my method of carrying around a 4x5in kit for available-light photography. The soft case holds twenty-five 4x5in film holders, while the hard case holds lenses and other accessories. A dark cloth is used as a shoulder pad to cushion the weight of the camera/tripod combination.

HOW THE VIEW CAMERA WORKS The view camera, or technical camera as it is sometimes called, provides a wonderfully clever system of opto-mechanical adjustments that allow precise control over field of view, focus, and perspective that no other camera system can emulate.

Ordinary cameras are rigidly constructed so that the lens and the film are always held in a particular alignment to one another. Although the lens is focused by mechanically varying its distance from the film, the mechanism by which it is moved is carefully designed so that the axis of the lens always maintains the same orientation relative to the film plane. Thus, the lens and the film may not always be the same distance apart, but, in all conventional solid-body cameras, a line drawn through the exact middle of the lens will always be located perfectly perpendicular to the film plane and always in a position that is perfectly centered within the image area. View cameras are designed to be similarly rigid and precise, but the alignment between the lens and the film plane is not fixed. Instead it may be adjusted and then locked in position. These adjustments (or movements) make the view camera a powerful and versatile photographic tool.

The modern view camera is constructed from a modular system of interlocking parts that may be selected by the photographer according to the requirements of various types of work, but the basic configuration typically consists of a rigid bar or tube (called the monorail) on which are mounted front and back standards linked by a flexible light-tight bellows. (The flatbed camera or field camera is an alternate configuration that is collapsible and lighter in weight, thus more portable but significantly less adjustable.)

The standards are sophisticated mechanical supports for the lens and the focusing ground glass/film holder. They are built to allow all the movements necessary for complete image control. They can be moved forward and backward (focus/magnification), up and down (rise/fall), and side to side (shift). They can be rotated around a vertical axis (swing) as well as tilted forward or backward around a horizontal axis (tilt). Fancy view cameras achieve the movements by manipulating precision geared mechanisms with finely calibrated vernier dials, while less expensive versions use friction-dampened sliding controls. All view cameras have some method of freezing the adjustments (lock) so that nothing changes just before or during the actual exposure.

View camera movements have three main functions: control of magnification, focus, and perspective. Control of magnification is sometimes important when making precise copy photographs of renderings or of architectural models. Focus control and perspective control are critical when making architectural photographs of rooms and buildings. For example, a street-level, wide-angle view of a tall building with a landscaped courtyard in the foreground might require a perfectly vertical rear standard to keep the image of the structure rectilinear in appearance, a substantial rise on the front standard to bring the top of the building into the field of view, and, in order to shift the plane of focus to include the complete foreground, a slight forward tilt of the front standard. The variations are subtle and endless and magnificently effective. Professionals cope with the long set-up times, the expense, and the physical burdens because the images that may be achieved with view cameras are consistently superior to those of other cameras. (See chapter 3 for more information on view cameras.)

HOW A PROFESSIONAL CREATES A PHOTOGRAPHS　Big cameras are not a guarantee of success in architectural photography. The technology must be in place, of course, but the real work is intellectual in nature, and requires a tricky balance between aesthetic and practical considerations. The process is called "previsualization," and it involves the assimilation and analysis of all information concerning the purpose of the photograph, the nature of the subject, the budget, and the expectations of the client. The term "previsualization" has a respectable pedigree: it was first introduced by the venerable nature photographer Ansel Adams as a compact way to describe the essence of the Zone System, the sophisticated method of exposure control Adams developed with Fred Archer.

Clients of competent professional photographers must expect to answer the following questions when a job is in the preliminary stages:

1. What is the purpose of the photography?
2. When is the photo required?
3. What is the state of completion of the subject building?
4. Is the landscaping in place?
5. Is the building occupied?
6. What is the orientation and material of the main facade?
7. How many different views are required?
8. Are architectural details and embellishments to be photographed separately?
9. Are there any special features that the client wishes to highlight?
10. Can furnishings and artwork be moved around during photography?
11. Is access to the site restricted to any particular time of day?
12. Is access to the site restricted by other structures nearby?
13. Is the client willing to arrange access, security, and site clean-up/preparation?
14. Will the client attend the shoot?
15. For out-of-town jobs, how will parties deal with time lost to bad weather?
16. Is the photographer's client the architect, the architect's client, or a magazine editor?
17. Who will evaluate the work and how will any costs for reshooting be handled?
18. Who will own/store the negatives after the job is done?
19. What is the budget, and who is to be billed? (see #16)
20. Will the client attend a pre-shooting walk-through of the project?

As these questions are answered the photographer will assemble a visual database that will assist in the selection of equipment and photographic approach. Every assignment is different. A tour of the site will suggest certain times of the day/year and certain camera angles. The client's expectations and budget will determine the degree of effort necessary and/or possible. Before the photography begins, most of the technical and artistic decisions will have been made, although flexibility and adaptability are necessary to cope with on-location variables such as weather and the activities of other people in or around the building.

Seasoned professionals are so good at previsualization that they can discuss the proposed photo as if it were a real object, although certainty will be moderated by common sense and no promises will be made that cannot be kept. The degree to which the description of the previsualized photo matches the picture that is actually delivered is a measure of a photographer's abilities.

PRICING　Aside from simply having to get the job done well, the cost of architectural photography is a fundamental concern for any client. Even the most well-established firm might hesitate to spend thousands of dollars for a comprehensive photographic documentation of a large project. Those unfamiliar with the price structure for professional work are often alarmed to learn the facts, and might quickly decide that first-class photography is financially out of range.

Although there will always be wide variations in pricing from place to place and between photographers working in different circumstances, some typical scenarios can be drawn by examining the evolution of a "day rate" for a well-established commercial photographer (a generalist of the type discussed earlier) who is asked to produce some first-rate views of a new building for publication in a national journal.

Most of the photographer's time is probably spent shooting a variety of assignments for advertising agencies, graphic designers, institutions, and corporations. Some of the work is done on location, but much is done in a studio (which the photographer owns or

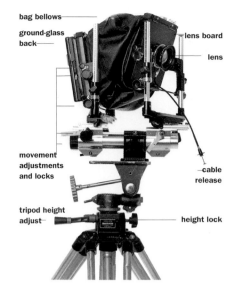

bag bellows
ground-glass back
lens board
lens
movement adjustments and locks
cable release
tripod height adjust
height lock

My battered and often repaired Toyo 45g 4x5in view camera with bag bellows and movements.

rents) under controlled conditions. This necessitates a sizable investment in lighting para-phernalia. Since the 4x5in view camera is the advertising industry standard for critical work as well as the camera of choice for architectural work, the basic equipment is close at hand. (Although much of the equipment used for commercial work is suitable for archi-tectural work, some specialized items may have to be purchased. Three or four ultra-wide-angle lenses, at up to $1500 each, are commonly required for shooting buildings and interiors but not essential for the majority of regular jobs.) Of necessity, the photographer will also own a complete 35mm kit. A medium-format camera, using 60mm roll film is a mandatory, but expensive, requirement for commercial work. Photographers working with high-end digital equipment will have leased or purchased hardware worth $50,000, or more. Very likely the photographer will maintain a darkroom for processing black-and-white, and possibly color, film and prints. Large-volume studios and the occasional perfectionist may also invest in equipment to process color transparencies.

Working tools quickly add up to an investment of between $100,000 to $250,000, excluding the cost of renting or purchasing a building in a downtown location for studio and darkroom space. A busy photographer may require a full-time or part-time assistant and a secretary. An agent or "rep" employed to find new clients or attend to existing accounts may get fifteen to forty percent of gross billings. All these expenses can easily create an overhead of several hundred dollars per day.

Other factors, such as a reputation for reliability, contribute to the rates photographers charge: a reputable shooter will guarantee good results first time out, relieving the client of the worry and aggravation of having to reshoot. In the advertising business, where the ability to produce extremely high-quality work in a very short time is critical, fees esca-late according to the cost of the campaign. A photographic illustration for an ad in a glossy national magazine (which might charge $50,000 for a one page insertion) may fetch up to $5000, while a similar image for a local newspaper (at $1000 for a full page) may be had for $200 or less. The operating principle here is that the more money is being spent buying the advertising space, the more responsibility rests on the shoulders of the photog-rapher to produce work that justifies the expenditure.

Well-established photographers typically bill at levels similar to lawyers and account-ants. A day rate for commercial work, the cost to the client for six to eight hours of a pho-tographer's time, may be anything from $500 to $5000, depending on the circumstances of the job and the particular professional.

The normal day rate for architectural work falls closer to the lower end of the scale. This is because the client, who might be an architect or interior designer, is likely to be the end user of the photographs and will not be reselling them at a profit; the budget for photography will therefore not support higher fees. Unfortunately, we have already seen that the good photographers (consequently the busy photographers) need higher rates to stay in business. In the specific case of photography for architectural journals, the rate structure is depressed compared to advertising photography standards because the photos are used for editorial commercial purposes. Even assignments from national magazines rarely exceed $1500 per day. In addition, most users of architectural photography are ignorant of the incidental costs of producing professional work. Other than the fees to the photographer, the client is ultimately responsible for Polaroid test shots, conventional color or black-and-white film, processing, proofs, and prints (as well as such extra expenses as transportation, accommodation, and meals on location).

The ubiquitous 35mm camera and the processing industry that supports it have condi-tioned consumers to low prices for photographs. Professional films are produced to much higher standards and in significantly smaller quantities, so they are substantially more expensive than materials intended for the amateur market. A typical professional photo-graph, produced in 4x5in format, might require the following expenses:

1. One to four Polaroid tests (to check camera alignment and exposure) at $4.00 each.
2. Two sheets color negative film (insurance against mechanical damage) at $5.00 each.
3. Film processing at $4.00 each
4. Proof print or contact sheet at $7.50 each
5. Reproduction quality enlargements at $20.00 each.

If clients are accustomed to buying blowups for $4.95 at the one-hour photo outlet, $50 or $80 per shot can be upsetting, considering that in an eight-hour day of continuous shoot-ing, a quick photographer can produce thirty or more large-format exposures.

An invoice from a professional lab/photog-rapher an an order form/envelope from a one-hour lab. Same industry, but profoundly different approaches.

There are several other variables that exert upward pressure on the cost of professional photographic services. First, most architectural work must of necessity be carried on outdoors, so the photographer and equipment are subjected to environmental stresses like temperature, moisture, dust, and wind, all of which are destructive to optical devices (and concentration). Second, variations of weather, sun angle, and the seasons sometimes result in canceled sessions due to conditions that are beyond the control of the photographer. Furthermore, location work demands advance planning, site inspections, and a variety of official authorizations.

Because commercial photography is essentially an exercise in control, the politics of the job and other capricious disruptions are disconcerting and, inevitably, expensive. Finally, within the advertising milieu the work of commercial photographers is usually judged by professional buyers of photography, so inconsistent and misguided evaluations, although possible, are rare. When the same photographers work for architects and related practitioners, the evaluation process is usually subjective at best, and often just plain arbitrary. Since the cost of reshooting to the client's satisfaction is often borne by the photographer, some cushion must be built into the negotiated price of the work.

SELECTING A PROFESSIONAL PHOTOGRAPHER

EXPERIENCE AND TEMPERAMENT Finding someone to make reproduction-quality architectural photographs involves a little research and some subjective decisions. The research is necessary just to turn up a few names: the yellow pages in the phone book will list "photographers, commercial," while colleagues and friends will recommend whomever they have been using. Probably the most reliable source will be the art directors at advertising agencies. Since these people regularly risk their reputation and many thousands of dollars of their clients' money on the work of professional photographers, they will know who is good in town.

As I mentioned earlier, it is unlikely that your search will turn up a professional who shoots only architectural work. It is more likely that your search will turn up competent people who have never shot architectural work. Even if you do find someone highly recommended who has shot some architectural work, the next step is the hardest: evaluating their photographic credentials and deciding whether or not you can work together.

Making a determination on a photographer's ability to perform on your behalf is a three-tiered process. First it is necessary to meet the person and, during an interview, make a judgment about character. Next, you will be shown a portfolio, and from that you will have to make a judgment about the quality of the work. Finally, you will have to assign at least one actual job, the results of which will hopefully confirm your choice.

Information about character and temperament will be gleaned in perfectly natural ways. Unless the name was actually plucked from the phone book, some aspects of reputation will be volunteered by whoever recommended the photographer. Look for genuine patience as the central element of the personality in any photographer you may consider. Typical advertising jobs might be conceived, organized, and shot within only two or three days, which is considerably shorter than the time required to design, construct, and photographically document a building. On assignment an architectural photographer stalking a certain shot might be obliged to wait hours for the right sunlight, days for the right weather, or months for the right season.

Since architectural assignments tend to involve extensive planning and the cooperation of many people, tact and consideration are necessary characteristics. Some successful commercial photographers work in a jet-set world of big budgets and bigger egos; in response, they can develop a rather abrasive and demanding personal style simply as a way of getting things done. This is inappropriate in the more measured and conservative environment in which architects and related practitioners function.

Finally, look for a photographer with a quick and original mind and an obvious and natural graphic sense. Much commercial work, although demanding, is highly stylized and rigidly structured. Photographers are generally provided with detailed layouts that must be matched precisely. There is no question that a great deal of skill is required to do this well, but a slightly different process exists in architectural photography. There are no layouts to follow on location; instead, the photographer must walk through and around the structure and extract views and angles that will result in an effective two dimensional

representation of the architect's intentions. As a client, you will depend on the photographer's ability to understand your work, and then respond to it in another "language."

EVALUATING A PHOTOGRAPHER'S PORTFOLIO Should you encounter a photographer who has done architectural work already, his or her portfolio will include original prints and possibly some recent tear sheets of published images. Presumably, anyone who has had work published in reputable journals has the skills that you need. I have already listed what I consider to be the necessary elements of good architectural photography. Nevertheless, trust your own response to the pictures you are shown. Do they evoke a mood appropriate to the subject? Do they accurately convey the intentions of the designer of the building pictured? Do they demonstrably enhance the positive characteristics of the building and minimize its flaws? Do you feel comfortable looking at the photographs, or must you exert some effort to extract the information you want? If your first response to the portfolio is ambivalent, you will likely have a negative reaction to photographs of your own projects produced by the same person. Fortunately, one's initial positive reaction can usually be trusted.

If the portfolio presented by the photographer does not contain specifically architectural images, the process of evaluation is somewhat more convoluted. You will have to extract from the photographs not only whether the photographer is competent, but also whether he or she can be educated (largely by you) to provide the results you need. If you feel out of your depth, perhaps a graphic artist friend might help you with the evaluation. Here are some basic guidelines:

1. The photographs should be clear, detailed, and natural in color.
2. Special effects should have a readily perceived purpose.
3. The graphic approach should make immediate sense.
4. The photos should include examples of first-rate work with all formats.
5. The graphic sense of the photographer will be easier to perceive in a B&W photograph.
6. There must be some photos that show an ability to work with large-scale subjects.
7. Photographers should select images to present that logically apply to your situation.
8. A photographer who shows more than a dozen photos is likely lacking in confidence.

ESTABLISHING A WORKING RELATIONSHIP Once you have found someone whose work and personality appeals to you, the next logical step is to give a test assignment. It should be a simple matter to select a project and describe the kind of photographs required, and then see if the photographer can complete the job on time and within the budget. Things get somewhat more complicated if the final shots are not exactly what you wanted. When the shoot goes well, everyone is usually happy. However, a photographer cannot produce exactly what is requested every time; why this is so, and the manner in which this situation is handled by the client will determine the nature of the relationship between the client and the photographer.

In assigning work, the client has a responsibility to keep his or her level of expectation within reasonable bounds. The experienced photographer will help (basically out of self-defense) by pointing out the limitations of the site and the building from a photographic perspective. Quite often, adjacent structures interfere with the best site-lines; sometimes the orientation of the building or the time of year prevents a decent sun angle. In fact, everything mentioned on the list of what makes a good architectural photograph has some sort of negative manifestation under certain circumstances, and clients must respect the photographer's diagnosis when expectations are being formulated.

The most difficult of all of these possible negative factors (and unfortunately, one that sometimes remains unspoken) is the architectural design of the building in question. Architects view their projects in the same way most people view their own children; they should always look good in a picture. The forces of ego work so strongly that even when presented with photographic evidence of deficiencies in the building, the unrealistic client would rather shoot the messenger than admit to any shortcomings in his own work. Such a client tends to try out one photographer after another, seeking the one who has the magic touch that will turn a sow's ear into a silk purse. Personal dishonesty is essentially self-defeating. It is in everyone's best interest to be profoundly realistic about the visual potential of projects that are to be documented.

Many designers make the mistake of assuming that professional photographers will immediately recognize and relate to the subtleties of their work. This assumption can lead to all kinds of trouble, especially at the beginning of the designer/photographer relationship. It is important to remember that in the absence of specific instructions most photographers, particularly those who are not specialists in architectural work, may not immediately understand what is good, bad, or indifferent about the project to be documented. It is only reasonable to point out those elements that are to be featured as well as deficiencies to be avoided or de-emphasized. Clients who avoid this process are like sick people who expect the doctor to guess where they hurt.

EVALUATING THE FINISHED WORK

LOOKING AT PROFESSIONAL PHOTOGRAPHS Excellence is a mark of professional work in any field, and some technical guidelines have already been provided for evaluating architectural photographs. Mastery of technique is a prerequisite, a foundation for the real work of making buildings look great. Everyone involved in the process—designer, photographer, publisher—essentially wants the same thing. However, it falls to the photographer alone to turn expectations and desires into two-dimensional reality. The final photograph is the evidence of how successful the effort has been.

The reasonable evaluation of a professional photograph is a process that begins long before the picture is delivered. In fact, the guidelines are established by the photographer, during the preparation for shooting. Earlier I mentioned the term "previsualization," the mental exercise that allows the photographer to accurately predict what the final images will look like. The wise buyer of architectural photography will become involved in the previsualization exercise during the site-tour, and perhaps at a meeting a day or two later, as a means of establishing what is and what is not reasonable to expect of the photographer. Once this has been established, a reasonable criterion, a reality-based criterion, by which the final images may be judged will have also been established. The evaluation of the photographer's work is therefore not an arbitrary exercise based on the subjective demands of the client; rather, it is a simple comparison between what the photographer said would be delivered and what is actually delivered.

Working together in this way through one or more cycles of previsualization/photography/evaluation will quickly show how trustworthy the photographer's judgment is.

TYPICAL AREAS OF DISPUTE Almost all grief related to architectural photography by professional photographers involves a foul-up in one of three areas: cost, deadlines, and "quality" of the images.

It is only prudent to work out the money matters before any shooting begins. The process of previsualization should encompass the budget as well as aesthetic matters, so the experienced photographer will be able to make an estimate that will accurately predict the amount on the final invoice. It is amazing how often the subject of money is avoided until the job is done and a bill is delivered. There must be some kind of subconscious avoidance mechanism at work that prevents otherwise rational people from dealing with such matters up front. It just does not make any sense.

At the beginning of a professional relationship, it is sensible to have a written quote in hand before giving the go-ahead on any job. It is not unfriendly or mean-spirited to maintain this practice as the relationship matures. Inevitably, a written agreement is protection for both parties. Nevertheless, it is very common in the high-speed world of commercial photography to rely on verbal agreements only; in the event of a dispute, lack of a contract or letter of agreement is a big disadvantage.

Unforeseen circumstances can punch holes in any agreement and some flexibility is required to make things work in the real world. Bad weather, uncooperative tenants, and clients who add to the shot-list while the job is in progress will slow down any photographer. The key to holding the line on costs and deadlines is consultation, however brief, whenever circumstances change. Surprise, not change, is the real killer. Photographers must not assume that clients will accommodate what might seem like unavoidable delays or expenses and clients must not assume that photographers are godlike manipulators of reality. A quick progress report or a civilized inquiry during the work will go a long way towards avoiding disputes later on.

Money and deadlines are fairly clear-cut matters and can be dealt with objectively, especially if a written agreement is in effect. "Quality" is not so easy to pin down, but if the procedures I suggested earlier are followed, really bitter disagreements over the professionalism of the work simply will not arise.

There is one circumstance, however, that can result in major arguments, regardless of the degree of harmony between photographer and client. In this case, the mutual preparations are useless, because there is a hidden client, a third party, that must evaluate the photographs for their own purposes. This happens whenever photographs are intended for publication, or when the client's client will be the ultimate user. In these situations the photographer's client is in reality acting as an agent for somebody else. The wild card is the third party's prerogative of rejecting the work. It is amazing how quickly things change for the photographer when the person for whom the photos were produced is under negative pressure from outside.

This is a circumstance in which the integrity and self-confidence of both photographer and client are tested. Some clients will approve the results of a particular assignment but then, at a later time, will defer to the negative judgment of a third party and demand a reshoot. This, in my opinion, is unprofessional behavior. On the other hand, a client with some backbone and self respect will stand by his own good judgment and support his or her supplier. More often than not, a tactful yet strong show of support will be enough to reverse what is, in reality, a subjective evaluation made at a distance.

CIRCUMSTANCES THAT REQUIRE A RESHOOT From time to time even the most meticulous preparations will result in photographs that are unacceptable. The photographer's client is the ultimate judge, and if the photographer wants the work, the client must be satisfied. A reshoot will only be necessary when a photographer has not delivered what was promised; the promise will have been made and understood early on, so the failure to deliver will be obvious, and the remedy is to do it again. Incompetence is not necessarily the reason for such failures, and a reshoot, although unpleasant and inconvenient, does not necessarily mark the end of a productive relationship. The opposite may often be true. When working with reputable people a reshoot will simply serve to sharpen attention, thus enhancing the process of collaboration and planning on the next go-round.

When the reshoot is precipitated by the photographer's own error, misjudgment, or carelessness, there is no question that the entire cost of the "repair" is his. However, when the client's ambiguous instructions or simple change of mind has caused the problem, the costs should be covered by the client. When the reason for the reshoot falls somewhere in the middle, when bad photos result from assumptions and expectations on both sides not properly resolved in the previsualization stage, a negotiated sharing of expenses is the only acceptable course.

When dealing with a third-party demand for a reshoot, the satisfied client should make the case that extra costs should be covered by that third party, unless this will result in a loss of face that cannot be accepted. Then the client must bite the bullet and pay for the additional work. When budgets are tight and the client/photographer rapport is strong, the photographer may chose to share the burden as a professional courtesy. Should this happen often, however, the client risks losing the goodwill of the photographer.

Any self-respecting photographer will have a clear insight into what is and is not acceptable work. In most cases a good professional will arrange for a reshoot, without even informing the client, whenever the results of a session fall below his or her professional standards. It is not unusual for some tricky shots to be redone two or three or even four times before a particular effect is captured exactly as the photographer wishes. The seemingly high rates of some photographers are calculated to accommodate this level of perfectionism. Bargain-basement shooters do not work in this way because they don't know any better or simply cannot afford the expense. Professionals work in this way when they are paid well enough. Clients who shortchange their suppliers ultimately do themselves an injury.

TRAINING YOUR PHOTOGRAPHER A good commercial portfolio will demonstrate technical skills, and an accommodating personality will assure satisfactory interaction on a human level, but if a reshoot of the first or second assignment is necessary it will indicate that the photographer you have selected needs some instruction specific to the discipline

of architectural work. What is missing will most likely be a subjective element and, consequently something difficult to convey in words. The process of teaching a photographer to properly record your projects is more of an apprenticeship, a transmittal of a design tradition, an introduction to your world view.

My own introduction to architectural photography exemplifies this process. Some fifteen years ago I was starting out as a commercial photographer in Winnipeg, a city of 500,000 in the Canadian midwest. By a stroke of fate one of my clients, a graphic designer, asked me to produce some photographs to illustrate a color brochure he was doing for a group of mechanical engineers. The job involved photographs of several high-profile buildings that the engineering firm had worked on. These buildings were spread out across the country, and one "pretty" image was required for each of them. I would have one day to shoot at each location.

I had no previous experience with buildings, so I treated them like any other product. Because I was unable to consult with the architects, I asked myself what camera angle and what sun angle would best showcase what I felt were the important features of the structures, and, with only a few hours to work, I took my chances with the sky and weather conditions. The resulting photos were simple, but graphically strong. I had responded intuitively to the design of the buildings, and I had good luck with the lighting. The printed brochure turned out to be an attractive piece, and with a dozen copies under my arm I approached some local architects directly, hoping that there might be a market for this type of work.

I had no takers at first, but six months after my "campaign," one firm called me back. They had been short-listed for a major project, but had just lost out. They figured that the deciding factor was that their competitor had a better slide show; it was time to upgrade their library of photographs and the chief of design had remembered my work. He wanted to know if I would be interested in shooting a building they had recently finished.

The job was located in a city a few hundred miles away from home. I packed up my 4x5in gear and flew out there for a day and produced a dozen pleasing views. On my return I printed up some sample enlargements and presented them to my client, who was not satisfied. The pictures were attractive enough, he said, but I had missed shooting the "details." Would I go back again, and work closer to the building this time? This time bring back lots of pictures. He should have been more precise in describing what he wanted, he said. Money was not a problem. I could work for a couple of days if I needed to.

On the second trip I examined the building more closely; the second set of images used the overall architectural design as a starting point, but my main focus was on the components and surfaces of the building, on the mechanical fittings, the details of windows and doors, the textures of the building's skin. I started to realize that a building is more than a product, more than a just a big object. Buildings are densely designed, mechanically layered, sculpturally represented—all the important elements were not accessible in one glance.

When I spread out the second set of enlargements, thirty in all, I was confident that I had been successful in fulfilling the client's demands. Yes, he said this was good, and this was good, and this was good: but of the thirty prints he liked only six. Go back again, he said, and redo this shot in the early evening, just as the sky was turning magenta or dark blue. Reshoot this corner detail, but at sunrise so that the surface just catches the orange glow as it slides around the edge. Yes, this view of the windows on the west side is great, but go back and shoot it again at mid morning when the facade is in shadow. You would get a spectacular reflection of the building next door that will put all the other shots in some kind of context.

So, I went back again, but this time I was working differently. My client cared about his work. My client loved his work. He expected me to understand and to appreciate his work on the most subtle and rarefied levels. Also, he expected me to do my work in the same way—to complement his designs with strong photos that showed what he had done, and why. My client educated me to his needs, and, after that introduction, I was able to regularly (and much more efficiently) provide what he wanted.

II WHEN TO DO IT YOURSELF

TYPICAL IN-HOUSE PHOTOGRAPHY

COSTS AND BENEFITS Professional architectural photography is an expensive proposition. The benefits that result when your firm's work appears in a national or international journal or when new work is brought in because of an impressive photographic presentation do ultimately justify the costs. Nevertheless, image-building is a slow business and a return on investment may be years in coming. The question arises; how can a range of utilitarian and exotic photographic needs be satisfied without breaking the bank?

One solution might be to find a talented photographer just beginning his or her career, and teach them how to do the necessary work. This is a satisfactory approach as long as one is prepared to start again with someone new whenever the first protege evolves beyond one's price range or moves to a bigger or more glamorous market. This can be a yearly cycle with ambitious young photographers.

If the money and the time it takes to "break in" a fresh photographer are obstacles that stand in your way, consider learning to do the photography yourself. You, or someone in your firm, can use the time that would otherwise be spent supervising a professional to acquire the basic technical skills. At the same time, the money, or part of the money, that would have been spent on professional fees and expenses could be spent acquiring the basic tools and materials to produce the work. Of course, an amateur will never be able to compete with a professional all the time, but with the right approach a motivated amateur can do a tremendous amount of pleasing work at a fraction of the cost. At the very least, someone who has attempted to do this work on their own will end up qualified to manage a professional architectural photographer when sufficient funds do become available.

We have seen that the fixed costs borne by a professional can result in a cost of up to $60 per image when that image is produced with several others during a day or half-day of shooting. When only one signature image is requested the tariff can rise to $100 or even $500. Such costs are justified by the equipment, the time, and the talent of the photographer. It is unlikely that a nonprofessional will match the professionally obtained results exactly, no matter how inspired that amateur may be. One major difference, as we have seen, is the formidable technical gap between 4x5in and 35mm equipment.

But let us agree, for the moment, to overlook this opto-mechanical barrier. Can the amateur compete with the professional on the aesthetic level? I say yes, particularly if the amateur is trained and experienced in some other design modality. Even an appreciation of design in some other form—be it architectural, mechanical, or structural—is enough to engender an ability to render a pleasingly composed photograph, provided a minimum of technical knowledge is present as well. Photographic technology is just not so intimidating that it prevents professionals working in some other discipline from learning to use it effectively.

A direct comparison of the costs of professionally produced work and that produced by amateurs is difficult unless the technical approach is consistent for both of them. However, assume that a large-format-equipped professional can produce a decent 8x10in print of a certain building under certain conditions for $150. My opinion is that a well-prepared amateur, using 35mm equipment, can produce an 8x10in print of the same shot, made under the same conditions, for under $25. Now, a "well-prepared" amateur will have spent some money on equipment and some time learning how to use it, but if that is done properly, the only unavoidable difference between the photos will be the technical superiority of large-format cameras over small-format cameras. Again, in my opinion, this technical disparity can be made small enough to be insignificant for many applications.

WHO DOES THE WORK Photographs play a significant role in any marketing or promotional thrust. Secondary uses might be progress reports, historical documentation, or documentation of deficiencies in a contractor's performance. If architectural photography is to be done in-house, it seems logical that the person who has the most pressing need for the photos should actually produce them, or directly supervise whoever does. However a problem arises in pinpointing the appropriate person because each area of photography is important to different people. For example, the partner who is responsible for litigation with a dishonest sub-contractor has a pressing need for clear visual evidence of shoddy workmanship, while the partner responsible for finding new work has a pressing need for strong, attractive images that will showcase the firm's premier projects.

Professional photographers sidestep this apparent dilemma because they usually are people in whom a love and appreciation of the technical and the practical are combined with an active and highly developed aesthetic impulse. Architects fit this same profile to some degree in that all levels of design, from the aesthetic to the mechanical, are major concerns. In actual practice, however, hands-on technical work is often minimal. Selecting structural materials and site inspections are the closest most designers get. The production of decent photographs begins as an exercise in the control of a moderately complicated technical process, and anyone who will do well at it must have an affinity for technology itself. Still, a technician alone cannot produce beautiful photographs: an artistic element must be grafted onto the mechanical.

Every firm will already have established a productive system for the division of labor among members of different temperaments and capabilities. If in-house architectural photography is to be undertaken, then the responsibilities for doing a proper job of it should be integrated into the existing structure, rather than haphazardly imposed upon it. Sufficient time should be taken in the early stages to plan who is to be responsible for what based on interest, capability, and the need to know. Because photography is popularly conceived to be something anyone can do, there will be pressure not to take this process very seriously. It is counterproductive to take this view, however. Later, when the work is flowing smoothly and the benefits of producing the photographs in-house start to accrue, everyone will be pleased.

TYPICAL EQUIPMENT, MATERIALS, TECHNIQUES Most practitioners who attempt to photograph their own work start out with some form of 35mm camera. Occasionally, an instant camera will be used, but only for "quick and dirty" snapshots where the quality of the image is not as important as the content and the speed with which it develops.

Generally slides or prints are shot with somebody's personal camera (likely equipped with zoom lens and auto-exposure) and then processed at the drug-store or one-hour photofinishing outlet. The resulting piles of unedited slides, negatives, and 3x5in prints are stashed haphazardly around the office. A proposal call or a presentation to a prospective client precipitates a feverish search for a few vaguely remembered images, and then a mad rush back to the photofinisher who is hard pressed to produce four or five mushy looking machine-made enlargements by two o'clock the same day. These substandard prints are then meticulously mounted on carefully laid-out and lettered display boards and sent by a courier in a panic to wherever the meeting is to take place; lack of time is offered as the excuse for the poor quality of the photos...sound familiar?

The more organized office may already own a 35mm camera, two or three interchangeable lenses, and perhaps a tripod. Whoever heads out on an inspection tour of a job in progress will grab a few shots on the run. When the job is completed, the designer responsible for the project might take a couple of photos before the client or the tenant moves in. Technically, the final images are more consistent because a professional lab rather than the one-hour outlet at the mall does the processing. The prints, negatives, and slides may even be chronologically arranged in a dedicated binder with plastic storage pages. Overall, this approach is superior to the first, but the images themselves, although noticeably better technically, are still just snapshots.

WHEN TO IMPROVE YOUR SKILLS

EVALUATING YOUR CURRENT PRACTICES As I mentioned earlier, we are experiencing a proliferation of highly "produced" images. All printed media, from billboards to soup-can labels, incorporate photographs that are skillfully made and lavishly presented. Popular magazines, professional journals, and gorgeous "coffee table" books regularly deliver first-class architectural photography. Consequently, all of us are fully aware of what level of work is possible, at least from professionals.

We have been educated by a kind of visual osmosis, and it is this unconscious awareness of what is possible that allows a practical evaluation of one's own photographic efforts. Right now, it may not be possible to identify exactly why one photograph is different from another, but certainly some discrepancy is immediately evident. If this discrepancy is creating discomfort when presentations are being prepared and presented, when prospective clients are reviewing your shots of completed projects, or when you are simply looking

for something decent to tack up on your walls at the office, it is time to improve your skills as a photographer.

FORMALIZING YOUR REQUIREMENTS To improve one's efforts requires the establishment of a goal, and a path by which that goal may be obtained. It is not unreasonable to wish to emulate the work of the very best professional photographers, but it may be technically and financially impractical. Let us assume for now that some professional-level work is not impossible for an amateur to produce, given the right tools, materials, and training. At this point it is necessary to determine what the requirements really are, and which of those requirements may be economically and efficiently fulfilled in-house.

Here, arranged basically in ascending order of technical difficulty, is a comprehensive list of photographic problems routinely dealt with by professionals:

1. Copy work of drawings, renderings and perspectives.
2. Progress/construction photos/historical documentation (exterior views).
3. Exterior views of uncrowded, well-landscaped low, medium, and high-rise buildings.
4. Progress/construction photos/historical documentation (interior views).
5. Photographs of architectural models.
6. Interior views of large and very large spaces (available daylight).
7. Interior views under tungsten, fluorescent, or mercury/sodium vapor artificial light.
8. Interior views under mixed artificial light.
9. Interior views as above, but with supplemental photographic lighting.
10. Exterior and interior views as above but in very crowded conditions.
11. Exterior views as above but at night.
12. Exterior views as above but with supplemental photographic lighting.
13. Exterior views as above but under winter conditions.

All the work mentioned can be produced at any of several different levels of sophistication (in ascending order):

1. Legal/documentary.
2. Reproduction-quality black-and-white for newspapers or press releases.
3. Color prints for portfolio/presentation.
4. Reproduction-quality color prints or slides for publication in professional journals.
5. Fine-art-quality prints for display in homes, offices, galleries, and "glitzy" books.

An image that exists on the fine art level can be rendered suitable for legal/documentary purposes, but the reverse is not usually possible.

At some time or other, photographs that represent every combination of these two lists will be required by every practitioner. I suggest that, by extrapolating from my lists, a list of your own be drawn up (arranged in ascending order of importance) that records your requirements from the past couple of years. Add to your list whatever you anticipate will be needed in the near future.

REASONABLE EXPECTATIONS There is no question in my mind that anyone interested in doing so can learn to produce results of portfolio/presentation quality working in the situations one through seven as described above using only a 35mm camera and a modest assortment of accessories. Highly motivated individuals, who are willing to invest more time and perhaps an additional $1500-$2500 in more sophisticated accessories, can expect to add eight through thirteen as well as push their work up to reproduction or even fine art quality in some circumstances.

PROFESSIONAL VERSUS AN ADVANCED AMATEUR In the description of how a professional photographer goes about creating a photograph I indicated that the operative principal was a process called previsualization. In the following chapters technical information and aesthetic guidelines will be offered that will allow those of you who are interested to use this same technique to determine what is and what is not possible for you to undertake successfully on your own. Once you are capable of making this decision reliably, you will know when it is appropriate and financially sensible to hire a professional and when to tackle the job yourself.

III BASIC TECHNICAL CONSIDERATIONS

EQUIPMENT

VIEW-CAMERA BASICS Although I have assumed so far that any amateur who wishes to do architectural photography will select 35mm cameras as working tools, this need not always be the case. An informed choice of cameras cannot be made without an understanding of the relative advantages of the various systems available. We have already learned that the view camera offers a wide range of technical adjustments, but exactly what these adjustments are and how they facilitate the photography of buildings deserves a little more study. Once an understanding of the control possible with a large-format camera is achieved, the capabilities of small- and medium-format cameras will be much easier to appreciate.

As described in chapter one, the view camera is mechanically configured to allow virtually limitless adjustments to the relative positions of the film plane and the lens. Solid-body cameras need lenses that project an image just large enough to cover the frame from corner to corner, but view-camera movements work only if the projected image is sufficiently wide to accommodate any significant off-axis displacements. Lenses with good coverage and high resolution are difficult to make and expensive to buy, particularly for the extreme wide-angle types so necessary for architectural work. It is encouraging to note, however, that truly excellent large-format lenses are readily available today, whereas even fifteen years ago they were very hard to come by at any price.

28

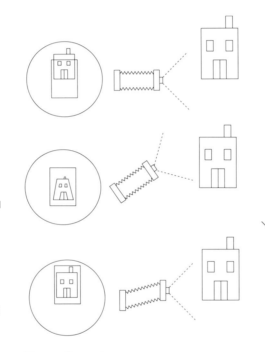

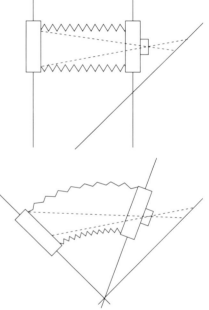

Clockwise from top left: A schematic of a conventional monorail view camera as seen from the side, with no movements; the same camera viewed from the top— again, no movements; a top view showing front and rear swing; a top view showing front and back shifts.

The top figure shows how the image of a tall subject is projected by a lens mounted on a view camera employing no movements. The top of the building is cut off at the film, even though a complete image of the subject is present within the image circle projected by the lens. The center figure shows how the image of the subject changes when the camera and lens are tilted upward. The image of the subject is now within the boundaries of the film, but the vertical lines of the subject now converge. The bottom figure shows how the image of the subject is affected by implementing front rise. The image of the subject is now within the boundaries of the film, and all vertical lines are parallel.

These drawings illustrate the famous Schlemflug principal governing view camera focus-control technique. In the top figure the film and lens planes are parallel, but not the subject plane. The Schlemflug principal states that the image of the subject will be in perfect focus at the film plane only if imaginary lines extended from the film, lens, and subjects planes intersect at a point. The bottom figure shows how front and rear view camera tilts permit this condition to be achieved. Note that projections from the three critical planes now intersect. The subject will now be in critical focus at the film plane.

Front rise is the most useful view-camera control for architectural photography. Ordinarily, if a camera is level and pointed at a tall subject, the top part of the subject will not be visible, even if the camera is fitted with a wide-angle lens. Tilting the camera upward brings the whole subject into view, but the vertical lines of the subject will appear to converge. Front rise keeps the vertical lines parallel by allowing the film plane to remain vertical. The upper part of the subject is brought into view by a vertical displacement of the lens above the center of the film plane (the lens is physically moved upwards), rather than by tilting the camera. (Refer to the accompanying diagrams for a technical explanation of this procedure.) Front fall is used in a similar way when the subject extends below the uncorrected field of view. Rear rise and fall are used whenever front rise and fall is insufficient, but the camera will have to be raised or lowered to maintain the composition.

Front and rear shifts are horizontal displacements of the lens or the film. These controls allow very wide subjects to be accommodated in the same way that front rise and fall accommodates very tall subjects. Sometimes a dead-on rectilinear view cannot be achieved because the perfect camera position is blocked by an obstacle; in such awkward circumstances shifting the lens and/or the rear standard will allow an off-center camera location while still maintaining perspective integrity. This is very useful for shooting architectural interiors and for eliminating bothersome reflections.

Front swings and tilts are focus controls. Virtually all lenses are designed so that the plane of focus is a flat field oriented perpendicular to the axis of the lens. Focus problems arise whenever the plane of focus is not parallel to the subject plane. Such a misalignment occurs whenever the camera must be tilted, for example, to encompass a tall subject. The view camera allows the lens, and thus the plane of focus, to be conveniently manipulated; close and distant subjects may be reproduced in sharp focus by simply tilting or swinging the lens board.

Back swings and tilts are movements of the film plane used to alter perspective, vantage point, and plane of focus. To preserve natural perspective, the subject and the film plane must be parallel. Back swings and tilts are used to maintain this critical relationship whenever the camera must be tilted or angled to accommodate a particularly wide subject that cannot be included even with fully extended front rise, fall, or shift. In such cases front tilt and/or swing is used to restore focus.

On a monorail-type view camera both front and rear standards may be used for focusing. Image size (magnification) at the film plane is a function of the lens-to-subject distance. This is controlled by first setting the lens-to-subject distance on the front standard and then fine-tuning the focus by adjusting the rear standard. Flatbed or field cameras do not usually allow back focusing, so the whole camera must be moved to change image size. This is a limitation in precise studio work, but not a problem for general architectural photography.

Focusing is accomplished by viewing the reversed and inverted image that the lens projects on a ground-glass screen. The shutter must be open and the film holder removed before the image can be seen on the ground glass. Unfortunately, the image is often maddeningly dark and difficult to evaluate, particularly with wide-angle lenses. A loupe or flip-down jeweler's magnifier is an indispensable focusing aid, as is a light-proof, dark cloth to shade the ground glass. Once the photograph has been lined up and carefully focused, the shutter must be closed and a film holder inserted in order to make an exposure. The vagaries of focusing a view camera under difficult circumstances make Polaroid tests for focus and composition indispensable.

View cameras are available in an astounding variety of sizes. Film dimensions range from 2 1/4x2 3/4in to 20x24in. The most common large format, 4x5in, has evolved as the compromise; it successfully balances technical quality, camera weight, and a focusing image that is sufficiently large to view without eyestrain.

SMALL-FORMAT BASICS Miniature cameras forgo almost all the technical advantages of larger cameras in exchange for convenience of operation. In the not-too-distant past, this trade-off made small cameras third fiddle to medium- and large-format cameras, at least as far as professionals were concerned. Recently, however, there have been some changes. Like the internal combustion engine, which has been sustained over many decades by heroic engineering, the 35mm camera has been revitalized and elevated by several scientific advances, particularly in film technology. Fortunately for 35mm enthusiasts,

small-format images are noticeably improved. Even in professional circles the little negatives are acknowledged as quite satisfactory in many applications, whereas previously they were barely acceptable. (Large-format users have also benefited from film improvements; 4x5in image quality has skyrocketed.)

Although there are several different mechanical manifestations of 35mm equipment, the single lens reflex, or SLR, is the most highly developed and the one most suited to our purposes. The term "single lens reflex" refers to the basic design of the camera, which uses a hinged, front-surfaced mirror to divert the image projected by the lens into the viewfinder. A prism in the finder presents a bright, right-side-up image at the camera's eyepiece. Because the taking lens is also the viewing lens, it is possible to preview almost exactly what the film will record, at least in terms of the composition. The mirror retracts up and out of the way during the instant of exposure. This clever system permits lenses with different characteristics (wide-angle, telephoto, zoom, etc.) to be easily interchanged, making the SLR a very versatile tool.

This illustration describes the function of a single lens reflex (SLR) camera. In the viewing mode, the image projected by the lens is diverted by a mirror onto a small, ground-glass screen. The image that is formed on the screen is reversed left to right and upside down by the lens. This condition is corrected by the prism, which also diverts the image to the eyepiece for viewing. When a photograph is made, the mirror is momentarily flipped up out of the way so that the image projected by the lens can reach the film. At the same instant, the automatic diaphragm mechanism sets the aperture to the correct f-stop. After the exposure the mirror and aperture automatically return to their former positions.

A comprehensive 35mm system. The top row shows various lens shades; below are lenses from 20mm to 300mm in focal length. My rather battered Nikon F3 SLR camera sits on top of a motor drive attachment. A 28mm PC lens (shown on page 54) should be included.

There are, of course, many optional bells and whistles, such as auto-focus and auto-exposure, associated with today's SLR cameras, but for our purposes nothing except lens interchangeability is really important. Improvements in optical performance and a wider selection of lenses are the recent developments specific to small-format equipment that are critical for architectural work. Because the 35mm SLR is so universally popular, high-quality cameras and lenses are available at prices that are only a fraction of the cost of view-camera equipment. Because the viewfinder system is bright, accurate, and quick, 35mm SLR cameras are extremely easy to use. A comprehensive system consisting of several lenses, a couple of camera bodies, and a few other accessories can weigh less than twenty pounds and occupy less than one cubic foot of space. Because 35mm film is consumed in huge quantities, and because ten 35mm images use the same amount of material as one 4x5in image, operating expenses for small cameras are remarkably low.

MEDIUM-FORMAT BASICS Medium-format cameras use 60mm-wide roll film. They are hybrids that borrow technical features from both large and small formats. As is the case for 35mm systems, the most popular medium-format configuration is the single lens reflex. Effortless interchangeability of lenses is again the major advantage, although interchangeability is often extended to film backs (35mm, 6x4.5cm, 6x6cm, 6x7cm, 6x9cm, and Polaroid backs are available for some professional cameras) and viewfinders. With an image area up to five times greater than that of 35mm images, medium-format negatives and slides can be made sharper and more detailed; they are also much easier to view when editing. Unfortunately, a penalty in bulk and weight must be paid in exchange. Only very recently have medium-format systems evolved close to the point where they are as fast to operate as their miniature counterparts. (Several medium-format systems have now incorporated motorized film advance and auto-exposure, and a few have added auto-focus.) The choice of lenses offered even by the most progressive manufacturers is limited compared to what is available for 35mm. Prices for quality equipment are astronomical.

SELECTING A FORMAT Deciding on a working format involves a three-way trade-off between cost, image-making ability, and practicality. In absolute terms, large format wins for sheer technical virtuosity and small format wins for ease of operation and low cost. In the commercial world, work that does not require view-camera movements is usually done with medium-format equipment, the most efficient way of producing excellent technical quality while still permitting the photographer to maintain a rapid pace.

A medium-format SLR system (Hasselblad). Left to right rows, top to bottom: roll film back, Polaroid back, incident me-ter; 6x6 SLR, cable release, hand grip; 40mm, 60mm, and 150mm lenses; level, lens shades.

The choice for budget-restricted architectural photographers is difficult to make, since view-camera movements are absolutely essential for many difficult shots. Nevertheless, two special considerations, both of which I have held back until now, tip the scales toward 35mm as the most sensible way to go.

The first special consideration has to do with the recent introduction of several high-performance films, most notably Kodak's Ektar 25 and Ektar 125, new high resolution color negative films. Enlargements pulled from 35mm Ektar 25 negatives look like prints made from the very best medium format films of only three or four years ago. (Ektar 125 sacrifices surprisingly little resolution for a significant increase in speed.)

The second, and equally persuasive, consideration is the availability of certain special lenses that mimic some view-camera movements. These clever devices, referred to as perspective control (PC) lenses, provide a limited degree of vertical rise, vertical fall, and/or horizontal shift. Although PC lenses are available for medium-format cameras, they are not as flexible as the 35mm variety. A little later I will be more specific about the technical capabilities of the 35mm format, PC lenses, and high-resolution films like Ektar 25, but for now I will simply say that I recommend the small-format approach for in-house architectural photography. *(See color plates 1 and 2.)*

32

An interesting coincidence. My 35mm photo on the front cover, and my 4x5in photo on the back cover. Quality is fairly consistent since the 35mm image is simple and bold, while the 4x5in image is highly detailed.

CAMERA BASICS Having made some preliminary arguments, it is time to begin assembling the technical knowledge necessary to start shooting.

A camera is a light-tight box that holds a lens and a light-sensitive material (film) in precise mechanical alignment. The lens projects an image of some object onto the film, which, after chemical development, becomes a permanent record of that image. The amount of image-forming light must be regulated to accommodate the physical characteristics of the film. This regulation is achieved with two specialized mechanical devices: a shutter and a diaphragm.

The shutter is a door through which the light must pass. It may be set to open and close automatically for short periods of time (1/1000 second to 1 second), or it may be operated manually for longer periods of time.

The diaphragm controls the size of a variable aperture (much like the iris of the human eye) that is built into the lens. The size of the opening is carefully calibrated in units called f-stops. The larger the area of the aperture opening, the greater the intensity (or brightness) of the light that is passed by the lens. F-stops are determined by the formula $f = F/d$, where "F" is the focal length of the lens (the distance from the center of a particular lens to the film plane when the lens is focused precisely on a very distant object), and "d" is the diameter of the lens entrance pupil. A large "f" number means that a dim or low intensity light is passed by the lens. For photographic purposes a maximum aperture of f1 is considered quite large, whereas f64 would be considered small. The light-gathering capability of the lens (the speed of the lens), is a function of the size of the aperture.

These 35mm slides show how quick and easy to use small-format equipment can be. These photos and color plates 3–8, details of heritage buildings in downtown Winnipeg, were all made during a two-hour stroll on a warm summer evening. I carried only a camera and a long telephoto lens. In lieu of a tripod, I braced myself against various street-level objects like posts or buildings to avoid camera shake.

III

33

For the purpose of determining the correct exposure (the amount of light permitted to strike a particular film), the aperture setting and the shutter speed are inversely related; in other words, if the aperture is increased (widened) the shutter speed must be decreased (shortened in duration), and vice versa. All cameras of all formats incorporate a lens, a diaphragm, a shutter, and a light-tight box to hold them together.

A 35MM PRIMER We have, of course, a special interest in the 35mm versions of the light-tight box. The evolution of the 35mm camera began with basic elements but now includes comprehensive photographic systems that may be tailored to suit a wide variety of photographic purposes. Much of what is offered by the various manufacturers is not necessary for what we have to do. You will see that many of the innovations that are so prolifically advertised at such great expense are actually hindrances. In fact, 35mm architectural photography requires only the most basic camera functions.

Here is a list of the most valuable features, followed by a brief explanation of why I think they are so important:
1. Sturdy and precise construction.
2. A built-in light meter that may be operated manually.
3. A wide selection of quality optics (including PC lenses).
4. An electronically governed shutter with an extended slow-speed range.
5. A tripod socket.

1. As a fundamental prerequisite, the machine with which the work is done need not be fancy, but must be reliable and accurate. This means that the camera body, the "light-tight box," must be physically robust with an accurate film-handling mechanism and a rigid lens mount. 35mm SLR cameras always have a shutter built in, unlike view cameras and many medium-format cameras that have a separate shutter in each lens, so results with all lenses depend on the performance of the camera itself. Since the single lens reflex design uses a moving mirror together with a fixed prism, a small ground-glass screen, and a Fresnel lens for viewing and focusing, the positioning and stability of these components are also critical. Fortunately, all of these variables are well controlled in the products of the major camera manufacturers.

2. It is necessary to measure the brightness level of any scene that is being photographed so that the camera shutter and the lens aperture can be preset to produce the optimum result on the film. Virtually all SLRs available today have a metering system that measures the light gathered by the lens. Since these meters see what the lens sees they are called through-the-lens (TTL) or behind-the-lens (BTL) meters. Although many professionals prefer hand-held exposure meters of various types, BTL meters are more than satisfactory in most circumstances provided they can be used in a nonautomatic mode. The situations encountered by architectural photographers are not the same as the scenes with which automatic-exposure systems are programmed to cope. If the auto-exposure system cannot be disabled by the photographer when necessary, results are poor. When and how tiffs should be done will be examined later.

3. Easy lens interchangeability is one of the most attractive features of small cameras. All modern cameras use a bayonet-type mount with a spring-loaded latch. Some older cameras use fussy screw mounts while bargain-basement brands have mounts that are sloppy and unreliable. Precise focus depends upon precise alignment between lens, film, and focusing system. This is, in fact, the camera body's main mechanical function. In addition, since SLRs use the taking lens as part of the viewfinder, the lens's diaphragm must be open wide to allow the brightest possible image for ease of composing and focusing. At the instant of exposure the diaphragm must be closed down to the correct working aperture as determined by the exposure meter. An automatic diaphragm (as opposed to a manual or preset diaphragm) that accomplishes this function is built into the camera body and couples to each lens via a small pin or lever in the lens mount. The complexity and inherent fragility of this important mechanism is another reason to buy professional-quality equipment.

The most important aspect of lens interchangeability is not mechanical, but optical in nature. On a basic level, various kinds of lenses offer various kinds of photographic effects, the value of which will be discussed in detail shortly. On a more sophisticated level, the optical properties (the performance) of a particular lens sets an upper limit on the quality of the final images. There are many subtle technical parameters that must be carefully optimized by lens makers, particularly for extreme wide-angle and PC lenses. Superior lenses are absolutely essential for good work. (This condition is an absolute for work with high-end digital capture, as well: *See Chapter 17.*)

4. Earlier I discussed the role played by the adjustable diaphragm in setting the correct exposure. There is, however, another crucial photographic variable that is altered whenever the diaphragm is changed in size. It is called depth of field and refers to the range of acceptable image sharpness around the point of perfect focus. For example, a lens set at a moderately wide aperture and focused on an object ten feet away might render two other objects positioned nine and twelve feet away as acceptably clear; in this case, the depth of field would be two feet. If, however, a much smaller aperture was selected, objects located at seven feet and at fourteen feet might be in focus, as well. The depth of field would now be seven feet. Wide depth of field is often required for architectural subjects. You will recall that reducing aperture size also reduces the amount of light reaching the film, and that extending the length of the exposure compensates for this. In practice, the exposure times for much architectural work ranges from one-half second to sixty seconds. A camera that is capable of electronically timing long exposures is very convenient.

5. Of course, it is impossible to hold a camera critically steady for long exposures without a tripod.

AN OVERVIEW OF FILM TYPES Photographic films are made by coating a thin layer of light-sensitive material on a plastic base. Energy, in the form of photons, triggers changes in the sensitive material at the molecular level. These changes are rendered permanent, and visible to the human eye, by chemical development. When the photons are organized and delivered to the surface of the film by a photographic lens, an image of some object can be recorded as a two-dimensional pattern. When photography was a new technology, these patterns could only be captured as variations of light and dark, but soon systems for color reproduction were devised as well. Today there is an amazing choice of photographic films available from three basic categories: black-and-white negative, color negative, and color positive. Each film type has very specific properties and applications.

Black-and-white photographs are required for newspapers, newsletters, historical records, and legal documentation, as well as for reproduction in magazines and books. As an aesthetic statement, monochromatic images bypass the distractions of color and emphasize the form of the image as opposed to the content. Chemically the black-and-white process remains very much as it was in the early days of photography, although present-day materials are much more sensitive to light and capable of much higher resolution. The overwhelming proliferation of high-quality color films and processing have made it difficult to get black-and-white films properly developed and printed; as a consequence some professionals maintain their own black-and-white darkrooms. Special printing papers that allow photographs originally produced in color to be accurately rendered in black and white have been developed, although it is not easy to locate a photofinisher who can make a good job of such conversions.

Color negative films combine three or more layers of light sensitive material, each of which records a portion of the color spectrum. As in a black-and-white negative, the tonalities in a color negative image are reversed compared to the tonalities of the subject. Color negatives look very strange because this reversal applies to color (a yellow object is represented by a blue image, since blue and yellow are complementary colors) as well as density. The color and the density return to normal when the negative is printed.

Color positive films (also called transparency, reversal, or slide films) are intended for direct viewing or reproduction. Positive films are processed to become an unreversed, true-to-life image without the additional step of printing, so the final image is potentially higher in quality than that made from negative films.

CONSIDERATIONS FOR BLACK-AND-WHITE These days, the cost of producing excellent work in black-and-white is about the same as for color. In fact, in most cases color is cheaper. As a result, the skills necessary for shooting and processing black-and-white are atrophying among professionals and have become virtually extinct among amateurs. This is a sad state of affairs. To my mind, a working knowledge of black-and-white technique and a deep appreciation of a beautiful black-and-white print are indispensable fundamentals, at least for professional photographers.

If there is any place where aesthetics and technology obviously intersect, it is at the point where black-and-white images are evaluated. Just how does one know when a print is technically superior? A good print, in commercial terms, is one that can be accurately reproduced in some other medium. Of course, such a print will be sharp and free of mechanical defects like fingerprints, dust spots and scratches. However, a wide range of tones with significant details visible in both highlight and shadow areas is the most important factor for reproducibility.

The densitometer is a special form of light meter used to measure density. A reflection densitometer measures reflection densities from photographic prints. In the case of negatives, a transmission densitometer measures image density by quantifying the amount of light transmitted through various points on the film. The brightness range, the range of tones from very light to very dark, may be plotted on a graph according to the densitometer readouts. These graphs, called characteristic curves, are different for various films and paper types, and they may be further altered by variations in exposure and development.

A scientific appreciation of black-and-white image quality takes years to achieve. Some dedicated photographers are practitioners of the Zone System developed by Ansel Adams and Fred Archer. This comprehensive system for image control divides the possible range of photographic densities into ten zones, from deep black to pure white, and describes techniques that enable the photographer to fit subjects onto the tonal scale. Those proficient in the Zone System can exactly previsualize how any negative and print will look before the shutter is tripped.

Although I have never practiced the Zone System, I have read two books by Ansel Adams: *The Negative* and *The Print*. Together, these densely written tracts offer an intense lesson in how far photographic technique can be taken in pursuit of beauty. I highly recommend them.

Many of the skills used in photography interlock; refinement of one ability leads to or requires advancement in other related areas. For example, someone who regularly makes black-and-white prints inevitably acquires a really thorough understanding of what constitutes a good black-and-white negative, because bad negatives are extremely difficult to print; what is not present in the negative to begin with cannot be added in the darkroom. Producing a negative is a process that begins in the camera and is finished in the darkroom. Producing a print is a process that takes place entirely within the darkroom. It is necessary to master the whole process of exposure, negative processing, and print making in order to always achieve first-class results.

I do not recommend that everyone become an expert, but it pays to become familiar with the potential of the medium. Excellent chromogenic black-and-white films, like Kodak T400CN and Ilford XP2, are now widely available, and can be processed and printed by any lab capable of handling regular color negative films. Study the examples provided, and insist that any professional black-and-white photography or photo finishing you buy are first-rate.

COLOR POSITIVE VERSUS COLOR NEGATIVE Modern color materials are vastly superior to the films available even a short while ago. There is, however, a prejudice in the nonphotographic printing trade that transparencies are superior to prints from negatives. This was true ten years ago but now a color transparency has only a marginal edge.

Color negative is a tremendously flexible medium. It is much more tolerant of exposure error and unusual lighting conditions than color positive films. Color balance, density, and cropping are easily controlled in the darkroom and multiple copies can be made quickly at a reasonable cost. Retouching a large print is easier and safer than fiddling with an original slide. Similarly, prints may be given away or lost, while the original negative remains secure.

Despite all this, transparencies have a psychological advantage. Because they are viewed by transmitted, rather than reflected, light, transparencies do appear "richer" than an otherwise identical print. Nevertheless, the irrefutable fact is that when a transparency is reproduced on paper, whether photographically or photo-mechanically, its brightness range is reduced; it becomes a "print" like any other.

In most circumstances a color negative and a color transparency can record exactly the same degree of detail. In other words, the resolution of a negative and of a transparency can be identical. A print made from either medium loses some detail by virtue of the fact that a print is one generation away from the original image. A well-made transparency, however, may be reproduced directly, which of course eliminates any losses associated with the enlarging process.

Transparencies have another significant technical advantage—they can reproduce delicate highlight details more accurately than prints made from negatives. This subtle superiority is important for very light subjects such as snow, glass, and bright metal.

The arguments in favor of transparency films for reproduction were much stronger several years ago when color negative materials were much less sophisticated. Old habits die hard, however, and the 4x5in transparency is still favored by many publishers. Small transparencies are popular as well, mostly because they are so handy. For example, plastic slide files, 8 1/2x11in sheets with twenty 2x2in pockets, are standard in the magazine business for convenient viewing, shipping and storage of 35mm transparencies. (*See color plates 9–10, 11–14.*)

FILM FOR ARCHITECTURAL PHOTOGRAPHY The definition of a good architectural photograph that I offered earlier encompasses the following technical (as opposed to aesthetic) considerations: the image must have an abundance of detail, and the color must be accurate. When all other variables are controlled, both these requirements are limited by the characteristics of the film, especially when working in 35mm.

A well-paid professional is obligated to select the materials that give the very best results, regardless of the effort which is associated with the proper use of those materials. However, a practical-minded amateur is free to select the tools and materials that adequately serve his or her purpose, while ensuring convenience and economy by consciously choosing some acceptable compromises. I recommend color negatives films as a universal film for architectural photography with this notion of acceptable compromise firmly in mind. My reasoning is straightforward, but please bear with me as I outline the argument in photographic terms.

The advantages of color positive film are real. An excellent transparency will exhibit a wealth of detail (particularly in highlight and very deep shadow areas) as well as rich and natural color. But, there are costs in time, inconvenience, and money, all of which flow from the fact that the final slide is the same piece of film that was exposed in the camera. Unlike a color negative, which may be manipulated during the printing process, a transparency has only one chance at perfection and must consequently be right the first time; there is, for all practical purposes, no margin for error. Such a strict condition means that the exposure and lighting for each shot must be flawless. This is no easy task in architectural work, where there are many photographically imperfect elements. Consider the following: variations of color balance introduced by nonstandard sources such as fluorescent, mercury vapor, or sodium vapor lights must be analyzed by test exposures that will indicate what filters are required when the final shots are made. Exposure is problematic wherever extremes of light and dark are present, as in a daylight shot of an interior view with windows; the narrow exposure "latitude" of color positive films must be accommodated by an expensive and time-consuming procedure called bracketing, in which several additional exposures are made slightly above and below the measured exposure. Graphically speaking, the image must be composed perfectly as well, since the film in the camera is the final product.

The disadvantages of color negative film are real. It is true that some quality is lost whenever a print is made. The additional step, the creation of a "second generation," inevitably involves a measurable degradation of the original image as well as adds to the cost of processing. However, as you will see shortly, the losses in quality and the extra expense are insignificant compared to the tremendous flexibility of the color negative/print process. Tricky problems of exposure, color balance, and composition can be transported from the shooting location into the darkroom, where they can be fixed quite painlessly. As a bonus, excellent materials are available for generating black and white prints as well as color slides from color negatives; if the original color negative is of decent quality its offspring can serve multiple purposes.

PROCESSING

AN OVERVIEW OF THE OPTIONS Processing color materials is not a magical procedure, although it is rather complex. Consistency is the prime consideration and a fair amount of skill and knowledge is required of people who wish to exercise complete control over their work. Only very dedicated professionals and the most fastidious amateurs develop their own color film and prints; everyone else is unavoidably dependent on the work of a variety of photofinishers.

You are likely familiar with the services available at the drugstore or supermarket; film is dropped off and retrieved a few days later after having been shipped to some central plant where development and printing is done by automatic machines. One-hour processing is much the same, except the machines are close at hand and the work is done while you wait. Since the processing is done mechanically there are few choices of print size and no possibility of creative or remedial interventions.

Professional photographers and advanced amateurs need more input into the processing of their work; there are several important manipulations possible only when the process

38

These images illustrate a powerful printing technique. This photo is an unmanipulated, detail shot of a light fixture and part of the ceiling of a heritage building.

This photo is a "paper dodging mask" made by carefully cutting away the overexposed area of the image. The paper mask is placed on top of the photographic paper in the darkroom during an extra exposure. The mask is moved gently in a circular motion in order to make the borders of the darkened area soft-edged.

This photo is the finished product. The chandelier is now properly exposed. Additional burning-in has darkened the highlight around the chandelier's anchor, as well. Camera: Toyo 4x5in, lens 150mm (moderate wide-angle), film Kodak Vericolor III Type S.

is managed by a skilled technician as opposed to a machine. That is not to say that machines do not do the bulk of the work, but simply that the work of the machines can be tailored to suit specific photographic purposes. This expertise will be found only at a professional color laboratory, also known as a custom lab.

THE PROFESSIONAL APPROACH TO PROCESSING You will not be able to buy 35¢ 3x5in machine-made prints at a custom lab. The work done at such places is different from one-hour outlets in the same way that an artisan cabinet-maker is different from a worker in a factory that cranks out furniture on a large scale; the tools may be similar, but they are put to much different use.

The manufacturers of photographic films and chemicals prescribe exactly how their products are to be handled so that results are predictable. Well-tended machines with properly replenished chemistry will satisfy the basic requirements. In fact, a competent one-hour or drugstore processor will be able to do a fine job of film developing and basic printing. Unfortunately, most of these operations are not so consistent that results will be the same from month to month, week to week, or even day to day. Professional labs are always consistent. This uniformity is critical, especially for color transparencies.

In any complex process, alterations in prescribed practice will yield a variety of results. In the development of color film, the list of prescribed practices is very long. Those who are familiar with the work, however, regularly manipulate the process to alter film speed (sensitivity to light), color balance, and contrast (the distance between the darkest and the lightest tones in a photographic image). Interventions of this kind are often required on behalf of photographers shooting with color positive films; tests shots are processed first, then various parameters are modified so that the rest of the film turns out exactly right.

THE VALUE OF A HANDMADE PRINT Those of us who depend on color negative films do not usually require any modifications in the film processing. Instead, the really useful manipulations are performed in the darkroom while the negatives are being printed.

When prints are made by machine, the negative is scanned electronically, analyzed to determine an "average" reading of the variables, and then the exposure times and color controls are set automatically. Machines "assume" that all photographic subjects are sufficiently homogeneous to allow acceptable results using this method.

In the world of architecture, the simple statistical algorithms that animate the machines are inadequate. The full potential of the positive/negative system is realized only when the critical decisions are made by skilled and empathetic human beings. In fact, human intervention in an otherwise implacable and predictable opto-chemical process marks the end of photographic technology and the beginning of art.

A true appreciation of the possibilities requires a thorough examination of a series of examples of machine-made and human-made prints. From the illustrations offered above and in color plates 15–17, it is obvious that the creative input of human beings is an absolutely crucial and powerful ingredient.

My recommendation that color negative film be adopted as a universal medium for architectural work is based on the assumption that all photographs will be printed by professionals in custom labs. Unless you are a professional photographer with a lot of experience and equipment, perfect color transparencies of the subjects in question are basically out of reach. However, a dedicated amateur, without outrageous effort and without wildly expensive tools, can produce truly acceptable color negatives. Unfortunately, those acceptable negatives will look quite ordinary, and sometimes downright bad, when printed by unfeeling machinery. Fortunately, when an enlightened human printer makes intelligent use of the all the controls offered within the printing process, those "ordinary" negatives can be wrought into wonderful enlargements.

I believe that a dedicated amateur, working in 35mm color negative and supported by a skilled color printer, can produce professional-looking results at a fraction of the cost of hiring a professional. Consider the following scenario: a 4x5in transparency of an interior view with several windows during daylight hours could take a professional several hours

An example of print control. My evening view of IBM Canada's Toronto headquarters was first printed normally. In the final version the whole image was printed quite dark overall, in addition to extra burning-in for the foreground and sky. Camera: Toyo 4x5in, lens 150mm (normal), film Kodak Vericolor III Type S. No perspective controls required.

This line drawing illustrates how a measure of perspective control can be achieved in the darkroom. The top image shows the subject as it appears in real life. The second image shows how the building is pictured by a camera without perspective controls. The diagram to the right shows the negative image being projected by the enlarger onto an easel, which is aligned parallel to the negative plane. The third image shows the effect that is achieved by tilting the easel—the vertical lines of the subject become parallel again, but the whole image is elongated somewhat. In practice, this elongation is fairly mild for small corrections.

to produce. This is because the brightness level in the room must be raised by supplementary photographic lighting (of appropriate color balance) to a level that matches that of the window light, or, conversely, the window light must be attenuated by application of large, expensive, neutral density filters. Total cost for time and material could exceed $500.

The same room could be photographed by an amateur in a few minutes without any special considerations for the windows. The resulting color negative, because of its inherent ability to record a very wide brightness range, will contain adequate detail in the highlight and shadow areas. A machine-made print, however, will look terrible because such a wide brightness range will not read on the print without some extra work. A good printer will burn-in (darken) the bright areas and dodge (lighten) the dark areas; at the same time overall color balance will be corrected and the image will be cropped to the appropriate size and shape. In this way, a ten or fifteen dollar custom-made print will buy the equivalent of one, two, or even three hundred dollars worth of professional photographic expertise. The responsibility of the amateur photographer in this case is to ensure that the color negative is good enough to allow the printmaker sufficient latitude to work his or her magic. (And this is true whether the negative is to be printed conventionally, or scanned and printed digitally.) The technical instructions in the following chapters are intended to help you do just that.

IV AESTHETIC CONSIDERATIONS

DESIGNING A PHOTOGRAPH

DOCUMENTARY VERSUS PICTORIAL Photography can be one of the most pragmatic of technical crafts or it can be one of the most ephemeral and subjective of the arts. Even in the seemingly narrow confines of architectural photography there is still room for a variety of approaches, each of which has a different purpose.

As we will see, the maxim "a photograph never lies" is a sentiment that presumes that the camera is a trustworthy recording device, a preserver of facts and conditions as they really exist or as they really existed in the past. Certainly, it can be—so long as the techniques employed in the making of "factual" images are straightforward and unobtrusive. This is documentary photography, and it can only be practiced by people whose intentions are straightforward as well. Such work does not necessarily have an aesthetic component, although there is no reason to exclude it unless the conscious effort to make a picture attractive obscures the original purpose of telling the truth. Some documentary work has an offhand, accidental beauty that flows from the unpretentious nature of the documentary approach.

On the other end of the scale is pictorial photography, an old-fashioned but appropriate phrase, which refers to photographs that try, successfully or not, to elevate the subject into the rarefied world of fine art.

In my experience, many photographs of buildings are commissioned by clients who ask for documentary photographs, but who expect pictorial photographs. The realities of the marketplace dictate that any photograph intended to promote architectural services or sell a particular building will have to do what all other forms of advertising photography do: present reality in the most appealing way possible.

EVALUATING THE POTENTIAL OF SITES Architectural photos are limited aesthetically first by the nature of the structures to be photographed and second by the purpose that the photograph is expected to serve. For example, if the photograph of a building under construction is simply a progress photo, intended to prove that a particular mechanical aspect of the work has been completed, niceties of perspective and lighting are of marginal concern; as long as there is sufficient illumination to record the important details, everyone will be happy. However, if the photo of the same site is to be presented at a meeting of potential investors or tenants, it is much more important to emphasize and exalt the architectural design elements of the structure, the interrelationship of the structure with other buildings nearby, and the quality and texture of the building's material.

There are some basic elements that must be present if the "pictorial" approach is to be successful. First, the building or the room must have some aesthetic qualities. Second, the size of the room or the location of the building must allow for a camera position that yields a photographically pleasing point of view. Third, the light, whether natural or artificial, must be appropriate. The following discussion about the nature of light and lenses will make the significance of all these factors very clear.

LIGHT

PHOTOGRAPHIC SEEING Literally translated, "photography" means "drawing with light." Any real understanding of photography begins with an appreciation of the technically variable qualities of light itself: color, intensity, direction, and specularity. Of these four qualities, specularity is of critical importance.

Specularity is a function of the size of the light source in relation to whatever is being illuminated. For example, the sun on a cloudless day is a highly specular light source, while an overcast sky is non-specular, or highly diffused. Among photographers, specular light is referred to as "hard" and non-specular light is "soft." An object illuminated by a hard light throws a shadow with hard, precisely defined edges; the shadows from a soft light source are fuzzy and undefined.

The first step in learning to previsualize a photographic effect, to predict what something will look like after the whole photographic process has been completed, is to learn to see and appreciate exactly how the infinite manifestations of light affect the appearance of things.

Nature's basic palette evolves from the specularity of light, together with its direction (angle of incidence). What we actually see, what evokes that which we automatically hold to be real, is nothing more than organized energy—energy in the form of photons of light. The manner in which this light strikes a particular object and the way in which the surfaces of the object alter the characteristics of the light trigger intense emotional reactions in our highly conditioned brains. For example, harsh, direct sunlight strongly emphasizes certain patterns and textures that can suggest boldness or power, while the diffused light of an early morning sky just before sunrise softens and embellishes whatever it illuminates. All the great photographers have intuitively cataloged a phenomenal range of natural light conditions and their subjective effects; unlike other visual artists who are free to create whatever "light" they need with paint or pencil, photographers must "collect" light from nature. Since nature cannot be easily manipulated or controlled, much of the skill involved in photography has to do with the patient observation of changing conditions, good timing, and good luck.

There is no mystery to all of this; the only requirement is a willingness to pay attention. Your own responses will guide you.

THE SKY, THE SEASONS, AND TIME OF DAY Since daylight is the primary light source for most exterior architectural views (as well as many interior views), the factors that determine the characteristics of sunlight are fundamentally important.

The exact location of the sun in relation to an architectural subject is a function of the position of the building on the surface of the planet (longitude and latitude), the orientation of its main facade (direction), the rotation of the earth about its axis (time of day), and the location of the earth in its yearly progression around the sun (the season). Astronomical considerations might seem somewhat grand, but the object of the exercise is to produce a strong photograph; consequently, the angle of incidence of sunlight is of critical importance. In fact, the photographic evaluation of a particular site is a parallel effort to the sun study that an architect does when designing a building.

The design and texture of a given building will dictate the sun angle best suited for a powerful image. Since the position of the sun is dependent on the natural variables listed above, the role of the photographer is a passive one and usually involves a couple of visits to the site at different times of day; if the photograph is required quickly, the time of day will be the only variable, insofar as the angle of the sun is concerned. When the need is less urgent, it is quite sensible to wait until the sun comes round to some optimum location. (In the northern latitudes where I work, north-facing buildings are illuminated by direct sunlight for only a few weeks in the summertime, and even then the light shines down from more or less directly overhead for much of the day. Since this condition is very unflattering for most structures, early morning and late evening shots are favored.)

In the studio the commercial photographer works with special tools that modify light in order to achieve certain visual effects. Outdoors, light is modified by serendipitous natural phenomena that the photographer must recognize, anticipate, and use to advantage. The range of choices begins with naked sunlight at high noon and extends virtually forever. Weather, particularly the presence or absence of clouds, is perhaps the most significant manipulator of sunlight. Pictorially, clouds in many forms are often welcome elements and are included within an image for dramatic effect. In terms of the current discussion, clouds are important simply because they are modifiers of sunlight; they cannot alter the direction from which the sun shines, but they can alter the specularity of sunlight by varying degrees. The accompanying sketches illustrate this principle.

Many other natural events and phenomena have an impact on outdoor photography. For several months after the eruption of the Mount Saint Helens volcano, the sky over North America was dulled by the many tons of light ash that were suspended in the upper atmosphere. Air pollution and smoke from forest fires also affect the characteristics of daylight, particularly around sunrise and sunset. During winter, snow on the ground modifies sunlight by reflection, while ice particles in the air contribute some very subtle diffusion effects.

It is important to recognize that none of the profoundly important aspects of architectural photography just described are even remotely related to film or equipment. On the contrary, they demand aesthetic choices that have to do with one's personal appreciation of the delightfully abundant manifestations of natural light. *(See color plates 18–21.)*

These sketches illustrate how a highly specular light source, like the sun, is converted into a highly diffuse light source. The top image shows direct sunlight and the precise shadow it creates. The bottom image shows how a layer of cloud effectively spreads out the sunlight—the clouds themselves become the light source, as far as the subject is concerned. Since light is coming from many directions at once, the subject is softly illuminated and thus casts a very indistinct shadow.

This Winnipeg apartment building by Akman & Sons was shot in the fall to add a little color to what would have otherwise been a rather monochromatic image. The camera angle was chosen to show the complete facade while allowing the tree on the right to partially obscure the large rental sign in the lower foreground.
Camera: Toyo 4x5in, lens: 90mm (moderate wide-angle), film: Kodak Vericolor III Type S. Perspective controls were necessary for this shot.

INTENSITY AND COLOR So far we have dealt with the qualities of direction and specularity in relation to natural light, but there are two other important considerations, namely color and intensity. Of these two, intensity (the quantity of light) is the least significant. Generally the absolute degree of brightness is not a worrisome factor, except in very dim conditions such as those encountered during night photography. Within a particular image, however, the relative brightness levels of various elements (contrast) is quite significant. The next chapter will deal with the technical restraints imposed by excessive or insufficient image contrast, but for now let us consider the aesthetic implications.

Both direction and specularity of light have a bearing on image contrast, and image contrast, in turn, has an emotional impact. For example, hard sunlight falling from an elevated angle upon a starkly fashioned stone facade results in a deeply chiseled image with dark shadows and brash highlights; the monumental constructions favored by the Nazis were always portrayed in this way. The same structures illuminated by softened, diffused light coming from a low angle lose some of their garish, authoritarian overtones and take on a more spiritual (albeit Wagnerian) flavor.

The color of light complements and enhances the mood evoked by the sculptural influences of sun angle and specularity. It is measured precisely according to the Kelvin color temperature scale. So-called "photographic" daylight is 5500° Kelvin, but this actually varies according to time of day, time of year, geographical location, and air purity. A sunset at the end of a dusty prairie day would radiate very warm light, perhaps as low as 2500° Kelvin, while high noon up in the Rocky Mountains could register a very cool 20,000° Kelvin. "Daylight" color films are balanced for 5500° K.

The way photographic film and paper render color is different than the way human minds and memory do. The brain expects to see the world in a certain light; there is in each of us an unconscious impulse to impose a "natural" color balance upon everything we look at. In fact, we seek out familiar visual "clues" such as skin tones, blue sky, or leaf green, and automatically rearrange the images we perceive so that these color markers fall within a normal, or comfortable, range. This phenomenon is called "color constancy" and is easily demonstrated: a room lit by warm tungsten light seems natural enough, but outside at dusk we quickly become acclimatized to the ambient light condition, which is typically much cooler than the artificial light. The same room, viewed from the outside in, now looks extremely yellow. This phenomenon is not simply a matter of relative color, it is an actual shift or tilt in perception.

The emotional power of color comes into play whenever the ability of the brain to correct color balance is exercised; slight corrections alter one's mood very subtly while gross discrepancies, beyond the capability of the brain to compensate, result in a very strong response. Even the vocabulary we use to describe color conditions (warm, cool, neutral) attributes an emotional weight to this physical property. Since the recording mechanisms of photographic materials are predictable and subject to manipulation by the photographer, the color balance of a photograph can either accurately track what is offered in nature or embellish it.

AESTHETIC CONSIDERATIONS IN LIGHTING Everything that has been discussed in relation to natural light applies to artificial light; however, the modifiers of photographic lighting are manipulated by the photographer rather than by nature. Since it is a major undertaking to illuminate an entire building, full scale photographic lighting is usually considered for interior views only; outside at night photographers must rely on whatever street or flood lighting is available.

Color balance becomes a very important consideration when artificial light sources are encountered. Each type of manmade light—be it tungsten, fluorescent, mercury-vapor, sodium-vapor, or electronic flash—has a characteristic spectrum that must be matched to the natural ambient light and to the characteristics of the film. These technical matters will be discussed in detail in the next chapter.

AESTHETICS AND FORMAT

LIMITATIONS AND POTENTIALS OF VARIOUS FORMATS The notion that format affects the appearance of a photographic image begins very simply with the shape of the frame. Since medium-format systems generally lack perspective controls and are priced at the same level or higher than 4x5in systems, I will limit my comments to a comparison between the very rectangular 35mm image and the much squarer image produced by the larger format cameras.

The standard sizes for photographic enlargements (5x7in, 8x10in, 11x14in, 16x20in, etc.) evolved from the view-camera technology of over one hundred years ago. It is a testament to the strength of these traditions that the original dimensions have remained intact despite the onslaught of the 35mm usurper and despite extensive metrication. In fact, most enlargements from 35mm negatives are cropped to fit the 8x10in format, resulting in a loss of about 20% of the actual image area. For black-and-white photographs, 8x10in is the industry standard for most printing and publishing.

Photographers are naturally inclined to fill the frame; it is an instinctive desire not to waste film, in order to keep cropping to a minimum, and thus preserve image quality. This desire must be thwarted when shooting 35mm simply to conform to the established norms of publishing and photofinishing. Those wishing to take advantage of the elongated format must find a custom lab that will preserve the whole 35mm image by producing 6x10in prints rather than the standard 8x10in prints. The same approach would be necessary for the large-format user who wishes to eliminate unnecessary foreground or background details in photographs of very tall or very horizontal buildings or interiors.

Transparencies cannot be cropped during processing since the actual film exposed in the camera becomes the final product; cropping must be done by mechanically masking the slides with opaque materials such as tape or cardboard. This is not impossible for the larger formats, but it is extremely difficult for 35mm.

In the magazine business, color 35mm slides or 4x5in transparencies have been preferred over color prints for many years. Cropping is usually the prerogative of the editor or art director of the publication, so the aesthetic considerations related to the shape of the image are largely out of the hands of the photographer. New negative films and improved photographic enlarging paper have increased the quality of the negative/positive process, and the publishing industry is slowly coming around to accept well-made color prints. Of course, when enlargements are submitted for publication, the photographer working with a custom printer has much more control over the final image shape. Nevertheless, nothing prevents the editor or art director from extracting a smaller image from whatever is submitted.

The aesthetics of any particular format are influenced as much by the mechanical nature of the equipment as by the shape of the frame. At a basic level, tripod-bound large-format equipment is much slower to use. The cumbersome mechanical process of camera setup and adjustment encourages a deliberate and contemplative approach to picture-making; the positive manifestation of an extended time frame might be insightful

These similar photos illustrate the effects of cropping. They were made for historian Gwen Dowsett and show details of a barn built by Mennonite settlers. Cropping the first photo to eliminate the cast metal pump and corrugated well casing on the left "ages" the image considerably—the only clue that the second photo was made in the twentieth century is the metal roof, which could be eliminated by further cropping if desired. Camera: Hassleblad ELX (medium format), lens: 100mm (normal), film: Kodak Vericolor III Type S. No perspective controls.

and thought-provoking photographs, while the negative implications (boredom induced by the slow pace) might yield exactly opposite results. The highly mobile 35mm user must fight the tendency to produce facile snapshots. Producing first-class photography with small cameras, although mechanically easier than with larger formats, demands both a technical and an artistic self-discipline, a requirement that flies in the face of the rapid-fire stereotype promoted by the manufacturers of "automatic" miniature cameras.

Finally, the cost of operating a particular format has an undeniable impact on the characteristics of the photographs. We have seen that the mechanical limitations of large-format machines force photographers to work at a steady (and hopefully dignified) pace. There is no choice. The relatively high cost of the film and processing further inhibit the photographer by discouraging experimentation and risk-taking: every image must count. On the other hand, small cameras encourage experimentation and risk-taking. Unlike professionals, who are able to evaluate photographic situations and make decisions intellectually without the need for trial-and-error learning on real film, beginners, or even advanced amateurs, must study the results of their efforts in order to progress. With thirty-six inexpensive pictures per role, the 35mm photographer can afford the few minutes and the few dollars it takes to photographically explore a fleeting light condition or record several subtle variations of composition.

TOWARD A PERFECT 35MM IMAGE In terms of detail and color, carefully made images of different "parentage" can barely be distinguished. The technical degradation associated with the process of reproduction for the printed page is partly responsible; the nuances of the superior large-format photos and the minor faults of the 35mm photos are somewhat submerged by the limitations of ink and printing press. Still, this only reinforces the argument that for all practical purposes the two formats are very competitive.

More noticeable are the differences associated with the optomechanical capabilities of each system. Of main concern here is limited 35mm perspective control. Nevertheless, the photos in this book clearly show that a surprising variety of photographs can be made without perspective controls of any sort, and that the control available with 35mm PC lenses, although less than that available with 4x5in technology, is still considerable.

I could, I suppose, provide a chart that would spell out all these observations in quantitative scientific terms, but photographs are virtually never examined in such a fastidious manner. Look carefully at the samples provided, and I believe that you will agree that 35mm systems are capable of producing fine results.

ROLE OF THE RETOUCH ARTIST There is a limit to what can be done with even the most sophisticated photographic technology regardless of format. When these limits are exceeded, photographs can be saved by the work of the retouch artist. Like the view camera itself, retouching has been an invaluable element of photography since the beginning. Although it is no longer necessary to hand-color monochromatic images, it is still sometimes necessary to airbrush a pleasant blue over a dull gray overcast sky. In the city where I work, the public works department will remove and replace an offensive street lamp for $800; my retoucher will do it (at my convenience) for around $150. He regularly removes "for lease" signs and straightens crooked blinds, as well as cleans up oil-stained driveways, odd reflections, and overlooked litter (*see color plates 26–27*). Power lines are his specialty. Certain strictly photographic problems can be repaired as well; "washed-out" overexposed windows within available-light interior shots and off-color patches due to incompatible light sources can both be retouched. My particular favorite is the restoration of skies that have been eliminated when extreme perspective corrections force the image to the very edge of the lens's coverage. Very compelling presentations result when the retoucher skillfully grafts a photograph of an architectural model onto the image of an existing skyline.

Even more sophisticated work can be done using electronic retouching technology and digitized images that have been scanned or created with digital cameras. (*See Chapter 18, "Working with Digital Images," especially the section "Electronic Image Enhancement" on page 198f.*)

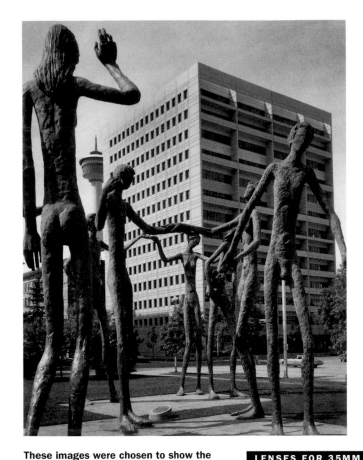

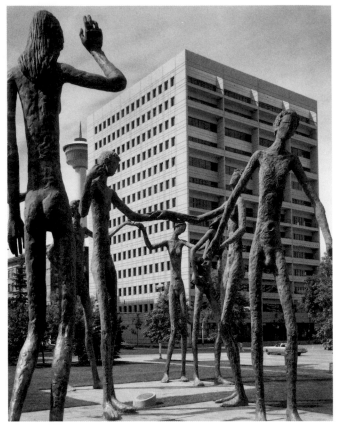

48

These images were chosen to show the skills of my retoucher, Ray Phillips of Phillips Advertising Art Ltd. in Winnipeg. A modest office building in downtown Calgary by IKOY Architects was photographed through a grouping of sculpted figures located in a park across the street. The otherwise perfect camera angle left an unfortunately positioned pole clearly visible between the legs of the figure on the right—Ray made it go away.

Camera: Toyo 4x5in, lens: 90mm (moderate wide-angle), film: Kodak Vericolor III Type S. Modest perspective controls.

LENSES FOR 35MM SYSTEMS

THE BIOLOGICAL OPTICAL SYSTEM Human vision is nature's almost perfect response to the visible portion of the electromagnetic spectrum. I say almost perfect because as spectacular as the system might be, there is a flaw: the lens is not interchangeable.

The eye itself is a truly amazing creation. A biological automatic diaphragm, the iris, changes the effective f-stop from about f5.6 in dim light to approximately f22 in bright light. Quick corrections are made according to relative brightness of different objects within a scene, thus allowing us to see a tonal range much wider than even present-day photographic technology can accommodate. More amazing still is the fact that focusing is accomplished by actually changing the shape of the lens itself. This very useful mechanical process goes on continually and quickly, yielding the illusion of almost infinite depth of field. Focus corrections are made spontaneously as one's attention shifts between different objects within the field of view. Overall angle of acceptance is very nearly 180° with an area of critical sharpness of approximately 40°.

NORMAL LENSES (45–58MM) We have all heard the expression "through the camera's eye." The phrase is a simple expression of the realization that the camera's eye is not at all like our own. Learning about lenses is the real beginning of a mastery of photography.

The brain, like the NASA computers that generate a full-color map of Jupiter from a few electronic clues, processes the data relayed along the optic nerve from the eye and then reconstructs an image (the image we see mentally) so that everything looks all right. We are conditioned from childhood to expect the visual world to follow certain rules of perspective, and it is one of the brain's main functions to enforce these rules. That is why optical illusions are possible; the brain, attempting to keep things in some kind of order, may be tricked. This was demonstrated in a dramatic experiment in which the participants wore special glasses that made everything appear upside-down. Within a couple of weeks of constantly wearing these glasses, the subjects of the experiment reported that the world had righted itself and everything appeared normal. Upon removal of the reversing spectacles, everything looked upside-down. It took another couple of weeks without the lenses for things to come right side up again. The phenomenon is not unlike the games our minds play with color balance. *(See color plates 22–23.)*

I have made an effort to illustrate some of the properties of human vision because the selection and use of various focal length lenses in photography is profoundly influenced by our conditioned physiological and psychological seeing. Some optics, like perspective control lenses, are used to "put the world right" according to our innate expectations.

Other lenses, such as the extremely wide-angle "fish-eye," are used to shock and surprise; they can do this because the images they yield are so very different from what our poor brains keep trying to see. These days we have access to a fantastic range of 35mm optics with which to satisfy or tease our visual programming.

WIDE-ANGLE LENSES (8–40MM) It is easy to think of a wide-angle lens as a device to cram more stuff into the frame without having to move back and a telephoto (tele) lens as a device for getting close to the subject without moving forward. I will not deny that the mechanics of lens selection are significant, but I wish to emphasize that various focal lengths offer more than just a different angle of view. In fact, they each offer a different point of view, mechanically and aesthetically.

So-called perspective distortion is both the curse and the blessing of wide-angle work. The term "perspective distortion," however, has very little meaning apart from the brain's response to the optical phenomena of nature. The eye actually sees parallel vertical lines of a building converging just as the camera does. The eye sees nearby small objects as large and faraway large objects as small, just as the camera does. Yet, unlike film, which simply records what the lens presents, our brains interpret and reconstruct the images streaming in from outside. The brain wants to see verticals that do not converge and objects that appear their correct size.

By using photographic lenses to project the light reflected off three-dimensional objects onto a two-dimensional surface (film) and then presenting the flat image (photograph) out of context, we bypass our image-processing capabilities. In real-life situations the brain tries to correct apparent visual anomalies and, up to a point, succeeds; a photograph, being a fixed representation of a three-dimensional object, can only look how it looks. The power of lenses, and consequently the power of photography, derives from this ability to tease our optical preconditioning.

The perspective offered by very-wide to ultra-wide lenses (8–24mm for 35mm cameras) can push visual tension to the limits of tolerance. We will accept a rather odd-looking photograph when there is no choice in the matter—a fish-eye picture of the inside of a space capsule, for example. In fact, wide-angle effects are appreciated as spectacular tools for rendering dramatic views of buildings or urban landscapes. Like all good things in life however, this technique suffers when used in excess; continued reliance on wide-angle effects means that the photographer has surrendered the content of his or her images in favor of form. When the design of the photograph is a consequence of the lens's characteristics alone, the power of the imagery will decrease over time. Just like the folks with the upside-down glasses, we get used to sensational points of view. When this happens, our collective visual consciousness cries out for more natural perspectives and photographs in which form and content strike a harmonious balance. I will have more to say about the distortion associated with wide-angle lenses shortly.

MEDIUM TELEPHOTO LENSES (85–200MM) Short focal length of lenses emphasize details closest to the camera and give them an appearance of exaggerated size compared to similar objects farther away from the camera. The greater shooting distances required to picture the same objects with long lenses tend to flatten perspective and yield images with a less noticeable sense of depth; this "undistorted" presentation will enhance the innate elegance of the pictured objects.

Since 35mm systems have a very limited choice of lenses offering perspective control, sometimes long focal length lenses used at a distance are necessary to help render parallel vertical and horizontal lines properly. Things appear correctly rectilinear only when photographed dead-on by shorter lenses. Without perspective control, objects photographed from below appear to be tilted away from the camera, while objects photographed from above appear to be tilted toward the camera. For example, at a short distance, with the camera positioned below the geometric center of an object, the bottom of the object is closer to the lens than the top. The bottom, therefore, is rendered larger on the negative and the print looks bottom heavy. This is the typical ground level image of a tall building.

I have included this comprehensive portfolio to fully illustrate the use of the various types of lenses in the effective practice of architectural photography. The images are rendered in black-and-white so that graphic composition of each is presented clearly and simply. Sun angles were carefully predetermined so as to accent particular features of the structures. All photos were made with my Toyo 4x5in view camera on Kodak Vericolor III Type S color negative film, printed on Kodak Panalure black and white paper. The subject is IKOY Architects' Harborview Leisure Center, a municipal recreation facility built on a rehabilitated landfill site on the outskirts of Winnipeg. These photos were published in color in several well-known journals, including *Architectural Record*, *Canadian Architect Magazine*, and *Architecture Minnesota*.

Top left, top right, bottom left: These wide views establish the scale and context of the site from the west, east, and southeast, respectively. The first photo was shot with a normal lens from the top of a small hill. The other two photos were shot from low vantage points with moderate wide-angle lenses.

Bottom right: A moderate wide-angle lens and an eye-level vantage point allowed this well-balanced view of the whole complex, which includes boat docks, lookout tower, golf pro-shop, restaurants, and a small-scale convention center. A small aperture was used to preserve great depth of field.

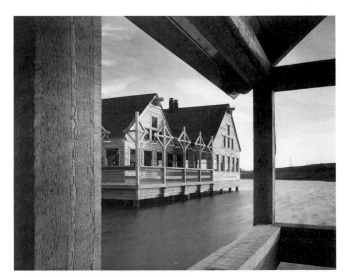

Top left: This moderate wide-angle view looks out from beneath a wooden canopy at a patio area. Reflected light from the paving stones illuminates the detail beneath the canopy—an effect that was strengthened by some judicious dodging during printmaking. Framing like this establishes the modest, comfortable scale of this project, while allowing the viewer to appreciate some of the smaller details of the construction. The wooden deck chairs in the middle distance were placed precisely so as to not overly complicate the view through the wooden posts.

Top right: This photo is an extreme wide-angle view taken from within a small shelter at the very end of the boat dock. The rough timbers seen close up are used to frame the restaurant and convention center situated across the water.

Bottom left, bottom right: By selecting moderate (bl) and long (br) telephoto lenses, I was able to focus in on relatively small details from a distance. In this approach very basic geometrical configurations within the subject determine the composition of the images. Lighting is important, as well, since the surface textures of objects shot close up become very significant.

52

Top left, bottom left: The two croppings change the emphasis and graphic impact of the images—the wider view has a more documentary flavor, while the closer view is more geometrically interesting because of the interaction of the various planes and lines.

Top right, bottom right: In the second photo, construction and wiring details of the lamp standards are clearly visible, as is the relative position and design of the small shelter across the water. In the first photo small detail is sacrificed, but the wider view yields a clearer understanding of the context, the landscaping, and the relationship between the light standards.

A long lens, however, puts the camera far enough away to make the difference between the top of the object and the camera and between the bottom of the object and the camera insignificant. This balances the perspective and makes the picture feel right.

Aside from aesthetic considerations, there are many circumstances in which the factor of image magnification alone is the basis for choosing a long lens. If mechanical or geographical barriers separate photographer and subject, telephotos will pull in a decent image size even from a very distant vantage point. The degree of magnification is directly proportional to the increase in focal length. Thus at the same camera-to-subject distance, a 200mm lens yields an image four times the size of a 50mm lens' image.

The inevitable limiting factor is that as image size increases, so does the significance of focusing error and camera movement, making a sturdy tripod a necessary accessory for this type of shooting. (As focal lengths stretch, it becomes increasingly difficult to hand-hold tele lenses without a loss of sharpness due to the magnification of camera motion. A rule of thumb is to never hand-hold at a shutter speed slower that the reciprocal of the focal length of the lens being used, e.g., for a 500mm use 1/500sec, for a 135mm use 1/125sec—the closest shutter speed to the reciprocal.) Depth of field is a function of aperture size, which in turn is a function of focal length. The longer the focal length the shallower the depth of field at a given f-stop, all else being equal. At wide apertures and close distances this may be a matter of inches or even fractions of inches.

LONG TELEPHOTO LENSES (250-1000MM) As we move up the scale of focal length past the medium teles, compression of natural perspective begins to dominate in a way that is opposite and complementary to the expansion of perspective yielded by short lenses. To encompass a given object we must move farther and farther away; the scene visible in the finder starts to bunch up and a view of fields, foothills, and mountains seems to grow out of one plane. Similarly, blocks of city skyscrapers begin to look like pancake-thin copies of themselves pasted onto poster board. Sports fans and voyeurs simply accept this fact of super-tele life; creative photographers make the most of it by watching for striking juxtapositions of objects normally seen as greatly separated. Sometimes the combination of extremely long lenses and air pollution or thermally induced turbulence will introduce odd distortions or color shifts. Like the compression effect, such optical mutations can be photographically interesting; if not, they may be reduced somewhat by polarizing, ultraviolet (UV), or appropriate color-correcting filters.

FIXED FOCAL LENGTH VERSUS ZOOM LENSES Mechanical and optical considerations have resulted in two families of lenses: fixed-focal-length lenses and zoom lenses.

Zoom lenses have adjustable focal lengths. In other words, their focal length is user-variable over a particular range (for example, 28–90mm or 80–200mm). Zoom lenses are extremely handy for fast work. Unfortunately, all the very best lenses (optically speaking), very long and very short focal length lenses (8–21mm and 1000+mm), and most specialty lenses (PC lenses, for example) are available only in the fixed focal length configuration.

The reasons for the above situation are related directly to the complications and compromises associated with the additional optical and mechanical elements required to make focal length a variable property. For my own work I prefer fixed-focal-length lenses for all critical work, but I do own several zoom lenses that I use for assignments such as audio-visual slide shows, where speed of operation is more important than technical excellence. However, I do believe that for the dedicated amateur architectural photographer it is best to stick with lenses of the fixed focal length variety. My advice is based on the assumption that most readers of this book have a great need for a modest number of high quality prints for portfolios, presentations, or publications and are not required to produce a large number of images (particularly 35mm slides) under pressure of time.

PERSPECTIVE CONTROL LENSES Perspective control lenses are in a class of their own, as far as architectural work is concerned. They are available only in a very limited range of focal lengths, but their application in this work is so universal that they warrant detailed study.

Basically they are specialized wide-angle lenses with exceptionally broad coverage. The large image circle is necessary because PC lenses are mounted in a mechanism that allows the lens axis to be shifted both horizontally and vertically; the perspective control feature

A 28–90mm zoom lens and the three prime lenses (28mm, 105mm, 50mm) it replaces.

This photo illustrates the Nikon 28mm perspective control lens. The lens is shown here at maximum sideways displacement, although in practice any direction or degree of shift may be used as required.

54

requires an image size that exceeds the conventional 24x36mm frame by greater than fifty percent. This shiftability mimics the movements built into view cameras, which also require lenses with exceptionally wide image circles. Using PC lenses is a simple matter of setting the camera level and then sliding the body of the lens in whatever direction is required to center the subject within the frame. Because the camera is level, the vertical lines of the subject will appear parallel. If the camera is aligned exactly perpendicular to the subject, horizontal as well as vertical lines will be properly parallel. There are other subtleties to PC lens use that I will discuss in the next chapter.

Unfortunately, there is an inconvenient limitation imposed by the mechanical flexibility necessary for PC operation. You will recall that SLR cameras use the taking lens as part of the viewfinder system; it is this innovation that allows very precise alignment and composition. Since the image for viewing must be bright enough to see clearly, an automatic diaphragm system keeps the lens aperture wide open until the moment of exposure. This process requires a mechanical linkage between the lens diaphragm and the camera body. This linkage, usually a pin on the back of the lens that couples to a sliding lever in the camera body, depends on a rigid and precise lens mount. The flexibility of the PC lens mount prevents the inclusion of an automatic diaphragm, which means the photographer becomes responsible for closing down the diaphragm before exposure and opening the diaphragm for easier viewing after the exposure is complete. This is an undeniable inconvenience. (The evolution of electronically managed cameras promises some relief, but at present Canon is the only manufacturer that offers PC lenses with auto-diaphragm.)

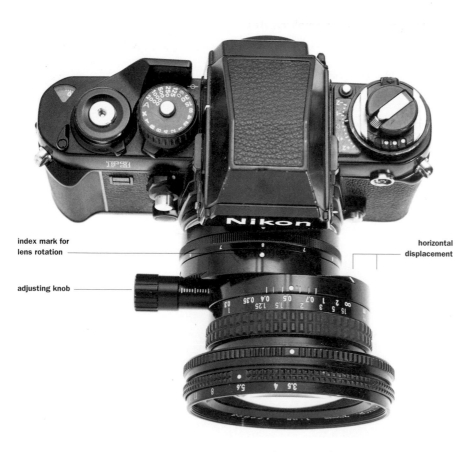

index mark for lens rotation

adjusting knob

horizontal displacement

There is another design constraint that limits the flexibility of PC lenses in 35mm work. Ordinary view cameras place virtually no restrictions on how close the rear element of the lens may be to the film plane. The best designs for small-format wide-angle lenses call for a very small separation, on the order of one-half to three-quarters of an inch.

Small-format SLR cameras require an inch or more of clearance so that the mirror that deflects the light to the viewfinder has an unobstructed path to swing up out of the way the instant an exposure is made. Retrofocus lenses allow a greater physical separation between the rear element and the film plane than their actual focal length calls for, but they depend on some clever optical tricks to do this. In fact, without sophisticated computer-aided design and modern high-performance optical glasses, PC lenses for small cameras could not exist.

In the next chapter I will make some specific suggestions regarding the selection and use of particular focal lengths.

POINT OF VIEW: PROBLEMS OF SPACE AND PROPORTION

So far in this discussion of lenses and their properties, the terms "perspective" and "point of view" have been used more or less interchangeably. Now it is time to make a distinction between them and, by doing so, explore the nuances of photographic manipulation of objects.

Architects get a lot of use out of the word "perspective"; besides the conventional dictionary definition, "a view of things in their true relationship or relative importance," a perspective is a technical illustration that portrays the appearance of a structure from a particular point of view. Therefore, a practical definition of perspective would be "that which is seen from a particular position in space." Since the "seer" can be a human eye or the lens of a camera, this definition applies to photographs as well as architectural drawings.

Everyone has an instinctive notion of natural perspective that has to do with the way things are observed during the ordinary course of events, from more or less eye level and from moderate distances. Most people do not spend much time looking "way, way up" at tall buildings or crawling around on all fours; consequently, we share a conventional catalog of viewpoints and visual expectations. Scale has something to do with these expectations, as does an internalized set of empirical geometrical laws: parallel lines do not converge, the earth is (for all practical purposes) quite flat, a chair is not bigger than a door.

As I mentioned earlier, much of the power of photography derives from the inability of the brain to reconfigure two-dimensional images. The innovative photographer makes unexpected and insightful observations by selecting an unusual point of view and recording the unique perspective on film.

The terms "perspective distortion" and "wide-angle distortion" refer to a rather backhanded optical deformation of the world as we are accustomed to seeing it. The distortion is really fictitious. Photographic lenses in general do not introduce real distortion. As a rule, the camera never lies. What we perceive as distortion, or unnatural perspective, results from precisely manufactured optical systems meekly obeying the laws of physics.

For a given image size, lenses of different focal lengths have different fields of view or angles of acceptance. The shorter the focal length, the wider the view. Since the opposite is also true, it stands to reason that in order to produce an identical size image of a particular object, a camera equipped with a relatively long focal length lens must be farther away from the object than the same camera equipped with a shorter focal length lens. Visually speaking, at great distances the contours or surface variations of an object such as a building are relatively unimportant, while close up, topography becomes significant. By selecting lenses of different focal lengths the apparent depth of a complex subject may be altered as the relative sizes of features in the foreground and the background are optically manipulated.

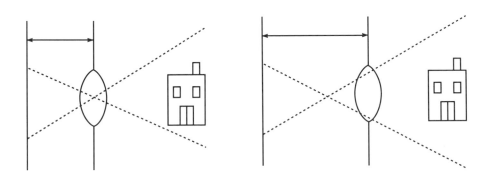

The drawing on the left shows a conventional lens. The lens-to-film distance is identical to the focal length. The drawing on the right shows a retrofocus lens. The lens-to-film distance is now greater than the focal length; this condition is necessary for short focal length lenses used with single lens reflex cameras since it permits sufficient room behind the lens for the motion of the reflex mirror.

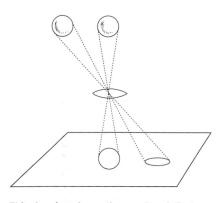

This drawing shows the results of displacing a spherical subject away from the lens axis perpendicular to the middle of the film plane. The image of the well-centered sphere is projected as a circle on the flat film but the image of the off-center sphere is projected by the lens as an ellipse.

WIDE-ANGLE DIFFICULTIES Photographers have a love-hate relationship with short focal length lenses. Although the commonly held belief that wide-angle lenses distort reality is not true, this does not imply that wide-angle photography is easy to do well. There are certain precautions that must be taken to produce tasteful images.

The above mentioned alteration of perspective is the main concern. Architectural photography is often carried out in functionally confined spaces such as heavily furnished rooms or crowded city streets. The subjects are large, and comfortable points of view are hard to come by. We must resort to wide-angle lenses because there really is no choice. In such situations the way in which the sizes of foreground and background objects are rendered in two dimensions is not a welcome design element, but instead an unavoidable anomaly to be dealt with as discreetly as possible. It can be a real eye-stopper when the ashtray on the coffee table looks as big as the fireplace.

To further complicate matters, there actually is a type of distortion that is unavoidably associated with wide-angle work. The line drawing to the left illustrates what happens to the image of a sphere projected onto a flat surface. As you can see, at the center of the frame the sphere appears perfectly round. As the spherical object is shifted away from the axis of the lens, its image becomes more and more elliptical. The effect is exaggerated as focal lengths get shorter.

In the next chapter I will offer some advice on how to cope with both apparent distortion of perspective and real distortion of shape.

V

57

BUYING EQUIPMENT AND SUPPLIES

If you are serious about producing first-quality architectural photography, you will not be able to buy your equipment at K Mart. This is not because the equipment available from department or discount outlets is not sufficiently sophisticated, but rather that it is, surprisingly, too sophisticated and too specialized. Photographic technology has become very user specific, and the cameras sold to the general public these days are finely tuned to serve that public. Automatic everything (auto-exposure, focus, film advance, film speed selection, etc.) cameras are not toys; in fact they are extremely well-made and exquisitely engineered. But they are just not for us; most of the currently available automatic features are unnecessary and sometimes confusing.

THE TRUTH ABOUT AUTOMATION I have made several rather disparaging remarks about the recent trend of giving over important photographic variables to electronic control. My opinion is based on the unfortunate fact that architectural photography does not benefit from this development.

Three principal automatic features are being pitched to a willing, and, for the most part, well-served public: auto-exposure, auto-focus, and auto-flash. These are helpful options for the ordinary amateur photographer since they largely guarantee freedom from the technical decisions that stand in the way of spontaneous shooting. The automatic functions are governed by logical algorithms programmed into computerlike microprocessors in the camera. These algorithms fail when confronted with typical architectural situations.

Auto-focus sensors determine subject-to-camera distance by measuring image contrast or by bouncing infrared or ultrasonic radiation off whatever is centered in the viewfinder. Either method will set the focus precisely on the closest solid object the system detects. A problem arises when the subject is not an identifiable object like a person or a tree, but is instead a space such as a room, or a building set within a landscaped environment. In these cases, depth of field is critical. According to the laws of optics, the true depth of field associated with a particular aperture extends from approximately one-third of the distance ahead of the exact point of focus to approximately two-thirds of the distance behind it. An auto-focus camera cannot know this without some fancy intervention by the photographer, yet it is a simple matter to set the proper focus manually.

Auto-exposure systems are similarly baffled by certain situations common to buildings and interiors. For example, bright patches within the image area, such as windows, light fixtures, and reflections from glass curtain walls, will bias the camera towards underexposure. Again, intervention by the photographer will be required, thus short-circuiting the benefits of exposure automation.

Auto-flash circuits trigger small electronic flash tubes when the level of ambient illumination is too low to allow reliable hand-held exposures. Since most of our work will involve small apertures and long shake-inducing exposures, this feature will often be invoked by the cameras that are so equipped. In practical terms, the light provided by such units is too weak to be of much use beyond a few feet, and, in addition, may well create unwanted reflections, highlights, or flare.

WHERE AND HOW TO BUY Cameras suited to the kind of work in which we are interested are rather difficult to come by. As I mentioned earlier, what is required is mechanical reliability and precision, coupled with a built-in, manually operated light meter. Motorized film advance is a definite convenience, but automatic focus, film loading, and film speed indexing is superfluous and sometimes even an obstacle to the work at hand. Cameras without these options are difficult to find brand new because so many electronic bells and whistles have become standard equipment.

The most direct route to these cameras is an industrial photographic supply house that services working professionals. You can find one by checking the yellow pages under "photography supplies, industrial" or "photography supplies, commercial." Any professional photographer can point you in the right direction as well. Professionals prefer simple but well-made equipment, so the sales staff at such a store will be familiar with whatever new cameras are available that fit that description. Also, there is no reason to avoid reconditioned equipment if it is recommended by knowledgeable people. Many classic cameras made five, ten, or even fifteen years ago fulfill the criteria for our particular work

quite admirably. Since camera manufacturers, unlike car manufacturers, have managed to maintain the integrity of their basic designs over the last couple of decades, most of today's lenses will fit on older camera bodies, so optical obsolescence is not a worry

For the bolder among you, particularly those with photographically minded friends, the newspaper want-ads are always a source of "pre-owned" cameras, lenses, and accessories. People rarely mistreat quality photographic equipment, but it is still a good idea to have a repair technician check out any machine you are seriously considering. Ask a professional photographer to recommend a reliable service person, or look in the yellow pages under "camera repair."

A less convenient but highly competitive source of both new and used professional-level equipment can be found through advertisements in the back of the larger photography magazines. Mail order houses in New York, Los Angeles, and other major centers are usually trustworthy and relatively speedy. There may be some problems with local warranty service, but if shipping a broken or damaged camera across the country for repair does not bother you, then do not hesitate to take advantage of the deeply discounted prices.

If the price of the very best equipment should give you pause, consider leasing as an alternative to buying. Almost any company engaged in leasing cars, computers, or office technology will be happy to lease high-end camera gear. In the bigger cities, occasional users can also rent. A final option might be for your specific professional association to purchase some decent equipment that could be shared by its members.

Film can be bought just about anywhere, but the professionally oriented products mentioned throughout the text will be easier to obtain through industrial suppliers. Some custom processing labs sell professional films, as well.

ONE CAMERA/ONE LENS ($300-$500) It is, of course, impossible to recommend a list of standardized equipment for in-house architectural documentation, as every practice will have its own particular needs and resources. Nevertheless, even the most basic efforts will require, at the very least, a camera and a lens. There are several cameras from the major manufacturers that would be appropriate. Canon, Nikon, Pentax, Olympus, and Minolta all have produced no-frills, non-automatic cameras, and a wide range of quality lenses are available for them. I have owned many functional and reliable cameras and lenses made by Nikon, Canon, and Minolta. However, you will have to rely on professional photographer friends or trustworthy camera salespeople to help with the choice.

Whatever the brand of camera you select, the "normal" lens (typically 45–58mm), will not do for most architectural work. It is possible to buy both new and used camera bodies without a normal lens, so when budget restrictions limit equipment choices to one lens only, it should be a moderate wide-angle to moderate telephoto zoom of approximately 28-90mm.

Earlier, I indicated that zoom lenses cannot compete with the technical performance of fixed-focal-length lenses. The deficiencies are the inevitable consequences of the additional elements and the mechanical complexity that allows alteration of focal length. Here is a list of the zoom-related problems:

1. Smaller maximum apertures and dimmer, harder-to-focus viewfinder image.
2. Lower optical performance.
3. Higher susceptibility to flare (spurious non-image-forming light).
4. Tendency toward certain kinds of distortion.
5. Heavier and bulkier construction.

For a number of reasons these performance deficiencies are not sufficiently important to forgo the flexibility of "many lenses in one" that zooms offer to those with limited funds.

To begin with, smaller maximum apertures are not a major obstacle, since most architectural work will be done slowly enough to permit careful focusing. Also, wide maximum apertures have limited value in shooting "deep" subjects like buildings and rooms; in such cases very small apertures are required in order to achieve the depth of field necessary to maintain focus throughout. Happily, image resolution and image contrast improve significantly at smaller apertures.

Increased vulnerability to flare is a fact of life with zooms because all the additional glass tends to aggravate internal reflections. However, some simple precautions will minimize image degradation—for example, avoiding extra-bright sources such as windows or exposed lights within or just outside the frame.

Camera want ads, *Winnipeg Free Press.* Prices are in Canadian dollars. Used prices in the U.S. will be 30%%–50% lower.

If you were to follow up the "Camera For Sale" classified advertisement for the Canon A-1 this is what you might get.
Top row: Canon lens shade for 28mm lens, Camera A-1 camera with BTL light meter, normal lens.
Bottom row: wide-angle lens, power winder (a low-budget, slightly slower speed version of a motor drive), and a general purpose lens shade.

V

59

A certain kind of distortion that plagues some zoom lenses is more problematic than simple flare—barrel or pincushion distortion is a non-linear response to straight lines. Properly called curvilinear distortion, this problem occurs as a result of the introduction of an aperture. Retrofocus wide-angle and telephoto lenses also exhibit this deficiency to some degree due to their asymmetrical designs. In the "barrel" mode straight lines are bent slightly outward, away from the center of the image, while in the "pincushion" mode the deformation is inward. The change from barrel to pincushion occurs as the focal length is varied. Non-linear distortion is becoming less and less of a problem with every new generation of zoom lenses; therefore I recommend that the newest lens possible be selected. Such lenses do not necessarily have to be made by the same manufacturer as the camera body: Tamron, Vivitar, and others make fine after-market accessories.

The size and weight of most zooms is not really a concern for architectural jobs since the use of small apertures dictates long exposure times, which in turn demand a tripod; the use of a sturdy stand negates problems associated with poor "hand-holdability."

A MODEST 35MM SYSTEM ($500–$800) If the cash is available to start with more equipment, I suggest that zoom lenses be avoided in favor of three fixed focal length optics, namely a 20mm or 24mm extreme wide-angle, a 35mm moderate wide-angle, and a 90 or 105mm moderate telephoto. This group will cover most jobs easily, and the absence of zoom convenience will be balanced by improved technical performance.

A COMPREHENSIVE 35MM SYSTEM ($1000–$2500) Any truly complete outfit will include a perspective control lens. These useful devices are offered in various manifestations by several manufacturers, but I prefer the Nikon 28mm version because its edge to edge sharpness is very good, and its movements are generous. In fact, the Nikkor 28PC will take the place of a conventional 24 or 28mm wide-angle. I therefore suggest the following line-up: 20mm extreme wide-angle, 28mm PC, 35mm moderate wide-angle, 55mm Macro (a macro lens is a specially formulated "normal" lens intended for close-up and copy work, as well as more common tasks—short telephoto macro lenses are also available), 90 or 105mm moderate telephoto, 200 or 300mm extreme telephoto. Well-heeled and/or conscientious photographers would do well to include a second camera body in their collection of tools for emergency back-up in the field and for those times when both B&W and color must be shot.

INDISPENSABLE ACCESSORIES Regardless of how sophisticated or how simple a system you work with there are some accessories that you cannot do without.

First, a sturdy tripod is essential. As I have indicated, architectural photography usually requires great depth of field. Depth of field is a function of aperture (f-stop). Since aperture and exposure time are inversely related, exposure times are usually long, particularly with relatively insensitive, fine-grain, high-resolution films. Image quality is profoundly degraded by camera movement, so the easiest (and by far the cheapest) way to preserve good resolution is to mount the camera on a reliable stand. Choose a tripod with an easy-to-use but positive-acting locking system for both legs and head. Mechanical strength is important; tripods that use extra reinforcing connectors to join the legs and the center column are less prone to vibration. High-quality tripods are fairly expensive and possibly a touch heavier than you might expect, but, believe me, a good one is well worth the expense and the extra weight. Virtually any tripod will vibrate slightly when touched, so it is wise to use a cable release (a mechanically flexible remote-control trigger) rather than one's finger to trip the shutter.

Another modest but important accessory is the lens shade, a shallow cylindrical or rectangular tube that fastens to the front of the lens. As the name implies, a shade protects the lens from any light that originates slightly outside the lens's field of view. Without interference such light can strike the front element at an acute angle and randomly bounce around inside the lens barrel. Ultimately, it forms optical "noise" that causes varying degrees of flare— the result is a lowering of image contrast and an apparent reduction in sharpness. Every lens requires a different size shade for optimum shielding. Unfortunately, even the lens-builders themselves often do not take the time to determine the proper shape and length for each of their products. (This is particularly true for wide-angle and zoom lenses.) Aftermarket lens shades are only a couple of dollars each, so anyone can afford to

A Hassleblad medium-format SLR with an adjustable lens shade (for precise flare control) attached.

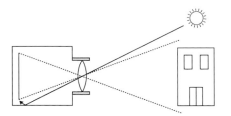

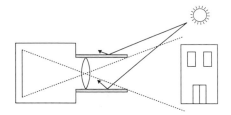

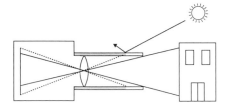

The top drawing shows how a lens shade that is too short permits non-image-forming light to enter the camera body and create image-degrading flare. The center drawing shows how a lens shade of proper length diverts or attenuates non-image-forming light. The bottom drawing shows how a lens shade that is too long controls non-image-forming light, but also cuts off parts of the subject.

experiment a bit until the perfect shade is found. The longer (deeper) the better, but do not go so far as to cause image cut-off at the corner of the frame. The diagrams on the left show how lens shades work.

To line up the vertical and horizontal elements of rectilinear subjects, most well-stocked photo stores supply simple bubble levels designed to slip into your camera's accessory shoe (the small clip that usually secures a small flash unit). Similarly, these alignments are much easier if the camera viewfinder screen is inscribed with a grid. Some 35mm SLR cameras are designed to accept interchangeable finders, and each manufacturer will have a special screen intended for architectural work. If your camera does not happen to have the interchangeable feature, any competent repairperson can score a grid pattern on the stock screen for about fifty dollars.

The photo on the right shows how I modified a Vise-Grip pliers to accommodate a spare tripod head. This handy tool allows easy camera mounting when the pyramidal shape of a tripod prevents getting low enough to the ground or near enough to the edge of a stairway, balcony, or parapet. A magazine or a piece of thick cardboard can be used to prevent any damage to decorative railings or the leg of your tripod.

Finally, every camera bag should carry a selection of basic filters. Filters are flat pieces of non-distorting optical glass or plastic that have special light-modifying capabilities. They are mounted on the front of the taking lens in the same way as a lens shade. Chapter 15 is devoted to the selection and use of filters. For now, here are the names of the basic filter categories: polarizing, color-balancing, color-correcting, special-effect, and neutral-density.

This is a photo of a very useful camera clamp fabricated from a tripod head and a Vise-Grip welding clamp. It is particularly handy for low shooting angles when attached to the leg of a tripod. Use a magazine or heavy cardboard to protect the surface finish when attaching to a decorative banister, desk top, table leg, etc.

SHOOTING ECONOMICALLY

PREVISUALIZATION Entire books have been devoted to methods like Ansel Adams's Zone System, a practical application of densitometry by which the enlightened photographer might intellectually previsualize the final results of photographic undertakings. The ability to previsualize a photographic effect before the film is exposed and processed requires a knowledge of exactly how light-sensitive materials respond to light. A first step toward such knowledge is to understand that for every type of film there is a minimum exposure level below which a measurable image density will not be recorded, and that there is also a maximum exposure level beyond which an increase in exposure will not build up any more image density. Between the cutoff points of minimum and maximum exposure levels lies a more or less linear range of sensitivity throughout which an increase in exposure results in a predictable increase in density. Real-life situations are visually rich because they offer a range of brightness, or luminance levels, by which we can distinguish one object from another. (Color plays a role in this process of differentiation, but for now we will consider only brightness levels.) Previsualization, therefore, is an exercise in determining an appropriate combination of camera settings so that the range of acceptance of the film is properly matched to the range of luminances (the brightness ratio) in the scene to be recorded.

SIMPLE EXPOSURE TECHNIQUES The business of matching film response to actual conditions is called exposure control. Unlike the interests of fine artists, who use careful exposure technique to enhance subtleties of expression, our interest is mostly practical; it is necessary to control as many variables as possible in order to guarantee good results with a minimum investment of time and money.

Proper exposure places the subject's brightness range safely within the limits marked by the maximum and minimum levels of sensitivity. This is done by using the film's International Standards Organization (ISO) rating and a measuring instrument called a light meter (or exposure meter).

The ISO designation is a number that represents the sensitivity to light of a given film. The higher the ISO, the more sensitive the film. By today's standards, ISO 1600 is very high while ISO 50 is very low. Sometimes the ISO number is used as part of the film's name; Kodak Supra 100 has an ISO of 100. In real life, there is no such thing as an absolute value for sensitivity. Film speed is a characteristic that changes under various exposure and processing conditions, so many photographers determine a personal effective film speed by experience or testing. An empirically determined film speed is assigned a number called an exposure index (EI) that replaces the ISO rating.

Left: An older model, reflected light meter with "fly's eye" lens array in front of the photo-voltaic photocell (top), exposure dial (middle), and meter readout (bottom). Center: A modern Minolta incident light meter to measure available light and electronic flash. Diffuser dome is at the top. Right: A sophisticated Gossen Spot-Master spotmeter for very precise exposure measurements at a distance. The lens is on the left, the viewfinder on the right, and hand grip on the bottom.

Meters work because of the following rule: a subject of known reflectance, illuminated by a known amount of light, will produce a predictable density on the film when an appropriate combination of aperture and shutter speed is chosen. The meter's job is to measure the amount of light and then recommend appropriate f-stop and shutter speed combinations. For calibration purposes the "subject of known reflectance" is a card painted a shade of gray that reflects 18% of the light that strikes it. When the film's ISO (or EI) is dialed into the light meter, and when the light meter is pointed at an 18%-gray card, the readout will give a combination of f-stop and shutter speed values that will result in an 18%-gray tone on the processed print or slide. The mathematical average of the many brightness levels within a typical subject yields the same reflectance as an 18%-gray card; consequently a light meter pointed at the world automatically gives a reading based on what the meter perceives to be an average light level.

A photo of three 35mm negatives of the same subject, bracketed 1 1/2 f-stops apart. The lighter image is underexposed and lacks detail. The darkest image is overexposed and too dense for proper printing. The middle negative exhibits a full tonal range and will print very well.

For our purposes (with a few exceptions that will be explored later) the light-meter reading can be a reliable starting point for a simple yet efficient procedure to guarantee proper exposure. The procedure is called "bracketing" and involves making a series of additional exposures above and below the measured exposure. For negative films brackets equaling 50% and 200% of the indicated exposure (plus or minus one stop) will generally insure a usable image, while transparency film (which is much more sensitive to exposure error) requires four extra exposures: -1 1/3 stops, -2/3 stop, +2/3 stop, and +1 1/3 stop.

In practical terms, the camera is loaded with a film of a certain ISO (or EI). This number is dialed into the appropriate control on the camera's light meter. The meter will recommend an exposure setting, say f11 at 1/125th of a second. Bracketing exposures of one full

stop on either side of the measured exposure would yield f8 and f16 at 1/125th of a second or alternately f11 at 1/60th and 1/250th of a second, since f-stop and shutter speed are reciprocally related. Halfstop or third-stop brackets are made by selecting settings that fall partway between the f-stop numbers on the aperture control ring of the lens. Some lenses have detentes or painted markings at the half-stops, while others do not, in which case a guess will have to be made. The bracketed exposures are examined after processing and the best ones are retained while the rest are discarded. The people at the lab will assist in making correct choices. The extra film used for the brackets is a small investment compared to the inconvenience and expense of repeating an unsuccessful shoot.

I demonstrate the gray-card exposure method with a BTL metering SLR camera. A gray card is angled to catch the available light. The card should fill the whole frame in the viewfinder, although it need not be in precise focus.

SPECIFIC FILMS AND PROCESSING OPTIONS There are dozens of wonderful films available, but I am intimately familiar with only those I use regularly in my own work. Here is a list of the materials I depend on:

1. Fuji NPC (daylight, medim-contrast, general-purpose color negative, ISO 160)
2. Fuji Reals (daylight, low-contrast, fluorescent-tolerant color negative, ISO 100)
3. Fuji NPH (daylight, wide-latitude, high-speed color negative, ISO 400)
4. Kodak Portra 100T (tungsten-balanced, long-exposure tolerant, color negative, ISO 100)
5. Fuji Provia (daylight, general-purpose color transparency, ISO 100)
6. Fuji Velvia (daylight, high-saturation, high-resolution color transparency, ISO 50)
7. Kodak EPY (tungsten-balanced, long-exposure tolerant color transparency, ISO 64)
8. Kodak T400CN (chromogenic, black-and-white negative, ISO 400)

Both black-and-white and color negative films benefit from more exposure than their official ISO ratings require; therefore I generally set my exposure meters on an EI of one-half the designated ISO for these films. Transparency films, as a rule must be exposed at their official ISO ratings.

In Chapter 3, Itolled the print-making services of professional custom processing labs. I believe it is best to depend on these people for film processing, as well. Results will be more consistent and the occasional special service, such as pushing (processing for higher speed and increasing contrast) or pulling (processing for lower speed and reducing contrast), will be available when you need them. Skilled technicians can offer advice regarding exotic darkroom options, exposure technique, and other concerns once a working relationship and a regular flow of work has been established.

POLAROID TESTING A sophisticated approach to exposure (and composition) control commonly used by professionals takes advantage of instant-developing films. All 4x5in and many medium-format cameras will accept special Polaroid film backs that allow very precise previews of camera setup and lighting. It is possible to have a 35mm camera body custom-modified for this type of testing, but the image is too small to be really useful and the modification is prohibitively expensive.

Nevertheless, instant-camera testing for 35mm photography is possible with special cameras, as long as those cameras have conventional f-stop and shutter speed adjustments. The cameras are pricey (several hundred dollars) and difficult to locate second-hand, but they are very useful. Polaroid films have stable ISO ratings that are comparable to conventional films, so once a decent exposure has been determined using instant film it can then be transposed to the 35mm camera. This method is for perfectionists with deep pockets only.

KEEPING RECORDS The best technique in the world is rendered useless by a poor memory. Your learning curve will be accelerated and your technical accomplishments safeguarded if you take the time to maintain a written record of film, lens, meter readings, exposure settings, light conditions, and processing details for every roll of film. There are actually dedicated photographic notebooks available through professional supply houses. However, the lack of an official-looking journal is no excuse for not doing one's homework.

FILING AND STORING NEGATIVES AND SLIDES Easy access and worry-free protection of your photographic output is assured if a few simple practices are followed religiously. Edit your negatives and slides as soon as they come back from processing. Those images that are redundant or of no real value (outtakes) should be discarded right away. (Film is susceptible to scratches and attack by skin oils as well as other commonplace contaminants carried on the fingers: handle by the edges only.) All negatives and slides should be kept in vinyl storage sleeves (available at most camera stores) and stored flat, cool, and dry. A large three-ring binder with divider cards or an ordinary letter-size cardboard folder for each job and a regular filing cabinet drawer will go a long way toward keeping things organized and within easy reach. For archival storage, photographic materials should be stored in a freezer. Low temperature and low relative humidity are important for long life.

1, 2 These images show how far photographic technology has progressed in the last few years. The top image of the Government of Canada Toxicology Laboratory, Smith-Carter Architects, Winnipeg, was photographed on 4x5in Vericolor film using a view camera and a 90mm moderate wide-angle lens, while the bottom image was made on 35mm Kodak Ektar 25 film with a Nikon single lens reflex camera and a 28mm PC lens. Moderate perspective controls were employed in each instance. I am hard pressed to distinguish between them technically. Careful examination of the original prints show that the 4x5in version has slightly greater resolution—probably due to optics.

3–8 These 35mm color slides show how quick and easy to use small-format equipment can be. These photos, details of heritage buildings in downtown Winnipeg, were all made during a leisurely two-hour stroll on a warm summer evening. I carried only a camera and a long telephoto lens. In lieu of a tripod, I braced myself against various street-level objects like posts or buildings to avoid camera shake.

9, 10 These two similar images show how
the differences between transparency and
color negative films are diminished by the
process of non-photographic reproduction.
Both images depict aspects of the block-
long atrium hallway of IKOY Architects'
William Davis Computer Center at the Uni-
versity of Waterloo, Waterloo, Ontario. The
first photo was reproduced directly from
4x5in Kodak Ektachrome film; the second
photo was made on Kodak Vericolor III
negative film and reproduced from an
8x10in print. I think you will agree that
they are virtually indistinguishable, techni-
cally speaking. Camera: Toyo 4x5in,
lens: 90mm (moderate wide-angle). Perspec-
tive controls were used.

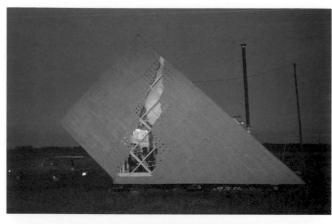

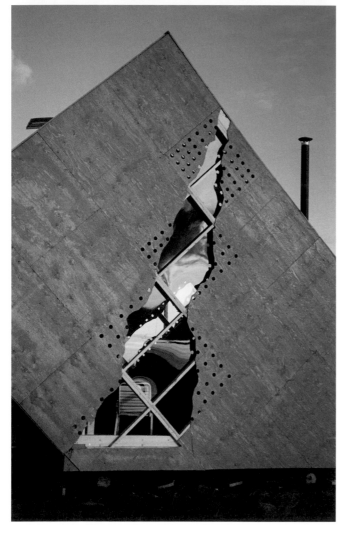

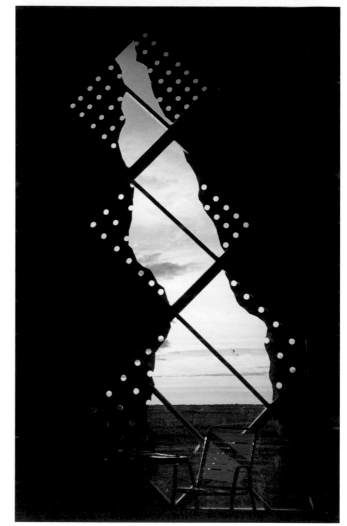

11–14 This small-format portfolio was shot with a 35mm Nikon SLR and Kodak Ektacolor Gold 200 film by Ron Keenburg, chief of design (the "K") at IKOY Architects. They depict the IKOY hunting/fishing lodge built in northern Manitoba. I processed the film and produced carefully printed enlargements that were used as IKOY's successful entry in the 1990 Governor General's Awards for Architecture competition (Canada's highest honor for design). The sharpness of the Kodak Ektacolor Gold 200 film is noticeably less than that of the much slower Ektar 25, but the photos quite adequately served the purpose for which they were intended. Subjects such as this—fairly simple, bold shapes with clearly defined edges—are the type best suited for 35mm photography.

15 These photos, all made from the same negative, show the power of print controls. This is a view of the Museum of Anthropology, University of British Columbia, Arthur Erickson, architect. This is my very first architectural photo. This particular print is completely unmanipulated—just a straight print made at normal color settings and exposure. Camera: Linhof Technica 6x7in (medium format field camera), lens: 65mm (moderate wide-angle), film: Kodak Vericolor II Type S. No perspective controls required.

16 The same image printed with a magenta color caste.

17 The same image printed with several manipulation techniques. First the sky and foreground were "burned in" (darkened) by increasing exposure time to these areas by about 150%—the building was "dodged" (held back, or lightened) during this process. Next, areas of the image to the extreme left and right were burned in by a further 75%. The color settings on the enlarger were adjusted for a very warm color balance, and then the reflection of the sunset was selectively burned in.

18, 19 These two photos—details of a very old handmade door and latch—were made from the same camera position and show how quality of light affects the power of an image. The pictures were part of a documentary shoot for Canadian historian Gwen Dowsett, who was studying the vernacular architecture of Manitoba's early Ukrainian immigrants. The photo above was made while the sun was obscured by a cloud—the light is very soft, and yields a rather dull effect. The photo on the right was made just a minute or two later, just after the cloud passed and permitted the early morning sun to skim the subject. Apparent depth and richness of color were dramatically increased by the direct sunlight. Camera: Hassleblad ELX (medium format), lens: 100mm (normal), film: Kodak Vericolor III Type S. No perspective controls.

20 The vantage point here was chosen to
highlight IKOY's imaginative and unortho-
dox use of conventional materials. Cam-
era: Toyo 4x5in, lens: 150mm (normal),
film: Kodak Vericolor III Type S. Perspective
controls were not used.

21 Careful camera positioning revealed a
pleasing mirror image of the IKOY deck
and pool while showing off details of the
stair at the same time. The overcast sky
makes the shot less confusing by eliminat-
ing heavy shadows. Camera: Toyo 4x5in,
lens: 75mm (extreme wide-angle), film:
Kodak Vericolor III Type S. Perspective con-
trols were required.

22 This ultra-wide-angle view of a restored cathedral in Regina—Clifford Wiens, architect—was made by available light from the balcony at the back of the church. Notice how the blue-magenta color of the columns and pews in the foreground argues with the warmer tones toward the alter. Stained glass pieces to each side of the alter are backlit with fluorescent lamps—note the blue-green spill on the wall around them. Camera: Toyo 4x5in, lens: 47mm (extreme wide-angle), film: Kodak Vericolor III Type S. No perspective controls required because of the elevated viewpoint.

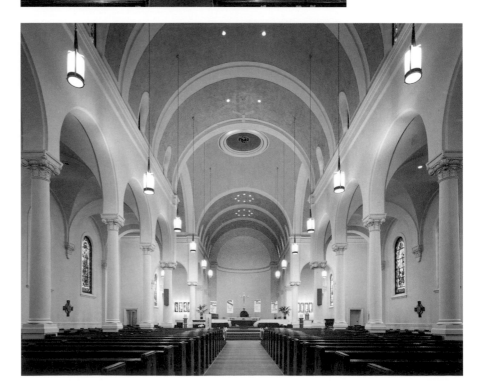

23 This view is shot from floor level. Note how the inclusion of the stained glass windows in the composition makes the blue-magenta cast of the columns more acceptable. This is a psychological trick: if the viewer is shown the reason for a photographic condition, the viewer becomes more tolerant of that condition. Also note that the change in vantage point has shifted the predominant color balance of the pews and central carpeting toward a warmer, more natural tone. From the new viewing angle the predominant light source is no longer window light, but tungsten. I dodged the fluorescent highlights to each side of the alter, which made them lighter and less objectionably blue-green. The hanging tungsten fixtures were individually burned in to yield more detail. Camera: Toyo 4x5in, lens 75mm (very wide-angle), film Vericolor III Type S. Extreme perspective controls because of the viewpoint.

24, 25 **This a close up view of a unique wire and wood-block curtain that architect Clifford Wiens designed to separate the main alter from a smaller chapel directly behind it. Vertical lines were permitted to converge for effect. The print on the right is identical to that on the left, except that the ceiling fixtures have been switched on, enhancing the celestial feeling and increasing the perception of depth by adding detail to the walls and arches. It pays to pay attention to subtle effects.** Camera: Toyo 4x5in, lens: 75mm (very wide-angle), film: Vericolor III Type S. Extreme perspective controls required because of the floor-level viewpoint.

26, 27 This elevation of a two-story Akman & Sons suburban office building was shot under pressure of deadline—the windows were supposed to have been tidy. Since the picture was needed for a promotional brochure I asked Ray Phillips to eliminate the signs plus some other unsightly details in the foreground. Camera: Hassleblad ELX (medium format), lens: 60mm (moderate wide-angle), film: Kodak Vericolor III Type S. No perspective controls.

28 These three 35mm Kodak Ektachrome slides of the Air Canada Head Office in Winnipeg, Smith-Carter Architects, show the technical effects of a one-stop bracket around a metered exposure. The differences are small but significant—study the difference in the highlight detail as exposure changes.

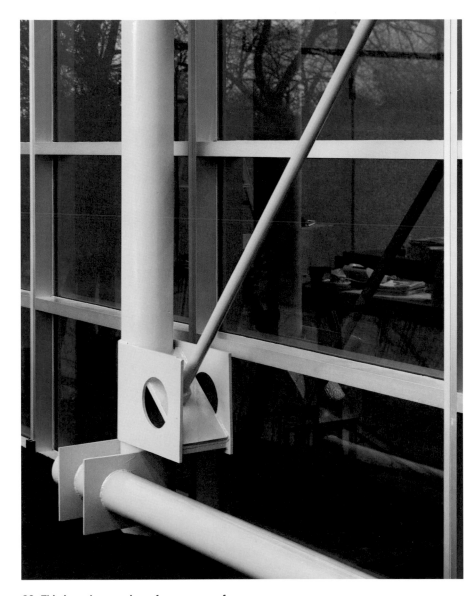

30, 31 I offer this nondescript hallway as a lesson in on-camera filtration. The photo at the top is an unfiltered exposure with daylight-balanced Ektachrome under cool-white fluorescent lighting. The film reacts strongly to the excessively greenish spectrum produced by these lights. A more pleasing neutral color balance is pretty well restored by shooting through a 30M (magenta) Kodak Color Compensating gelatin filter (below). A very similar correction can be achieved in the darkroom when making prints from unfiltered color negatives.

29 This is a closeup view of one corner of a custom-made stress-relief structure. Available fluorescent lighting illuminates the yellow steel tubing and window mullions. The extra magenta filtration required to compensate for the green characteristic of fluorescents renders the twilight sky in extra rich tones. Reflections from inside the building were diminished by using a polarizing filter on the camera lens.
Camera: Toyo 4x5in, lens: 90mm (moderate wide-angle) plus polarizing filter, film: Kodak Vericolor III Type S. Perspective controls were required.

32 In this picture, daylight competes with fluorescent lighting. The overall color balance of the print is set to make the fluorescent-lit areas appear neutral in color. As a result, the areas in which daylight predominates appear somewhat magenta. This effect is minimized, however, by the fact that daylight areas are also overexposed and consequently rather pastel. Camera: Toyo 4x5in, lens: 75mm (extreme wide-angle), film: Kodak Vericolor III Type S. Perspective controls were required.

The photographs on these two pages document the restored turn-of-the-century Bank of Hamilton Building. The renovations were supervised by The Prairie Partnership Architects. All interior views were shot by available light.

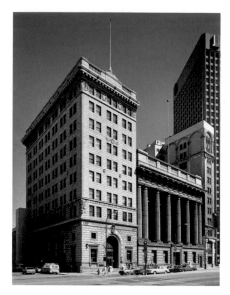

33 This view was made from street level and shows how the building fits into the urban landscape. Late afternoon sunlight fully illuminates the main facade and highlights elements of the nearby structures. Camera: Toyo 4x5in, lens: 90mm (moderate wide-angle), film: Kodak Vericolor III Type S. Fairly extreme perspective controls were required to maintain rectilinearity at close quarters.

34 Still at street level, but now much closer, this view of the entrance relies on the steep sun angle to highlight the texture and detailing of the stone and metal work. A moderate telephoto lens was used to compress perspective. I was working to a fairly tight budget, otherwise I would have asked a retoucher to eliminate the wires above the door, and the sign post to the right of the stairs. Camera: Toyo 4x5in, lens: 250mm (moderate telephoto), film: Kodak Vericolor III Type S. No perspective controls required.

35 The main banking hall viewed through the lobby doors. I shot the interior on a different day—I wanted very dull daylight inside to reduce color balance conflicts. I made the prints quite yellow to enhance the warm feel of the original brass fittings and tungsten light fixtures and to minimize the blue of the ambient daylight. Camera: Toyo 4x5in, lens: 90mm (moderate wide-angle), film: Kodak Vericolor III Type S. Moderate perspective controls.

37 This is a shot of the main banking hall from the vantage point of a small mezzanine. Careful burning and dodging of the print was required to maintain detail throughout. It is very clear how the mixture of daylight and tungsten light induces shifts in color balance across the image, but in this case the discrepancy is not objectionable, in fact it adds to the "old world" ambience. Camera: Toyo 4x5in, lens: 90mm (moderate wide-angle), film: Kodak Vericolor III Type S. Extreme perspective controls required.

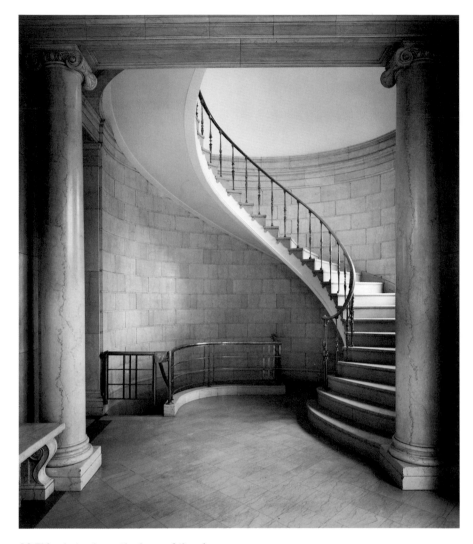

36 This photo shows the base of the circular stairway in true rectilinear alignment. Color balance is uneven, but as in the shots of the banking hall, the obvious shifts are acceptable because of the age and complexity of subject. Camera: Toyo 4x5in, lens: 90mm (moderate wide-angle), film: Kodak Vericolor III Type S. Moderate perspective controls.

The images on these two pages illustrate color to black-and-white conversions.

38, 39 A magical image made by available light without perspective controls. Careful alignment of the wide-angle-equipped camera captures the graceful curve of this stairway at the Carleton Club, Winnipeg, by Smith-Carter Architects. Small tungsten lamps behind the handrail project interesting shadows on the curved wall to which the individually mounted steps are attached. The conversion from color to black-and-white is successful because the tones and geometry of the image are sufficiently distinct to maintain the graphic impact. Camera: Toyo 4x5in, lens: 47mm (extreme wide-angle), film: Kodak Vericolor II Type L.

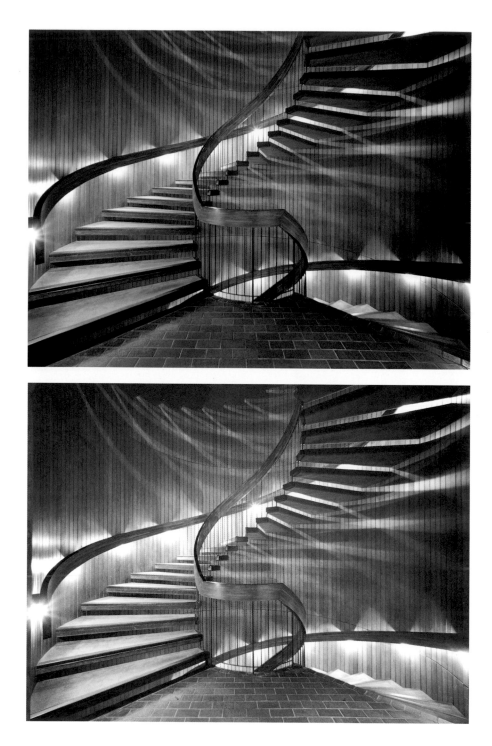

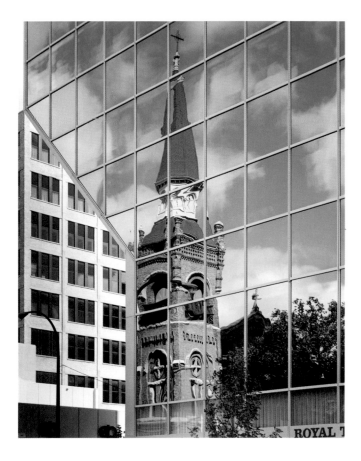

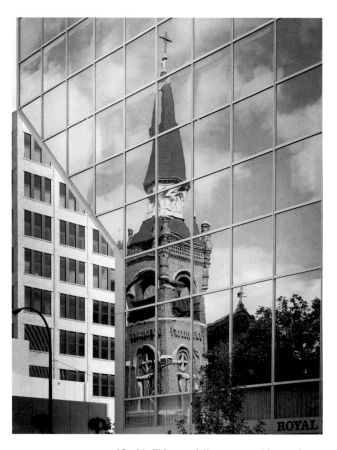

40, 41 This carefully composed image is a photographic pun: it records a very particular point of view and sets up a playful interaction between the main subject—the glass building partially shown in the foreground—and the surrounding structures. The color version is more immediately accessible, simple because the additional information makes the composition less ambiguous. Technically the conversion to black and white is satisfactory, but the monochromatic rendering makes an already complex picture a little confusing. Camera: Toyo 4x5in, lens: 150mm (normal), film: Kodak Vericolor III Type S.

42 This is a 4x5in copy transparency of an IKOY rendering—a proposed Agriculture Canada Research Station and Laboratory, Brandon, Manitoba. The slide was made by Custom Images, a professional color lab in Winnipeg. The original drawing is held flat against a perforated easel by vacuum suction, and photographed together with Kodak Color Control Patches and a Kodak Gray Scale so that densitometric measurements can be used to make accurate prints at a future date.

43, 44 This office building rises near the banks of the Saskatchewan River, in Saskatoon, Saskatchewan. This is the first project I photographed for IKOY Architects. The two photographs show how a little extra effort makes photographs much more interesting. Both images were made from the same vantage point, but twelve hours apart. The second photo was taken at night, with about a 90 second exposure. Arrangements were made to have the building fully illuminated. Serendipitously, nearby buildings were relatively dark, leaving my clients' building (second from the left) shining like a jewel in the winter night. Note how various light sources are each recorded as different colors. Camera: Toyo 4x5in, lens: 150mm (normal), film: Kodak Vericolor III Type S. Perspective controls unnecessary.

Please note: The advice in this chapter will be based on the assumption that the work will be shot exclusively on 35mm equipment.

A TYPICAL EXTERIOR SHOT

DEFINING THE JOB First things first: the proper beginning for any photographic project is to gather information and then think. Only professional artists and highly motivated amateurs make photographs for the sheer joy of it. Although there is no monopoly on aesthetic pleasure, most everyone makes photographs for a specific reason. Define your own reasons, and the work will be much more straightforward. Refer to the list of pertinent questions given on pages 15–16.

CHOOSING FILM AND EQUIPMENT In a typical scenario, architectural photography is intended to be a combination of documentary record and selling tool. This means that the images must be clear, comprehensive, and attractive. Technically, they must be versatile, since it may be necessary to generate color prints suitable for inclusion in a portfolio, black-and-white prints for newspaper or photocopy reproduction, and a few color slides for audio-visual presentation. The end use, therefore, dictates some technical choices even before the actual subject of the photos is considered.

The amount of time and the money available further limit technical choices. For example, each of the above mentioned end products (color prints, black-and-white prints, and color slides) will be technically superior if they are produced with films dedicated to that particular medium. In other words, if the very best results are required and if the resources are there, the photographs should be shot on three different films. If time is not a problem but cash is, the alternative would be to use Kodak Supra 100, one of the highest resolution color negative films now available. With this approach the work tends to go rather slowly because the resulting long exposures keep the camera tripod-bound. To speed things up, albeit at the expense of some quality, a faster film such as the Fuji NPH (ISO 400) will get the camera off the tripod. I strongly recommend you do some comparative testing. A working familiarity with film performance is essential to the successful visualization of the final image.

Equipment choices and equipment availability are interlocked. After deciding on a format, most professionals will pack a wide selection of lenses, and then base their specific choices on the shooting angles dictated by tile accessibility and the size of the subject. The compact nature of 35mm equipment makes this easy to do for amateur work. However, even if you will be using fast film, I suggest carrying a tripod along to each job just in case low light-levels force exposures into the "non-handholdable" range.

SELECTING ANGLES AND TIME OF DAY Determining the best points of view and the best sun angles is the real work of the architectural photographer. In the studio, the commercial photograpber creates a scene in which the lighting and the camera position best portray the subject. However, when working outdoors with subjects of monumental scale, virtually all controls, except for the choice of camera position and the time of day, are eliminated. The technique of finding the right angles is a Zen-like process of observation and surrender—surrender to both the workings of nature and the not-quite-invisible hand of the architect who fashioned the building and its surroundings. If the photographer is the architect (or someone involved in the creation of the design), then finding pleasing angles will be easier, although the mechanics of the process will be the same.

A site inspection, preferably in the company of the designer, is essential. The first efforts should be directed to finding suitable views from eye level, from below eye level, and from above eye level. The higher vantage points might be located on nearby buildings or hills, while the lower vantage points might require a bit of crawling around. Glass or metal-clad buildings are tricky because different perspectives invoke different reflections that have to be integrated as second order compositional elements.

The exact point of view (I refer now to fine tuning, which involves very precise camera movements of a few inches to a few feet) depends on small but significant details such as the interaction between foreground objects like trees, lampposts, or street signs, and elements of the building's facade.

Next, decide on what angle of sunlight will be most effective. This is a subjective criterion, and changes according to exactly where on the style-scale of "straightforward documentary" to "high drama" you wish to place your work. (Consideration of style relates to the choice of angles as well, but the range of choices is more limited.) A simple rule

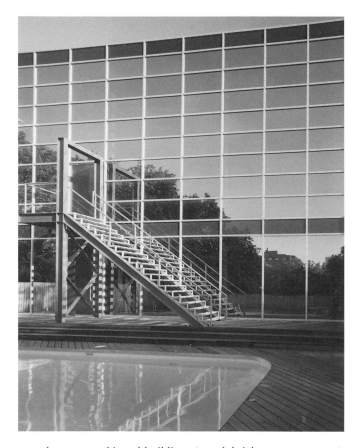

says that coarse-skinned buildings (wood, brick, cement, stucco) are best highlighted by steeply angled, direct sunlight, while smooth-skinned buildings (glass, metal, tile) are enhanced by interesting reflected light, such as that from an unusual sunrise, sunset, or cloud formation. Aside from the predictable progression of the sun's arc through the sky, natural light is capricious. Patience is an asset in this work.

You will note that all preliminary photographic choices can be made without any reference to photographic hardware; the first steps of the previsualization process involve only an aesthetic empathy with the subject, based on careful observation of how the natural and the man-made worlds interact.

OPTICAL CONSIDERATIONS After points of view and sun angle are determined, the capabilities of the lenses at hand must be considered. In the best of all possible worlds every choice of camera position would be easily accessible, but in the real world the laws of optics impose some rather brutal restrictions. Except for recording details and shooting from a distance, most architectural photography depends heavily on wide-angle lenses; therefore, angle of acceptance is critical. Strictly speaking, each different point of view around a given site will demand a lens of different focal length. If perspective correction (parallel vertical lines) is not a major concern, the infinite variability of zoom lenses is a definite advantage. But as we have seen, zooms have problems (there is no such thing as a PC zoom, for example), so those interested in the best optical performance and/or perspective correction must rely on lenses of fixed focal lengths. The corollary of this fact is that some desirable points of view must be sacrificed or modified because the lenses available are not exactly the right focal length.

To preserve the parallel lines of the subject, the film plane and the principal subject-plane must be parallel. When the lens is not positioned on a line perpendicular to the exact center of the subject, either crop the image from an ultra-wide-angle lens or use perspective controls. Unfortunately, PC lenses are available in only a couple of focal lengths, typically 28mm and 35mm, while extreme wide-angle lenses introduce problems of dimensional ambiguity. When the limits of coverage or perspective controls are reached, the camera has to be either moved away from the subject or tilted upwards.

As discussed in Chapter 4, the gratuitous use of "unnatural" perspectives that result in converging vertical lines and odd spatial juxtapositions can get tiresome. Generally

Left: An early morning shot of the rear wall of the IKOY Office. The exposure was made just as the sun reached a position that fully illuminated the structure while leaving the pool and deck in shadow. This leads the eye directly to the stairway entrance and enhances the contrast between the reflections of structural details and the blue of the water. This is an excellent illustration of the effective exploitation of natural lighting conditions. Camera: Toyo 4x5in, lens: 90mm (moderate wide-angle), film: Kodak Vericolor III Type S. Perspective controls were required.

Right: An extreme close-up showing the treatment at the corners of the steel mezzanine supports in IKOY's Winnipeg office. To achieve maximum impact, the photo was made by direct sunlight at a time of the day when the wall behind the joint was not directly illuminated. Camera: Toyo 4x5in, lens: 250mm (moderate telephoto), film: Kodak Vericolor III Type S. Perspective controls were required.

speaking, we are most comfortable when that which we know to be upright is rendered as upright in a photograph. Similarly, we are most comfortable when objects that we know to be of a certain relative size are so rendered in a photograph. Bearing these truths in mind, it is not difficult to understand that lenses of different focal lengths have clearly definable comfort zones within which three-dimensional subjects of familiar proportions may be comfortably translated into two dimensions. From experience I can say that moderate wide-angle lenses can be trusted not to exaggerate perspective to a noticeable degree; they have a wide comfort zone and can be used freely all around the compass, both dead-on or from very acute angles. The dimensions of the subject and the angles of acceptance of the lenses in question geometrically predict minimum working distances; extreme wide-angle lenses are real problem-solvers in tight circumstances, but they have a very narrow comfort zone and consequently must be used much more carefully. The following advice regarding low, medium, and high-rise buildings is given with special attention to the eccentricities of wide-angle lenses. Some consolation may be taken in the knowledge that even professional photographers with a full compliment of 4x5in equipment are frequently confounded by the limits of the available technology.

LOW, MEDIUM, AND HIGH-RISE BUILDINGS I use the word "mechanical" to describe those variables in photographic practice that are neither completely aesthetic nor completely technical. The size and shape of the subject are largely mechanical considerations; in photographic terms the geometry of the subject creates problems that, given the nature of the tools available, have to be dealt with in rather predictable ways.

Eye-level photography from the street is the most common type of architectural work because it yields images that look right (and it is easy on the back). Nevertheless, the mechanical problems associated with this approach escalate according to the size of the structure because larger subjects demand greater camera-to-subject distance. Adversely, skyscrapers are crowded together in congested urban neighborhoods while strip malls are usually surrounded by acres of parking lots.

Low-profile buildings of one or two stories are the least technically demanding to photograph. Generally, moderate wide-angle or even normal lenses will permit rectilinear elevations and angled views to be made without a struggle. The problems in this case are more aesthetic than technical, since many industrial side-by-sides and low-budget suburban strip malls are not highly interesting photographically.

It is possible to add some visual interest to dull low-rise subjects by using their architectural embellishments, however unprepossessing they might be, to advantage. For example, most multi-tenant structures have a stand-alone signpost or marquee; this could be positioned as a foreground element to one side of the frame to break up the horizontality of a suburban/industrial landscape. The front wall of most low-rise buildings have some decorative texturing, such as brick, stained wood, or exposed aggregate. By getting fairly close to the embellished surface and shooting at an angle along its length with a moderate wide-angle lens, detail elements can become the compositional focus. This effect can be enhanced by choosing a "glancing" sun angle that is opposed about

Low camera angle, early morning light, and a big pile of crushed rock were employed to dress up this shot of a suburban cement plant: Tallcrete Building, IKOY Architects, Winnipeg. Camera: Toyo 4x5in, lens: 75mm (extreme wide-angle), film: Kodak Vericolor III Type S. No perspective control necessary.

This photo shows how to deal with low-budget condominiums—clever framing and the right light. Low-angled sunlight and the fall foliage of the modest landscaping elevated these simple wood-frame side-by-sides, shot with a moderate wide-angle lens. (IKOY Architects.) Camera: Toyo 4x5in, lens: 90mm (moderate wide-angle), film: Kodak Vericolor III Type S. With the camera at eye level, perspective controls were unnecessary.

90° to the camera angle. (Such a sun angle is quite dramatic in the right situation, but it is also pitiless in revealing mechanical flaws. Chose a smaller angle when shooting imperfect finishes.) If a PC lens is available, shooting from a lower-than-eye-level camera position can add to the sense of drama.

Since strongly horizontal images allow for a broad expanse of sky, if possible make your photographs on a day when interesting cloud formations are visible from the best camera positions. When shooting black-and-white materials the tone of the sky can be deepened and the textures of the clouds enhanced by shooting with yellow or red filter over the lens. In color, skies can be enriched with a polarizing filter.

What might otherwise be simple documentary-quality images of very plain structures can sometimes be greatly improved by shooting around dusk or dawn when the sky is often particularly pretty. For example, warmly colored reflections will dress up rows of windows that would appear monotonous in broad daylight.

In some circumstances a bird's-eye view of a low-rise building can make an effective photograph. Low-budget structures generally have only tar, gravel, and ventilation equipment on the roof, but some more elaborate structures allow for more attractive finishing. It is not unusual to find a bit of greenery around such buildings as well. From an elevated point of view, possibly a nearby rooftop or balcony, a photo of the whole site might be quite attractive. If no elevated vantage point is available, you might create your own. It is surprising how different things look from the top of an eight or ten foot ladder. Really ambitious photographers might even rent a cherry picker—a truck with a hydraulically operated lift such as those used by power-line workers or window cleaners. They rent out for about $75 an hour with an operator.

Many low buildings are surrounded by oil-stained concrete driveways and parking lots. If the negative visual effects of the dirty paving cannot be eliminated by cropping the image, a couple of clean late-model cars can be included in the composition as camouflage. (For ground-level shots use a slightly elevated camera angle so that the cars do not unduly obstruct the view of the building.) When an unsightly foreground simply cannot be avoided, ask the printer at the color lab to burn-in the offending area so that it attracts less attention. (Burning-in is also effective in deepening the color of a pale or overcast sky.)

Several of the techniques suggested above will work with medium-rise buildings, although without perspective control lenses it will be more difficult to shoot close up and

These pictures were made at about the same time of day, yet the different camera positions yielded strikingly different tonalities. This occurred mainly because of the change in the reflection—from a different angle we see darker or lighter parts of the sky. These photos also illustrate the effect of maintaining or relinquishing rectilinearity. The facade's grid is most powerful when presented dead-on, while the converging view is more playful, and less mechanical. Camera: Toyo 4x5in, lens: 90mm (moderate wide-angle), film: Kodak Vericolor III Type S printed on B&W Kodak Panalure paper. Perspective controls were required.

Left: This picture shows how a dramatic sky—and the reflection of a dramatic sky—can dress up a fairly ordinary structure. The partial overcast softened shadows as well, making the windows the brightest part of the image, a condition that leads the eye away from the sparsely land-scaped foreground. The soft light retains detail in the darker wall, thus maintaining a fairly balanced look. Camera: Hassle-blad ELX (medium format), lens: 60mm (moderate wide-angle), film: Ilford FP4 (ISO 64). No perspective controls required.

Right: This one-story building is the RH Laboratory on the campus of the University of Manitoba. The photo is an example of how reflections can be used to enhance an image. I chose an evening with broken clouds so that the wispy shapes would soften and enrich the black shiny panels. The modest landscaping was used to ad-vantage by selecting a low camera angle. Camera: Toyo 4x5in, lens: 90mm (moder-ate wide-angle), film: Kodak Vericolor III Type S. Modest perspective controls.

at lower angles. Buildings of several stories are often more expensive than buildings of only one or two stories, so it is likely that finishing and landscaping are superior. Choose angles that highlight these elements to improve your photos. Taller buildings usually have a lot of windows, so reflections of interesting cloud and light conditions can figure prominently in your compositions. If the reflections from particular angles are distracting, a polarizing filter can sometimes attenuate or eliminate them altogether. Whenever windows are prominent, take the time to go from room to room and arrange blinds and drapery so that they appear uniform and tidy from the outside. Actually, this applies to low-rise buildings as well. (High-rise buildings often use highly reflective mirror-like glass, which largely eliminates this problem.)

It may be necessary to get above street level in order to avoid converging verticals. Should the neighboring structures be too tall, however, shooting from a rooftop will cause the same problem, but in reverse (diverging verticals). The solution is to shoot through a window. Results will be best if the windows open, but if the windows are permanently sealed, a few precautions are necessary. First, turn off all the lights in the room; even if you cannot see them the fixtures might cause distracting reflections in your photos. To further reduce the possibility of reflections get as close to the glass as possible, in fact it is best to have the lens actually touching the glass surface; if you use this method, first ensure that the glass does not vibrate with passing traffic or activity within the room (a soft-rubber lens shade will effectively isolate the camera from such vibrations.) Be aware that if the window is tinted it will induce a color-cast in transparency films. This is not a worry with color negative films, which can be color-balanced during the printing stage. Remember to clean the window.

High-rise buildings are difficult to photograph with 35mm equipment. The main task is an exercise in photographic detective work, since a good combination of point of view and sun angle that does not require extreme perspective correction is very tricky to find. The problems associated with this search are as much diplomatic as they are photographic. Since most of the useful viewpoints will be found inside or on top of neighboring high-rise buildings, you will need to negotiate with reluctant building managers, security guards, and maintenance people. Aside from their own good natures these people have no real reason to help you, so be patient. It may be necessary to arrange in advance for written permission to access certain buildings. You may have to pay for a security person to escort you.

Once on location, be prepared for some unusual mechanical obstacles. Vertical metal ladders, narrow walkways, and restricted parapets are typical on top of tall buildings. Some physical contortion and creative clamping may be necessary to secure the camera properly. Extremes of temperature, wind, and vibration are problematic up high, as is air quality. Both urban smog and natural haze can stain or obscure an otherwise decent sight line, although polarizers or ultraviolet filters are sometimes helpful in improving image contrast and color. As a rule, high-rise hopping is very demanding and slow going. A whole day of work might yield only three or four good images.

Aesthetically speaking, photographing tall structures is attended by design difficulties not unlike those presented by very horizontal structures, with the added complication of contextual clutter. Wide but low buildings allow the use of the sky as a compositional

component, but tall buildings are usually found in the company of other tall buildings and there is no guarantee that they will appear side-by-side in harmonious configurations. Skylines are haphazardly arranged in modern cities. Pleasing views will be apparent only after an automobile tour that circumnavigates all the districts surrounding the downtown area. It is a good idea to have a friend do the driving while you do the looking. Real persistence sometimes pays off in the discovery of a location that reveals the building of interest nestled within a sensational framework of other structures or spotlit by a serendipitous shaft of sunlight.

From close by, the facade and the first few floors of skyscrapers can be shot with a reasonable possibility of maintaining parallel verticals, but to capture the whole height on film usually means tilting the camera. The exaggerated views afforded by extreme wide-angle lenses are sometimes welcome in these circumstances, particularly if there is a decent-looking entranceway, corporate logo, or piece of sculpture that can be incorporated in the lower foreground. Should there be a position on the street that is sufficiently distant to allow the building to be photographed in its rectilinear entirety with a 24mm or 28mm PC lens, special care must be taken in order to avoid obstructions like vehicles, street signs, streetlamps, and pedestrians. The exact time of day is critical for this work; the shadows of deep urban canyons

seem to retreat for only minutes at a time. Skyscrapers act like giant sundials and darken each of their neighbors in turn as the daylight hours pass. Since modern buildings are often embellished with sleek metallic surfaces or curtain walls of subtly colored mirror glass, changes in the light conditions will be amplified at certain angles. Be careful to avoid unattractive reflections. Polarizing filters are helpful in emphasizing and de-emphasizing certain reflective phenomena, although they can make some varieties of glass appear distorted or discolored.

Light can be used to isolate and emphasize tall buildings even after the sun has set, assuming the cooperation of the building management can be enlisted in the enterprise. These days many tenants will switch off office lights at the end of the day in order to save energy; if the building you are shooting is completely lit up at three or four o'clock in the morning there is a good chance that it will stand out boldly against a mainly dark field *(see color plates 42–43)*. Later I will offer specific pointers for dealing with the problems of shooting at night.

Features of a small urban park and the inclusion of the Calgary tower place this IKOY Architects' apartment building (the one with the dark circle painted on it) in context. Tall buildings can be seen from quite a distance in uncrowded cities like Calgary, so there are often many choices for a contextual view—it just takes a little effort to find them. Camera: Toyo 4x5in, lens: 90mm (moderate wide-angle), film: Kodak Vericolor III Type S. No perspective controls necessary.

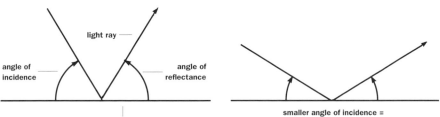

light ray

angle of incidence

angle of reflectance

reflective surface

smaller angle of incidence = smaller angle of reflectance

This drawing shows how the angle of incidence is equal to the angle of reflectance. It is necessary to understand this very basic optical phenomenon in order to successfully photograph reflective materials like glass, metal, or surfaces treated with high-gloss paint.

AERIAL PHOTOGRAPHY There are some buildings that simply cannot be adequately photographed from ground level or from some vantage point on neighboring structures. This can be equally true of tall skyscrapers, sprawling suburban malls, or complicated industrial sites. The solution is to get up high in a helicopter or light plane. This does not have to be an expensive production undertaken by experts only. Like other seemingly intimidating photographic techniques, aerial photography can be straightforward and economical if a few simple guidelines are kept in mind. I will deal with the mechanical aspects first, relevant technical aspects second, and the financial considerations last.

It is prudent to organize an aerial shoot at least a week or two in advance. All air traffic is strictly monitored and controlled so pilots will need a few days to obtain the necessary permission from regulatory bodies in order to fly low over urban areas. In my area flying above one thousand feet is not difficult to arrange. To get lower, a fair amount of red tape has to be dealt with.

A little research with the yellow pages or a few phone calls to local television news producers will yield a list of flyers experienced in working with cameramen. Call ahead and arrange a time to take a look at the plane or helicopter from which you will be working. Generally a door or window can be removed so that there is a relatively unobstructed opening through which photographs can be made. Take your camera along. Sit in the actual passenger seat and familiarize yourself with the restrictions imposed by the structure of the aircraft and the seat belt/safety harness that you will have to wear. Discuss with the pilot how you will communicate while in the air (i.e. headset or hand signs), and what maneuvers can be safely and conveniently executed while airborne.

There are a number of technical decisions to be made. The first is what time of day to shoot. Since dust in the atmosphere and urban smog tend to reduce contrast, strong side light is best for good subject modeling. This means early morning or early evening, depending on the orientation of the building. The air is cleaner in the early morning.

Film, format, and lens selection is necessarily limited. View cameras are, of course, out of the question: aircraft are always moving so there is not time to set up and, even if there were, buffeting would likely shred the bellows. Small- or medium-format SLR cameras are preferable because they permit a good mechanical grip, rapid shooting, and quick lens changes. From a thousand feet up a "normal lens" (50mm in 35mm format, 80-100mm in medium format) will cover a whole city block. This is fine for contextual shots but the most useful lenses for individual structures will be short telephotos (85-135mm in 35mm, 150-250mm in medium format).

Fast shutter speeds are required to counter mechanical vibration and horizontal motion through the air. In fact, it is best to keep to the highest shutter speed available. Since the subject-to-camera distances dictated by aerial work require no focusing (professionals simply tape focusing rings in the "infinity" position), depth of field is not a problem. Select an aperture one or two stops smaller than the maximum for the lens you are using. With ISO 100 film in bright daylight a typical setting might be f4 at 1/1000sec.

Shooting while flying by the subject requires that the photographer "pan" the camera—i.e., keep the subject framed in the viewfinder by shifting in the direction opposite to the movement of the aircraft. This is a tricky activity: fast shutter speeds and the rapid-fire convenience of a motor-driven camera make it easier to get usable images. Although helicopters can hover in mid-air and thus reduce the need for panning, they vibrate rather brutally (photographically speaking), so very high shutter speeds are still required.

All this might sound exotic to the beginner, but it is usually a lot of fun and will yield some very interesting photographs. Costs can be kept reasonably low by good planning. Make certain that your arrangements can be changed at no cost and at short notice as determined by weather. Since your job will likely involve only a short time in the air, this should not be a problem with small operators. Second, plan your flight so that time in the air is minimized—determine the best angles ahead of time and work out a sensible flight pattern with the pilot. Finally, familiarize yourself thoroughly with any equipment you plan to use, and take along spares in case of a breakdown. A lightweight flexible cable connected to the camera's tripod screw and tethered to the plane at the other end will give some peace of mind for the nervous among you. Check with a general insurance agent to make sure that your equipment (and any equipment you rent) is covered for aerial work.

Actual costs vary depending on the amount of time in the air and the size of the aircraft. I prefer working from a small helicopter, which costs $300 per hour. With a cooperative

pilot I can fly from the airport to downtown, shoot half a dozen different angles of a particular building, and get back to the airport in about forty minutes. A small plane is less money—perhaps $75 to $125 per hour—but less flexible in the air. The same assignment might take 1 1/2 hours in a plane.

A way of reducing costs is to split expenses with other interested parties. It will take an extra hour to shoot four to six additional buildings for their owners or designers, but that extra work will pay for your own shoot.

MAKING THE ACTUAL EXPOSURES Working outdoors involves several straight-forward techniques that must be adhered to regardless of the exact nature of the subject:
1. Color film must always be intended for use under daylight conditions, i.e. 5500° Kelvin.
2. The exact position of the sun relative to the front element of the lens must be controlled carefully, particularly with wide-angle lenses and cross-lighting, in order to guard against loss of image contrast due to flare.
3. Camera motion of any sort cannot be tolerated if images of the highest quality are expected. The reduction in sharpness that results from even the tiniest movement is so subtle as to be easily blamed on poor lenses or low film resolution. With small apertures, exposures made in even very bright daylight can be 1/30 of a second or longer. Most people, including professional photographers, cannot reliably hold a camera steady for that length of time. Use a tripod and a cable release. When using the tripod, or when using a hand-held camera, always gently squeeze the shutter release, rather than give it a quick jab.
4. Any image that includes the sun or a reflection of the sun within the frame cannot be expected to "turn out." There is no reason not to try for an unusual effect, but be aware that results will be unpredictable and make sure there are more conventional shots of the same subject as backups. Film is relatively inexpensive, so it is prudent to make backups of all images made with new or experimental techniques.
5. Do not trust the light meter to give you an exact measurement for every condition. Use the technique of bracketing exposures as described on page 62.
6. Keep records of meter readings, film type, lenses used, and bracketing range. Compare the results with your notes in order to foster familiarity with the responses of your film and equipment to a variety of situations.

PROCESSING AND VIEWING THE RESULTS As I mentioned in Chapter 3, there is a valuable pool of photographic expertise available at the custom color lab. The technical people there are constantly dealing with the output of working professionals; consequently they are aware of what picture faults are caused by shortcomings of the film, the equipment, or the photographer. The costs of having your materials processed by a professional lab will be somewhat higher than the drugstore or the one-hour lab, but the investment is well worth it. These days a repeat customer in any service-oriented business is a valuable customer, so once you make it known that you rely on their good work, the people at the lab will have a lot of cogent advice to offer. They do not have the time to be long-winded, but good listeners and quick learners will benefit from their experience.

It is wise to get in the habit of evaluating photographs with the proper light source. Transparencies should be illuminated with a light box made specifically for that purpose rather than the ceiling fluorescents or a handy window. Similarly, color prints should be examined under fairly bright daylight, or simulated daylight, conditions. Color and density are hard to evaluate subjectively if the viewing light is always changing. The people at the color lab will have proper sources set up for examining results immediately after processing and they can suggest suppliers should you decide to buy your own. I recommend it.

WORKING INDOORS

DEFINING THE JOB There is a considerable change in photographic gear necessary when architectural documentation moves inside. First, the generosity of the sun is largely cut off and we must often make do with difficult artificial conditions and/or whatever spills onto the scene from windows that are not necessarily conveniently placed. A parallel burden is the dramatic change of scale and proportion that must be accommodated; the same equipment will be put to quite different use with a new selection of films and

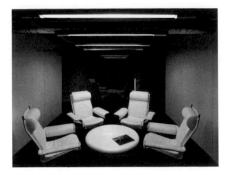

This sparsely furnished space is one of the smallest in the IKOY Office. Shot by the available light of the suspended fluorescent tubes, the meticulously placed furniture is obviously—but not obnoxiously—distorted by the unavoidable use of an extreme wide-angle lens. Camera: Toyo 4x5in, lens: 75mm (extreme wide-angle), film: Kodak Vericolor III Type S. Perspective controls were not required.

techniques. I do not mean to imply that working indoors is an impossible task for amateurs, just that it is necessary to define a few basic principles and approaches before starting in.

To begin with, the apparent distortion introduced by wide-angle lenses becomes much more of a problem at the close distances typical of work indoors. Extravagantly large spaces such as concert halls, arenas, and industrial plants are not too difficult to manage in this regard, but they are encountered less often than offices, private homes, and modestly sized retail storefronts, which are quite difficult.

Second, all the interiors just mentioned will be illuminated, more often than not, by an artificial source. Sometimes a variety of man-made lights, each radiating a different segment of the visible spectrum, are encountered together at a particular location.

Finally, the conditioned expectations of most people will limit the choice of camera position, at least for most modest sized interiors, to those that are exactly at, or very close to, eye-level. This fact, in combination with the more vexatious characteristics of wide-angle lenses, means that, along with moving the camera, it often becomes necessary to carefully rearrange furniture, plants, and other decorative elements in order to maximize the photographic potential of a particular room.

The above listed variables become more troublesome to control according to the degree of visual sophistication required of the final image. A documentary or progress photo does not need the technical fine tuning that a glamorous interior "portrait" does. The amount of work involved varies tremendously according to how the job is defined. My advice will attempt to cover all the technical bases as simply as possible.

RELATIVE COLOR AND RELATIVE BRIGHTNESS Color balance is an important issue of indoor photography. If the artificial light in a room is different in color temperature from 5500°K daylight, various combinations of film, filters, and processing will bring things back to normal. Relative color becomes significant when several sources of different color temperatures are mixed together; some of the areas that the different sources illuminate will appear to be strangely colored in the photographs because film is much more sensitive to relative color balance than our compensative brains. Some technical advice on how to deal with synthetic sources and relative color balance follows shortly.

Relative brightness refers to the contrast, or brightness ratio, within a particular scene. Outside, where the only light source is the sun, we can predict that the ratios will usually fall within a range that can be accommodated by color or black-and-white negative films. (Certain subjects lit by harsh direct sunlight will exceed the capability of transparency films, in which case the exposure brackets that retain some detail in the highlight areas, at the expense of completely black shadows, are preferred.) Indoors, the ratios can stretch well beyond the recording ability of even the most forgiving negative materials. The reason for this unwelcome condition is simply that outdoors, the light source (the sun) is rarely included within the image area, whereas indoors some light source (a light fixture or a window) will almost always be included within the image area.

There are a number of ways to cope with severe contrast. The simplest is to ignore it completely. To do this, take an exposure reading of the most important non-highlight area. Ensure that the meter does not pick up any of the bright spots or the reading will be skewed. The resulting negatives should then be printed normally, which will leave the troublesome bright areas pure white. There may be spiky shafts of flare or diffused "blooms" of brightness around the overexposed areas. If the highlights are tiny (small light fixtures, for example), they will not be particularly intrusive. However, windows are just too big to ignore, so steps must be taken to correct for the disparity in brightness between what is inside and what is outside.

DAYLIGHT INDOORS The first level of coping with available daylight is to compose images that do not include windows. Should this prove to be impossible, turn to a familiar exposure technique: meter the areas of significant interest, excluding the windows as before. This time, however, the processing will not be strictly "normal." Instruct the printer at the color lab to burn-in the windows. Manipulating the print is not a perfect solution, but for relatively large windows the effect is remarkably good.

Professionals balance the window light by lighting up the whole room with an intense dose of electronic flash. This approach requires some heavy-duty equipment and is beyond the capability of most amateurs. Really ambitious amateurs can try a relatively low-budget

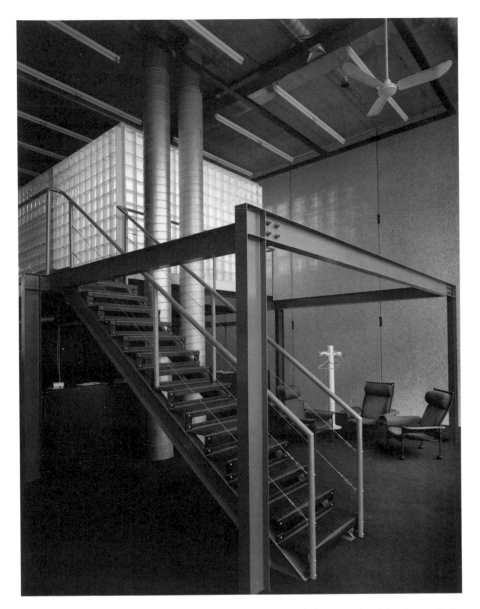

This dramatic view of the interior of the IKOY Office was made in the early morning. The room lights were switched off, and a single tungsten lamp without a reflector was placed inside the glassblock washroom/sauna that is situated on the mezzanine platform. The stairs, the galvanized ducts, and the green steel supports are illuminated by the weak ambient daylight coming through the windows.
Camera: Toyo 4x5in, lens: 90mm (moderate wide-angle), film: Kodak Vericolor III Type S. Perspective controls were required.

trick that approximates the effect of several thousand dollars worth of hardware. It is called painting with light and requires only one 500 or 1000 watt photographic tungsten light equipped with a daylight blue filter gel. This combination can be purchased for $150–$300 from a camera store or a theatrical lighting supply house.) Fake the picture during the early morning or in the evening so that the daylight level is low. Select a slow film and a small aperture. Extinguish the room's lights and lock the tripod-mounted camera's shutter open. During the exposure, stand just behind the camera and sweep the scene with the beam of the tungsten light. The "strokes" should be as uniform as possible, although darker areas can be hit with two or three passes. The final image will be a seamless composite. As a starting point, try Kodak Supra 100 at f22 and an exposure time of 3 minutes. The color lab will help determine the optimum exposure time and sweeping motion after examining the negatives from a test or two.

TUNGSTEN LIGHT Incandescent lights of all shapes and sizes depend on the visible radiation produced when a small coil of tungsten metal, called a filament, is heated. The exact color temperature of the light produced is a function of the degree of heating. Photo floods glow at 3400°K, tungsten halogen lights at 3200°K, while ordinary household bulbs are somewhat warmer, typically 2500°K. For all practical purposes, however, photographic and "ordinary" tungsten lights can be mixed without any ill effects; both sources produce similar results when used with tungsten-balanced film.

It is not uncommon for interiors, particularly those in private homes, to be lit entirely with incandescent bulbs. Two problems arise when shooting interiors lit in this way. First,

contrast (brightness range) is often too extreme since typically arranged household or office lighting is not always sufficiently evenly distributed for pleasant photographic effects. This may be remedied by painting with light, without the blue filter. Another approach requires a clever printer and a labor-intensive combination of selective burning-in and dodging. Color labs offer an even more sophisticated solution to excessive negative contrast called contrast-control masking. The tonal scale of difficult color negatives may be compressed by sandwiching the original image together with a same size, black-and-white positive called a mask. The areas of maximum density in the mask coincide with the areas of least density in the color negative; when the two are printed in perfect registration, the exposure in those areas is reduced. (The reverse is true for low contrast color negatives printed together with a negative black-and-white mask.) Well-done color-masking can produce prints of exceptional quality; the technique is useful for correcting contrast problems in negatives made under a variety of circumstances, both indoors and outdoors.

A second problem arises when the tungsten lights inside have to compete with daylight from outside. If the daylight predominates it is often possible to ignore the blue/yellow disparity; the prints are balanced to render the daylight areas properly, while the tungsten lights (plus a small patch of "territory" around each of them) are allowed to go yellow. The overall look is not always perfectly natural, but the effect can be quite acceptable, even cozy. The professional way of balancing tungsten to daylight is to cover the outside of the windows with large daylight-to-tungsten filter gels. This is an expensive and unwieldy solution. The alternative, a two-part exposure, is not much easier. The camera is set up and an exposure on daylight balanced film is made with the room lights off. The camera is then left until night when a second exposure is made with the lights on and a blue filter over the lens. (Simply shooting at night solves the color balance problem altogether at the expense of the natural, day-lit look.)

Difference in color temperature can be used to advantage to produce exaggerated twilight effects as the daylight levels outside fall below the tungsten levels inside. If the prints are color balanced to the now predominant tungsten illumination, the view through the windows will vary from very blue to richly magenta.

Note: Absolute light levels indoors are ordinarily substantially less than those outside. This means exposure times that can range upwards of one minute with slow films and small apertures. Bracketing around such long times can try one's patience.

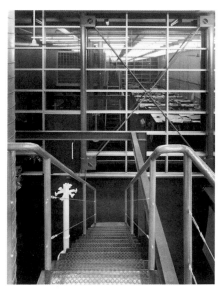

Since this shot was taken at night and the office was lit by a single source—fluorescent light—the color balance of the print was easily normalized in the color print.
Camera: Toyo 4x5in., lens: 75mm (extreme wide-angle), film: Kodak Vericolor III Type S. Very precise perspective controls required.

SODIUM-VAPOR AND MERCURY-VAPOR LIGHT Gas-discharge lights work by evaporating and electrically exciting materials in a vacuum. The resulting light falls within a narrow spectral range that is characteristic of the particular material. Sodium-vapor lamps emit a very yellow light, while mercury-vapor lamps shine green-blue.

It is not possible to achieve totally accurate color when these types of sources are involved. This is true because narrow spectrum light is not a linear source, so even very careful filtration will give only an approximate correction. Nevertheless, these lamps are common, particularly in industrial settings, and we have to do what we can with them.

As it happens, sodium-vapor lights work best without any filtration at all when using tungsten-balanced films. Mercury-vapor lights come in a number of tough-to-measure frequencies, but I have found that a 30M CC filter (magenta color-correction filter) or a 30R (red) CC filter works best with daylight-type transparency films. Daylight-balanced color negative films work well without filtration.

FLUORESCENT LIGHT The familiar fluorescent tube uses a high-voltage electrical discharge to excite special materials called phosphors to glow with visible light. The phosphors, not unlike those that are coated on the inside of television tubes, can have any number of characteristic colors. The typical choice for office, small-scale industrial, and institutional lighting is called cool-white: such fluorescent tubes are photographically recorded as strongly green compared to daylight, so they require a 30M CC filter over the lens for use with daylight-balanced color slide films. There are many different color fluorescent tubes, even some that simulate daylight. It is always best to shoot a test roll to guarantee correct filtration. Happily, color negative films work satisfactorily without filtration under all kinds of fluorescent lights since any required color correction can be done during printing. *(See color plates 29–32.)*

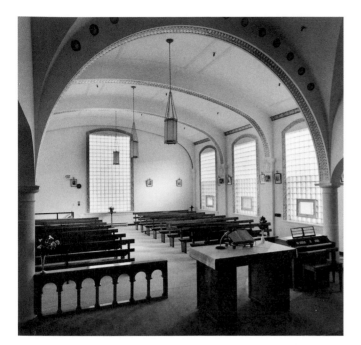 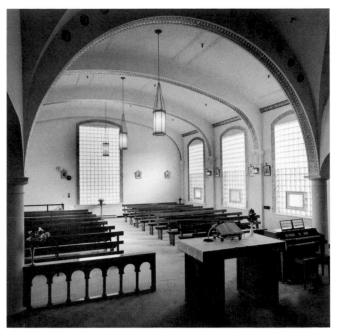

PROBLEMS WITH MIXED SOURCES The preceding discussion on tungsten light-
ing has already touched on a few of the basic techniques for coping with conflicting colors
from mixed sources. Here is a quick review of what has been mentioned already, plus some
additional tricks:

1. The most direct method of dealing with multiple sources is to eliminate all but the
 most important one. Shooting at night with artificial light as the only source is one
 approach, shooting during daylight hours with all man-made sources switched off is
 another. Those spaces with a combination of sources always have separate electrical
 circuits for each type of light. A little experimentation with the switches will reveal
 which light source is most appealing. Simply leave the least desirable light turned off.

2. When the lighting is distributed in such a way that none of the different sources can
 be eliminated, photographs can still be made, providing the final results do not need to
 look absolutely natural. Color slide films are most dramatically affected by mixed
 lighting, so it is best to avoid them altogether. Among color negative films Kodak
 Ektapress and Fuji Reala seem to be most tolerant. Really bizarre color distortion can
 be sidestepped completely with black-and-white materials.

3. When a natural-looking photograph is absolutely necessary some form of filtration will
 have to be used. The most obvious way is to filter one of the offending sources to match
 the other. For example, a common problem is a fluorescent-lit office or retail space in
 combination with daylight from large windows. In this case the fluorescent fixtures can
 be filtered with magenta gels. Filter material is available in large sheets for use behind
 the fixtures' diffusers or as preformed sleeves that can be slipped over each tube
 individually; either way it is a big effort. Still, taping jumbo-size green gels over the
 windows is no easier.

4. Tungsten/daylight or tungsten/fluorescent problems can be solved by cutting up
 appropriately colored gels (green-blue to match tungsten with fluorescent, plain blue
 to match tungsten with daylight) and stapling together little filter-cones that can be
 placed over the individual incandescent lamps. Alternately, ordinary screw-base bulbs
 can be replaced by blue-tinted lamps available at photo shops.

Considering the effort required to filter all the lights, shooting a double exposure with
color-balancing filtration on the camera looks rather appealing. The catch for the 35mm
photographer is that most small-format equipment does not allow multiple exposure.
However, a less sophisticated method goes part of the way toward making mixed sources
less bothersome. There are some situations where the scene is adequately lit by one of two
available sources, but where the final photo will look dead because the switched-off
fixtures need to be included in the image for reasons related to composition. In these cases,
an accomplice should be enlisted who can turn the fixtures on during part of the exposure.
For example, if a corporate boardroom is predominantly lit with fluorescent lights but has

These images show how turning on light
fixtures during part of an exposure can
make a more appealing shot in some inte-
rior situations. The pictures show the
restored chapel in a local convent photo-
graphed by available daylight. On the left,
the tungsten fixtures were left off during
the thirty-second exposure, while on the
right the lights were left on for ten sec-
onds. The shot with the lights on is much
more inviting because of the warmth of
the tungsten lamps. Detail in the glass
block windows was retained by burning in
during printing. Camera: Hassleblad ELX
(medium format), lens: 40mm (extreme
wide-angle), film: Fuji Reala. The shot was
made without perspective controls by plac-
ing the camera on top of a tripod extended
to six feet.

VI

some elaborate incandescent fixtures that are important to the design, a thirty-second exposure could be made with the incandescent lights on for only five of those thirty seconds. This would be enough to photographically animate the fixtures, but not enough to disturb the overall color balance of the room.

WHEN SUPPLEMENTARY LIGHTING IS REQUIRED Earlier I described the technique of "painting with light" that may be used whenever brightness ratios get out of hand. This method of supplementary lighting is handy and inexpensive, but it lacks a degree of finesse that is required for sophisticated results. In Chapter 4, I discussed an aspect of previsualization that involves studying and appreciating the infinite variety of natural lighting conditions. Indoors this process must sometimes be extended to the creative addition of artificial sources in order to achieve a special look. Truly sensitive application of artificial sources might be called "sculpting with light" as opposed to "painting with light." This aspect of interior photography is only for the very ambitious and the very patient. It requires some photographic lights, which may be purchased or rented, plus a fair amount of time to properly arrange them. Powerful electronic flash units are commonly used by professionals to match room levels with available daylight, but such exotic equipment is too delicate, too expensive, too heavy, and possibly too dangerous for amateurs. I recommend that tungsten lights be used instead. Color requirements will limit their use since they lose a fair amount of power when filtered. Nevertheless, they are lightweight, relatively inexpensive to buy or rent, and, because they are continuous sources, their effects on the subject are easy to see. A few words of warning: tungsten lights are extremely hot and consequently pose a fire risk. Also, take care to avoid damage to heat-sensitive subjects.

Lights can illuminate photographic subjects directly or indirectly. Direct lighting yields harsh shadows but also gives an easily controlled, sharp, and penetrating effect, which is advantageous for certain textures of subject. Indirect light, or bounce light, is softer, broader, and more natural in appearance. To achieve indirect lighting, some sort of reflector is required. Light, neutral-colored walls or ceilings may suffice, or silver or white reflector cards or umbrellas may be used.

A good quality photographic light may cost upwards of $150, and several may be required to light a large or complicated space. Umbrella reflectors cost from $50–$150,

Left: This detail in the IKOY Office was lit by electronic flash both inside and outside the glass block room. I needed to take control of the lighting in order to clearly contrast the texture of the glass with the steel and concrete. Camera: Toyo 4x5in, lens: 90mm (moderate wide-angle), film: Kodak Vericolor III Type S. Perspective controls were required.

Right: This image was chosen as the cover shot of several architectural journals, including Architectural Technology Magazine, that included IKOY Architects work. The photo was made with electronic flash illumination—the metal detail was isolated for dramatic effect by a sheet of gray paper taped to the wall behind it. Camera: Toyo 4x5in, lens: 150mm (normal), film: Kodak Vericolor III Type S. Perspective controls were required.

depending on size and construction. A 36in umbrella is considered small in size and casts a much harsher light than a 72in umbrella, which is considered large. Reflector cards can be made from white 4ft x 8in foam board, available at art supply stores. A complete system consisting of several lights, stands, extension cords, reflectors, and filters might cost $150 a day to rent.

The proper use of photographic lighting is easily the subject of an entire book. At the risk of being simplistic, I will say that the best way of learning lighting technique is to study well-lit images in the better publications, and to mentally visualize the size and placement of the lights. Surprisingly, the set-up for modest-sized interiors often consists of only two or three lamps bounced off the walls and ceiling just left, right, or slightly behind the camera so that the light evenly fills the area of the room being photographed. Sometimes a few direct sources are cleverly placed to subtly outline or highlight certain areas or objects of interest within the scene.

CONSIDERATIONS FOR LONG EXPOSURES　　Working indoors inevitably requires much longer exposures than those typical of exterior photography. There are two categories of concern: the first is basically mechanical and has to do with such things as camera and/or subject movement, while the second is more technological and has to do with the nonlinear changes in film sensitivity as shutter speeds are extended past five or ten seconds.

Small negatives are capable of outstanding performance when all the variables in the photographic process are well controlled. Unfortunately, the best films and lenses in the world are wasted when the camera or the subject moves during the time when the shutter is open. I have already recommended a tripod be used for exposures that are longer than 1/30 second. Such times are not uncommon even outdoors. Indoor light levels can be a couple of orders of magnitude less than light levels outdoors. Exposures can stretch to two or three minutes. It is critically important to keep the camera absolutely still.

The key to a rock-steady camera is a quality tripod. Because 35mm cameras are compact and lightweight, many novices and too many camera-store salespeople think that a compact and lightweight tripod will do. This logic is faulty. In fact, the heavier the camera the steadier it tends to be on a tripod, since a three-legged support tends to stiffen as it is loaded. Some professionals actually hang weights or a packed camera bag on their tripods in order to add to their stability. If the camera is not very heavy to begin with, the tripod itself must have a bit of weight and reasonable rigidity in order to perform well.

Any tripod you consider purchasing should be examined with its legs fully extended and the center column raised. There should be very little flexing or twisting and all locks should be positive acting and easy to operate. Tripods with additional supports linking the center column to the legs are preferred. Make certain that the tripod head (the articulated support that allows the camera to be tilted and rotated) is absolutely vibration-free when positioned both vertically and horizontally. Tripods and tripod heads may be purchased separately. Choose a combination that is both strong and easy to use. I strongly recommend heads that have separate locks for horizontal and vertical movement, as opposed to ball-and-socket heads, which have only one lock. Ball heads are very tempting because they are so compact; however, they are maddeningly tricky to level precisely.

Steadiness is such an important issue that I recommend testing the rigidity of the camera's own tripod socket (the threaded hole on the baseplate) as well as the rigidity of the tripod. Long or heavy lenses often come equipped with their own tripod sockets that are positioned to shift the mounting point closer to the center of gravity of the lens-camera combination; use these sockets whenever such lenses are fitted in order to relieve undue strain on the lens mount as well as to increase system rigidity.

There is a simple but effective technique that applies to the use of cameras on tripods. First, never release the shutter button with your finger. Even the most rigid tripod will permit some motion in response to direct physical pressure, no matter how slight, so use a flexible cable release. Next, be aware of the stability of the surface upon which the tripod is sitting. Even modern buildings sometimes have floors that vibrate with indoor pedestrian traffic or outdoor vehicular traffic. Select those moments when the floor is not moving to make your exposures. Similarly, avoid jarring the camera or flexing the floorboards by shifting your own position relative to the tripod when the shutter is open. Finally, most

quality tripods have rubber feet that can be screwed upwards to expose pointed metal tips: pay attention to the floor or ground surface texture and adjust the tripod's feet so that they will not slip. Rubber is good for tile, marble, concrete, and wooden floors while the steel tips work well for carpet, grass, gravel, bare earth, and ice.

Subject motion is not a big problem in architectural work, although there are some circumstances when it has to be considered. For example, trees, foliage, and water move around in response to the wind, as do flags and fabric awnings. When outdoor exposures hover around 1/15 second, such motion can degrade sharpness or distract the viewer. On the other hand, sometimes a little blur adds a bit of life to the scene.

Indoors, subject motion can be a problem as well. During long exposures, drapes, blinds, and plants can be shifted around by moving air. Hanging lamps and other decorative elements can be disturbed this way also. It is a good idea to turn off ventilation system fans and close windows while shooting long exposures.

People in pictures are more of a subject-movement problem indoors than outdoors. This is because outdoors the shutter speeds rarely exceed one second. I have found one second to be the maximum time a cooperative person can remain photographically still. Any longer, and even cooperative subjects move involuntarily. Photographs made at exposures in the range of one to five seconds will show people, or parts of people, as blurred.

It is interesting to note how photographic fashions change. Only a few years ago, any blurry figure in an architectural photo was considered either a technical flaw or an affectation. Recently, however, the same effect is more readily perceived as "natural." I believe this has occurred because pictures of buildings devoid of people may appear cold and lifeless—a few warm bodies make imposing structures look less forbidding. Following this logic, perfectly sharp images of people can look posed and stilted. A little blur implies normal human activity.

Very long exposures, on the order of thirty seconds or more, can make people disappear. For example, consider a camera set up on a tripod to photograph an interior corridor of a retail mall lit by dim artificial light. If the hallway is filled with moving people and the exposure is perhaps ninety seconds long, none of the people will be in one place long enough to register on the film. In other words, the mall will appear to be empty after the film is developed. This effect is somewhat unnerving the first time it is encountered, but it is actually quite a handy technique for simplifying some complex subjects.

The nonmechanical considerations of long exposures involve a quirk of film behavior called the "reciprocity effect." Earlier I mentioned that shutter speed and aperture are inversely related. When the size of the aperture is increased to admit more light, the shutter speed must be shortened to compensate, and vice versa. Unfortunately, this reciprocal relationship holds true for only part of a given film's characteristic curve (range of sensitivity). At the extremes of the characteristic curve linearity breaks down—at one end increasing the brightness of the light no longer induces a proportional increase in density, while at the other increasing the exposure time no longer induces a proportional increase in density.

Reciprocity failure has two negative effects if no corrective measures are taken: significant underexposure and color shift. There are two ways around these problems. The most direct approach is to choose a film that has been specially formulated to behave well at long exposure times, such as Portra 100T or Ektachrome EPY. Since the variety of reciprocity-failure-proof films is limited, from time to time the second method of control will be necessary: obtain a current copy of the Kodak Color Data Guide, which lists exposure corrections and compensating filtration for all Kodak color films. It is a simple matter to increase the measured exposure by the recommended factor, or to introduce the recommended color-correction filter. (I have found that color-correction filters are only necessary for transparency films; negative films can usually be properly balanced when prints are being made.) Expect corrective increases in exposure time on the order of 33% to 300% when daylight-type films are used in dim, artificially lit situations. It pays to experiment with your favorite materials in order to become familiar with their eccentricities under extreme conditions.

CONSIDERATIONS FOR WIDE-ANGLE LENSES Outdoor architectural subjects are typically one of three basic geometrical shapes: wide, square, or tall. Indoors, the subject

The furniture of this staff lounge area was arranged to minimize wide-angle effects. The wedge-shaped reflection of the lighting array is used as a design element in the photo. Camera: Toyo 4x5in, lens: 90mm (moderate wide-angle), film: Kodak Vericolor III Type S. Perspective controls were required.

is typically a space that is occupied by a variety of objects. Wide-angle lenses make the photography of interiors possible, but they demand some special attention in return. The main problem is one of relative proportion associated with the limited points of view available when working in tight spaces. Wide-angle lenses permit photographs to be made in such circumstances, but at a cost. Normal vision does not allow for entire rooms to be "swallowed" in one glance. In fact, our visual impression of a space is composed of a series of visual surveys that our minds integrate into a geometrically balanced whole; the shapes and relative proportions of individual objects and architectural embellishments are mentally preserved in a comfortable, natural way. The process of visual integration breaks down when we are constrained to record the same scene in two dimensions from a single vantage point—this is exactly what happens when we use wide-angle lenses indoors.

There are three problems that arise from the use of wide-angle lenses. The first two complications are dimensional in nature. You will recall that the process of rendering a three-dimensional object in two dimensions introduces some geometrical distortion. This is inevitable, and unavoidable. Also, wide-angle lenses create spatial or proportional distortions that cause the apparent relative sizes of familiar objects to be strangely altered. The only solution to these difficulties is very careful placement of the camera and very careful rearrangement of the movable objects in the room. You will have to learn which alterations in perspective and proportion are photographically acceptable and which are perceived as outlandish. This work is an exercise in damage control, and the results depend on the good taste of the photographer rather than on technical expertise.

The third problem associated with wide-angle lenses, edge falloff, is more optical in nature. Simply stated, wide-angle lenses, particularly extreme wide-angle lenses, project less light at the edge of the frame than in the center. Outdoors this is often not a major problem, since it is natural and effective for the sky and the foreground to appear a little darker than the main subject. However, with interiors we are less tolerant of density changes, especially since changes of density often induce slight color shifts as well. A deep blue photographic sky that picks up a bit of magenta as it shifts in density is much more acceptable than a sandy colored ceiling that slides toward pink at the top of the frame. Some of these problems can be minimized by simple cropping, burning-in, or dodging during printing, but with certain lenses under certain circumstances, more heavy-handed measures must be taken. Should you find edge falloff to be an intrusive defect in your work, consider obtaining a center-weighted neutral-density filter. This device is a disc of clear optical glass with a fuzzy gray spot in the middle. The spot is lighter at the edges than at its center. When placed over a wide-angle lens the filter compensates for the edge-falloff effect. Unfortunately there is not a big demand for this item, so its price is high ($250–$400)

and it is tricky to find. No 35 mm lens-maker sells a center-weighted filter, so one intended for view-camera lenses will have to be located and adapted.

THE JOYS OF COLOR NEGATIVE FILM Here is a list that recaps the many advantages of color negative films:

1. Wide exposure latitude.
2. Wide tolerance for variations in absolute and relative color balance.
3. Effectively immune to reciprocity-effect color shifts.
4. Relatively insensitive to reciprocity-effect underexposure problems.
5. Permits the balancing of densities within a scene during printing.
6. Allows the production of color or black-and-white prints and slides from a single exposure.
7. Allows easy cropping at the printing stage.
8. Competitive with transparency films for color saturation and resolution.
9. Available in a wide range of sensitivities.
10. Modern color negative films are eminently scannable, providing a very economical and flexible entry point into digital imaging.

WHAT A GOOD COLOR PRINTER CAN DO The technical flexibility of color negative materials can only be realized when the photographer works in harmonious partnership with a competent printer. The person who does the darkroom work must be sensitive to the desires of the photographer, the nature of the subject, and the potential of the medium. A successful exploitation of the points above depend on the experience, expertise, and taste of the processor/printer.

Any valuable working relationship depends on reliable communication between the partners. You will be expected to be able to tell your printer what kind of prints you like. Personal tastes vary and the negative/positive system is extremely flexible. After some experimentation you should know whether you want prints that are warm, cool, or neutral in color, and light, medium, or heavy in density. Similarly, you will have to decide on what is appropriate cropping, burning-in, and dodging for particular negatives. All custom labs will produce test prints to help you decide on the level of manipulation required. The printer or a competent go-between will view the tests with you and offer specific advice. If limitations in the negative will prevent a given shot from looking a certain way, you will be informed at this point. Assuming a realistic notion of the capabilities of the technology, the final prints should meet your approval in every way. In certain cases a final print might have to be remade once or twice in order to match the specifications promised at the test print stage. This should be done cheerfully and free-of-charge, unless the specifications have been unilaterally changed by the photographer after the test print was discussed.

Here is a review of the services you can expect from a competent lab:

1. Prints of decent color balance regardless of the original color of the light sources.
2. Precise control of local density in areas of the print larger than 1.5x1.5in.
3. Cropping to specification.
4. Contrast control for difficult negatives using masking techniques.
5. Routine spotting (removing dust marks with a small brush and retouching colors).
6. Easily readable proofs and test prints.
7. Push/pull processing of film when necessary.
8. Personal contact with the printer when necessary.
9. Good black-and-white prints and color slides from good color negatives.
10. Sensible recommendations on improving your technique.
11. All promises regarding delivery times and deadlines meticulously maintained.
12. Professional discretion (no gossiping about other clients' business).

FINE TUNING If you follow my recommendations, your pictures will always turn out. That is to say there will always be something visible on the film, at the very least a recognizable approximation of what you intended to produce. The nice thing about shooting buildings is that they are relatively permanent, photographically speaking, so images that fall short of your expectations can be attempted again and again. I can say quite unashamedly that, even at my "advanced" stage of development, certain tricky shots must sometimes be tried two or three times to get exactly what I had in mind.

It will take several months of weekly photographic activity to become truly comfortable with film and equipment behaviors. A guarantee of quick progress is an orderly filing system and a religious adherence to note taking. There is no point, with finished images in hand, in having to guess what you did or did not do correctly a couple of days or weeks ago. When you appeal to experts at the lab or at the camera shop for advice, a written record of your technical choices will facilitate the delivery of pertinent counsel.

It is a good idea to keep on hand a collection of fine images culled from magazines, books, or your own best work so that they may be referred to for comparison with those photos you feel are lacking in some undefined way. Eventually the qualities of outstanding work will become internalized, and the analysis of faults and deficiencies in your current project will come quickly and automatically.

Here is a list of variables that must be kept in mind when studying your photos:

1. The nature of the site, the building, or the room.
2. Quality and color of the available natural or man-made light.
3. The quality and quantity of any supplementary photographic lighting.
4. Film choice.
5. Equipment availability, selection, and use.
6. Point of view and the arrangement of any movable subject elements.
7. Ultimate use of the image.
8. Time and money available to do the work.
9. Degree of print manipulation required at the color lab.

Being unhappy with what you have produced is a good sign. High standards inspire good work. To make disappointment valuable, it is necessary to analyze the exact failings of the particular unsatisfactory images, postulate an improved technique or aesthetic approach, and then reshoot and reevaluate the results.

At first you may have to enlist the help of the good people at the processing lab to assist in a dispassionate analysis. After a bit of practice it will be a simple matter to divide photographic problems into the general headings we have just discussed, reread the pertinent chapters, and apply the recommended techniques more carefully or more imaginatively. When a specific fault of an aesthetic or technical nature is discovered, make a note to yourself on the back of the offending photo and bring it with you to the reshoot. This is a fail-safe way of correcting errors the second time out.

It is important to identify which of the above elements are under the complete or partial control of the photographer as opposed to those elements that are uncontrollable. There is no point in suffering over those thing one cannot change, but it is only sensible to maximize those things that one can change. It will always be possible to find the reason for a photographic fiasco but it is a personal matter whether or not the necessary effort can be mustered to put things right.

PHOTOGRAPHING ARCHITECTURAL DETAILS

DEFINING THE JOB Shooting details of texture or mechanical design demands a different approach than that which I have outlined for overall exterior or interior views. Exactly what constitutes a "detail" is somewhat flexible, but for the purpose of this discussion I will simply say that an architectural detail is any discrete component or group of components, forming part of a building or an interior, that can be isolated photographically. Details are photographed to emphasize the small-scale aspects of architectural design and construction. The general approach can be lavishly artistic, employing sophisticated lighting and unusual points of view, or it can be simple, unpretentious, and profoundly prosaic.

EQUIPMENT Since small-scale documentation involves a visual amplification of important fragments within a larger structure, the optics that are most effective have longer focal lengths. Wide-angle lenses are eschewed in favor of normal or short teles, with really long telephotos called into service when small areas of interest are separated from the camera by significant horizontal or vertical distances. It makes sense for an active architectural photographer to own one or two moderate teles or a telephoto zoom in the range of 90–200mm. Longer lenses, up to 1000mm, are easy to rent since they are favorites of both nature and sports photographers. Teles magnify camera motion and focus errors along with image size, so a sturdy tripod and a cable release are necessary.

FILM AND LIGHTING The form and texture of architectural details are equal in importance to their function. Light fixtures, doors and door frames, windows and window frames, roof and siding materials, and other visible structural components have a dual function that embraces both practicality and visual appeal. The practical aspects are best shown contextually in the larger views. Aspects of visual appeal are best shown via well-lit and well-composed "still-life" imagery, in much the same way that fine artists or commercial photographers elevate the objects and products upon which they focus. Unless grain or diffused focus are desired for some special purpose (perhaps as a motif in an exotic brochure), the sharpest and most accurate films are also the most desirable when shooting architectural details.

Lighting is a matter of taste, although the nature of the specific subject will suggest the most effective approach to take. For example, chrome, glass, and polished stone generally look best when illuminated by soft, indirect lighting from broad windows, an overcast sky, or nearby walls or other large reflectors while coarse stone, wood, and heavily textured fabric look best under harder, more angular light from direct sun or photographic lamps. Much can be done with available light, provided some thought goes into selecting the proper time of day and camera angles that capture the best ambient lighting effects.

TECHNIQUE The same technical "good housekeeping" applies to shooting details as to shooting larger views. It is important to keep the camera still while the shutter is open, and it is important to focus carefully on the most important subject plane. Because details are usually compact subjects, the camera's exposure meter can usually be trusted to give a reliable starting point for the exposure brackets. Appropriate accommodations must be made for reciprocity effects when working in low light. Great depth of field is not usually a concern. In fact, shallow depth of field is an effective tool for separating a sharply rendered detail from an out-of-focus background.

If photographs of architectural details are required for documentary purposes only, no special attention need be paid to aesthetic matters. If, however, the intent is to make an artistic statement, some thought must be given to image composition. All embellishments to buildings exist because someone designed them into the structure. To do justice to the original designer's intentions requires an appreciation of why and how the particular feature came to exist. Light conditions and point of view are then optimized in order to best present this knowledge with an empathetic visual. The correct approach is a celebration of the form of function.

Even the most ordinary architectural detail can be enhanced by careful composition and the right light. This image was part of a promotional brochure for a Spanish-style condominium development. The geometrical arrangement of the elements and the steeply raked sun angle combine to make an attractive picture. Camera: Toyo 4x5in, lens: 250mm (moderate telephoto), film: Kodak Vericolor III Type S. Perspective controls were used to insure perfect alignment of all the verticals.

A detail of the ceiling of the Bank of Hamilton Building. The original paint work with gold leaf embellishments was painstakingly restored by conservers from the Manitoba Museum of Man and Nature, who worked—on their backs—from scaffolds. They applied special solvents with toothbrushes! Camera: Toyo 4x5in, lens: 150mm (normal), film: Kodak Vericolor III Type S. No perspective controls.

Cool light from the window illuminates the wall and ceiling, while the warm light from the fixture illuminates the bottom of the stair—the resulting contrast defines the graceful curve of the steps and banister. Existing conditions can be used to advantage whenever additional photographic lighting is impossible. Camera: Toyo 4x5in, lens: 75mm (wide-angle), film: Kodak Vericolor III Type S.

IKOY uses all mechanical and electrical systems as design elements in their buildings. Here is a closeup detail of an electrical track that is suspended from the ceiling and runs the length of the building. This picture was lit by electronic flash in a large umbrella reflector. Camera: Toyo 4x5in, lens: 250mm (moderate telephoto), film: Kodak Vericolor III Type S. Perspective controls were required.

COPYING DRAWINGS, RENDERINGS, AND PERSPECTIVES

DEFINING THE JOB Some types of photography are not very glamorous, and copy work is a good example; the skills required are very simple, the time involved is negligible, and the necessary equipment is inexpensive. Copy work (flat work) is the reproduction of some existing two-dimensional image through photographic means. The copy might end up as a 35mm slide, an 8x10in print, or a wall-size mural. The basic criteria are sharpness, color fidelity, and contrast control. *(See color plate 42.)*

LIGHTING I prefer tungsten light for copy work because a bright, continuous source speeds up camera alignment and focusing. A little care must be taken with heat-sensitive originals, but normally there is no problem.

To arrange flat work, place the camera exactly perpendicular to the material being copied. Position lights at 45° on either side of the camera in order to project an even field of illumination. A single light is perfectly acceptable for copy work as long it can be adjusted for uniform brightness over the whole image area.

When the material to be photographed is not perfectly flat, changing the angle of the light will sometimes eliminate unwanted reflections and hot spots (small areas of excessive brightness), but some shiny, irregular surfaces (an oil-painting, for example) cannot be accommodated in this way. In such difficult cases the only remedy is polarization. Consider light as composed of energized particles, called photons, that vibrate as they travel along an otherwise straight path. The frequency (number of vibrations per second) determines the color of the light. The plane of the vibrations relative to the direction of travel determines the polarity of the light. Generally, the polarization of light is more or less random; the photons vibrate in any and all directions. A polarizing filter has a wonderful ability to transmit only those photons that are vibrating in one particular plane. The particular plane is called the axis of polarization. Two polarizing filters placed so that their respective axes of polarization are oriented at 90° to one another will be perfectly opaque to all light. (This property may be invoked electrically in certain materials. Liquid crystal displays [LCD's] operate on this principle.)

Many materials reflect or absorb light of only one polarity. For photographic purposes the reflectivity of such materials may be reduced by controlling the polarity of the illumination. Polarizing filters for lights are available in heat resistant sheets through suppliers of theatrical lighting equipment. Polarizing filters suitable for use with photographic lenses are made of optical quality glass and are available at any camera store. Virtually all troublesome reflections may be removed when both the copy camera and the copy lights are polarized.

LENSES There is no such thing as a perfect optical system, and each photographic lens will excel at some particular task. Most lenses for general shooting, including wide-angle, normal, and telephoto types, are designed to be used in situations where the size of the subject exceeds the size of the image at the film plane by a factor of approximately ten to one. In addition, their performance is optimized for distant subjects. This means that for precise copying of small images a special-purpose lens is required. Lenses specifically designed for copy work are designated as process lenses or apochromatic (apo) lenses. They are usually quite expensive. In most circumstances, however, any good quality lens will do a reasonable job if the image being copied is 8x10in or larger, and if the aperture is set two or three stops smaller than maximum. "Stopping down" in this way reduces aberrations (optical deficiencies) that exist at maximum aperture, while avoiding the image degradation that occurs as a result of diffraction at the very small apertures.

MECHANICAL CONSIDERATIONS As I mentioned, the camera must always be positioned exactly perpendicular to the surface of the material being copied. Of course it must be held very still for maximum definition. The most reliable method of achieving this precise condition is to use a copy stand, which, in it is simplest form, has a baseboard with a vertical column to which the camera is attached by way of an adjustable mounting plate. Two (sometimes four) lights are permanently attached to the baseboard at the prescribed 45° angle. Such a setup works fine for most copy work, but when shooting a lot of different size originals the constant variation of camera height can be hard on the back. I prefer to

have the camera at a fixed level, which allows me to keep my back straight, so I built a copy stand with a baseboard that may be adjusted for height with an electric motor. For really big drawings and posters I find it is convenient to put the camera on a tripod and tape the material to be copied to a wall.

FILM AND TECHNIQUE To copy artwork or graphics that will end up as large display panels or posters, use a fine grain color negative film such as Kodak Supra 100. Very presentable copy slides from color prints and drawings can be made with Kodak EPY tungsten-balanced Ektachrome. In this case I use an 18% gray-card (available at photographic supply stores) in combination with the camera's built-in meter to determine the starting exposure. Extreme closeup work, with an image-to-subject ratio of 1:2 or less, will require auxiliary closeup lenses, an extension tube (a carefully made cylinder that fits between the lens and the camera body to permit close focusing) or else a lens specially designed for high magnification, such as the Micro-Nikkor series made by Nikon. Extreme magnification will require some exposure compensation, but this is automatically taken into account with BTL (behind-the-lens) meters.

COLOR FIDELITY Sharpness is a photomechanical problem that is resolved by keeping the camera properly aligned and very steady, by focusing accurately, and by using a fine grain film. Maintaining color fidelity, however, is a matter of understanding the spectral response of photographic materials, rather than something that can be accomplished by a particular technique.

It is necessary to understand that color fidelity is not the same as color balance. Correct color balance is a rather subjective and imprecise term describing a print or slide that has no overall color bias; when grays are gray, and skies are blue, and grass is green, and skin looks "normal," color balance is said to be "neutral." On the other hand, color fidelity has to do with accuracy and implies that the film and film processing, as well as the enlarging paper and paper processing, will respond in a linear and predictable manner to a full palette of color. In other words, true color fidelity is achieved only when all colors are reproduced on photographic materials exactly as they appear in reality. Unfortunately, this serendipitous state of affairs will never happen because the color we see in prints and slides is generated by organic dyes that are physically limited in their ability to imitate the real world. An extreme but cogent example: a fluorescent yellow tennis ball will never look anything but a dull yellow-green when photographed because the colors in a print or a slide can only be a chemical approximation of real colors. Ektachrome will never glow in the dark.

All this can be expressed in numbers with graphs of spectral sensitivities, but the bottom line is simply that photographic materials are not honest about some colors. This can be very bothersome for precision copy work, particularly architectural renderings, where color fidelity is extremely important. Problems arise when certain paints and inks trigger the wrong response. One type of green used by a certain manufacturer of popular felt-pens reads as yellow with Ektachrome and lavender with Portra 100T. Sometimes the solution is to switch films. For example, the Fujichrome family of films handles some blues and greens much differently than the Kodak Ektachromes.

Anyone who expects copy prints to closely match their originals should study the limitations of the medium. Comprehensive testing is the only way to achieve totally predictable results. Once educated to the value of color testing, the artists who produce renderings and perspectives that will be copied can select their colors according to how well they photograph.

For most reliable results, position a Kodak Color Control Patch so that it appears at the edge of every copy negative. The patch is a 1x4in strip of cardboard that has been imprinted with a series of neutral color patches of different densities. It costs only a few dollars, but its inclusion in the frame allows the color lab to quickly determine the exact color balance with a densitometer and color analyzer. For black-and-white copy work, use a Kodak Gray Scale.

CONTRAST CONTROL Every copy photo will pick up a little contrast, and in the case of some soft, pastel-like originals (such as old faded photographs), this is not a problem. Originals with high contrast may pose a problem.

Controlled flare is an easy method of reducing contrast. When the copy negative is being made, position the original on a large white card. If the exposed edges of the card are lit, some non-image-forming light (flare) will spill over and effectively lower the overall brightness range. A deep black surround works best with low-contrast originals.

Although conventional practice officially precludes the manipulation of contrast in color materials by chemical means, I have found that both Ektachrome and Vericolor films respond well to slight changes in processing. Check with the color lab for details on what they can do.

In Chapter 6, I described the value of contrast-control masking for difficult negatives. This technique may also be used for controlling excessive contrast in copy work, although such an inconvenient and expensive approach should be considered only as a last resort.

ARCHITECTURAL MODELS

DEFINING THE JOB There are three interrelated factors that determine the photographic approach to architectural models: scale, point of view, and the degree to which real-life conditions are simulated. The most sophisticated models cost several thousand dollars and are large, highly detailed, and meant to be examined at every angle, from street-level to bird's-eye. Miniature cars, trees, people, and even Plexiglas "water" contribute to a very realistic appearance. At the other end of the scale are unpainted and unadorned assemblies made of foam-core or cardboard that are intended to represent only a building's basic shape.

LIGHTING AND TECHNIQUE As a rule architectural models are expected to be lit in a way that mimics sunlight; this is easy to do with a single tungsten light and some large white reflector cards positioned to brighten up the shadows. The general direction of the "sunshine" can be determined from the site-plan specifications. Any glass, metal, or plastic surface may be highlighted by carefully placing an additional light or a card of an appropriate color or texture so that its reflection is pleasingly visible from the camera position.

Several different vantage points or points of view may be required. The street-level view is the trickiest to carry off convincingly. The center of the lens will be just a fraction of an inch off the "ground" in order to duplicate an eye-level perspective, and miniature obstacles, such as elements of the landscape and other buildings, are sometimes more difficult to deal with than their real-life equivalents. Nevertheless, the same camera movements are required to maintain the parallelism of vertical and horizontal lines, so PC lenses are handy for this work.

Depth of field is inversely related to magnification, so overall focus becomes a problem with small subjects. When shooting architectural models, very small apertures are required to hold the focus all the way from front to back. Unfortunately, some loss in resolution is inevitable as diffraction tends to degrade image quality when small f-stops are used. This happens because light is bent, or diffracted, as it passes by a sharp edge such as the metal leaves that comprise the diaphragm of a lens. As the aperture is reduced, the ratio of glass area and the exposed length of the diaphragm's edge changes so that the diffraction effect becomes more noticeable. The correct photographic response to this condition is to choose the widest aperture that still permits the necessary depth of field. This choice is facilitated by a control called a depth-of-field preview button, which is standard on most SLR cameras. Depressing this button overrides the automatic diaphragm control that keeps the aperture wide open for easy focusing. Although the viewfinder image will appear darker with the preview button pressed, it is just possible to see the exact depth of field at the working aperture. The depth of field scale etched on the lens barrel is helpful in making this determination without having to struggle with a dark viewfinder.

BACKGROUNDS A technique that adds credibility to color photos of models is the creation of an artificial sky. This is easily done by taping a length of blue seamless paper (available in 9ft x 36ft rolls from photographic suppliers) to the wall behind the model. A tone that is slightly denser than the real sky works well if it is lit from the bottom to give a graduated effect. An alternate solution is to instruct the printer to burn-in the sky during processing. Clouds can be added by having an artist airbrush directly onto the seamless or

onto the final print. Once or twice I have glued tufts of cotton batten to sky-blue seamless; it makes a surprisingly natural sky when lit softly from above and photographed slightly out of focus.

To achieve a highly dramatic ambience project a slide of an exotic sky condition, such as a sunset, onto a white backdrop behind the model. For this technique the brightness of the artificial sun must be reduced to balance the brightness of the projected image. The projector can be mounted underneath the model, and a wide-angle projection lens can be rented to give a broad enough image to cover the background.

Whatever the type of sky used as a backdrop, it cannot be a continuous dome like the sky outside. It is therefore necessary to rotate the model itself, rather than reposition the camera, in order to shoot several views from different angles. When the model is moved, the artificial sun will have to be moved as well, or else the sun angles will be inaccurate. Since proper focus and camera position are both critical and relatively difficult to achieve with small subjects, it makes sense to plan the camera angles ahead of time so that the movement of the model can be kept to a minimum and performed in a logical way.

Views of Clifford Wiens's model of a new National Gallery of Canada. The cardboard and plastic miniature was shot at night in Wiens's Regina office. The room lights were extinguished, and a single photoflood was reflected off a large foam-core card mounted on a boom-arm for exact control over the card's position. View-camera controls were used to properly manage focus and perspective, but similar results are possible with less sophisticated equipment. Camera: Toyo 4x5in, lens: 150mm (normal), film: Kodak Vericolor III Type S, printed on Kodak black-and-white Panalure paper. Some perspective controls were used.

PROGRESS AND CONSTRUCTION PHOTOS

A typical progress photo, in this case photographed from ground level. Camera: Toyo 4x5in, lens: 90mm (moderate wide-angle), Film Kodak Vericolor III Type S. Perspective controls were used to give a rectilinear look, but are not really necessary to serve documentary purposes.

DEFINING THE JOB Making a visual record of a building under construction or documenting engineering details of existing structures is not necessarily the most creative photographic activity; like copy work, it is quite straightforward.

Progress photos may be requested by architects, engineers, contractors, developers, building owners, or even the bank that is financing the project. (On very large projects funds may be advanced to contractors and suppliers in stages based on the periodic presentation of photographic proof of work completed.) The main requirement for documentary shooting is accuracy.

The degree of detail to be recorded depends on the final use of the photos. A construction company may want to show the installation of structural elements of a steel and glass skyscraper, something easily photographed from a distance. An architect might be involved in a lawsuit with a contractor over some improperly installed materials, in which case closeup photos showing the exact condition of the defects would be necessary.

EQUIPMENT AND TECHNIQUE Color is not always required, but all prints must exhibit very high resolution. Therefore, film and equipment choices will be similar to other more exalted kinds of architectural work. Prints must be dated, and all negatives filed for easy access. If a series of images are needed to show the progress of construction over time, return to the exact same camera positions at approximately the same time of day for each visit to the site. This will ensure that the photos make immediate visual sense when viewed either in pairs or all together.

Photographs of mechanical details in dark locations require some supplementary lighting. Tungsten lights would be clumsy to use on construction sites, but less so in finished buildings. The painting-with-light technique described earlier is handy for covering large areas. When freedom of movement is essential the appropriate tool is a battery-powered portable flash. Small units are available quite cheaply, and bigger, more powerful versions can be rented. With a single, powerful flash, big spaces can be illuminated, but only at a documentary level. A short extension cord may be used to get the flash-head off the camera; if the flash is separated from the camera, even by an arm's length, the subject will be better defined by the texture of shadows and highlights.

Note: Some flash units have built-in sensors to determine correct exposure while others use sensors incorporated in the camera. In the first case exposure bracketing may be achieved by altering the diaphragm settings, but the second case will require the ISO setting on the flash to be adjusted between exposures.

Although most progress and documentary photographs will never be coveted for their aesthetic qualities, it is never a waste of time to try for harmony and balance in any photographs you make. Well-composed images are more appealing and more effective, if only on a subconscious level. Similarly, if parallel verticals can be preserved, your work will have a more professional look.

CONSIDERATIONS FOR DIRTY OR HAZARDOUS LOCATIONS Construction is a messy business. Exposure to dust and grime are hard on photographic equipment. (Cement dust is particularly insidious.) It is only prudent to protect delicate cameras and lenses from harmful exposure to the detritus of building sites by observing a few simple precautions.

Avoid windy and rainy days. On large projects things do not change all that much within twenty-four or forty-eight hours, so there is some leeway to pick weather conditions that are calm. When dusty or wet conditions are unavoidable, put your camera in a plastic bag. Cut out holes slightly smaller than the lens and the viewfinder eyepiece (thus insuring a snug, waterproof fit) and secure the plastic at these locations with elastic bands; you will find that the controls may be easily manipulated through the polyethylene. Use your car or some other sheltered space when changing film or lenses. Store the exposed film in plastic while on the site. Keep camera bags closed and/or encased in plastic, as well.

A number of hazards exist on construction sites. If the camera must be placed on a tripod, chose a position that is stable (the edges of deep excavations can be unpredictable, especially when wet) and well out of the path of machinery or busy laborers. It is easy to become absorbed in the photographic process, so try to stay alert to the surroundings. Keep an ear open for invisible hazards such as workers drilling through nearby walls or ceilings.

Watch your step. Empty stairwells may be hidden or poorly covered and there may be dangerous obstacles on the floor. Wear a hard hat and proper protective footwear. Cement dust is carcinogenic, so a filter mask is not excessive wherever concrete is being mixed, drilled, or cut up.

After leaving a construction area, use a soft brush, compressed air, or a vacuum to dust-off your equipment inside and out. (Camera stores sell canned compressed air that is handy on location, but avoid ozone-eating freon if possible.)

JOB-SITE ETIQUETTE It is in your own best interest to find out who is the construction foreman on large projects and inform him or her whenever you are on the site. You will be advised of any dangerous locations or procedures (blasting, for example), and the construction workers will be informed of your presence. The foreman has a legal responsibility for everyone's safety, so do not argue. Hard hat signs should be obeyed, as should warnings that call for protective goggles or earplugs. Never interfere with the flow of workers, machinery, or materials unless prior arrangements have been made.

It is highly likely you will encounter the same construction companies over and over again during several years of shooting construction sites, so it is both prudent and kind to supply a print or two for free as a professional courtesy.

WEATHER CONSIDERATIONS: WIND, RAIN, LOW TEMPERATURES

We have considered how weather makes variations in light and sky that are both essential and welcome as visual excitement in architectural photographs. The side effects of such variability form a set of mechanical problems that have to be scrupulously managed if that visual excitement is to be effectively captured.

Wind introduces mechanical energy that causes movement of elements of the subject as well as the equipment. In the earlier section on tripod technique, I discussed how subject movement affects the look of architectural photos. To recap briefly, let me say that a certain degree of blur in foliage or flags can actually enhance the "reality quotient" of an image. By that I mean that "perfect" photographs of buildings tend to look like reproductions of elaborate architectural models rather than real views. Wind-induced movement can counteract this feeling of unreality.

Wind can interfere with what you are trying to do when it induces camera motion that degrades overall resolution. Yet wind is only rarely a continuous force, so by paying attention it is possible to chose moments of relative calm to make a photo. After all, you only need a few seconds or less. When this approach is impossible, camera motion can be dealt with by securing the camera to an immovable support or by using high shutter speeds. In my experience hand-held cameras need to be set at 1/250sec or above to prevent loss of sharpness due to noticeably buffeting gusts. To detect camera motion that might not be readily apparent when the camera is mounted on a tripod or clamped to some other anchor, attach a bubble-level and see if the bubble settles down completely. If it does not, avoid shutter speeds of longer than 1/30sec.

Wind introduces both visual and mechanical contaminants. Dust and other particulate debris in the atmosphere will reduce sharpness and create off-color skies. This is not always visually objectionable but grit in the air will eventually work its way into cameras and lenses. Professional equipment is designed to resist this sort of invasion to some degree, but protective measures, like the plastic bag trick described earlier, should always be taken when conditions become extreme. Remember that even though 35mm film is capable of wonderful results, all negatives or slides made by small-format equipment must be highly magnified to be useful; dust in the camera results in difficult-to-retouch black spots or scratch-induced black lines on the final images. The best approach is simply to avoid shooting on really windy days.

A plastic bag in combination with a lens shade will ensure that rain water stays off the front surface of the lens. Rain in the air will reduce sharpness but water on the streets often looks great. Grass and other foliage looks nicer when wet, as well. Although I do not recommend working in the rain, shooting just after a downpour is sometimes the only way to de-emphasize the grime of some urban centers.

Where I live winter lasts eight months of the year and low temperatures are a fact of life. Most modern equipment uses lubricants that permit normal mechanical operation in

the cold. Nevertheless, do not force any control that becomes stiff at low temperatures. Avoid breathing directly on cold cameras since moisture from the breath will condense on lens elements and reduce performance. Equipment that has been outside in the cold should be protected from condensation with plastic before being brought back indoors. It is not too inconvenient to seal up the whole camera case inside a garbage bag.

Cameras with electronically governed functions may shut down in the cold due to reduced battery power. In these circumstances it is necessary to keep batteries warm by either shielding the whole camera beneath warm clothing or by using a custom-made extension cord to separate the battery from the camera. An alternative might be to keep the battery in a warm pocket until just before use.

Modern films are mechanically very tough, but they may become brittle at low temperatures. Avoid sharp bends when loading. Cold, dry conditions can induce static electric discharges inside a camera, so turn off motor drives and instead advance film manually with a slow, even motion.

I have found that thin cotton gardening gloves are great for protecting hands from the cold; if this proves too clumsy, you might try cutting away the cloth at the fingertips.

HOW TO TAKE GOOD PHOTOS AT NIGHT

INTRODUCTION We are compelled to shoot at night by bad sun angles, the need to eliminate intrusive urban clutter, or the simple desire to show off a building in a novel way. Several problems are encountered in this work. Low light levels, high image contrast, reciprocity failure due to long exposures, and odd color balance due to mixed artificial light sources have been thoroughly examined in Chapter 6.

Just like other photographic challenges, the special inconveniences of working in the dark will be made easier by thinking and planning ahead. It is sensible to select camera locations and arrange for access to private property well ahead of time. Confirm any arrangements with a phone call just before the end of the business day so that chances for confusion in the evening are minimized. Carry identification. Your own business card, your client's business card, and the business card of whoever gave permission for you to be wherever you need to be will prove helpful in certain circumstances. High security locations will require a formal letter and/or a security person as escort. Be prepared to explain what you are doing to the police, as well. And remember, working in the dark is easier with a flashlight.

VERY LONG EXPOSURES Normal interior shooting involves exposures of usually no more than one or two minutes with even the slowest films; outdoors at night, exposures for faster films will be about the same. However, a combination of low light and slow films will yield exposure times of five minutes or more, and bracketing becomes a real chore. Many BTL exposure meters will not even show a reading at such dim levels.

A professional quality hand-held exposure meter will help, but experimentation and record keeping will also make working at night a lot easier. Many street-lighting situations are similar in color and brightness, so what works in one place will often work again in another. For a typical, urban, street scene you might try f8 at one minute for ISO 100 film with plus or minus two stop brackets (i.e., 15sec, 30sec, 1min, 2min, and 4min). Evaluate the processed film with the help of the lab staff, and adjust the exposure accordingly. After a bit of experience only plus or minus one stop brackets will be needed. Reciprocity failure due to long exposures leads to nonlinear color responses in most films. However, a good printer can usually establish an approximate color correction that will be acceptable.

SUPPLEMENTARY LIGHTING Very long exposures allow time for some fairly easy photographic manipulation. Raising light levels way above the existing ambient conditions is virtually impossible, but with a little effort important details can be reinforced and dark areas opened up with some cleverly applied artificial light. If a source of electricity is available, one hand-held photographic light of 500 or 1000 watts can highlight specific areas using the painting-with-light method introduced earlier. Portable battery-operated video lights or multiple flashes from battery-operated electronic flash units will work in locations without a source of A.C. power. It is important to keep the light moving smoothly to avoid hot spots. Watch out for direct reflections from windows or other shiny surfaces.

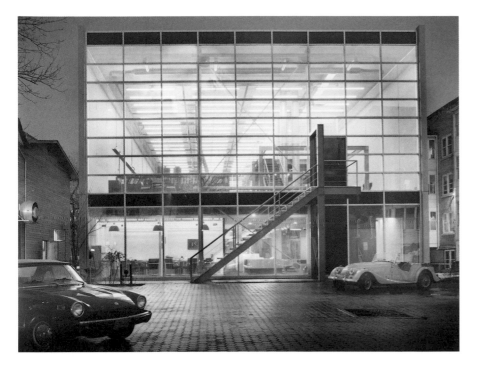

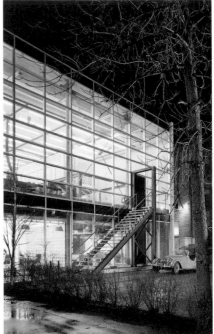

If the exposure times are sufficiently long, say five or ten minutes, it is possible to lock the camera shutter open and walk right up to the target building with the light in hand. As long as you keep moving and do not shine the light directly at the camera you can cover a very large area with light and still not be seen in the photograph. Strange, but true.

TOWARD PHOTOGRAPHIC PERFECTION

SMALL-FORMAT LIMITATIONS Having followed my arguments to this point, you should have a fairly clear understanding of how far one can go with small cameras. In this day and age it is certainly quite far. Fine-grained color negative films like Ektar 25 and Fuji Reala permit outstandingly detailed enlargements. Moving to the more temperamental color transparency films will enhance color fidelity and highlight detail: new films like Fuji Velvia, Ektachrome 50, and Agfachrome 50 are approaching the exalted technical plateau occupied for many years by the venerable Kodachrome 25 (still available, and still the standard for 35mm resolution and color-fidelity).

All of the films mentioned above are capable of results that will satisfy many photo editors and most critically-minded architects. We now know, however, that good results are dependent on a painstaking methodology: slow films (ISO 25-64) require tripod-bound cameras for the small-aperture/wide-depth-of-field work so typical of exterior and interior photography. Exposure is critical too, since slow films, particularly slow slide films, exaggerate subject contrast compared to their higher-speed relatives. Careful management of basic exposure is mandatory. Bracketing is essential. In many cases supplemental artificial lighting will be required to bring the tonal range of interior views that include unshaded windows or bright light-fixtures within recordable limits. Exterior views of high-contrast subjects (such as buildings with shiny metal mullions or highly reflective glass) may have to be shot under partially cloudy conditions so as to avoid the technical extremes associated with direct sunlight.

Even when exposure or contrast buildup is under control, high resolution films push the technological limits of 35mm photography in another, less manageable way. In those circumstances where one has calculated a perfect exposure, has ensured that the camera was steady and carefully focused, and has selected the depth of field appropriate to the depth of the subject, the final results may be limited not by the film stock but by the optical properties of the lens used to take the picture. I must add to this disturbing fact yet another disturbing fact: perspective control lenses (the architectural photography workhorses) exhibit more optical flaws than conventional lenses.

You will recall that PC lenses mimic the rise/fall/shift movements of the large-format view camera in order to allow small-format workers a measure of perspective control. Like

The office of IKOY Architects, Winnipeg— nighttime shots of the front exterior. The parking lot was dampened with a garden hose to make the images more interesting with reflections. The "painting with light" technique was used to add some detail to the tree, the car on the right, and the painted steel stairway support.
Camera: Toyo 4x5in, lens: 90mm (moderate wide-angle), film: Kodak Vericolor III Type S. Perspective controls were required.

the lenses of view cameras, PC lenses have a much wider image circle than the actual size of the film format: the property allows movements without image cutoff. Such extreme coverage comes at a price—an inevitable decrease in resolution at the edges of the field. This degeneration is exaggerated in small-format lenses intended for use with SLR cameras because of a further limitation on their construction: such lenses must allow sufficient room for the swinging mirror between the back of the lens and the film plane. This room can be provided only by retrofocus lenses. Unfortunately, perfection in ultra-wide-angle retrofocus lenses is much more difficult to achieve than in conventionally designed ultra-wide-angle lenses. This is why PC lenses are so expensive.

Perspective control lenses are undeniably useful tools. However, the fact remains that they—and, to a more moderate degree, all small-format ultra-wide-angle lenses—are increasingly unsharp toward the outer edges of the image field. Consequently, even when every photographer-controlled variable has been carefully managed to achieve high-quality results, the 35mm image will still be limited by hardware.

RESPONSES TO SMALL-FORMAT LIMITATIONS There is some consolation in knowing that understanding the shortcomings outlined above demands a high level of insight into photographic technology. Nevertheless, those who find the limitations of the medium upsetting must find some remedy.

There are three approaches: the first is psychological. It is a fairly straightforward process to say to oneself, "enough is enough." After all, the uses to which most practitioners will put their photos are adequately served by work produced with currently available 35mm technology. Publications, portfolios, and presentations can be reasonably accommodated using the methods already outlined.

The second approach, for those infrequent situations where there is a real need for a higher level of photographic perfection, is to obtain the services of a professional photographer. It is usually time to retain a professional when a high-profile architectural journal demands a set of original 4x5in transparencies, or when the degree of perspective control required for a particular shot may be beyond the capabilities of your small-format equipment.

A little experience will help determine whether or not the first two options will serve over the long term. If you feel that your photographic needs are met by regular use of small-format equipment in combination with the occasional professional assignment, then there is no problem. However, if even well-made 35mm images regularly seem inadequate, and if the available professional photographers are too expensive or too obtuse, you may wish to consider moving up in format.

BEYOND 35MM There is a wide range of photographic technology beyond miniature format. Fortunately, the skills required to operate bigger cameras are virtually the same as those required for excellent 35mm work. I have emphasized that most of the effort involved in excellent photography has nothing to do with cameras; rather, it is an intellectual/emotional process of observation, appreciation, and previsualization. Still, having made the decision to explore another technology, some new information is required.

MEDIUM-FORMAT SLR'S Medium-format single lens reflex cameras produce some of the benefits of a 4x5in within a "miniature" body. The luscious medium-format image is indeed a technical equivalent to a 4x5in image, yet the tremendous mechanical flexibility of a large-format view cameras is generally unavailable in medium-format systems. A well-made medium-format image is virtually equivalent to a well-made 4x5in so long as the capability of the film is the only consideration—there is no doubt that either medium transcends the possibilities of 35mm in terms of resolution, tonal gradation, and even color saturation, simply because of image size. In addition, larger images and lower magnifications permit the use of faster films of lower inherent contrast, a valuable attribute in this work since many architectural subjects exhibit very wide tonal ranges.

Some exotic (and brutally expensive) medium-format designs such as the Fuji 6x8cm system or the Linhof Technika 6x7 do incorporate a flexible bellows and a limited range of movements, but in general medium-format SLR cameras are really elaborated 35mm cameras. Although their advantages rest mainly with large film size, there are some other appealing aspects to medium-format cameras. For example, some have interchangeable

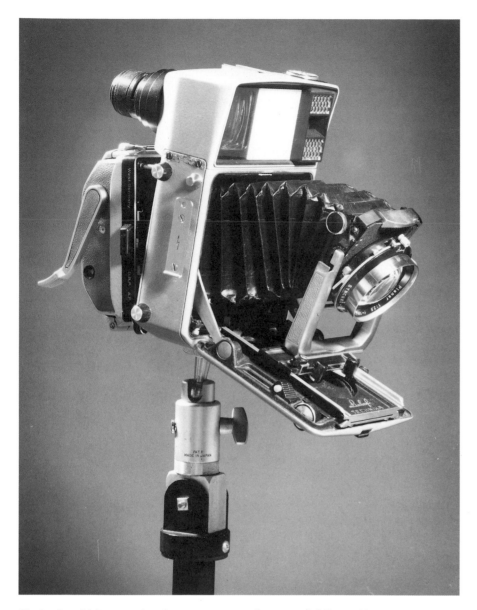

A medium-format flatbed camera ("press camera") showing movements. This camera by Linhof features a coupled range finder/viewfinder. To focus the camera when movements are used, a ground-glass back must be substituted for the roll-film back shown in the photo.

An Asahi Pentax medium-format SLR that looks and operates like a giant 35mm SLR.

film backs, which means that they can accommodate several different film stocks by simply switching backs (usually a quick, one-handed operation). Such cameras will accept special Polaroid film backs, as well. This allows more or less instant testing/confirmation of composition and exposure: a real advantage in tricky situations. Since medium-format images need not be enlarged to the same degree as 35mm images, and since all good medium-format lenses are made to the same high standards used for small-format lenses, optical performance tends to be relatively better overall. Some disadvantages: extreme wide-angle lenses are not easy to obtain and PC lenses intended for medium format do not cover as wide an image field (and are therefore less useful) as those available for miniature format. Medium-format machines are relatively awkward to hold, they are vibration-prone even when mounted on a tripod, they consume film at an alarming rate, and they are usually bulky, heavy, and very expensive.

To recap, medium-format SLR systems will improve the technical quality of photographic images, but at a cost in convenience of operation, physical bulk, and degree of perspective control.

NON-SLR MEDIUM-FORMAT CAMERAS Single lens reflex cameras are popular because they permit easy lens interchangeability. The mirror and prism viewfinder system always relays to the photographer exactly what the taking lens sees, so framing and focusing are straightforward operations. Unfortunately, the SLR systems are heavy (solid glass prisms big enough for medium format are fairly weighty), they introduce vibration due to the additional moving parts (mirror, automatic diaphragm), and they suffer from the

restrictions in lens performance associated with retrofocus designs. (Theoretically retro-focus lenses can perform very well but they are hard to design and construct, so the best ones are quite costly.) Dispensing with the SLR concept allows cameras to be sized down and optical performance to be upgraded with the use of less expensive non-retrofocus lenses. This is achieved by incorporating a separate optical viewfinder with or without a coupled range finder (a device for determining camera-to-subject distance by a system of optical triangulation). Optical finders are less accurate when used with long focal length lenses, therefore some of the most interesting non-SLR roll film cameras are offered with non-interchangeable wide-angle lenses.

There are several cameras worth considering by those who wish to integrate the advantages of miniature cameras with the advantages of a larger format. I think that it would be quite reasonable to own a comprehensive 35mm system in addition to one of the wide-angle/optical finder type medium-format cameras. Such equipment would combine the ability to produce detail shots, medium views, long telephoto shots, copy work, and the ubiquitous 35mm slide while allowing the production of highly detailed wide views where precise reproduction of a myriad of small details is important. Fuji, Mamiya, Linhof, and others all offer such cameras, some of which include a rise/fall/shift capability (monitored by moving frame lines in the optical viewfinder). Dedicated wide-angle roll film cameras are available with extended image sizes such as 6x9cm, 6x12cm, or even 6x17cm for truly panoramic wide-angle views.

A 4X5 PRIMER For those not interested in half measures, a 4x5in view camera is the only option. Some economies are possible by selecting a basic camera with less-than-laboratory-grade controls and a modest array of lenses, but, any way you look at it, moving up to large format is a costly step.

I will make the assumption that the serious worker will acquire a monorail-based view camera and at least three or possibly four lenses, namely an extreme wide-angle (65–75mm), a moderate wide-angle (90mm), and a lens of "normal" focal length (135–150mm). Moderate or long telephoto lenses (250–450mm) will be required for details or working at a distance. One may expect to spend $2500–$3500 for this equipment new, about one third less for used. Sometimes these items are advertised in the want ads of the local paper—they are more easily located through the large mail-order suppliers that advertise in photography magazines.

A comprehensive 4x5in system.
Top row: front standard, clock timer, rear standard, bellows above monorail.
Middle row: 150mm and 250mm lenses, ground-glass back, two polarizing filters, center-graduated neutral density filter.
Bottom row: 47mm, 75mm, and 90mm lenses, roll-film back above Polaroid back.

98

Large-format cameras are less convenient to use than SLRs because they do not have viewfinders. Instead, the image projected by the taking lens must be evaluated on a ground-glass screen in the film back. Lenses of relatively small maximum aperture (f8) may have the same resolution as lenses with wide maximum aperture (f4-f5.6), but they will be difficult to work with due to the dim image they project on the ground-glass. The diameter of the projected image circle will likely be smaller with smaller aperture lenses, so the range of corrective movements will also be restricted. For this reason lenses of wide maximum aperture are preferred by those who must use view cameras often. Smaller aperture lenses are significantly less expensive, however, so greater care in focusing will yield economic benefits.

Monorail view cameras intended for use with 6cm roll film or 6x7cm sheet film are available—I do not recommend them simply because a ground-glass image smaller than 4x5in is just too difficult to evaluate without eye strain.

A number of 4x5in film holders and a light-tight changing bag for loading them will be required. A Polaroid film back is both a luxury and a necessity. (It is a luxury because 4x5in Polaroid film costs about $2.00 a shot and generates an inordinate amount of garbage; it is a necessity because you will waste a lot of time and money without the guarantees provided by on-site previews of your work.) Typical films to use are Kodak Vericolor III Type S (ISO 160) for daylight color negatives, Kodak Vericolor II Type L (ISO 80) for tungsten artificial light color negatives, Kodak Ektachrome EPP (ISO 100) for daylight transparencies, and Kodak Ektachrome Type 6118 (ISO 64) for tungsten artificial light transparencies. My standard test film is Polaroid type 54 (ISO 100)—a coaterless black-and-white material that produces highly detailed test prints in forty-five seconds at room temperature. Type 58 (ISO 75) is useful for evaluating color balance under both daylight and tungsten conditions: when exposure times are shorter than five seconds the film is correctly balanced for 5500K, at exposures longer than thirty seconds built-in reciprocity effects alter response to match 3200K sources. (Polaroid recommends a processing time of one minute for Type 58, but I have found that ninety seconds is better.)

In addition to the camera, lenses, and film backs the following accessories will be required: a bag bellows (a soft, extraordinarily flexible bellows usually made of leather, required for use with wide-angle lenses), a dark cloth (an opaque cloth to drape over one's head and the back of the camera to permit viewing the dim ground-glass image), a sturdy tripod, cable releases for all lenses, a loupe to magnify the ground-glass image for precise focus, and an incident light meter.

Until now we have depended on the BTL/TTL light meter and bracketing for exposure control. With the higher cost of large-format sheet film, extensive bracketing becomes prohibitively expensive—an incident light meter reading confirmed by a Polaroid test is more reliable. Behind-the-lens meters measure the light reflected by the surface of the subject. Incident meters circumvent the vagaries of subject tonality by measuring the light that impinges on the subject, rather than the light that the subject reflects. It does this by way of a translucent diffuser—a plastic dome about one inch in diameter that sits on top of a photocell (a crystalline device that converts light energy into electrical energy). Light striking the dome from different directions is mixed together by the diffuser and measured by the photocell, which then activates the light meter's readout. To take an incident light reading, hold the meter at the position of the subject and point it at the camera or at the main light source. Use the setting suggested by the meter for a Polaroid test exposure. Visually evaluate any deviation from the ideal and then correct for it in the exposure of the real film. With a reliable lab, a familiar film stock, a well-calibrated incident meter, and accurate shutters, economy-minded photographers can dispense with brackets altogether. Nevertheless, when I work in 4x5in format, I always shoot two color negatives at the same exposure as insurance against mechanical or chemical damage during processing. When I shoot big color transparencies I bracket two or three stops as insurance against slight variations in film speed or processing conditions.

The large-format learning curve is very quick, particularly when the process is expedited on the job with Polaroid tests. Anyone who has done good work in small format should do well with big cameras under the same conditions. It will quickly become apparent that the various controls available on the view camera are invaluable tools that greatly facilitate image management. Those accustomed to the right-side-up image in the viewfinder of an SLR will at first find it a little odd to be evaluating an inverted and left-to-right reversed

Leo Kopelow levels the view camera before lining up a shot.

image on the view camera's ground glass. This disorientation will soon pass. After all, it is common practice for graphic artists to turn their work upside down in order to better evaluate balance and composition.

REASONABLE EXPECTATIONS Substantial investments of cash and patience will be rewarded—carefully made large-format images will take your breath away. It is possible to subvert the potential of the medium by inappropriate choices of lenses, film, and point of view, but such errors are rare simply because the deliberate pace of view camera work encourages precision.

Examine your large-format negatives or transparencies with a loupe and a light table. When evaluating your work be certain to distinguish between camera movement, imprecise focus, and optical deficiencies. There will inevitably be some loss of sharpness toward the outer edge of the image projected by even the very best lenses. Cheap or damaged lenses will exhibit an exaggerated edge softness. Keep in mind that at moderate apertures (typically f11–f22), virtually all view-camera lenses will be critically sharp in the central image area. If this is not the case it is most likely that you have either focused poorly or you have allowed the camera, or a part of the camera, to move during the exposure. Sometimes lack of sharpness is a result of film slipping slightly within the film holder or of misalignment of the film holder within the film back. Other culprits might be a small movement of the front standard, back standard, or tripod due to a malfunctioning or improperly actuated lock. Even a fingerprint on the lens will degrade sharpness noticeably. A bellow can act like a sail outdoors: a slight breeze may move the whole camera enough to degenerate an otherwise perfectly sharp image.

Good, repeatable results are only possible with a fastidious routine of careful camera setup, precise focus, secure locking of all movement, and correct exposures.

YOU DON'T HAVE TO WORK ALONE It will become evident that working by one-self, particularly with large-format cameras, can sometimes be an overwhelming proposition. Why not follow the example of the majority of professional photographers who—when confronted with a big job—take on some extra help?

The costs of large-format equipment and film make the expense of hiring an assistant seem relatively small. If the helper is a colleague or an employee, the only real cost will be the time lost from other work. Such people need not be highly skilled in a photographic sense, since carrying equipment, helping to rearrange furniture, or cleaning up an outdoor site is not very complicated.

Keep in mind that more sophisticated helpers will improve picture making in the same way that sophisticated technicians at the color lab can improve print making. Every city supports some people who specialize in assisting photographers on a free-lance basis. They may be located by asking professional photographers or industrial photographic suppliers. Technical schools or universities that teach photography are also good sources. Remuneration varies from minimum wage up to $25 per hour, depending on experience.

A skilled assistant will accelerate the photographic process by anticipating what equipment is required for a particular shot, how the equipment should be set up, and where the equipment will be moved for the next shot. They will offer advice about lighting, lens selection, and point of view based on their experience with other professional photographers' methods. Some assistants intend to be professional photographers themselves, so their enthusiasm on location can be quite inspirational both technically and aesthetically.

Those jobs that demand supplementary lighting can be facilitated using the expertise of theatrical or cinematographic lighting specialists. This need not be as imposing an undertaking as it might sound. Consider that in almost any urban center there will be at least one business that specializes in supplying a variety of lighting equipment to those who produce television, film, or theater. Their staff will know about color balance and contrast control and they will be able to suggest which instruments and accessories are appropriate for your problem shots. Very likely they will be able to "rent" a technician to set up and operate the lights as well. Since still photographers work on a much more flexible schedule and on a much smaller scale than the other users of rental lighting, rates will be manageable. Similarly, independent film and theater production companies often have their own lighting and lighting technicians; the possibility of a little extra income between projects is often very attractive to them.

MAGAZINES AND NEWSPAPERS

TECHNICAL REQUIREMENTS FOR PUBLICATION I cannot say what makes an architectural project suitable for publication, but the technical criteria for architectural photos intended for publication are fairly straightforward. I have already commented on the ancient argument between transparencies and prints. The following specifications apply to both:

1. The image must be clear, with an abundance of detail and consistent focus.
2. The color must appear natural and appropriate for the scene.
3. Perspective and point of view should be natural and pleasing.
4. Sun angle, sky conditions, and seasonal variations should be appropriate.
5. The subject must be portrayed in its proper context relative to the site.
6. The scale of the subject must be properly established.

Look familiar? These same characteristics of quality architectural photographs were listed in Chapter 1. Hopefully, the nuances of what goes into such images are now familiar, as well. Here are a few more tips:

7. Prints should be carefully produced and 8x10in in size.
8. 35mm transparencies of exceptional quality are okay, but larger is better.
9. A self-addressed stamped envelope should accompany all submissions.
10. Do not send away material that cannot be replaced. (Another argument in favor of prints!)

These are pages from *Architectural Record*, April 1983, featuring the IKOY Office. A comprehensive submission results in a comprehensive publication if both the project and the photography are regarded as worthwhile by the editors of architectural journals.

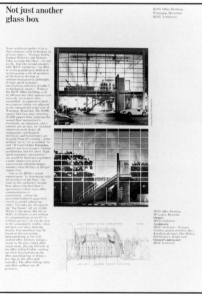

Two covers: *Architecture Magazine,* **March 1987,** *Architectural Technology Magazine,* **Fall 1987.**

HOW TO DEAL WITH AN EDITOR Successful interactions with photo editors begin with an understanding of what it is they do for a living: they are charged with assembling the visuals that illustrate and support the written editorial material. Piles of pictures of all sorts must be evaluated. Generally, professional offerings are not dealt with any differently from those of advanced amateurs, but all too often a sow's ear must be made into a reasonable facsimile of a silk purse. Those images that are ultimately selected to accompany the written editorial material must be carefully cropped and captioned.

The way to warm the heart of a photo editor, and consequently the way to maximize the use of your images in the magazine, is to attend to all the above mentioned details yourself. Thus, make certain that the images you submit are logically appropriate illustrations for the text, aesthetically as well as technically excellent, and clearly captioned. (Easily removed stick-on labels are best for prints, since pen or pencil markings may cause stains or mechanical damage. Use stick-on numbers and a separate clearly printed list for 35mm slides.) Captions should indicate who the photographer was, when the image was made, and why the image is significant.

Dealing with an editor is not always a one-way operation. If the level of work submitted is acceptable but incomplete in some way, you can expect to be asked to supply whatever additional images are necessary. It is at this point that many amateurs (and some professionals) get tripped up. Magazines have highly developed editorial policies. These policies are reinforced by methods that vary from the very subtle to the very heavy-handed. Selection, cropping, sizing, placement, and the use of color are methods of manipulating the significance of particular images to serve the editorial policy of the magazine. These methods do not directly involve the photographer who has made an unsolicited submission, but a call for additional specific material does. A personal decision must be made about how such requests will be handled; arguments over style, technical approach, and the value of particular images are profoundly unwelcome by most magazine editors. Professional photographers are sometimes threatened by detailed requests, which they may interpret as criticism. Amateurs are sometimes threatened by specific requests since they have a personal stake in the way the building or interior will be represented in the magazine. For example, a request for a closeup picture of a structural defect may irritate the photographer/architect whose building is being subjected to a critical review.

It is necessary to understand that editorial exposure in a publication is not always a straightforward public relations vehicle. Any magazine exists to serve its readers and its advertisers; their welfare will usually be considered ahead of the welfare of contributors. When everyone's needs coincide, relations with editors can be wonderfully peaceful. In the event of a dispute, the contributor should understand that he or she will inevitably have to defer to the wishes of the editor or else withdraw the entire submission. To establish a working rapport, it is best to query the editor with a detailed proposal letter before submitting a comprehensive body of work.

Canadian Architect Magazine **chose this shot as the cover of the issue that featured the IKOY Office. A large sheet of seamless paper was used to isolate the elements in which I was interested from the rest of the room. Available light was sufficient here.** Camera: Toyo 4x5in, lens: 150mm (normal), film: Kodak Vericolor III Type S. Perspective controls were not required.

SHIPPING AND HANDLING Earlier I mentioned that all submitted materials should be accompanied by a stamped, self-addressed envelope and that irreplaceable materials should never be sent as part of an unsolicited submission—these are the basic rules. In addition, it is only sensible to pack photographs carefully. Usually two sheets of stiff corrugated cardboard or foam board will protect prints and slides sandwiched between them. Heavy duty envelopes or padded shipping pouches are preferred over craft envelopes, as well. Never ship glass-mounted slides. Always sleeve large-format transparencies. Photographic suppliers that cater to professionals often stock very attractive transparency-mounting systems that consist of a black cardboard frame enclosed by a specially made sleeve with a clear plastic front and a frosted plastic back. These mounts handle several 35mm or medium-format transparencies, or one large-format transparency. At one or two dollars each, they are a good investment since they protect slides from fingerprints and provide a diffused viewing light at the same time.

Deadlines are critical, so never trust the postal system. Independent couriers such as Federal Express are expensive but quick; they keep track of shipments via way-bill numbers and computers so shipments seldom go astray. If material is requested by a magazine, you will usually be able to ship collect via their favored courier. Don't be shy—ask for an account number.

WHEN YOU PAY THEM, WHEN THEY PAY YOU You will never really have to pay a magazine directly to get a photograph published. However, all photos produced and submitted on speculation will of course be produced at your own cost. It is extremely unlikely that these costs will ever be recovered should the material eventually be accepted

for publication. A query letter that outlines the proposed article and the photography that would be required to support it will sometimes result in the offer of some money for professional photography or for the materials needed to produce the work in-house. The exact amount will depend on the practices and size of the publication in question. Although there is no question that any publication will happily accept quality photographs if offered for free, they are quite used to paying for good work produced on assignment by professional photographers. The remuneration for amateur work will have to be diplomatically negotiated, with actual costs for materials as a starting point.

WHAT TO SEND Earlier I mentioned that editors have considerable power over the effect and importance of the images they choose to publish, while the creation and selection of images for submission is the first and sometimes the only control that rests with the contributor.

Sending images on speculation is a form of advocacy since there are professional benefits that accrue from publication of one's architectural or interior design projects. The natural impulse is to make certain that whatever is published will be a positive and flattering representation of your work. The preceding chapters are all dedicated to the acquisition of the skills necessary to do this, but the last (and sometimes the most difficult) task is to ruthlessly edit one's own photographs.

Editing is an exercise in minimalism; it is necessary to eliminate all but the most essential images. The very best photographers do this as they shoot, so that both time and materials are conserved at once. Some professionals and advanced amateurs as well as most beginners tend to shoot prodigious amounts of film with the intention of weeding out the inferior pictures after processing. Working this way exposes the photographer to the sometimes irresistible temptation to retain images that are less than excellent. When using 35mm, a shooting ratio of 20:1 (twenty mediocre shots for each good one) is not at all unreasonable. A magazine submission should be composed of pictures that have been culled from your first rough edit. Sending a small number of wonderful pictures that you have carefully preselected will ensure that the photo editor's work begins with a visual record that accurately reflects your personal interpretation of the subject. Assuming the original submission was first-class, you will not be unduly compromised should the editor request additional images; the quality of the photos will earn a measure of professional respect and your views will be considered seriously.

A GOOD BLACK-AND-WHITE PRINT Although most national magazines publish in full color, there will always be a need for high quality black-and-white photographs for use in press releases, technical and legal documentation, and newspapers. Standards of reproduction vary, but it is important to be able to recognize the characteristics of a reproducible print, if only to ensure that your lab produces satisfactory work. It is incumbent on the contributor to submit excellent prints. While the published result may end up noticeably worse than a good original, it will certainly never be any better than a poor original.

This photo of a dilapidated prairie farmhouse shows the wealth of detail that can be preserved on carefully made small-format negatives. This photo was made on slow speed black-and-white film with a tripod-mounted camera. A yellow filter was used to enhance the contrast between the sky and the clouds. Camera: Leica M4 (35mm range finder), lens: 35mm (moderate wide-angle) with yellow filter, film: Kodak Panatomic-X (ISO 50).

VIII

105

A superior print will exhibit a range of tones from pure white to deep black, with an abundance of intermediate values where appropriate. Both highlight and shadow areas should retain some modulation of tone, and fine details should be rendered clearly.

BLACK-AND-WHITE CONVERSIONS Part of the convenience of working with color negative materials is the relative ease with which black-and-white prints may be produced from them. Kodak has introduced three black-and-white printing papers for this purpose: Panalure L, M, and H—low, medium, and high contrast, respectively. These excellent materials will render images of great detail and natural tonality from a wide range of color negatives (*see colorplates 38–41*). Any lab that is capable of producing ordinary black-and-white enlargements can produce Panalure prints using the same chemistry and equipment. In a pinch, ordinary black-and-white paper may be used with color negatives, but the tonal range will be noticeably altered and the image, particularly with 35mm color negatives, will appear very grainy. Such a print would be only barely adequate for reproduction in the newspaper or by photocopier.

Slanting early morning sunlight skims the sculptured detail of the facade of the Manitoba Law Courts Building in this black-and-white photograph. A perfectly symmetrical view, combined with the purposely converging verticals, provides a sense of power and drama. Careful printing maintained detail in the carved crest shadowed by the overhanging canopy.
Camera: Hasselblad ELX (medium format), lens: 40mm (extreme wide-angle), film: Fuji Reala, printed on Kodak B&W Panalure paper.

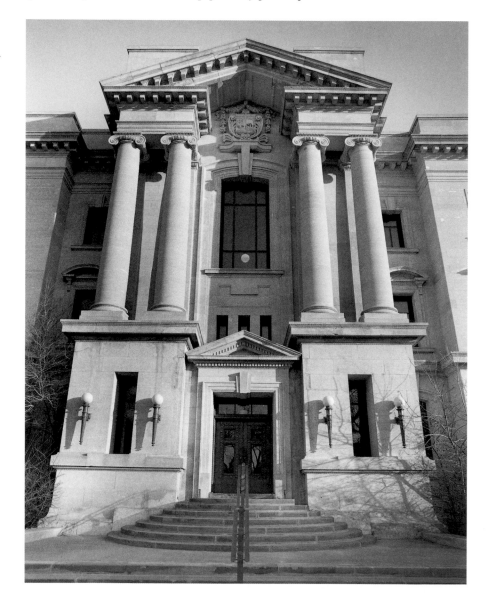

Where black-and-white services are not available, there is a handy alternative that can produce very pleasing results. Kodak TC400CN and Ilford XP2 are chromogenic black-and-white films that can be processed and printed in the same chemistry as regular color negative materials. The resulting monochrome image is not composed of metallic silver as it would be in a conventional black-and-white film; rather it is made up of a chemical dye. When printed on the same machines as ordinary color prints, a little care by the operator will result in very useful

black-and-white prints. Conservatively rated at ISO 400, this material is quite sensitive to light, and has the very wide exposure latitude characteristics of color negative film, to which it is closely related in structure. Excellent enlargements may be easily made with conventional black-and-white printing papers. I recommend XP-2 as the most convenient route to high-quality black-and-white photographs, particularly when a reliable lab cannot be located.

Monochrome conversions of color slides require a bit more technology since there are no black-and-white papers that will produce a positive image from a positive original. Your processing lab will have to make a black-and-white internegative by copying the slide with black-and-white film. This may be done with a slide-duplicating camera or by contact printing. The latter is inconvenient but technically superior since it bypasses the losses associated with any opto-mechanical system. Assuming a very high-quality original slide, you can expect good to fair results with either method. Nevertheless, if you know in advance that good monochromatic prints will be required, I strongly recommend that you shoot in fine-grain color negative, XP-2, or conventional black-and-white film (in ascending order of technical quality) rather than rely on converting color slides.

A final word: if your color work is to be published in black-and-white, never allow the magazine or newspaper to make the conversion in-house. You will always be much better served by supervising the conversion at your own color lab. This does not have to be a point of conflict if you simply say that you wish to maintain high standards without having to impose on the publisher's staff.

DEADLINES All publishing deadlines must be scrupulously respected if you expect to be taken seriously by the photo editors of magazines, newspapers, and in-house newsletters. It is important, therefore, to allow sufficient time to shoot, process, edit, and print whatever photographs are required.

Every photographer will have a characteristic speed of operation; just how long it takes to analyze the photographic possibilities of a site, decide on equipment and film, pick the appropriate time of day, and arrange for access where necessary, will be different for everyone. Weather and traffic conditions must be taken into account, since these unpredictable variables may delay even the most carefully planned shoot.

Processing film of any kind will usually take less then a day in any large urban center. Photographers in smaller communities may have to wait two to three days. Machine-made prints in color are commonly available at one-hour processors or within a day from conventional color labs. Machine-made enlargements may take anywhere from two to five days. Custom color labs can turn around excellent hand-made prints in one day by special request (usually with a rush fee tacked on), but two to four days is generally regarded as "normal" service. Special processes, such as black-and-white conversions, duplicate transparencies, or outsize prints, may take anywhere from a week to ten days. It is a good idea to get quotes on delivery time (as well as price) when planning time-sensitive projects.

From time to time circumstances may arise that demand virtually instant or overnight results. At these moments the history of your relationship with the color lab will be crucial. Have you regularly bypassed the more expensive lab in favor of the inferior, but cheaper, one-hour photo store? Have you neglected to recommend the lab to professional colleagues? Have you disputed invoices that included rush fees for previous special services? If you have, you cannot expect experienced professionals to cheerfully stay up all night to save your reputation.

A PROFESSIONAL'S PORTFOLIO

PRESENTATION FORMAT A collection of excellent photographs of your work is a premium selling tool for your professional services. In general there are two methods of presenting the material: prints and slides. I have always preferred prints, simply because I dislike the hassle of arranging for a projector and a darkened room, and because I value the personal contact that results when people physically handle and discuss carefully crafted photographs. My own portfolio consists of about thirty-six 11x14in color enlargements that have been laminated with plastic on both sides. The image area is smaller by three or four inches than the full paper size, so the pictures float serenely in a pure white field. Laminating makes the prints durable, but also gives the prints a pleasing weight and

strength. These mechanical characteristics are inevitably appreciated at subtle psychological levels as well. The prints fit handily into a typical attache case. Before any presentation I select the ten or twelve images that seem most appropriate to show.

A large number of prints is better managed by making laminated 8 1/2x11in prints, which can be punched to fit a variety of attractive three-ring binders. For crucial presentations, slick-looking suede or leather-bound binders can be suitably embossed.

Logos, technical data, and captions can be added to prints in a couple of different ways. If someone in your office has a good "hand" the most direct method is to do the lettering manually with a fine-line permanent marker directly on the surface of the print. The more painstaking among you may chose to use pressure-release type, such as Letraset, instead. Those with deep pockets can have captions professionally typeset and then photographically burned-in on the prints by the lab. Typesetting, a high-contrast negative, and burning-in may cost ten to twenty dollars per photo. Prints with titles prepared by any of the above techniques may be laminated afterwards without any special precautions.

WHEN TO USE SLIDES When visual information has to be delivered to a large group of people, 35mm transparencies are the undisputed winner. The big, bright, rich-looking image on the screen tends to focus the viewers' attention on the material being offered. If the commentary that accompanies the slides is interesting the overall effectiveness of the presentation can be very high. Some proposal calls and competitions ask specifically for slides as a means of standardizing entries for the convenience of the adjudicators.

The slide in the projector is the same piece of film that was exposed in the camera, thus the potential exists for really wonderful image-quality since the losses associated with a second-generation print are absent. On the other hand, the manipulations and corrections that may be incorporated during printing are also absent, so problem images can be painfully obvious. There are two ways of dealing with this dilemma: the first involves careful application of photographic technique in association with ruthless editing, while the second involves making copy slides of prints derived from conventional color negatives. Method one is preferable if the ultimate in technical quality is desired. However, method two integrates well with an existing body of color negative work and still allows for the beneficial interventions possible with the negative/positive system. Several sets of duplicate slides can be circulated around the city or the country while the originals remain safe at home. The copies may be made at the color lab or they may be made in-house using a closeup lens and the techniques discussed in Chapter 7. The slides that result will never be as good as perfect first-generation slides, but they are quite satisfactory for presentation purposes. My own architectural clients have used such slides for years without any problems. Copy slides should never be used for reproduction purposes, however; color separations should always be made from first-generation slides or directly from color prints made from color negatives.

These pages are from the 1986 Royal Architectural Institute of Canada Governor General Award Catalog. They include IKOY Architects' winning entry for that year— The Red River Community College Auto/Diesel Shops. All the photographs are reproduced from 35mm slides.

Sometimes a demand for reproduction-quality large-format transparencies may be satisfied relatively inexpensively by having the color lab produce 4x5in duplicates directly from high-quality 35mm slides. Similarly, 4x5in transparencies can be made at the lab directly from high quality 35mm color negatives using Kodak Type 4111 color print film. Both these strategies will often satisfy the most critical photo editor, especially if such copies are not identified as duplicates.

WHAT TO INCLUDE In Chapter 1, I discussed how to evaluate the portfolio of a professional architectural photographer. It is interesting to consider that we have come full circle, in the sense that many of the criteria that we previously applied to professional photographers must now be applied to our own work. Here is a review of the important points concerning a portfolio of architectural photography:

1. The photographs should be clear, detailed, and natural in color.
2. Special effects should have a readily perceived purpose.
3. The graphic approach should make immediate sense.
4. The images must logically apply to the situation at hand.
5. Do not show any more photographs than are absolutely necessary.

The great temptation that must be overcome when assembling a professional portfolio is the impulse to include too much material. Quantity is no substitute for quality, and some restraint must always be exercised to prevent visual over-kill. Remember also that your audience will be looking for material that is applicable to their own special circumstances; it is wise to edit your portfolio for each presentation. The order in which photographs are presented is also important. In the commercial photography business the rule-of-thumb is to show your second-best image first, and your best image last.

CORPORATE CAPABILITY BROCHURES AND MAILERS

WORKING WITH A GRAPHIC ARTIST OR DESIGNER When the need arises for promotional material that can be distributed in large numbers, even photographically literate practitioners will have to turn to other professionals for assistance. Truly up-scale advertisements will be a sophisticated combination of good writing, good photography, good layout and design, together with good printing on quality paper. A graphic designer can coordinate all these varied creative components and find talented writers and printers if you do not happen to know any. However, our main interest here is the photographic component. My advice to anyone who wishes to produce visually strong promotional material is to engage a designer before any photography is undertaken. This is important because photographs that are intended to be integrated with other visual elements in a printed piece fulfill a different function than photos that are intended to stand alone. Consultation with the designer will inevitably result in a more effective effort.

Professional designers charge $25–$75 per hour. A brochure may require 8–25 hours work, depending on size and degree of sophistication. You can expect the designer to consult with you about the overall visual approach, the specifics of photography, copy, format, typefaces, and print stock. The designer will deal with the printer regarding matters of cost, deadlines, and quality. Selecting a designer is a parallel exercise to selecting a professional photographer; a portfolio of previous work, good references, and a personal interview will all be necessary to assist in making an informed choice.

It is uneconomical to make less than one or two thousand copies by mechanical reproduction. For such quantities, a well-produced color piece can cost anywhere from $.50 each for a folded 8 1/2x11in flyer to as much as $10.00 each for a glossy 24-page book. Some designers will help reduce costs and shorten delivery time through the use of desktop publishing techniques and equipment, although some loss in quality is to be expected if conventional printers are replaced entirely by electronic reproduction technology.

PHOTOCOPYING AND DESKTOP PUBLISHING These days many computer literate practitioners can bypass professional designers altogether by producing small runs of promotional material using their own personal computer (PC), a laser printer, and a color photocopier. Virtually any PC will do a great job of layout and typesetting so long as the operator has access to, and is fluent in, decent graphics software. If the essential peripherals (laser printer, $1500–$3000; color photocopier, $15,000–$40,000) are beyond your budget,

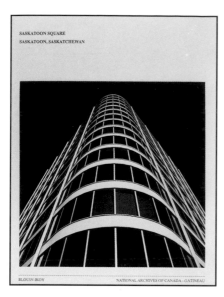

SASKATOON SQUARE
SASKATOON, SASKATCHEWAN

BLOUIN-IKOY NATIONAL ARCHIVES OF CANADA - GATINEAU

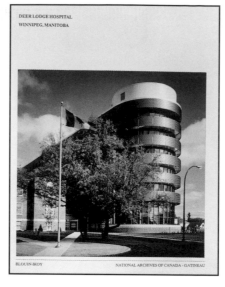

DEER LODGE HOSPITAL
WINNIPEG, MANITOBA

BLOUIN-IKOY NATIONAL ARCHIVES OF CANADA - GATINEAU

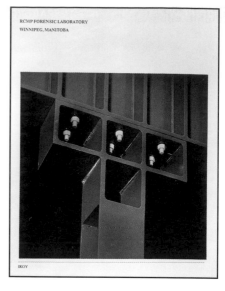

RCMP FORENSIC LABORATORY
WINNIPEG, MANITOBA

IKOY

These are project-specific promotional cover sheets intended for color photocopying—prepared from my photographs by IKOY Architects.

take your output disk to the "instant printer," the printing trade's equivalent of the one-hour photo lab. If an instant printer with the capability to read magnetic media cannot be found, most typesetting shops will be able to produce a first-class "hard-copy" (for a nominal fee), from which multiple photocopies can then be made. Photographs are incorporated into this process by preparing a set of prints at the exact size required for the layout. The pictures are trimmed and secured to the hard-copy sheets with a bit of glue. The resulting composite is then duplicated on an electrostatic copier as required. Using these techniques, quite pleasing results can be expected at about $.50 a page in quantities of 50–250. Note that photocopies tend to pick up considerable contrast, exaggerate some individual colors at the expense of others, and blur fine details.

Color photocopies and Polaroid photos can be used for rough but presentable images when deadlines are very pressing and no conventional photography of projects exists. A camera capable of using Polaroid film may be rented or borrowed. Not all Polaroid cameras are of the point-and-shoot variety: some even have interchangeable lenses. There are a variety of Polaroid film sizes as well—bigger is better for this work. I recommend Polaroid Type 664 for detailed black-and-white prints and Type 669 for low-contrast color prints. Type 668 yields snappier color prints for very low-contrast shooting situations. (Remember that the photocopier will increase contrast to some degree.) Any camera store or industrial photographic supplier can give you a number to call to get technical advice on all these matters directly from Polaroid Corporation.

The basic advice I have offered in previous chapters regarding lighting, point of view, time of day, exposure, etc., applies when shooting a building or interior with Polaroid materials. You will quickly find that exposure is the critical factor, but, happily, the narrow latitude of instant films is ameliorated by the instant feedback, so exposure settings can be fine-tuned quickly. Avoid making contact between skin or clothing and the chemically damp peel-away backing generated whenever a Polaroid shot is processed—carry along a bag for garbage.

The limitations of color photocopying will disguise most of the technical differences between Polaroid prints and conventional prints. Although I have found that high-quality color photocopiers will do a very readable rendering of a color print, there is no substitute for the real thing. If photocopies do not appeal, and it is necessary to produce a small number of top-quality promotion packages, you might consider a more expensive (but still manageable) alternative: multiple photographic prints. If you require only a few different images, have the lab quote on producing images to size, in quantity. At the lab I use, one hundred 8x10in prints from the same color negative cost only $1.75 each, and smaller prints are even less. Page-size photos can be punched and bound together with the copy, while smaller prints can be trimmed and secured with glue wherever appropriate spaces have been provided within the text. There is no doubt that this is a labor-intensive procedure, but the final results can be very satisfying.

DISPLAY PRINTS AND TRANSPARENCIES

AVAILABLE MATERIALS From time to time it will be necessary to prepare large photographs for display at professional meetings, competitions, building openings, or public forums. There are two basic approaches: large reflection prints and large transparencies (for which some sort of back lighting must be provided).

Conventional print materials are available in sheets up to 30x40in and in long rolls up to 48in wide. Not all labs can handle such big pieces, however, so such work may have to be sent out to specialized shops. Big prints made on conventional papers are vulnerable to all kinds of mechanical damage, so some sort of mounting and laminating is a prudent precaution. Masonite, plywood, Styrofoam, foam board, cardboard, and various types of plastic laminates can all be used for backing display prints. A clever, optically clear adhesive is now being used to face-mount prints directly onto sheets of Plexiglas, an operation that "frames" and protects in one step. It is often inconvenient to transport large rigid prints from place to place; however, ordinary prints will not stand up to repeated rolling and unrolling. When flexibility and durability are important, conventional photographic paper can be replaced by a very tough epoxy based material manufactured by Kodak called Duraflex. Although it is more expensive than ordinary paper, by about 50%, Duraflex can be processed normally despite the fact that it is virtually indestructible.

Two different technical approaches are possible when the glamour and effectiveness of back-lit displays prove irresistible. Kodak makes a companion product to Duraflex, called Duratrans. This material is used with color negatives and processed the same way as ordinary prints, but instead of an opaque backing, the emulsion is coated on a translucent plastic base that allows for lighting from behind. It is just as durable as Duraflex, and does an impressive job of turning images recorded on color negative film into super-sized transparencies. Back-lit displays are complicated to fabricate by oneself, so the best route is to locate an industrial supplier through the yellow pages ("displays systems," "advertising") or through a recommendation by the color lab. Ingeniously collapsible lightweight display units, starting around $1000, are the best technique if presentations must be made on a regular basis. One-time affairs may be dealt with by simply joining together two to four 4x8in sheets of foam board, Gatorboard, or suitably painted plywood to make an accordion-type stand to which prints and copy can be secured.

Ilford makes a very impressive (but more costly) alternate to Duratrans and Duraflex called Cibachrome Print Film. This gloriously accurate material is a material designed for printing directly from color slides. The color reproduction via Cibachrome is considered by some experts to be the very best available; however, it has an extremely high inherent contrast, requires more complicated and expensive chemistry, and works well with only certain slides. Nevertheless, if a competent Cibachrome printer is available, you might want to view some comparative samples of both print and transparency versions. Contrast masking is usually required for best results.

SUPPLEMENTING COMPETITION ENTRIES

Proposal calls and competitions demand some kind of photographic support, the effectiveness of which can be enhanced by a little effort. My advice regarding printed promotional material applies to this scenario as well, although in this case only one finished product is required as opposed to many.

To recap: any proposal or competition entry should be designed either by a professional designer or by someone familiar with the techniques. Photographs, drawings, perspectives, and written material should be carefully integrated into an effective layout with suitable type and clear, cogent headlines. In most cases this means mounting photographs and drawings made to size to several boards. Copy, captions, and headlines are hand lettered, typeset, or prepared by desktop publishing technology. Care is taken to ensure a professional, uncluttered representation of whatever is being "sold." Exact sizes for the boards will usually be supplied by whomever is running the competition. If the proposal is expected in the form of 35mm transparencies, the same techniques will work, except that accurate copy slides of the layouts are submitted rather than the boards themselves. A word of warning: your lab will be able to do a better job of producing color-matched prints to size if a reasonable time is allowed for the work. Do not wait until the last minute.

LONGEVITY OF PHOTOGRAPHIC MATERIALS

Because photographs look so good, people tend to assume that they will remain in the same state forever. Unfortunately, even carefully made images begin to deteriorate as soon as they are produced. Color photographs are composed of organic dyes, and, like all such pigments, they are subject to discoloration and fading by the action of a number of agents such as ultraviolet light, heat, moisture, and a wide variety of virtually unavoidable chemical pollutants. Black-and-white images are inherently more stable because they are composed of durable metallic silver, but even this seemingly permanent medium is vulnerable in several different ways.

The first consideration for ensuring the maximum life for photographs is proper processing. If black-and-white images are to be preserved over time they must be archivally processed, which involves an extra chemical bath, called Hypo-clear, that converts image-degrading by-products into more readily water-soluble forms that are then flushed away with clean running water. It is unlikely that commercial labs will take this kind of care unless special arrangements are made. Some fastidious fine-art photographers typically maintain archival standards, so the perfectionists among you could consider seeking out such people and enlisting their services to handle those black-and-white materials that must be protected for posterity. Life expectancy for commercially processed black-and-white materials might be twenty years, while archivally processed black-and-white materials that are stored in acid-free sleeves away from light will last two hundred or more years in pristine condition.

Unfortunately there are no special archival processes that will extend the life of color materials, so the only recourse for the preservation of important images past five or ten years is careful storage under controlled conditions. Films and prints will rapidly deteriorate (within one to five years) when exposed to light. Ultraviolet radiation from the sun or from fluorescent or mercury-vapor lamps is particularly damaging. Proper storage requires the use of acid-free archival sleeves, hermetically sealed plastic wrapping, and refrigeration. The main factor in image longevity is very low relative humidity.

POINT OF VIEW

POINT OF VIEW AS PSYCHO-OPTICAL EXERCISE I discussed in chapters 3 and 6 some of the implications of lens selection and point of view in image design. Now let us examine in more detail how and why a particular point of view is chosen to fit a preconceived aesthetic intention.

In photographic terms, point of view is a physical position from which something is considered, evaluated, and visually experienced. An asymmetrical three-dimensional object looks different from almost every different point of view. The same object looks different in a two-dimensional photo made from a particular point of view than it looks to the human eye from that same position. Human nature determines that we react to photographs emotionally, as well as rationally, so a variety of photographs—made from a variety of points of view—feel different, as well as look different. Each carries emotional implications: We look up in awe, down in disdain, directly level in equanimity. We can be critically close or dispassionately far. It is a psycho-optical, multidimensional chess game. Photographic point of view, therefore, is a point in physical space relative to the objects we record, but also a point in emotional space. Photography is a subtle business because we use physical tools to merge physical space and emotional space.

Selecting a point of view is one of the first and most powerful choices in the process of creating a photograph. Making the choice involves balancing physical reality with emotional insight and aesthetic principals. In the city we do not have an infinite range of shooting positions, but we certainly have many—a practical point of view can be found on the street, up a ladder, on a fire escape or a rooftop, at a window, or even aboard a hovering helicopter.

TRADITIONAL AND UNTRADITIONAL POINTS OF VIEW Much architectural work is done with the camera positioned at eye level, a very general condition that to most people simply means a point of view that somehow appears natural. There are, in fact, quite a range of eye levels; the two most common are associated with standing and sitting. Building designers incorporate other eye levels into their work—the view from an elevated walkway through an atrium, for example. Some photographic impact can be achieved by working against the expectations normally associated with natural points of view by shooting from very close to the ground or shooting from high up. Such choices can result in images that have a playful, spontaneous feel, but they can just as easily be awkward, or sinister, or just plain goofy.

Some magazines are publishing architectural photography that has a gritty, documentary feel, not unlike the edgy camera work that can be seen in some current movies and television. The main determinant of this style is a slight misalignment—that is, a point of view that is a little tilted and/or a little higher or lower than normal and/or a little or a lot undercorrected for perspective distortion. Add some blur from camera movement, and high speed film for grain, and the possibility exists to make a statement in a visual language that is perceived as more contemporary than that associated with absolute technical perfection. Good taste is the governing factor, but it pays to discuss the application of unorthodox techniques with your clients beforehand.

PREVISUALIZING WITH THE ARCHITECT Time and energy can be saved if the point of view can be partly played out first in one's head, rather than by racing around trying to find a physical location through trial and error. In the case of architectural photography, photographic previsualization is an entirely mental process that involves imagining how the building or space looks from different points of view, during different times of the day or of the year, or under different sorts of artificial illumination. Previsualization is an economical exercise, so architects should be willing to assist photographers by providing and discussing drawings, renderings, and snapshots of the projects they want properly documented. Plans can be marked up by designers to indicate both desirable and undesirable points of view.

Proposed points of view should be confirmed by a walk-through. A format mask—a black card with a hole in it cut to the same proportions as the camera frame—is a simple tool that assists in fine-tuning point of view and lens selection on location. A wide-angle perspective can be simulated by holding the mask close to the face; a telephoto perspective can be achieved with the mask held farther away. A high-tech version of this device is called an "optical finder." Linhof makes a variety of exquisitely precise versions featuring zoom optics for use with their extensive line of medium- and large-format field cameras. These cost

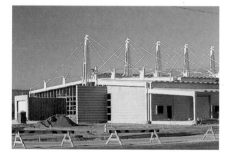
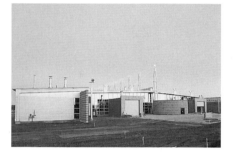

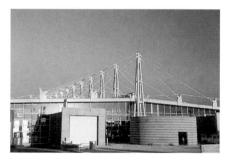

This series of 35mm images were made during the course of a day of hand-held, available-light shooting at IKOY Architect's Tank Maintenance Building at the Canadian Forces Base in Shilo, Manitoba. Camera: Canon EOS-1n, lenses: 24 and 35mm PC lenses, 28–105mm zoom, and 75–300mm zoom, film: Kodak EPP.

$200–$500 used, depending on vintage and condition. Many experienced photographers can make point-of-view judgments without such framing aids, but they will help photographically impaired clients to see what corrections are needed and possible, and what points of view are accessible or inaccessible.

Clamping devices can extend the range of usable camera locations to a surprising degree. My Vise-Grip pliers with tripod head attached (see photo on page 61) are regularly pressed into service to secure cameras to ladders, stairways, banisters, and other sufficiently robust structural elements. I also use nylon straps to steady camera/tripod combinations that have to be jammed into odd positions near railings, posts, parapets, vehicles, etc.

LENS SELECTION

AESTHETIC CONSIDERATIONS We survey the scene, make a judgment about point of view, assess the impact of physical obstructions, and finally find a spot to set up the camera. Which lens do we choose to make the picture? Chapter 10 will deal with the specifics of rigid body medium-format cameras, and Chapter 11 will address the specifics of adjustable medium- and large-format cameras, but the initial considerations of lens selection are common to all formats. We need to fill the frame by harmoniously balancing the subject of interest with background and foreground elements, while retaining an appropriate measure of control over horizontal and vertical parallel lines.

A camera position far away from the subject calls for long focal length lenses, making perspective control a relatively simple matter of aligning the camera and cropping judiciously. Shooting closer to the subject requires corrections that perhaps cannot be accommodated with ordinary lenses. Nevertheless, there is no question that relentlessly rectilinear alignment can get boring after a while. Many architectural photographs will benefit by the tasteful inclusion of subtly converging horizontal or vertical lines, a fact that extends the usefulness of rigid-body cameras.

BUYING THE RIGHT LENS If we set perspective control aside for the moment, lens selection becomes mainly a matter of choosing a focal length that offers a sufficiently wide angle of view to encompass the main subject and the desired foreground. This is easily done with zoom lenses, and only a little more complicated with a collection of fixed lenses.

There are certainly a lot of lenses on the market. All manufacturers of single lens reflex cameras offer many choices, and the main manufacturers—Canon, Nikon, and Minolta— offer two levels of quality: an expensive line intended for professional use and an economy

This photo shows a couple of classic 35mm rangefinder cameras; one of these Leica M4 cameras is fitted with a 90mm lens, while the other is fitted with an extreme wide-angle 21mm and accessory finder. Also pictured are 35mm, 50mm, and 135mm lenses and a Pentax digital spot meter. A few rolls of 35mm film are included for scale.

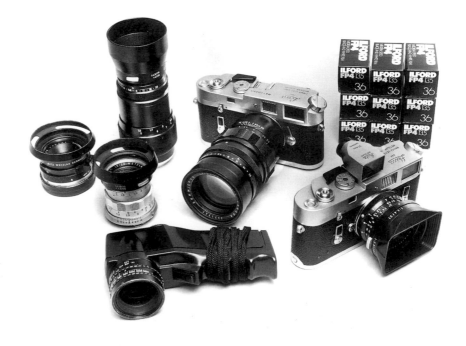

line. After-market suppliers like Sigma, Tamron, and Tokina provide a variety of high-, medium-, and low-end optics as well. Expensive lenses exhibit superior flare control and are generally faster and more mechanically refined than their cheaper counterparts, but optical performance is not necessarily a lot better, particularly for normal and long focal lengths used at smaller than maximum aperture. The wide-angle prime and zoom lenses on which architectural photographers depend are also available in a range of prices. A cheap wide-angle lens can be a good performer, but it is wise to shoot a test roll to check edge-to-edge sharpness and to rule out barrel and pincushion distortions.

Wider apertures and superior durability are desirable characteristics, but are they worth two to five times more cash? You will have to decide for yourself. I use 35mm only occasionally, but I have invested in professional-level camera bodies in order to access the full range of modern features like auto-focus, auto-bracketing, and sophisticated electronic flash control. However, I generally rely on the manufacturer's economy lenses in those instances where the optical performance and focal length and/or zoom range are comparable to the professional versions. For example, I quite happily rely on Canon's $400 f3.5–4.5, 28–105mm economy zoom rather than their professional "L" series f2.8, 28-70mm lens, which costs $1400 and is double the weight of its little brother. The cheaper lens performs well, and I simply do not shoot enough 35mm work to justify spending three times as much to obtain a more mechanically robust configuration.

DEDICATED PERSPECTIVE CONTROL LENSES

AVAILABLE HARDWARE Conventional fixed focal lenses and zoom lenses are easy to use and widely available, but for architectural photography precise alignment is a critical problem and perspective control lenses are required. I introduced PC lenses on pages 53–55 (note photo of PC lens on page 54), but I will elaborate here.

Nikon and Canon are the leaders in 35mm perspective control. Older Nikon 35mm and 28mm focal length PC lenses, distinguished by metal focusing rings, were first on the scene, but offered relatively poor performance outside of the central image area. The new Nikon PC lenses, with rubberized focusing rings, work better; they are sharper at the edges, with better coverage and wider movements. The sliding/rotating collar that provides the ability to be adjusted precludes an automatic diaphragm or auto-focus, so the lenses must be manually opened to maximum aperture for focusing, and then closed down for shooting. This operation is made easier by dual diaphragm adjusting rings—one ring is positioned by smartly locking clickstops to the required f-stop, while the second operates freely between the maximum opening and the preset minimum. This arrangement makes exact

Here is a 35mm PC-Nikkor lens fitted via custom adapter to a top-of-the-line Canon EOS-1 camera. In this illustration the lens is adjusted for maximum horizontal displacement.

IX

bracketing via f-stop a little awkward when the camera is not mounted on a tripod, but for most purposes the arrangement works well enough.

The 28mm f3.5 version exhibits more fall off (edge darkening) than the 35mm f2.8 model, so perfectionists may feel compelled to use a center-weighted graduated filter to compensate, particularly when extreme adjustments are required. Both lenses are relatively difficult to find second hand, but they do turn up occasionally. A used 35mm PC sells for approximately $500, while the 28mm PC can be had for $800–900.

Since the Nikon lenses are mechanically simple and since the Nikon lens mount is relatively narrow, both Nikon PC lenses can be adapted to fit Minolta and Canon camera bodies. This can be done by a shop that specializes in such work, such as Professional Camera Repair in New York City, (212) 382-0550, or, with a little effort, it can be done closer to home. A Minolta or Canon mount can be purchased for about $25 by special order through a camera retailer. The lens side of the new mount has to be carefully altered by a machine shop so that it can be fastened onto the back of the lens with the same screws that secured the original mount. The final thickness of the modified mount is critical, as this determines whether or not the lens will focus properly at infinity. I did my own measuring and then found a local machinist to make the modification for about $100.

Canon offers a range of PC lenses with very desirable characteristics. Three lenses are available: a 24mm f3.5, a 45mm f2.8, and a 90mm f2.8. All these lenses combine PC movements with adjustable tilt for focus control. (Focus control can be used to reduce depth of field for exaggerated narrow focus effects, or for enhancing depth of field to allow the use of larger apertures and faster shutter speeds.) The Canon PC lenses must be focused manually, but all offer autodiaphragm operation. They are priced new at approximately $1500 each. Since they were introduced only a few years ago, they are rarely seen on the used market. Optical performance for all three is outstanding. The 45mm and 90mm versions are very useful for shooting details and for overall views at a distance. The 24mm version is wonderfully suited for interiors and for tight situations outdoors; its range of adjustment exceeds that of the Nikon 28mm PC by about fifteen percent.

I have found the Canon 24mm PC lens and the Nikon 35mm PC lens to be the most useful combination for my wide-angle small-format architectural work.

PERSPECTIVE CONTROL ADAPTERS A versatile perspective control device is available from Horseman. The Horseman VCC (View Camera Converter) achieves lens shift as well as depth-of-field control by way of a very flexible bellows attached to a highly adjustable view camera–like front standard. As of 2001, adapters are available to fit the VCC to Canon, Nikon, Minolta, Contax, Olympus, Pentax, and Leica 35mm SLR cameras, as well as Hasselblad, Pentax, and Mamiya medium-format SLRs. Just like a typical view camera, the VCC front standard permits rise (14mm), fall (14mm), lateral shift (±30mm), plus swing (15° left/right), and tilt (15° forward/backward). This is a particularly flexible unit.

Zörk Film & Phototechnic of Munich, Germany, offers several very interesting products that also extend perspective and focus control to 35mm and medium-format cameras. The Zörk Pro Shift adapter can be used with enlarging lenses or view camera lenses. There are no bellows involved in its operation: A sliding plate provides ±20mm of shift and a very unusual swiveling ball arrangement allows the shift mechanism to rotate 360° and tilt up to 30°. Adapters are available for Mamiya, Pentax, Bronica, Rollei, and Hasselblad medium-format cameras and virtually all 35mm cameras.

The Zörk Panorama Shift adapter (PSA) for 35mm and medium-format cameras can produce up to 20mm shift when used with a variety of optics. The PSA rotates through 360°, with a click-stop every 30°, yielding shift capability in any direction. [Note: Zörk also offers a line of endoscopic lenses for use with its shift adapters. In medicine these lenses are employed to obtain interior views of body cavities or organs, but in combination with perspective control hardware they can be used to make focus and perspective controlled photographs right inside architectural models. This is, of course, a very specialized type of photography but it is useful to those architectural practitioners who build or commission highly detailed models for public display, presentations, marketing, or design development.]

The top image shows a Zörk shift adapter which permits the coupling of a Mamiya 50mm shift lens to a regular Hasselblad medium-format body. Below is the Zörk Panorama Shift adapter shown between a 35mm SLR camera body and a Mamiya 25mm wide-angle medium-format lens.
Image courtesy of Zörk Fototechnik.

PC PROTOCOLS One warning applies to the use of all retrofocus PC lenses with SLR cameras using BTL light meters: It is best to meter before shifting the lens. Most BTL meters work by reading the light projected on the camera's internal ground-glass focusing screen, but the focusing screen and the Fresnel lens associated with it are optimized for maximum brightness with the axis of the taking lens perfectly centered in the lens mount. When PC lenses are shifted for perspective adjustment, the viewfinders darken and light-meter readings become inaccurate.

Polarizing filters can cause exposure inaccuracies for similar reasons. Two types of polarizers are available: circular and linear. (These terms apply to optical rather than mechanical characteristics.) Circular polarizers are more compatible with BTL systems than linear polarizers; nevertheless, it is advisable to test your equipment when combining polarizers and PC lenses in order to learn exactly how shifting affects meter performance.

Precise perspective control requires that the camera be mounted on a tripod and carefully leveled. Some tripod heads have a bubble level built in, but no 35mm cameras do--the solution in this case is an accessory level that slips into the camera's accessory shoe. The high-end Minolta, Canon, and Nikon cameras accept interchangeable focusing screens, and all these manufacturers offer screens with etched grids that greatly facilitate lining up rectilinear architectural shots.

STYLISTIC CONSIDERATIONS IN 35MM WORK

OPTICAL CONSIDERATIONS Each lens behaves in a particular way, according to its own particular set of optical aberrations, and these behaviors engender specific and ardent enthusiasms. In all technology-dependent arts there are some exquisitely subtle criteria that artists use to distinguish one tool from another. Similarly priced lenses of different focal lengths purchased from the same manufacturer can reasonably be expected to exhibit similar attributes such as resolution, contrast, color transmission, response to non-image-forming light, and bokeh. ("Bokeh" is a Japanese word that refers to the surprisingly wide range of aesthetic properties associated with out-of-focus images. For example, small out-of-focus highlights are rendered by some lenses, such as the famous Lietz Summicron series, as soft-edged circles, by others, such as older Schneider Xenotars, as symmetrical teardrops, and by others, such as the otherwise exquisite Zeiss Planars, as multisided geometric forms.)

How to determine the various properties of lenses is the subject of much debate. Scientific people rely on several tests, including optical bench analyses with a special calibrating device called a collimator, as well as direct measurement of high-resolution negatives produced by photographing standardized test targets. A fairly good reading of sharpness, contrast, color transmission, image fall-off, and curvilinear (barrel or pincushion) distortion can be obtained simply by photographing a brick wall. For this test the camera should be aligned with the film plane parallel to the wall, and a series of exposures should be made at varying apertures. Repeat the test using a lens with which you are already familiar, and compare the two sets of images carefully. In addition, close examination of a series of comparative images featuring more general subjects will provide further insight. A high-resolution slide film, such as Fuji Velvia, is a suitable medium. Use a good, sharp loupe when looking at the results.

35MM AERIAL PHOTOGRAPHY In making stylistic choices one must assess the significant variables and select a technical approach that best suits the project at hand. Small-format equipment is of course easy to operate, lightweight, and compact, which, on a simple mechanical basis, extends the range of possible points of view considerably. In fact, there is one circumstance in which I always chose 35mm because of its mechanical flexibility in relation to point of view: aerial photography.

Time and space are limited inside an aircraft, so small cameras are much appreciated. Since vibration and movement diminish sharpness, the lens aperture must be set wide open to permit the fastest shutter speed possible, and fast 35mm lenses permit very fast shutter speeds. Since shooting from an aircraft means that the camera and the subject are always separated by a photographically significant distance, focus can be fixed at infinity—I use masking tape for this purpose—and perspective control is not an issue. Since sharpens and color saturation are important when shooting through atmospheric haze, I

prefer to use a high-resolution/high-contrast film like Fuji Velvia, but Velvia is slow (officially ISO 50, but practically ISO 40), so, again, fast lenses are an asset. Finally, automatic exposure bracketing, a high-speed motorized film advance, and microprocessor-controlled image stabilization (available in the Canon 75–300mm f4–5.6 USM IS zoom) further reduce response time to the quickly changing vistas below. I have experimented with medium- and large-format cameras in the air, but the results do not warrant the extra effort and expense.

FILM AND FEELING Because the 35mm format is so tiny, the technical peculiarities of film become stylistic variables as well. Every film exhibits a particular palette: some Ektachromes are cool and brash, some Fujichromes are warm and lush, some Agfachromes are neutral and precise. Color shift between highlights and shadows, reciprocity characteristics, and reaction to mixed lighting are all significant variables. So is the relationship between speed, grain, contrast, and resolution. Processing controls extend one's choices even further (*see Chapter 16*).

The fastidious professional and the committed artist will thoroughly test new materials and processing techniques before any critical work is undertaken. Because film choice so profoundly affects the appearance of the finished work, it is professionally prudent and practical to show test results in the form of sample photographs before undertaking an assignment; doing so establishes reasonable expectations for the client, and better working conditions for you. (*See page 63 for a selection of films I use regularly.*)

THE ULTIMATE TRADE-OFF Careful work with the right film coupled with a substantial investment in PC and ultra-wide-angle lenses will reduce one's stylistic restrictions while preserving the economy and ease of operations that make 35mm so appealing, but the same investment in medium- or large-format equipment will expand one's stylistic choices even further while reducing ease of operation and increasing costs. A professional photographer has no choice—one must have access to several formats in order to fulfill the expectations of a variety of clients.

WHY MEDIUM FORMAT?

I own one 35mm camera system and one 4x5in camera system, but I own—and use regularly—three different medium-format systems. This will indicate just how valuable big images are to the working professional. It is odd to consider, however, that the rising prominence of the medium format is largely propelled by the negative aspects of other formats: small-format systems are economical to operate but they lack many technical features that architectural photographers need, while large-format systems provide supreme technical control but are slow, heavy, and very expensive to operate. For those interested in quality architectural photography, the selection of a medium-format system is something of a forced compromise, a consequence of having to balance cost against quality, convenience against control, accessibility against versatility.

The world of the medium format is exploding with innovation: new films, cameras, optics, and accessories are announced regularly, and each refinement makes the medium-format compromise that much more respectable. In fact, when conditions warrant—for fully eighty percent of my assignments—I reach for medium-format hardware with a smile on my face.

MEDIUM-FORMAT SINGLE LENS REFLEX CAMERAS

INTRODUCTION This chapter deals with rigid body medium-format cameras, of which there are two main types: single lens reflex designs and non-reflex cameras. (Adjustable-body medium-format cameras and special purpose medium-format cameras will be addressed in chapters 11 and 12.)

All 35mm SLR cameras are essentially variations of one mechanical design, while medium-format SLR's range from elephantine 35mm look-alikes to exotic hybrids that weld space-age electronics to view-camera flexibility. All the variations have one thing in common: medium-format SLR's are intended to bring a measure of small-format convenience and flexibility to the making of larger negatives and transparencies. Toward that end each system provides, in varying degrees of sophistication, most or all of the following features: a comprehensive range of lenses (including extreme wide-angle lenses and a moderate wide-angle PC lens), interchangeable film backs or inserts, Polaroid capability, interchangeable viewfinders and ground-glass screens, autoexposure, electronically controlled shutter, and motor drive.

6X4.5CM AND 6X6CM SYSTEMS All current SLR's that produce 6x4.5cm (known as "645") or 6x6cm images are designed around a cube-shaped body that houses a lens mount, a reflex mirror, and a ground-glass screen and its associated Fresnel lens, as well as a complex gear train that links reflex mirror action, shutter cocking and firing, autodiaphragm, and film advance. The basic box is engineered to accept a film back or insert, a viewfinder, an array of lenses, and a manual advance crank and/or a motor drive.

Choosing between systems involves examining the pros and cons of specific manifestations of the various features and making a judgment as to which will work best for you. I have owned a number of different cameras of this type, but have settled on the Mamiya 645 as my workhorse. Here is why.

The first consideration was system weight—645 systems are significantly smaller than 6x6cm systems. Square-format cameras like the Hasselblads and the Bronica SQ-Ai are definitely quality machines supported by a wide range of accessories, but they are big and bulky and somewhat wasteful of film, since most commercial images end up as rectangles. It is, of course, extremely convenient to shoot both vertical and horizontal images without having to rotate a 6x6cm camera, but I was willing to give this up in favor of something lighter and more compact.

Current contenders in the 645 SLR world are the Bronica ETRSi, the Pentax 645, and the Mamiya Pro 645 that I favor. Bronica cameras are well made, but I find bracketing awkward because the aperture settings on Bronica lenses are strangely stiff. I also find the motor-drive grip to be too small and oddly shaped, which leads to discomfort and fatigue during a long day of shooting. Finally, the Bronica is noticeably heavier than the Mamiya.

The Pentax 645 is a tidy, exquisitely engineered device, with well-placed, easy-to-use controls and a very handy range of features and accessories. It is my runaway favorite, and I would be using this system now except for the fact that it lacks interchangeable film backs

and Polaroid capability, both of which are crucial for my work.

So I own Mamiya, and I am quite happy with it. It is fast to operate, easy to hold and adjust, and Polaroid ready. The older series C lenses were of very poor quality, but the new N series lenses are undeniably terrific. Used Mamiya equipment is widely available and costs item for item about half of what comparable Hasselblad equipment does. Mamiya equipment breaks a little more frequently than the Hasselblad stuff I used to own, but not often enough to make me worry. When I switched unannounced from Hasselblad to Mamiya, not one client noticed the change.

Anyone who finds the convenience and the specific aesthetic associated with the square image irresistibly appealing, and who is willing to pay the premium in weight and price, will certainly be able to exact a very high level of performance from the very reliable 6x6cm equipment. Most professionals consider the 6x6cm Hasselblad to be the classic medium-format SLR, and indeed this system has been vigorously and productively employed by so many for so long that its softly curved, almost art deco, chrome embellishments are instantly recognizable to generations of still photographers. The features and functionality of the fundamental design have been refined and extended many times over several decades, yet today's Hasselblads retain an impressive degree of backward compatibility with system lenses, backs, viewfinders, and accessories of years past.

The Bronica SQ-AI system is the only Japanese competitor to the Hasselblad. These cameras, lenses, and accessories—priced 25–50% less than the comparable Swedish products, item for item—are also very strong performers, though the Hasselblad provides perspective control options (discussed later in this chapter) that Bronica cannot match. Both systems offer an extensive range of lenses, lens shades, viewfinders, and backs (including Polaroid), as well as motordrive and autoexpose capability. Twelve exposures per roll is universal to the 6x6cm format.

6X7CM SLR SYSTEMS These big bruisers position the rectangular 6x7cm frame lengthwise on the film to obtain ten images per roll, as opposed to the fifteen frames that their 6x4.5cm little brothers produce. The 6x7cm format is close in proportion to the standard photographic 8x10in size and the regular 8x11in paper size, so absolute maximum image quality is achievable on roll film with very minimal cropping, but at a cost in weight and bulk.

Unique among the 6x7's is the Pentax 6x7cm, which looks like a 35mm SLR on steroids. Despite its bulk—it is approximately double the size of a 35mm—the camera handles much

These photos are typical of what is possible with a rigid body medium-format camera. In each image a balance was struck between appealing composition and perspective control. Some cropping is required to eliminated large areas of ceiling and floor, sky or foreground that were included in the frame when the camera was leveled in order to preserve vertical alignment. The view on the bottom right uses slight convergence of vertical lines as a design device. These shots were made as illustrations for a brochure for a small hotel. Camera: Mamiya 645, lenses: 35mm, 45mm, and 55mm, film: Kodak EPP; both images on the left were supplemented with electronic flash.

124

These are the first auto-focus medium-format camers, the Fuji 645 and 645W. Sporting, respectively, fixed 60mm and 45mm lenses, these machines are precise, compact, and thoroughly modern. Both have built-in auto-flash, auto-exposure capability, automatic film advance, automatic balanced fill flash, and electronic exposure data along the film edge. Image courtesy of Fuji Photo Film Company.

Here are the normal and wide-angle versions of the Fuji non-reflex medium-format cameras, the GW670III and the GSW690III. The GW670 produces 6x7cm images with its fixed 65mm lens. Both cameras share a number of handy features, including one-touch spool loading, two shutter buttons, hot shoe for electronic flash, shutter lock, rubberized body grip, built-in level, super accurate double-image rangefinder focusing, and both 120 and 220 film capability. Images courtesy of Fuji Photo Film Company.

the same as its diminutive antecedents. This system is well built and has a lot of fine lenses to go with it, but I am reluctant to recommend it because, like the Pentax 645, it lacks interchangeable backs and Polaroid capability. (Pentax, are you listening?)

The Bronica GS-I 6x7cm is a more refined version of its 645 sibling, but bigger and heavier. This is good equipment, but if you have to have 6x7cm images I would take a close look at the Mamiya RB67 and RZ67. These two cameras share two features that make them very desirable: rotating film backs and bellows focusing. Rotating film backs are endearingly convenient, since they allow vertical and horizontal flaming without rotating the camera. Bellows focusing allows very small subjects to be shot without close-up lenses or extension rings, which is handy for shooting small subjects like architectural models or drawings. The RZ—my favorite of the two—is a sleek electronic revamp of the RB, which has been a reliable industry workhorse for many years.

THE FUJI GX680II This very expensive, underadvertised camera is in a class by itself, not only because it sports an oddball format—6x8cm—but because it is the only medium-format SLR that offers some view-camera-type movements. I will discuss this feature thoroughly in the next chapter, but I mention it now because this ability to be adjusted is the reason why I own a GX680II system, as opposed to one of the excellent 6x7cm cameras mentioned above.

NON-REFLEX MEDIUM-FORMAT CAMERAS

INTRODUCTION In the same way that medium-format SLR's are a homage to 35mm SLR systems, non-reflex medium-format cameras are modeled after the classic 35mm rangefinders—essentially a sleek, brick-shaped body with a split-image range/viewfinder in one corner and a lens in a helical focusing mount fixed to the middle. The goal of the non-reflex medium-format camera is to pare down the mechanical shell and create a lean, mean machine capable of exquisite performance without all the noisy hardware associated with SLR's. At about $1200 new each, these cameras are good values for those who want to point and shoot at a very high level.

High-end non-reflex cameras are wonderfully precise and compact picture-making machines, so many professionals use them simply because they are easier than SLR cameras to pack and carry on assignment. Some shooters choose these cameras because split-image optical rangefinders make focusing into a quantitative yes or no operation as opposed to the rather qualitative is it or isn't it business typical with ground-glass focusing. Of less concern to architectural photographers is the absence of finder blackout at the exact moment of exposure, which is characteristic of reflex viewing systems.

AVAILABLE CAMERAS Fuji makes several 6x4.5cm and 6x9cm rangefinder cameras with non-interchangeable normal or wide-angle lenses—and these machines look like beefed-up Leicas. The Fuji GA645 (with 60mm lens) and the GA645W (with 45mm lens) come with autofocus and other 35mm-like features, such as auto-exposure and power advance. There are some even more compact Fuji medium-format fixed-lens folding cameras. A little digging will turn up some excellent machines of similar design that are no longer manufactured. Perhaps the best examples are the Plaubel Makina 6x7cm and its still very useful ancestor, the Zeiss Ikon Super Ikonta C, both of which are wonders of compact engineering available for about $1500 used.

The most fully realized non-SLR system is the Mamiya 7, a 6x7cm rangefinder with interchangeable lenses. This camera has a long list of very modern bells and whistles: an auto-indexing brightline parallax-corrected viewfinder (a non-reflex optical viewfinder that uses lighter—that is, brighter—frame lines to show the image area) that matches up with near-perfect 65mm, 80mm, and 150mm lenses; a fantastic 43mm extreme wide-angle lens; auto or manual exposure control; and flash synch at all shutter speeds. The whole system—a steal at $8000, plus $900 for a Polaroid back—takes up less space and weighs less then a 35mm SLR with the equivalent lenses and accessories. Also available is the Mamiya 6, the 6x6cm predecessor of the 7.

There are a surprising number of non-SLR medium-format cameras that are designed specifically for wide-angle and panoramic use. These will be discussed in Chapter 12.

FIXED FOCAL LENGTH LENSES The ubiquitous 35mm SLR does not lack for lenses. Camera manufacturers themselves typically offer both a professional and an amateur line, and these are generously supplemented with a wide choice of after-market optics, many of which are made to professional standards. This is not the case for the medium-format SLR, simply because the smaller market cannot support so many choices. Consequently, we are dependent on each manufacturer to supply sufficient lenses to make their systems useful. Happily, in recent years virtually every maker has expanded and upgraded its system's lenses to the point that quality, availability, and durability are not the issues they were even a decade ago. This is bad news perhaps for Hasselblad and Rollei, still considered by many to be the absolute leaders in optical quality and precision manufacturing, but good news for budget-minded photographers.

Of particular interest to architectural shooters are extreme wide-angle lenses, and it is encouraging to see that these indispensable tools are available, in recently updated incarnations, from every medium-format SLR maker. I make regular use of the superb 35mm wideangle (equivalent to a 20mm on a 35mm camera) that Mamiya provides for the 645 system, but I can chose a 45mm or a 55mm as well.

Range-finder cameras are not so well served. They are available with moderate wide-angle lenses only, the exception being the glorious Mamiya 7. This camera can be fitted with a well-corrected 43mm, the widest, and I believe the best, rectilinear extreme wide-angle lens available for any 6x7cm interchangeable lens medium-format camera.

ZOOMS Sadly absent from the roll-film universe are extreme-to-moderate wide-angle zoom lenses. These flexible creatures make 35mm SLR's into seductive speed demons, invaluable for rapid-fire test shooting during site inspections and walk-throughs. If such lenses were available in medium format a lot of eminently publishable photography could be produced at similar speeds. Only less useful moderate wide-angle-to-short-telephoto zooms are available, so we must stand and wait. To those innovative lens makers out there I say, on behalf of architectural photographers everywhere, get to work!

PERSPECTIVE CONTROL LENSES If you look hard enough you can find a moderate wide-angle PC lens for almost every medium-format SLR except the Pentax 645. A 50mm PC for the Mamiya 645 is available new at about $1400; a 75mm PC is available for the Pentax 6x7cm for around $2000 and for the Mamiya RZ67 and RB67 at about $3000. Used PC lenses are scarce and generally priced at about a third less than new. A 55mm Schneider PC was made at one time for the Bronica 645 camera and for the Hasselblad; either one of these lenses would be quite a rare find for aficionados of those systems.

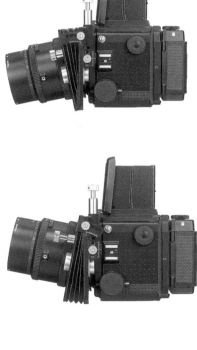

PERSPECTIVE CONTROL ADAPTERS The PC-Mutar 1.4X Shift Converter is available for those already invested in the Hasselblad system who want a somewhat more economical measure of perspective control. The Mutar uses a precisely controlled sliding-plate system to achieve ±16 mm vertical shift capability for regular Hasselblad lenses from 40 to 100 mm focal length. The device is optimized for use with the Distagon f4 40mm lens, the widest interchangeable rectilinear lens in the product line, which becomes an effective f5.6 56mm PC lens when mounted. Image quality is superb even at full aperture. (Since vertical shift facility requires mechanical separation of the camera and the shutter, the shutter must be separately cocked and then released synchronously with the camera using a twin cable release.)

Another versatile perspective control adapter is offered by Mamiya for use with their RZ67 medium-format camera. The Mamiya RZ Tilt/Shift adapter accepts all Mamiya RZ lenses. Based upon a bellows mechanism and incorporating an electronic data bus, the adapter maintains all normal lens functions while adding control of perspective and depth of field with view camera–like tilt and shift movements. Because of the extra separation that it introduces between lens and film plane, the RZ Tilt/Shift Adapter will not focus at infinity with the wider-angle lenses. Two special lenses are available for infinity focus: 75mm f/4.5 Short Barrel and 180mm f/4.5 Short Barrel. Focusing at a maximum distance of 10 feet is possible with regular Mamiya lenses 180mm or longer. The adapter works well with wide lenses at the very close working distances encountered when shooting architectural models.

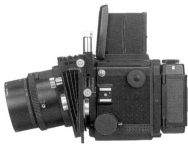

These three images demonstrate the movements the Mamiya RZ Tilt/Shift adapter is capable of. Images courtesy of Mamiya USA.

STYLISTIC CONSIDERATIONS Most of my comments in Chapter 9 about working style and applications for 35mm SLR cameras apply, with a few reservations and additions, to medium-format SLR cameras—surely a testimonial for the good work undertaken by the developers of the sophisticated roll-film systems now available.

Motor drives that function at only one or two frames per second (as opposed to ten frames per second) plus the lack of autobracketing, autofocus, and extreme wide-angle zooms make medium-format cameras considerably slower to operate than nimble 35's. But compared to any view camera, they are pocket rockets.

One modest technical feature makes several of the medium-format cameras even more useful in tight spaces than most 35mm cameras—full-frame waist-level finders. The term is a little misleading, since it applies to any viewfinder configuration that allows one to view the reflex image by looking into the top of the body, rather than from behind. This simple trick means that one can easily focus a camera that is literally backed against a wall or tucked deeply into a corner or clamped upside down to a ceiling. In fact any of a number of otherwise impossible physical circumstances will yield useful new points of view.

AN INTERESTING HYBRID The Hasselblad XPAN, a joint effort with Fuji of Japan, is a unique dual-format 35mm camera and not at all like the medium-format machines that made Hasselblad justifiably famous. In normal mode it is a precision Leica-like rangefinder compact that produces regular 24x36mm images. In panorama mode, available mid-roll at the flick of a switch, the film gate changes to an astonishing 24mmx65mm. Although this camera lacks perspective control, it does have interchangeable lenses, including a new ultra-wide 30mm aspheric (which comes with its own center-graduated neutral density filter), making it particularly useful for low, wide buildings outdoors and broad interiors views indoors.

XI ADJUSTABLE MEDIUM- AND LARGE-FORMAT CAMERAS

IMAGE VIEWING

THE ART AND SCIENCE OF "VIEWFINDING" I do not think there is a word in the dictionary that describes the collection of optomechanical operations associated with framing and focusing a camera, but "viewfinding" would be an appropriate term. Viewfinding is a critical task for any photographer, but it is especially challenging for those of us who depend on adjustable cameras.

An adjustable camera permits alteration of the physical alignment between lens and film plane, a procedure that, as we have seen, adds a significant measure of image control, but also impairs viewfinding. There are only three ways to visually predetermine what any given set of adjustments are doing to an image: a video monitor, a Polaroid test, or careful analysis of a ground-glass image. A video monitor—not a particularly precise instrument—requires a computer and a digital camera or a digital back attached to a conventional camera, so its usefulness is limited. Most adjustable cameras will accept an instant film adapter, but even a 4x5in Polaroid print, due to its inherent lack of resolution, yields only an approximation of the final image. A Polaroid negative made with Type 55 or Type 665 material will provide considerably more image data, but only when examined with a loupe; Polaroid negatives are wet with caustic chemicals when they are first peeled apart, so this option is profoundly awkward, at best. It would seem that those of us who want to maximize the potential of adjustable cameras, just like the photographers who strained and squinted under a dark cloth one hundred and fifty years ago, are required to spend much of our time staring at a fragment of ground glass. (Not all adjustable cameras have ground-glass focusing. Special-purpose wide-angle and panoramic cameras that use coupled optical finders will be discussed in the next chapter.)

BEATTIE SYSTEMS TO THE RESCUE A ground-glass screen remains the universal viewfinding instrument because it works reasonably well, particularly when used under ample illumination and in conjunction with a magnifier of some sort. Unfortunately, the practicality of ground-glass focusing is limited by image brightness, a severe technical constraint for architectural photographers who must work in dim conditions with wide-angle lenses.

Happily, there is a modern tool that makes life under the dark cloth much easier: the Beattie IntenScreen Plus. This device is made of plastic rather than glass. The image-forming surface is created with a sophisticated computer-controlled laser rather than by etching glass with caustic chemicals, so its optical properties can be exquisitely controlled. The result is a viewfinding screen that is up to four stops brighter than a conventional ground glass; this can mean the difference between a job that is nearly impossible to do and one that is almost easy to do. I am hopelessly and utterly dependent on the Beattie screens I have fitted to all my adjustable cameras. You can contact Beattie Systems at (800) 251-6333.

Virtually any camera that uses a conventional ground-glass screen will accept a Beattie screen. One warning: I was forced to adapt one to my 4x5in Linhof Technikardan on my own because the Linhof technician who normally services the camera refused to do it. He feels that plastic screens are not sufficiently rigid to maintain perfect flatness, a requirement for accurate focusing, and he is not entirely alone in this belief. My own testing and experience prove him wrong, but I periodically check focusing accuracy against a glass screen, just to make sure.

CAMERA TYPES

INTRODUCTION There are a few single lens reflex medium-format cameras that are somewhat adjustable.

Next in line are the combat-hardened children of the monorail, the metal or wooden collapsible field cameras. Offered as a practical, compact alternate by many of the manufacturers of monorail systems, these cameras also are available in a wide range of prices and mechanical sophistication.

Finally, the monorail view camera represents the ultimate in ability to be adjusted, just as it did a century ago. Today there are several committed manufacturers and literally dozens of such cameras from which to choose. Prices range from a couple of hundred dollars to many thousands. At the low end are simple wooden kits and very basic metal factory-made

units, and at the high end are a few technological marvels that brilliantly exploit the most modern achievements in metallurgy, fiber-reinforced plastics, and computer-aided design and manufacturing techniques.

I own three high-end adjustable cameras, one from each category. Here are my choices.

SINGLE LENS REFLEX CAMERA—FUJI GX680II The previous chapter describes how several medium-format SLR manufacturers have tried in various ways to incorporate a measure of adjustment into their equipment. Of these only Hasselblad and Fuji offer a system-wide approach.

For all Hasselblad lenses the 1.4X Mutar Shift Converter provides a measure of perspective control while extending focal length by a factor of 1.4 and reducing maximum aperture by one stop. This effectively makes the 40mm f4 Distagon extreme wide-angle lens into an 56mm F5.6 moderate wide-angle PC lens—not extraordinarily useful for tight situations. The Hasselblad Flex-Body adapter ($2500) is a mechanically brilliant but bizarre accessory that turns a variety of combinations of Hasselblad lenses, viewfinders, and backs into a small, inconvenient view camera. To my mind, neither of these solutions is at all practical for serious architectural work.

The Fuji GX680II is a 6x8cm reflex camera that features a bellows-focusing front standard with a useful degree of rise, fall, shift, swing, and tilt and a range of microprocessor-

This detail taken from within a few feet of a skylight used a telephoto lens for magnification. The camera movements were set to minimize depth of field and thus direct the viewer's attention more authoritatively to the sharply rendered connector sphere located in the lower third of the frame. This locating effect was subtly enhanced with a .6ND grad, used to slightly darken the upper third of the frame.
Camera: Fuji GX680II, lens: 259mm (telephoto), film: Kodak Ektachrome EPP.

The Fuji GX680II with 50mm extreme wide-angle lens, angle viewfinder, and roll film back looms over the Linhof Super Technika 23, with 47mm Super Angulon extreme wide-angle lens, and reflex viewer. Plainly visible on the top of the Linhof is the cutaway that allows extreme front rise with wide angle lenses. The rangefinder has been removed from the right side of the camera, and an extra tripod socket has been mounted in its place.

130

controlled leaf-shutter lenses from 50mm extreme wide-angle to 300mm moderate telephoto. These features by themselves are enough to make the GX680II a desirable system, but there is much more. Here are four additional features that make this camera even more useful for architectural work:

1. Interchangeable screens—Beattie makes a very bright screen with an etched grid for this camera, and it works wonderfully. Even very convoluted contortions with the 50mm lens can be easily monitored through the viewfinder.

2. Interchangeable finders—a light, bright porroflex angled finder (a porroflex design uses carefully positioned front-surface mirrors, instead of a heavy, solid glass prism, to project a right-side-up image to the viewfinder), collapsible waist-level finder, fixed waist-level finder with adjustable magnifier, or an auto-exposure finder.

3. Rotating film backs—120 (9 exposure) or 220 (18 exposure) 6x8cm backs, 10 exposure 6x7cm back, and Polaroid back.

4. Interchangeable bellows—normal, wide-angle, and extended wide-angle bellows.
All this works together to give the Fuji its one great advantage—it is fast—and its one great disadvantage—it is heavy. Still, a comprehensive system easily fits into a conventional soft case, which in turn sits easily on a collapsible two-wheel dolly.

I bought a used Fuji GX680II (the latest model) with 65mm, 135mm, and 250mm lenses and two 120 backs for $5000. I have added a new 50mm lens ($2750), a new wide-angle bag bellows ($100), a used 100mm lens ($750), a used 220 back ($500), a new angle finder ($500), and a new Polaroid back ($400). The system is a joy to use and it has paid for itself in less than a year. (See Chapter 13 for a survey of a photo shoot using my GX680II.)

FIELD CAMERA—LINHOF SUPER TECHNIKA 23 A tremendous number of shooters regard 4x5in Linhof Technikas as the penultimate expression of field-camera technology, and I have to agree. This sort of respect has to be earned, and Linhof, an old German firm that is profoundly committed to extremely high optical and mechanical standards, certainly deserves all the goodwill its products have accumulated over the years.

The 4x5in Linhof Technika is a beautifully conceived and beautifully fabricated metal folding camera that features an extendible bed; an enormous range of interchangeable lenses with coupled rangefinder focusing; a rotating back that swings and tilts and accepts 6x7in and 6x9in roll film, 4x5in sheet film, and Polaroid film; as well as a front standard with rise,

fall, swing, tilt, and shift. A host of other accessories are available, including a reflex adapter for the ground-glass back, a special focusing adapter for extreme wide-angle lenses, and a sensational anatomically correct grip. This is a terrific machine, but, at approximately $5000 new for the most current version, it should be.

Although I have met a couple of architectural photographers who use 4x5in Technikas, I personally think that the advantages of a folding field camera are significantly attenuated in a body of this size (8x7x4in, folded) and weight (6.5lbs). To my mind the baby Linhof, or, as it is officially called, the Linhof Super Technika 23 (for 2x3in), is a much more attractive incarnation at 7x5x3in and 4lbs, especially considering that all its accessories are similarly downsized. The smaller camera faithfully preserves all the features of the 4x5in version, except for front swing, the degree of front fall (for which I have developed a modification), and the price: the most current version of this camera is $7000. Pretty shocking, I know, but there is a feverish trade in used Linhof equipment, and a perfectly serviceable ten- or fifteen-year-old unit can be had for $1000 or less.

My current Linhof 23 kit includes a body, two Super Rollex 6x7in 120 backs, one Super Rollex 6x9in 120 back, a Polaroid back, a reflex finder/magnifier, and 47mm, 58mm, 75mm, 150mm, and 270mm lenses. All of this fits into a case that is about the same size and weight as my 35mm outfit.

Linhof field cameras are very rigid metal boxes with hinged lids. The camera back is attached to the frame of the box with telescoping rods, about one inch in length, at each cor-

ner. Each rod can be locked at any point along its travel, thus allowing back swing and back tilt. The inside of the lid supports the telescoping metal rails that guide the front standard for focusing. The front standard can be released to slide all the way into the box, right up against the back, allowing the lid to fold up, clam-style, for transport.

The little Linhof will handle a surprising number of difficult jobs extremely well, particularly those that require moderate wide-angle through telephoto coverage. But the very compact, rigid system makes wide-angle work difficult because very short focal length lenses must be set deep into the box in order to focus, so some modifications are required to make the camera more useful with extreme wide-angle lenses. (Warning: Linhof purists should not read the following paragraphs.)

First, the top of the front standard bumps into the upper wall of the box before maximum front rise can be effected. But this is an important movement, perhaps the most useful in architectural photography since it allows the rectilinear imaging of tall buildings. To correct this problem I carried over a modification that Linhof itself made to remedy this problem on late-model 4x5in Technikas—on these cameras the manufacturer provides a lockable, hinged panel that can be easily flipped out of the way to allow unobstructed front rise. I modified my little Linhof by taking a similar bite out of its top panel. The basic box is a very strong, one-piece, aluminum alloy casting, so its integrity is not inordinately compromised by this modification. I now have more front rise than I can use.

What a difference two centimeters can make. Here are two otherwise identical images of Architectura's Royal Canadian Mounted Police detachment in North Vancouver, one made with a 6x7cm roll film back, and the other made with a 6x9cm roll film back. Even though I was backed right against a brick wall with my widest lens I could not obtain the framing I wanted until I remembered that I had packed a 6x9cm back for the Linhof. A quick switch, and a Polaroid test confirmed I could make the shot.

Camera: Linhof Super Technika 23, lens: 47mm (extreme wide-angle), film: Kodak Ektachrome EPP.

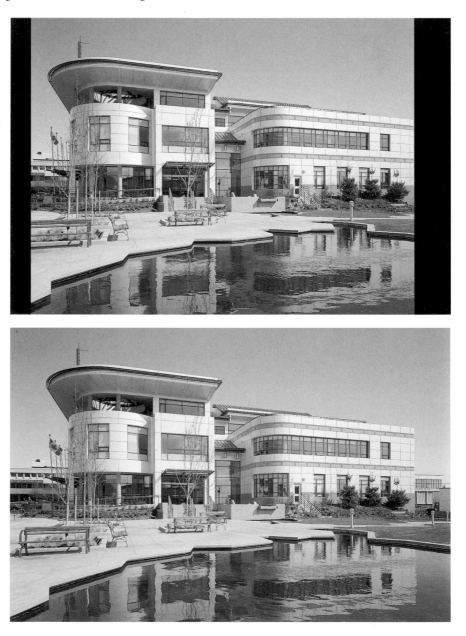

Linhof has only partially addressed a second problem. This has to do with focusing extreme wide-angle lenses. Such lenses mounted on a flat lens board must be positioned so close to the film plane when focused at infinity that the front standard comes off the back end of the focusing rails, which of course sabotages the fine rack-and-pinion vernier focusing action. Linhof supplies a recessed lens board for 65mm lenses, which permits the front standard to remain on the focusing rails, allowing normal focusing operation. But no lenses of less than 65mm focal length will work with this board. I found a local machinist who was able to modify the 65mm recessed boards to accommodate both the 58mm Super Angulon and the 47mm Super Angulon extreme wide-angle lenses. Used together with a specially adapted Beattie screen, these lenses and their special boards greatly extend the usefulness of the camera for architectural work.

A final wide-angle problem has to do with vertical fall, a useful movement that is required for interior work where the camera is situated near eye level, above the geometric center of the view being recorded. A radical solution is to mount the camera upside down so that front rise becomes front fall, but the contortions that would then be required to operate the controls make this less than appealing. My solution was to make another mechanical modification. Upon opening, the hinged folding lid is locked into position by two spring-loaded sliding steel brackets. All Linhof parts are over-engineered, and one of these brackets, in combination with the sturdy hinge, is more than strong enough to rigidly secure the lid and the focusing rails that are attached to it. This is important, since the brackets limit horizontal shift with short lenses. Removing the right bracket altogether greatly extends the range of shift in that direction, a useful feature in itself, but even more useful when the camera is tilted 90° so that sideways shift is transformed into vertical fall. This is an easy maneuver to achieve with all tripod heads, and it is a position that still allows unimpeded access to the controls.

The lure of the tiny Technika 23 for those jobs where portability is paramount is such that I have gone to some lengths to make focusing easier. I ordered a custom grid screen from Beattie ($240) and found a used rotating Linhof right-angle magnifying finder ($300). This setup does not come close to the easy efficiency of my Beattie-equipped Fuji GX680II, but it is, nevertheless, extremely usable. All these machinations might seem complex, but they make the baby Linhof, already a compact marvel, into a powerful tool for working in tight spaces.

A couple of very credible alternatives to the 4x5in Technikas are made by Toyo and Calumet/Horseman. At approximately $2000 new, these cameras are priced much more realistically than the patrician German machines after which they are modeled, and they certainly offer competitive features, though some might feel they lack a certain Teutonic cache.

MONORAIL CAMERA—LINHOF TECHNIKARDAN 45 Earlier in this book I examined the classic monorail view camera. Nothing else can match the degree of perspective and focus control that this configuration offers. There is no practical alternative to 4x5in when a technically difficult shot requires extreme corrections or when a client simply demands the highest-quality image possible. But architectural work by its very nature means location work, and lugging around a comprehensive monorail system—camera, accessories, lenses, tripod, cases, etc.—is a real chore. Several view-camera manufacturers have recognized the problems of large-format location work and have produced high-tech, ultra-compact, full-featured machines that make life a lot easier for the traveling photographic perfectionist. Of all the cameras belonging to this genre, the Linhof Technikardan 45S ($3750) is the smallest and, to my mind, the most elemental offering. When I decided to downsize my 4x5in kit, I bought a used Technikardan 45, the precursor to the 45S, for $2000.

This camera uses a telescoping, rectangular-section monorail, two L-shaped standards, and an interchangeable bellows to allow virtually unrestricted movements with lenses of 47mm through 480mm. An adapter is available that accepts the Technika 23 compact lens boards, so I can use the same lenses on both systems. The only convenience-related compromise is a nonrotating back; it must be removed and remounted in order to switch from horizontal to vertical framing (a fifteen-second operation). But this is not unreasonable for a package that folds up to book size (8x10x4in) and weighs only 6.6lbs. My Technikardan kit, with ample film and a Polaroid back included, weighs about 50% more than my Technika kit and occupies a case that is two inches deeper, three inches wider, and four inches longer.

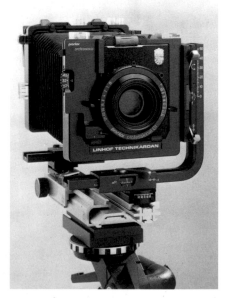

The Linhof Technikardan 45

SOME INNOVATIVE VARIATIONS Perspective control became quaintly available with the accidentally art-deco Hasselblad Flexbody and Arcbody. These appealingly miniaturized view cameras brought tilt and shift to the extensive medium-format Hasselblad system. They integrate quite well with the product line, accepting all existing Hasselblad rollfilm and Polaroid backs. The available movements are calibrated in millimeters and degrees for accuracy and repeatability, while ground-glass focusing is facilitated by a magnifier hood and a series of interchangeable fresnel inserts that ameliorate the light fall-off that occurs when lenses are positioned off axis. The Flexbody accepts the same lenses as the traditional rigid bodies, which makes it an attractive accessory for someone already committed to the Hasselblad system, while the Arcbody, which was designed for a wider range of movements—28mm vertical rise, as opposed to 14mm for the Flexbody—uses 35mm, 45mm, & 75mm Rodenstock APO Grandagon view-camera lenses mounted in shutters on proprietary lens boards. Camera operation for both units is somewhat unusual. Horizontal shift is achieved by turning the camera on its side and vertical fall by complete inversion. Their main advantage, aside from compatibility with the formidable Hasselblad system, is small size and sturdy construction.

The Arcbody was introduced in 1997 and was never widely accepted. Despite its rather endearing design, the Arcbody was discontinued in March 2001. It is available used. The Flexbody was introduced in 1995 and remains in production today, presumably because it permits the regular Hasselblad lenses to do double duty.

Obviously, among camera manufacturers, Hasselblad is not alone in the belief that there are lots of well-heeled perspective-control enthusiasts out there. Another Swiss manufacturer, ALPA, and the more widely known Japanese manufacturer Horseman offer finely made non-reflex cameras dedicated to just this kind of work. The Horseman SW612 PRO and the ALPA 12 S/WA are similar in construction in that they are beautifully crafted viewfinderless boxes that accept 120 or 220 rollfilm and a series of wide-angle lenses in adjustable, proprietary mounts.

Incorporating almost all the features I was seeking when I modified the Linhof Technica 23, as described earlier, the Horseman SW612 PRO offers both lateral shift and vertical rise and fall in a solid, user-friendly configuration. The body consists of three metal frames that move relative to each oter on tapered roller bearings. The front frame provides ±17mm vertical shift, while the rear frame shifts side-to-side ±15mm. Built-in fluid levels facilitate accurate alignment for all three axes. The camera accepts interchangeable lenses of 35, 45, 55, 65, 75 and 90mm focal length, all Rodenstock Grandagons in dedicated scale-focusing helical mounts. A very bright optical viewfinder adapts for the various lenses and formats via rotating, snap-on masks. 6x12cm, 6x7cm and 6x9cm rollfilm backs are available from Horseman, but any other Graflex-type backs can be used as well.

The ALPA 12 S/WA is somewhat less adjustable than the Horseman, but it is so well-built and so meticulously finished, that it is a real pleasure to hold and operate. It accepts interchangeable lenses and interchangeable film backs, both digital and Polaroid. Formats include 6x4.5, 6x6, 6x7, 6x8, 6x9, and 6x12cm. An extensive system of adapters makes it possible to use backs built by Hasselblad, Horseman, Mamiya, and Linhof, as well as several different types of focusing screens, and right-angle viewfinders. There are many lenses to choose from, including 35, 45, and 55mm Apo-Grandagons from Rodenstock, in addition to 38, 47, and 58mm Super Angulons from Schneider. Vertical shift to a maximum of 25mm is built into the system. Fall of 25mm is accomplished with the ALPA multifunctional attachment. There is no provision for lateral shift.

ALPA paid special attention to the optical finder. The device incorporates five multi-coated elements and provides a 120° angle of acceptance together with a built-in spirit level that is visible in the viewfinder. The eyepiece focuses ±2 dioptrines to adjust for individual variations in vision. Interchangeable transparent viewfinder masks are available for most focal lengths and formats. This is very possibly the best accessory finder presently available.

The top image shows the Hasselblad Arcbody together with two Rodagon lenses in dedicated mounts.
Below is the Hasselblad Flexbody, shown fitted with a regular Hasselblad system lens and roll film back. Note the rise and tilt capability. Image courtesy of Hasselblad USA

LENSES FOR VIEW CAMERAS

FINDING APPROPRIATE LENSES There are thousands of lenses available for view* camera use, and almost as many prices and levels of sophistication. Older uncoated or single-coated lenses can be had for $100 or less, but most of them will have limited coverage, low contrast, problems with internal flair, and low resolving power. The newest multicoated lenses can cost well over $1500, but coverage will be wide and the image will be sharp edge-to-edge.

Like the manufacturers of name brand lenses for 35mm cameras, the makers of view-camera lenses typically provide more than one line of products. Modern economy lenses will have slightly smaller image circles and one or two stops smaller maximum apertures, as compared to their more expensive siblings. Other optical properties, such as sharpness and contrast, also improve incrementally with price, but less dramatically.

The rightly famous Schneider Super Angulon illustrates this point well. Perhaps the most commonly used 4x5in wide-angle focal length is 90mm, approximately equivalent to a 28mm in small format. Schneider currently makes three different 90mm lenses, the economy model f8 version ($850) has an image circle of 216mm, the brighter f5.6 Super Angulon ($1400) has a 235mm image circle, while the f5.6 Super Angulon XL ($1600) covers an outstanding 259mm. Only 190mm is required to cover 4x5in film. The original Schneider 90mm lens, the 1940s vintage f6.8 Angulon, covered only 210mm, but with no coating and with soft edges. Such a lens can be had for about $200 used.

BUYING USED LENSES I have been well served by several of the large mail-order suppliers who advertise in photography periodicals. Shutterbug Magazine is perhaps the best source for suppliers, both commercial and private, of used large-format equipment. I bought my Fuji GX68011 system from a photographer who listed the equipment in a Shutterbug classified ad. Here are a few factors that must be weighed when contemplating a purchase:

1. Coverage: Lots of coverage means lots of room to maneuver when making perspective control and focus adjustments. Obtain the comparative data from the vendor of any lens you might be considering.

2. Sharpness: Many inexpensive lenses are acceptably sharp in the center portion of the image circle, but for a view-camera lens to be truly useful it must be sharp to the outer edges of the image circle. Whenever possible, test before you buy.

3. Glass: A few fine scratches or tiny dings on the surface of a lens will significantly reduce the price, but insignificantly affect the performance. Only very obvious imperfections visibly degrade image quality. Internal bubbles indicate that cemented lens elements are separating, a result of age, physical shock, manufacturing defect, or high temperatures; these lenses should be avoided.

4. Coating: Optical coating reduces flare by controlling internal reflections between lens elements. Some modestly priced uncoated lenses are extremely good optically, but special care must be taken to protect against non-image-forming light with appropriate lens shades. Modern multicoating offers the best flare control, but 1960–70 vintage single coating is a significant improvement over no coating at all.

5. Physical condition: Most cosmetic damage reduces lens price but does not affect its optical performance. Minor dings to front filter threads can often be fixed with special nylon-tipped pliers wielded by a camera repair technician. Serious dents indicate a blow sufficient to cause optical misalignment, so keep looking.

6. Shutter: All view-camera lenses are mounted in shutters. Try all speeds. Frozen or dragging shutters can be cleaned and recalibrated for about $50–$100, provided parts are available. Most shutters made within the last fifteen or twenty years have a lever that allows quick opening for focusing; older units have to be locked upon "B" (for "bulb," as in "flashbulb") or "T" (for "time") for viewing, a major inconvenience. Do not forget to check flash synch: many older shutters are not set up for "X" synchronization, which is needed for electronic flash. Good glass can be remounted in a reconditioned modern shutter for about $200, a reasonable expenditure if you find a bargain-priced high-quality lens in an irreparable shutter.

Photographic technology has evolved through a rich interaction between science and art, and nothing illustrates the nature of this interaction better than the many delightfully idiosyncratic cameras that have been developed to fulfill special purposes. Two of these special purposes—wide-angle photography and panoramic photography—are of particular interest to architectural photographers. Many clever and highly usable cameras have been created to make this kind of work easier.

WIDE-ANGLE CAMERAS

AVAILABLE EQUIPMENT Because architectural photographers often work very close to relatively large subjects or within confined interior spaces, we are dependent on extreme wide-angle lenses. In many instances, simply attaching a wide-field lens to a conventional camera will get the job done, but a little experience with this approach quickly demonstrates that the mechanical configuration of the camera body determines the level of effort required to get the job done correctly.

Since conventional view cameras and single lens reflex cameras must accommodate an extensive variety of optics, their lens mounts and viewfinders—even their physical proportions—are necessarily optical and mechanical compromises. SLR cameras require complex and consequently expensive retrofocus designs. As we have seen, such lenses can be very high performers, but at a cost in weight, speed, and ease of focusing. Excellent wide-angle lenses are available for view camera applications, but, as we have also seen, their use demands special bellows and recessed lens boards that work awkwardly or not at all with very short lenses.

Wide-angle cameras are designed specifically so they can be ergonomically and photographically optimized for wide-angle photography. Typically they are engineered around a specific lens—often a Schneider 47mm, 58mm, or 65mm Super Angulon—that is fixed in a metal or plastic conical mount with helical focusing. The bodies are relatively thin, book-shaped, metal rectangles with optical viewfinders on top. Some have ground-glass focusing

The Cambo Wide is a refined, Swiss-made, wide-angle and panoramic camera. It accepts a variety of roll film, 4x5in film, and Polaroid backs and a variety of lenses, including 47mm, 58mm, 65mm, 75mm, 90mm, and 100mm. Precision gear-driven shift ranges from ±7mm to ±15mm, depending on the lens. Each lens comes in its own precision helical focusing mount. An optical finder with built-in spirit level costs $400. Photo courtesy Calumet Photographic.

and interchangeable lens capability, and several provide vertical and horizontal shift. Both roll film and sheet film versions are widely available. Many of these cameras sport non-slip finishes, built-in hand grips, and integral spirit, or bubble, levels.

TECHNICAL AND STYLISTIC LIMITATIONS AND APPLICATIONS Lightweight, dedicated wide-angle cameras bring a spontaneity and efficiency to medium- and large-format extreme wide-angle work that is unavailable with any other approach. Many professionals will pack one of these cameras along with their regular medium-format or 4x5in gear in order to speed up extreme wide-angle shooting. The stylistic complexities of wide-angle shooting have been discussed elsewhere in this book (see pages 56 and 80–82)—an investment in a dedicated camera simply makes the job easier.

PANORAMIC CAMERAS

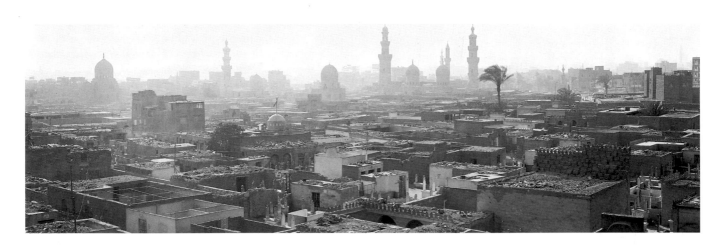

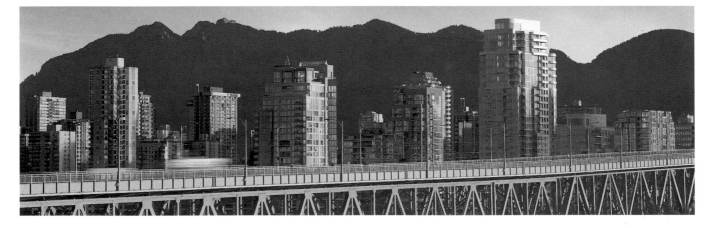

THE PANORAMIC IMAGE Walk into any architect's office and you will likely find a cork board with a crude collage of 4x6in prints arranged end to end to form a wide, horizontal view of a job in progress, a site being considered for development, or a complicated interior space. Such an assemblage is, more or less, a panoramic image.

A panorama can be a wide-angle view, but is not necessarily. A true panoramic image is defined by its shape or aspect ratio—the proportion of height to width—rather than by angle of view. The minimum ratio is 1:2, but there are cameras available that will produce aspect ratios of 1:3, 1:4, 1:6, and beyond.

By eliminating sizable slices off the top and bottom of a horizontal image, the panoramic approach imposes a potentially dramatic aesthetic on the viewer. In a surprising number of situations it is desirable and effective to strongly attenuate the significance of sky and foreground or ceiling and floor, but with conventional cameras such an approach wastes film and is mechanically clumsy.

There are two basic types of panoramic cameras: non-rotational cameras are configured

These beautiful panoramic views were produced by Vancouver photographer Albert Normandin with a V-PAN camera. The adjustability of the V-PAN allowed for perfectly aligned vertical lines. It is interesting to note that the panoramic format gives the viewer a "wide-angle feeling," even with extremely long lenses.
Camera: V-PAN, lenses: top—135mm (normal), bottom—720mm (extreme telephoto), film: Fuji Velvia RVP.

with a fixed lens and a flat film plane, while rotational cameras employ either a swinging lens or a moving body/moving film technique to achieve extreme aspect ratios.

NON-ROTATIONAL CAMERAS Some non-rotational panoramic cameras use large-format sheet film that must be custom cut to fit special film holders, such as 4x10in, 7x17in, or even 8x20in. Much more common, and much more useful, are the machines that use medium-format or 35mm roll film. These cameras look like squashed and stretched wide-angle cameras. They offer some or all of the following features: interchangeable lenses, parallax-coupled optical finders with integrated spirit levels, ground-glass focusing, perspective control, variable aspect ratio, 120 and 220 capability, and superior ability to be handheld.

Also available (from Sinar-Bron and from Calumet/Horseman) are 6x12cm panoramic roll-film adapters that fit 4x5in view cameras.

138

ROTATIONAL CAMERAS These unconventional cameras are perhaps the most exotic photographic devices that are of use to architectural photographers. Their quaint clockwork mechanisms make them look, sound, and behave much differently than fixed lens/body cameras, and they are capable of producing extraordinarily wide views, even beyond 360°.

The swing-lens variety depends on a spring- or motor-driven, pivot-mounted lens that rotates through a fixed arc of 120° to 150°. The image is exposed progressively, from one end of the film to the other, by light projected through a slit-shaped shutter positioned behind the lens. A curved film plane retains a uniform focus.

Full rotation cameras use a fixed lens attached to a rotating body. As the body rotates, the film is shifted at the same speed, but in the opposite direction. The image forming light is projected through a slit shutter, resulting in a seamless representation of the world that surrounds the camera.

ADVANTAGES AND DISADVANTAGES OF PANORAMIC CAMERA TYPES Since non-rotational panoramic cameras are mechanically simple, they can provide a reasonable wide-angle/wide-aspect ratio in a lightweight, reliable, and relatively silent package, making such cameras the favorites of many architectural shooters. Simplicity of design keeps prices reasonable as well, though high-quality large-format wide-

This is the Roundshot Super 35, perhaps the most sophisticated panoramic camera available. Camera rotation, film motion, and exposure are controlled by a microprocessor. The combination of rotating camera and moving film allows panoramic views beyond 360°. It accepts interchangeable Nikon, Contax, or Leica lenses 13–300mm in focal length. A similar medium-format version is also available.

angle lenses and small production runs inevitably push the cost for complete cameras above those for "normal" non-SLR cameras.

Part- and full-rotation panoramic cameras are necessary for extreme wide-angle coverage and aspect ratios (150°, or 1:4, and beyond). But these powerful machines can be heavy, complicated, and noisy. Consequently they are a burden to lug around on location, they are subject to a variety of exotic mechanical problems (such as banding—adjacent vertical strips of uneven exposure, caused by a sticky shutter or film-drive mechanism), and they can be distracting or annoying to people nearby and photographer alike. Precision clockwork, and an even smaller market, make these machines relatively expensive to buy and maintain.

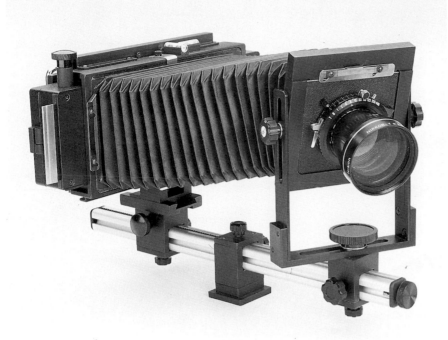

TECHNICAL AND STYLISTIC LIMITATIONS AND APPLICATIONS Panoramic photography is almost as old as photography itself. Crank-operated rotating cameras were used as early as the mid-1800s to record sweeping frontier landscapes, the fields of war, and the grandest achievements of industry. Architectural subjects were especially favored, and the complexities of the emerging industrial cities were captured by fixed-lens panoramic cameras mounted to balloons, specially constructed towers, and even birds.

The precision and scope offered by modern panoramic cameras has greatly extended their usefulness for interior and exterior architectural applications. A tremendous amount of very striking work is being generated by photographers who have taken the time to think through the aesthetic complexities inherent in the elongated format.

Two design concerns need to be addressed when considering panoramic views. First, the strongly horizontal shape of the images requires the visual integration of a string of objects and shapes into a logical, harmonious, continuum. This is just as difficult as it sounds, since it demands a shift from our conditioned foreground/subject/background thinking. A viewing mask cut to the same aspect ratio of the format with which you are working will help. Some photographers take scissors and tape on location and assemble instant panoramic proofs from a series of conventionally made Polaroids. The key is to look for attractive horizontal interconnections. The horizon itself is an obvious connector, but other elements of the natural or man-made landscape—such as roadways, skylines, waterways, decorative plantings and hedges, bridges, or a repeating pattern of architectural details—will help move the eye along smoothly.

The second consideration is the unique manifestation of perspective distortion that is associated with images of extreme aspect ratios. Cigar-effect distortion occurs when subjects with parallel horizontal lines are shot with the camera that is level, but close-up. Because of the wide view, the lines appear widest apart in the center of the frame, and progressively closer together toward the edges of the frame. This effect diminishes as the camera is moved away from the subject, but for all practical purposes it is always a factor that has to be dealt with creatively. Two related effects occur when the camera is tilted. The end-of-the-earth effect happens when a distant vista is photographed with the camera tilted down, which makes the ends of the horizon line bend down. The horizon line bends upwards—creating a bowl effect—when the camera is tilted upwards. These apparent distortions are the reason that many panoramic pictures are produced with the camera perfectly level, which results in a straight horizon running through the exact middle of the frame. Cameras with vertical shift are desirable in this instance because they allow a straight horizon to be positioned above or below the midpoint for a more interesting look.

This is the V-PAN 617, the only panoramic camera that offers front standard view-camera movements. It is shown here in two configurations: the image on the left shows the camera with a long bellows, extended monorail, and a telephoto lens, while that on the right shows the camera with bag bellows, short monorail, and wide-angle lens. The V-Pan features rack-and-pinion focusing, a bright Beattie screen, and a simple and robust 6x17cm roll film holder. It can be used with any view-camera lens capable of covering the image area. Photos courtesy of V-PAN.

INTRODUCTION To my mind there are no advanced techniques, only basic techniques amplified by experience and imaginatively applied. The most accomplished musicians practice scales every day, and it follows that even the most complex architectural photography assignments can be, and should be, deconstructed into a series of more or less straightforward decisions and tasks. In my own work this insight is tested and verified regularly, as shown in the following chronology of a four-day location shoot in Vancouver, British Columbia, during which many of the illustrations for the second half of this book were produced. *(See especially color plates 69–84.)*

PREPARING FOR THE SHOOT

GENESIS This assignment, like all commercial work, began as a problem that needed to be solved. The first edition of *How to Photograph Buildings and Interiors* had sold out, and my publisher, Princeton Architectural Press, wanted me to quickly produce a second edition. The call came at the end of March, still midwinter in Winnipeg, my home town in Canada's Midwest, and I had no current images to illustrate the technical points that needed to be addressed in the new text.

MARKETING Since Winnipeg was buried in snow, I would have to shoot something on the west coast, where spring had already started. I regularly photograph low-rise commercial buildings and private homes in Vancouver for a manufacturer of high-tech windows and architectural moldings, so I knew the city and the local suppliers and labs. I also had a solid working relationship with Vancouver native John De Jardin, who is a terrific assistant.

But I needed some beautiful buildings, so I decided to make a bold proposition to someone for whom I had never worked—Arthur Erickson, considered by many to be Canada's foremost architect. My intention was to fly out to Vancouver and shoot his most recent project on a conditional cost-shared basis. I would retain publication rights to the photos for use in the forthcoming book, and he would pay the cost of production for any images that were useful to him.

He graciously listened to my proposition, asked a few intelligent questions, and requested a copy of the first edition of this book for review. De Jardin delivered his personal copy, and Erickson liked it, commenting, "I picked up a few good tips."

The first phase of the new library complex at the University of British Columbia (UBC) had opened only the day before I called. Erickson was principal designer and consultant, and he suggested that I contact Architectura, the architects of record, since they also wanted to document the building.

Peter Wreglesworth, a principal in Architectura with a special interest in marketing, knew my work and was receptive to the idea. He suggested that we add to the list two other projects on which Erickson had consulted, the Maggie Benston Student Services Building at Simon Fraser University (SFU) and the British Columbia Institute of Technology (BCIT), as well as one building that was designed entirely in-house at Architectura, the Royal Canadian Mounted Police (RCMP) detachment in North Vancouver.

DEFINING THE ASSIGNMENT It was necessary to identify and then synchronize the needs of Architectura, Erickson, and my publisher before the appropriate format, film, shooting style, and shooting schedule could be determined. I wanted the best illustrations possible for my book, but I also needed to fully satisfy the other participants in order to recover my costs and gain a toehold in a new market.

Arthur Erickson maintains a 35mm slide library of all his projects. Architectura uses 35mm slides and 8x10in color prints for presentation, electronic image files for desktop publishing applications, and large prints for display. My publisher needed prints or transparencies that would reproduce well in printed form, both in color and in black-and-white. I wanted to fulfill all these requirements and still be able to work economically with a physically manageable complement of equipment.

From each building both Wreglesworth and Erickson wanted several overall exterior views, two or three strong images of the main interior spaces, and a handful of details. I asked De Jardin to scout the locations and help me build a detailed impression of what, where, and when I could shoot—something I could not do myself without badgering my new clients on the telephone.

These shots show the Seven Oaks Hospital Wellness Institute by Smith-Carter Architects. Each illustrates various subtleties of interior available light techniques. TL: I carefully positioned the bed, wheelchair, table, and chairs to give a sense of depth and proportion to this photo of an industrial training area. TR: a solution to the problem of immovable concrete pillars; the camera and the moveable objects were positioned to focus the eye around the pillars while at the same time highlighting functional elements. CL: reflections, shadows, and repeating patterns liven up a simple corridor; a graduated filter was used to darken the windows on the left. CR: a mobile CRT display unit occupies part of the overexposed window area; depth and scale were established by positioning a chair in the foreground and diagnostic equipment visible through the doorway in the background. BL: a two-second exposure rendered the seniors' aquasize class as an interesting blur, adding some life to what might have been a sterile image of a swimming pool. BR: I selected a point of view that placed the playroom's mullion grid and lighting/ventilation grid into a visual counterpoint to emphasize the geometry of the space while de-emphasizing the overexposed windows. Camera: Fuji GX680II, lenses:50mm and 65mm, film: Kodak EPP film.

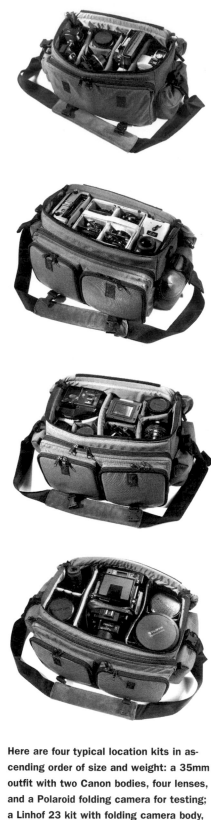

SELECTING THE APPROPRIATE FORMAT Everything hinged on the nature and situation of the buildings. Relatively low structures with attractive western, eastern, or southern exposures, situated in spacious, well-developed landscaping, do not require complicated maneuvering with wide-angle lenses and extreme perspective control. Well-positioned windows and skylights eliminate the need to drag photographic lighting across the country. After De Jardin completed his reconnaissance, it became clear that, except for BCIT—which was confined by a complicated urban canyon—I was in luck.

This job could have produced a stunning set of large-format transparencies, had I been so inclined. If economy and physical freedom were the only considerations, careful work with the right array of 35mm tools would have done a credible job as well. My choice, however, was medium format. Satisfactory photomechanical reproductions up to 8x11in can be easily made from small-format originals, but Architectura needed a few 11x14in or 16x20in enlargements. I wanted these prints to be impeccable, so medium-format color negatives were required. I wanted to present finished images before I flew home, so medium-format color transparencies were also required. Of course, quality 35mm slides and high-resolution scans could be made from both materials. (Most decent transparencies will convert reasonably well to black-and-white, but for difficult images one can achieve a greater measure of control by printing from the color negatives directly to Kodak Panalure black-and-white paper, which is available in three contrast grades.)

SELECTING THE APPROPRIATE SYSTEM All medium-format systems are not created equal. Since this job would require moderate perspective control with a full range of lenses, the Mamiya 645 would not do. The Linhof 6x7 Technika field camera is lightweight, flexible, and precise, but I would not need the extended vertical rise that this camera provides, and its view-camera-like handling would slow me down. The Fuji GX680II was the perfect choice. It offers sufficient perspective control with an appropriate range of optics, interchangeable film backs, Polaroid capability, and fast camera set-up and bracketing. The only disadvantage would be the system's weight, but I would have De Jardin to help me.

One problem: I had no extreme wide-angle lens for the GX680II. I called suppliers across Canada and the United States, only to learn that the 50mm lens I needed had been introduced too recently to have become a rentable item. Despite the $2750 price tag, I decided to buy one, and, thanks to plastic credit and Federal Express, I had one in my hands for testing well before my departure (it has paid for itself several times over since then).

I decided to bring the Linhof Technika and several lenses as a backup. This entire outfit fits into a bag exactly half the size of the one the Fuji system requires.

SELECTING FILM Virtually any modern film, properly handled, will make an impressive 6x8cm image. Nevertheless, I wanted maximum resolution, and since the camera would always be mounted on a tripod, slow, fine-grained film made sense. I chose two different transparency materials—Kodak Ektachrome EPP (ISO 100) and Fuji Velvia (ISO 50). EPP works well under normal daylight and its color response is sufficiently predictable to guarantee good results with filtration and long exposures. Velvia is very high contrast, a characteristic that yields highly saturated images under overcast skies and in the soft glow of pre-dawn and post-sunset. Unlike the recently introduced Ektachrome E100 films, both EPP and Velvia are tolerant of moderate variations in processing chemistry, a valuable attribute when working away from home. For color negative I chose Kodak PRN (ISO 100), which reacts much like EPP in most situations. (If I had to print from negatives made under low-contrast conditions, I could get some extra punch with Ektacolor Ultra high-contrast paper.)

For field testing I chose Polaroid Polapan Pro 100, which has an almost perfect exposure and contrast match for PRN and EPP. This coaterless (some instant prints require coating with a fixative immediately after development) black-and-white material requires only 30 seconds to process, as opposed to 120 seconds for Polacolor Pro 100. In this instance, I was happy to trade away color data in exchange for faster processing.

WHAT I TOOK Here is a detailed list of the photographic materials I took to Vancouver:
1. Fuji GX680II camera body, extra battery, and charger
2. Fuji right-angle prism finder and eye-level finder
3. 3 Fuji 120 film backs
4. Fuji Polaroid back

Here are four typical location kits in ascending order of size and weight: a 35mm outfit with two Canon bodies, four lenses, and a Polaroid folding camera for testing; a Linhof 23 kit with folding camera body, six lenses, a reflex viewfinder, Polaroid back, 6x7cm and 6x9cm roll film backs, and filter; a Mamiya 645 kit with two bodies, motor drive, prism finder, six lenses, two film backs, Polaroid back, bellows shade, and filter; a Fuji GX680II kit with one body, five lenses, porroflex finder, Polaroid back, two roll film backs, and filters.

5. Fuji bag bellows and regular bellows

6. Fuji 50mm, 65mm, 100mm, 135mm, and 250mm lenses

7. Flex-arm lens shade device

8. Minolta incident light exposure meter

9. A selection of Lee filters, filter pouch, filter holder, and lens adapters

10. Small flashlight

11. High-quality folding tool with a variety of implements (this ingenious device resembles an elaborate Swiss Army knife; made of high-strength stainless steel, it includes folding pliers, various knife blades, files, and screwdrivers)

12. Small clock with second hand

13. Cable release

14. Soft case for all of the above

15. 50 rolls of Ektachrome EPP 120

16. 25 rolls of Fuji Velvia 120

17. 20 rolls of Kodak PRN 120

18. 200 exposures worth of Polaroid Polapan Pro 100

19. Small plastic bag for garbage

20. Sharpie permanent marker

21. Linhof 6x7cm Technika camera

22. Linhof 58mm, 75mm, 90mm, 150mm, and 270mm lenses

23. Linhof 6x7cm, 6x9cm, and Polaroid backs

24. Vise-Grip pliers with tripod-head adapter

25. Three different jeweler's screwdrivers

26. Four nylon straps

27. Heavy-duty tripod

28. Collapsible two-wheel dolly with elastic cords

29. Portable light table and loupe

30. Film sleeves (sheets) and scissors

Here is the high-quality stainless-steel multi-use folding tool that I carry with me on location assignments.

STRATEGIC SCHEDULING Contemplative architectural shooting is best undertaken during weekends and holidays, as long as the appropriate permissions are arranged beforehand. To ensure against equipment or access problems outside of regular business hours I carry duplicates for key items and obtain the home phone numbers of critical people. (The phone numbers were not a problem, but the Fuji GX680II is simply too bulky and too expensive to duplicate; that is why I brought the Linhof along.)

I planned to shoot through a weekend that coincided with spring break. I would meet with Arthur Erickson and Peter Wreglesworth on Thursday morning, shoot Thursday afternoon through early Monday as weather permitted, present my work to Erickson and Wreglesworth late Monday, and then fly home early Tuesday.

A 1500-MILE COMMUTE For commercial photographers, getting there is not half the fun. Nevertheless, packing and transporting equipment for this job was relatively straightforward since no lighting equipment was needed.

Most airlines allow one carry-on piece of up to 30 pounds in weight and no larger than 9x14x22.5in, plus two 70-pound pieces of checked luggage, the linear dimensions of which may total no more than 62in. A large Coleman cooler is light, sturdy, safely nondescript, and just fits inside these guidelines while exactly accommodating the first twenty items on the list above. Clothes, notebook computer, electronic organizer, and other necessities were packed into a nylon shoulder bag. I also packed a small padded case containing the Linhof kit. All of this stuff, including the tripod, was strapped to the two-wheeler for easy transport to, from, and inside the airport.

MEETING WITH THE CLIENTS Arthur Erickson and Peter Wreglesworth had different needs and agendas; consequently I met with each of them separately early Thursday. John De Jardin came with me.

Erickson was generous with his time, and painstaking in his explanations of what he liked and what he did not like about the way the UBC Library and Maggie Benston had been realized. He had specified stainless steel for the main floor of the library, a surface that would have been wonderfully luminous and certainly much more appealing than the polished

Architectura
MAXIMAN EDWAR
GROUT CARTER INC.

500-1090 WEST GEORGIA STREET
VANCOUVER, BRITISH COLUMBIA
CANADA V6G 2Z6

TEL 604 682 8000
FAX 604 682 8008

02 April 1997

ARCHITECTURA.

To Whom it May Concern:

This letter will serve to introduce the bearer, Mr. Gerry Kopelow, a nationally recognized architectural photographer.

Mr. Kopelow is acting on our firms' behalf in photographing selected work of our firm.

Architectura was the Architectural Firm of Record for this building.

I would appreciate any assistance you could afford Mr. Kopelow in his work, photographing your building. Should you have any questions, or require clarification please do not hesitate to call me.

Yours truly,

Architectura

Peter Wreglesworth, MAIBC, FRAIC
Principal

PW/ch

This is an example of a useful letter of introduction for architectural photographers on assignment.

concrete and slate thresholds that were installed in its place. Erickson said, "It looks like they ran out of stone half-way through." Another problem for him was the way in which the graceful slim columns supporting the atrium roof were terminated at the upper level. Erickson had specified stainless steel cylinders; instead the builders used concrete painted silver ("tacky as hell" was his verdict on this one). One final sore point for Erickson was the mechanical framework for the perforated metal sheeting that formed the ceiling between the stacks of books. The contractor had cut corners by eliminating the rigid steel strapping that would have given each 4x8ft element an identical curvature. "Don't photograph that stuff," Erickson told me. "It will never look right." He was happier about the SFU building, though he warned us about the poor landscaping.

Our meeting with Wreglesworth was a little more formal. He had remembered my request for a "to whom it may concern" letter of introduction, and he had also prepared snapshots, drawings, and a couple of maps to help us get orientated. In Architectura's upscale boardroom he showed us the multi-projector audio-visual system that was waiting patiently for my photographs.

A DIARY OF THE SHOOT

THURSDAY, 12:30 P.M.　　High noon in the temperate latitudes does not offer much in the way of interesting light, so De Jardin and I hit the road for a tour of the sites. UBC, SFU, and the RCMP headquarters are located respectively about as far west, east, and north as one can go in Vancouver and still be connected to the city. BCIT is right downtown. Traffic is murder throughout this poorly planned, rapidly expanding metropolis. Including a walk-through at each stop, it takes more than three hours to complete the circuit, ending up at SFU, since Maggie Benston is the only building that is favorably positioned to catch the glow of the setting sun.

THURSDAY, 6:00 P.M.　　We crack open the Coleman cooler and prepare the gear for shooting. The soft case with the Fuji system and the plastic garbage bag are strapped to the two wheeler, and we begin a slow, ground-level arc around the building, starting at the southeastern corner.

The sun will not set for another hour and a half, but it is sufficiently low in the sky that its glancing rays nicely delineate a prominent facade. Well away from the building, on the side of a low hill, I maneuver the camera a few feet and then a few inches at a time to find an angle from which the glass and stone, and the metal sign on the building, are all attractively lit. There is an oil-stained service road in the near foreground, so I must lower the camera slightly to interpose part of the slope of a little hillock to hide the distracting mess. I select a slightly long lens, the 135mm, and use a bit of vertical rise and a little horizontal shift to achieve the proper framing. A polarizing filter works to fine-tune the luminosity of the reflective elements, darkening the sky a tad at the same time. Exposure and geometry are confirmed with a Polaroid. While I do all this De Jardin is patiently picking up litter and moving a couple of ugly blue recycling containers out of the shot.

Some clouds are moving in from the north, and a short wait yields a transient but satisfyingly balanced composition, quickly captured on PRN color negative (two identical exposures, no bracketing) and on EPP color transparency (two identical exposures bracketed ±1 stop). De Jardin intercepts pedestrian traffic while this is going on. The first shot takes twelve minutes.

THURSDAY, 7:30 P.M.　　Several shots later we have worked our way around to the front of the building. We see a four-story elevation composed of wide rows of reflective glass set in broadly castellated, light-colored masonry walls, framed above and to the sides by other concrete buildings, the weathered surfaces of which are beginning to appear ominously dark as twilight approaches.

This is to be a signature shot, and I want it warm, simple, and full of light. I search for a close, low camera position in order to eliminate some of the heavier-looking architecture in the background. I want to include some interesting details, if only because these structures are Arthur Erickson's own work from almost thirty years ago. All this takes a bit of effort, since I cannot use my widest lens, the new 50mm, as it upsets the symmetry of the facade at the extreme edges of the frame by stretching the square windows into rectangles; De Jardin

counts down the minutes to sunset while I scuttle about on my hands and knees.

Finally I find my spot. I add a graduated blue filter to darken the sky, and a graduated sepia filter to obscure the patchy lawn that appears in the foreground and that Erickson warned me about, then make a Polaroid test and await the sunset. Unfortunately, a patchy line of trees to the west makes the direct reflection of the setting sun a ragged jumble. I switch to Velvia, test again, and wait. Forty minutes later the afterglow paints the building with a pastel wash of subtle color, and I grab my shots.

THURSDAY, 9:30 P.M. I take an extra minute for a couple of experimental shots with a sunset grad over the lens, then it is time to pack up and head west across the city to De Jardin's place—a thirty-minute drive at this time of day—where he will put me up in a spare room. On the way home we plan our schedule for the next day.

FRIDAY, 6:00 A.M. We arrive at Maggie Benston only to find that we had miscalculated the position of the rising sun. Direct light would not touch the front of the building until later in the morning. Instead of waiting for the sun to come around—it would be unflatteringly high in the sky by that time, anyway—we head west across town, completing the forty-minute trek to UBC just in time to make some bright, edgy, ground-level perspective views of the library.

This building is a high-tech glass box embellished with vertical glass fins supported by short, horizontal, stainless-steel stanchions that protrude, in a grid pattern, from the curtain wall. The whole thing sits on a substantial-looking pedestal fashioned from rough-hewn granite blocks. All the transparent elements are specially fabricated to be opaque to ultraviolet radiation and are mechanically configured to provide a pleasing amount of natural illumination without chemically compromising the materials stored inside the building.

I use a conveniently located tree limb to mask the hot spot created by the reflection of the sun in the glass curtain wall, and a polarizer to subtly alter the balance between reflected and transmitted light for a rich, three-dimensional effect. A graduated blue and a .6 neutral density (.6ND) grad increase saturation in the sky and foreground. While the light lasts I make several variations from perspectives that emphasize differing foreground elements.

Here is the UBC library, shot about half an hour after sunset. This building faces east, so the evening sky at this time was quite light. I darkened it with a #2 blue grad on top of a .6ND grad. This preserved a rich sky color, while allowing a long enough exposure to pick up some detail in the stonework on the front of the building. Camera: Fuji GX680II, lens: 65mm (moderate wide-angle), film: Fuji Velvia RVP.

XIII

147

FRIDAY, 7:30 A.M. A stroke of luck. We are greeted warmly by the head librarian on her way to work. Architectural photography is wonderfully expedited by happy tenants, and this woman was a big fan of Erickson's work. Instead of making us endure an endless enumeration of defects and deficiencies—a typical experience on location—she cheerfully unlocks the front door and escorts us to the atrium on the top floor, just in time to record some serene, pleasantly monochromatic interior details, plus a dramatic near-panoramic image featuring part of the Vancouver skyline.

For these shots a CC10M filter is used to counter the slight green caste produced by the thick plate glass, and a .3ND grad balances the exposure, top to bottom. The smaller views are made with the 100mm moderated wide-angle lens, while the very wide view is made with the powerful 50mm lens. Horizontal shift helps minimize size-distortion effects and keeps the vertical columns properly proportioned.

Here are two views of the Maggie Benston Student Services Centre, shot from the same location but with different lenses. The wide-angle view is fairly ordinary looking, but the close-up is a strong, geometric collage of shapes and boldly highlights many attractive details.
Camera: Fuji GX680II, lenses: 65mm (moderate wide-angle) and 250mm (telephoto), film: Kodak Ektachrome EPP.

FRIDAY, 10:00 A.M. We pack up and head back toward SFU, with a quick stop at a downtown color lab to drop off the first few rolls of transparency material for processing. The folks at the lab know me, and I have called ahead, so they will fit my film into their next E-6 run, which should be ready to view around 1:00 P.M.

FRIDAY, 11:30 A.M. After slogging through heavy traffic, we find that the sun, as predicted, is now high and harsh above the Maggie Benston Student Services Building. This precludes exterior work, but inside is a different story.

The three interior floors of Maggie Benston are configured in a broad 180° curve around a massive yet graceful stairway, and all of this is lit softly from above by a huge circular skylight supported by a delicate geometric lattice composed of thin metal rods. Light levels are sufficient for conveniently short exposures, on the order of 30 seconds on the outside bracket.

The job here is to capture an image that preserves the expansive, quietly cheerful feel of the place without exaggerating the size and shape of the necessarily substantial structural elements that make such an open geometry possible. On his preliminary tour, De Jardin had flagged a spot close to the balustrade at the west end of the second-floor balcony, and his judgment was right. I am able to set up several sweeping horizontal and vertical views from locations within a few feet of each other. For example, by shifting the camera a little sideways, the two large white pillars that support the staircase and roof can be made to merge, by degrees, into one. I cannot be sure exactly which condition will appeal to the designer, so I provide a choice by making a series of ever-so-slightly different images.

The camera is set up and Polaroid tests are made while De Jardin patiently shifts trash containers, recycling bins, furniture, posters, and plants. I use the 50mm lens with maximum vertical fall and horizontal shift. A CC10M filter counterbalances the green light reflecting from the many plants and shrubs on the balconies and the floor below, while a .9ND soft grad darkens the skylight and moderates the unbalanced top-to-bottom gradient of available light.

FRIDAY, 1:30 P.M. We head back downtown to check the first batch of processed film. On the way we take a look at BCIT, only to find that we have missed the narrow window of direct light on its most interesting facade by about thirty minutes. I relax after a quick call to the weather office on De Jardin's cellular phone confirms that the excellent weather is expected to hold for the next two days.

I have asked the lab technicians to sleeve, but not cut, my transparencies, since this allows more convenient editing of the bracketed frames. Labs generally have counter-top light tables for the convenience of their customers, but they provide only low-cost magnifiers because they are expensive to replace should they develop legs. To get a really good look at my images I always bring my own loupe along. So far each shooting situation has yielded terrific images, both technically and aesthetically.

The lab is open until 6:00 P.M., so if we make it back by then we will be able to see the Maggie Benston interiors.

FRIDAY, 3:30 P.M. The UBC Library faces west, and the back of the building is quite literally a blank wall, to which a multimillion-dollar final phase will be attached in the near future. In the absence of direct sun, however, I am able to shoot a few close-ups of the unconventional glass work that embellishes the facade. Erickson told me that this glass is permeated with microscopic ceramic dots that attenuate the potentially damaging rays of the early morning sun. Photographically this glass proves to be a difficult material, especially when viewed through a polarizing filter. Because of the strange tonalities I encounter, it takes almost half an hour to find a camera angle that works technically and aesthetically at the same time. An 81B filter warms up the bluish open shade.

Inside, I am able to find several more interior details, although it is something of a struggle to avoid all the sub-standard finishing details that so irritate Erickson. While I do this, I ask De Jardin to scout around for a higher vantage point that will show off the interesting but complicated relationship between the library, the cobblestone courtyard that surrounds it, and the streetlike walkway and gardens that have been carved out of the gentle slope terminating the courtyard at its western extremity.

De Jardin thinks that the roof of the old library, a hundred yards to the west, will do the trick, and I agree. After about forty minutes of phone diplomacy he arranges permission and a guide to get us up there early Monday morning.

FRIDAY, 5:45 P.M. We make it back to the lab in time to retrieve the last batch of transparencies. Everything shot inside Maggie Benston worked out just fine.

Thursday had been an eighteen-hour working day. This day was shorter, but still very productive. We decide to head home. Back at De Jardin's we learn that he has to return earlier than expected to his main job. He can still give me early Saturday morning and Monday morning, but Saturday afternoon and all day Sunday he will have to attend to personal business.

Since many of the signature images I needed have already been shot, I am not overly concerned. The work will be more tiring, but there is no lighting equipment to set up and tear down, and the weather should hold. I will manage.

SATURDAY, 5:30 A.M. De Jardin and I arrive at the UBC Library just in time for some really nice views that feature the sweet predawn glow reflected in the glass curtain wall. While I set up the camera, De Jardin scrapes posters off lampposts and removes some signs from the windows on the library's front door. I make my basic shots, plus a few additional images with the Lee sunset grad, and then, as the sun rises higher, move closer to look for boldly lit details.

SATURDAY, 9:30 A.M. I have everything I want, and we head back to drop De Jardin off at his place.

SATURDAY, 11:00 A.M. I drive downtown to BCIT. This building is uniquely situated in that its south and west facades are separated by three older buildings around which the new structure had been "wrapped." To further complicate matters, the streetscape is a dense urban clutter of utility poles, trash bins, newspaper kiosks, and unsightly signage. An

elevated shot, perhaps in the early evening, from a building across the street might result in an interesting overall view, but De Jardin has guessed wrong on this one, and the one building to which he had secured permission to enter is not the one I need. Since Erickson's input on this project was limited, I decide to go after a few exterior and interior details only.

I have an hour and a half before the sun swings around to where I need it, and I want to look around inside. My generic letter of introduction is good enough for the security guard. The interior is almost entirely ordinary-looking classrooms, but the main stairway is an interesting triangular spiral of stainless steel and glass.

A convenient balcony provides a conventional sidelong view, but after that I spend almost an hour making a dramatic view with the camera planted on the ground floor pointing directly up. I use a waist-level finder to align the camera, which is clamped to the leg of the tripod about six inches off the floor. The sunlight is slanting through the window and reflecting up through the stairwell off the stainless steel. A shaft of light cuts across the 65mm wide-angle lens at a very inconvenient angle, and some fancy Polaroid-assisted fine-tuning is required to shade the lens enough to eliminate flair without vignetting the image.

Some fancy filtration is required as well: a .9ND grad is positioned to just darken the corner of the frame in which a piece of sky encroaches, an 81D and a CC20M counteract the green from the tinted window glass and the blue reflections from the stainless steel. The ambient light is somewhat exotic, and because I cannot predict exactly how it will record I shoot both EPP and Velvia.

Outside I find a half dozen representative details. As I shoot—without De Jardin's assistance—I must keep track of the equipment while maintaining a constant flow of friendly small talk with a little group of curious pedestrians. Because a strong vertical correction is required, I shoot these exteriors with the Linhof and the 270mm lens. An 81B filter adds warmth to the rather cold-looking metal.

SATURDAY 12:45 P.M. I have not yet seen Architectura's RCMP detachment in North Vancouver, so I pack up and make the 45-minute drive. Letter or no letter, the duty sergeant will not let me inside. What I can see of the interior is fairly nondescript, so I let the matter go. Outside there is only one significant view, and, serendipitously, the sun will illuminate it just nicely in about half an hour.

The eastern face of the building is on the edge of a landscaped public space that features an asymmetrical reflecting pool and some benches. The best photographic point of view occurs right at the most western edge of the park, which abuts a brick wall. The Fuji camera with the 50mm lens lacks sufficient front rise for a perfectly rectilinear view, so I switch to the Linhof with the 58mm. This focal length does not provide a wide enough view to encompass the whole building at once. I am despondent until I remember I packed a 6x9cm back for the Linhof. A quick change and I am ready for the perfect sunlight to slide into place.

I have borrowed De Jardin's cellular phone, an implement I have decided is indispensable, and while I wait I use it to find a lab that will process E6 film on Sunday. The only place is a small one-hour outfit in a suburban mall. I decide to check it out tomorrow.

SATURDAY 3:30 P.M. I make it to my downtown lab in time for the last E6 run.

SATURDAY 8:00 P.M. Back at De Jardin's house I start to edit the processed film with the aid of the scissors, loupe, and portable light table that I brought from home. This is one of my favorite activities. Well-made transparencies are beautiful objects in themselves, and I enjoy studying the subtle effects rendered by lens, light, and filtration. I select the best exposures and arrange them into 8x11in filing sheets.

As I do this I think about what still needs to be shot, and how and when to do it. Arthur Erickson had requested a very specific perspective of the Maggie Benston Building, even describing the exact position on an adjacent parking structure from which he would like the shot taken. I will also need to take some medium and small interior details of Maggie Benston and twilight views of the UBC Library.

SUNDAY, 10:30 A.M. I arrive to an empty Maggie Benston Building. Working alone in a beautifully designed, totally deserted building can be a very Zen-like experience. Much of the work I had come to Vancouver to do has been successfully accomplished, so I can

approach the remaining work at a leisurely and worry-free pace.

I spend an hour wandering around on the top floor studying the geodesic-type lattice of rods and spherical connectors that hold up the skylight. I find two configurations in interesting light, both of which I shoot with a wide aperture, f5.6. I want a narrow depth of field to make the pieces in the foreground predominate over those in the background. I use some swing and tilt to exaggerate this effect.

SUNDAY, 12:15 P.M. By the time I make it outside, the day has become overcast. A few minutes searching takes me to the position on the parking structure specified by Erickson. From this vantage point, a few degrees above Maggie Benston, the tiered roofs and their plantings of grass and slender trees make a visible checkerboard below. I use maximum front fall to maintain proper alignment with the 100mm, moderate wide-angle lens, and Velvia film to boost the contrast, adding an 81D filter for warming and a blue grad to give some color to the dull sky.

SUNDAY, 3:30 P.M. I make my way to the one-hour photo lab. It is small but clean. I tell the proprietors that I am a professional and they very kindly give me a tour of the facilities. They show me some E6 that they had run earlier in the day, and it looks fine. (I am reminded of my father-in-law, a fastidious surgeon who inspects the kitchens of any restaurant where he eats. Better to be safe then sorry.)

I divide my remaining unprocessed film into two piles and hand over one of them; the second batch I will take to the professional lab the next morning. Splitting the film in this way provides some protection against lab accidents or mishandling, something of which I am particularly wary with a new supplier. These folks promise to have my film ready in two hours. I take in a movie nearby, and return to find my film processed, sleeved, and looking good.

This view of the Maggie Benston Student Services Centre is a favorite of the architect. A distracting foreground was eliminated by cropping in the camera. A carefully adjusted polarizer controlled the highlight detail in the lettering and the glass. Camera: Fuji GX680II, lens: 135mm (normal), film: Kodak Ektachrome EPP.

SUNDAY, 7:30 P.M. One of the most attractive features of the UBC Library is its jewel-like transparency under certain conditions. I have staked out two locations, a perfectly perpendicular elevation and a southerly perspective, from which to make a series of images as the sun sets. Since the light behind the building will be relatively bright, I need a blue grad to darken the sky. A CC30M filter is required to correct for the fluorescent lights inside and for the mercury vapor street lamps outside. A polarizer enhances the transparency of the facade, but sucks up two full stops. Velvia film must be derated to ISO 20 because of the decrease in sensitivity due to reciprocity effects associated with long exposures. Despite focusing very carefully, I am reluctant to shoot wider than f11 with the 65mm moderate wide-angle lens; even at this generous aperture exposures reach 3 minutes on the +1 stop brackets. Working like this is something of a crap shoot, but there is no way around it. As the sky darkens and the floodlighting warms up I shoot half a dozen widely bracketed rolls.

SUNDAY, 9:30 P.M. I edit all the processed film, arranging the shots logically into sleeves for presentation on Monday.

MONDAY, 8:00 A.M. De Jardin and I wait outside the old library at UBC. Our guide is late, but we confirm by phone that he is on his way. When he arrives we have to hustle through some dusty corridors, up a couple of decrepit cast-iron ladders, and through a creaky old door. We have to transfer the camera, tripod, and the equipment bag one item at a time past the narrow openings. We make it to our position on the sixty-foot parapet just in time for the ideal sun angle. The final shot of the assignment is made without a problem, and we hustle back down through the obstacle course.

MONDAY, 9:15 A.M. The last of the transparency film is turned over to the lab. They accepted a very large order just before I arrived, so my film will not be ready until 1:00 P.M., the time of my scheduled meeting with Arthur Erickson. I should have reserved some space on Friday! I call Erickson's office and, since he is running late, moving our meeting to 2:00 is not a problem. Peter Wreglesworth is OK for 3:30.

I visit some of the professional photography suppliers in downtown Vancouver while the film is in the soup, then retrieve the film and edit it on the spot.

PRESENTING THE FINISHED WORK Arthur Erickson is rushing through a tough day, but, ever gracious, he greets me warmly and sits down to take a look at the transparencies, using the loupe and the light table that I have set out for him. The work garners two exclamations of "beautiful," two of "excellent," and one of "spectacular." He asks me to send him a proof sheet once I have the color negative film processed.

A little later, Peter Wreglesworth looks carefully at the finished work and smiles. "I'm impressed," he says. "I think we will be working together again in the near future." He asks for proofs from the color negatives, as well. The proofs were sent and enough prints and slides were ordered to cover my Vancouver expenses.

I packed up a set of transparencies and prints for my publisher. Each image was numbered and captioned, then assigned a place in the text. I noted which images could be converted to black-and-white and which needed to print in color.

Everyone's purposes, including my own, were well served.

45 This is an example of an industrial interior shot with a rigid body medium-format camera. Shot on ISO 100 color negative material without filtration under sodium vapor lighting, the finished print exhibits good overall color balance and excellent resolution. The image lacks only perspective correction of the diverging verticals, a result of the elevated camera position. The two engineers in the middle distance were positioned with walkie-talkies, a necessity in many noisy industrial environments, and remained motionless for the one-second exposure. Camera: Mamiya 645, lens: 35mm (extreme wide angle), film: Kodak PRN color negative.

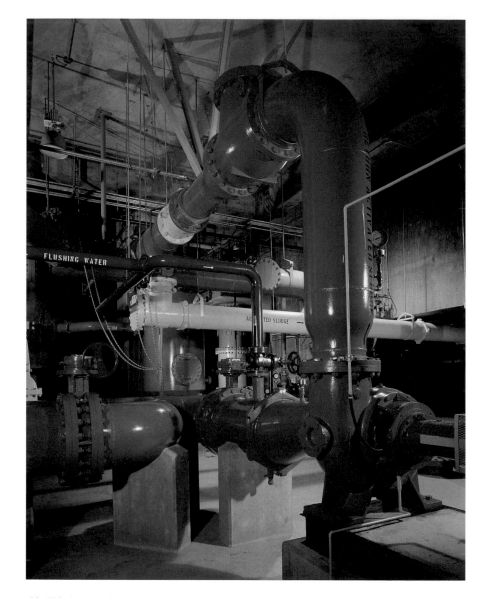

47 This detail from a Vancouver area pub was shot during early evening as ambient light was falling. The warmth around the sign and the streetlight are in pleasing contrast to the cooler available light. I measured the brightness of the area lit by the tungsten fixtures, then waited for the sunset to progress to the point where the ambient light fell to about 2/3 stop less. Camera: Linhof Super Technika 23, lens: 90mm (normal). film: Fuji Velvia RVP (chosen to enhance contrast and color saturation).

46 This image, shot underground at a water treatment facility, was commissioned for the front cover of an engineering firm's annual report. The challenge was to find an interesting configuration of pipes in a vertical format. Several powerful electronic flash units were carefully positioned to highlight the brightly colored pipes while providing enough background information to preserve a dramatic sense of depth. Camera: Linhof Technikardan 45, lens: 90mm (moderate wide-angle), film: Kodak Ektachrome EPP.

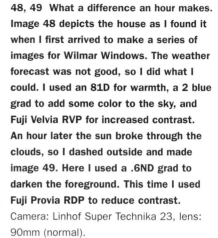

48, 49 What a difference an hour makes. Image **48** depicts the house as I found it when I first arrived to make a series of images for Wilmar Windows. The weather forecast was not good, so I did what I could. I used an 81D for warmth, a 2 blue grad to add some color to the sky, and Fuji Velvia RVP for increased contrast. An hour later the sun broke through the clouds, so I dashed outside and made image **49**. Here I used a .6ND grad to darken the foreground. This time I used Fuji Provia RDP to reduce contrast.
Camera: Linhof Super Technika 23, lens: 90mm (normal).

50, 51 Image 51 is a preliminary color test with unfiltered Ektachrome EPP. Image 50 is the final shot; it demonstrates the benefits of turning on additional lights, arranging furniture and plants, fine-tuning camera position, and shooting with a CC30M filter. Camera: Fuji GX680II, lens: 65mm (moderate wide-angle), film: Kodak Ektachrome EPP.

52, 53 These images show how one can have too much of a good thing. This recreational area was lit by a combination of skylight and fluorescent fixtures. Image 52, made with a CC30M filter, is overcorrected, while image 53, made with a CC10M, is just right. A .9ND hard grad was used in both cases to darken the skylight. Camera: Fuji GX680II, lens: 50mm (extreme wide-angle), film: Kodak Ektachrome EPP. Extreme vertical rise allowed the proper framing.

The images on this page show views before and after the application of filters. They show various Lee packages designed for commonly used effects: (clockwise from upper left) sky set, selective star set, pop set, and color grad set.

54, 55 The image to the left was reshot using Lee's sunset 2, .6 neutral density, and .9 neutral density to produce the image below. *Photos courtesy Lee Filters.*

56, 57 The image to the left was reshot using Lee's glass enhancer and 6pt star graduated to produce the image below. *Photos courtesy Lee Filters.*

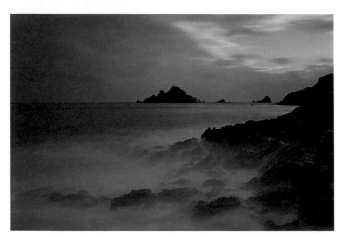

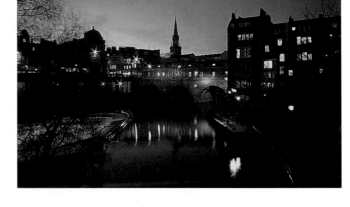

58, 59 The image to the left was reshot using Lee's pop green, pop blue, .6 neutral density, and .03 neutral density standard to produce the image below. *Photos courtesy Lee Filters.*

60, 61 The image to the left was reshot using Lee's magenta grad, .6 neutral density, .3 neutral density standard, yellow stripe, and pop red to produce the image below. *Photos courtesy Lee Filters.*

63 This stairway detail was made under a mixture of daylight and fluorescent lighting. A CC30M filter restored the overall color balance to neutral, but turned the daylight quite magenta. The effect was not unpleasant, since the daylight, which was coming from a glass door to the extreme right, provided some interesting highlights on the formed, enameled steel fixtures. A wide aperture was used to limit depth of field and limit the plane of perfect sharpness to the foreground elements only. Camera: Fuji GX680II, lens: 100mm (moderate wide-angle), film: Kodak Ektachrome EPP.

62 One cannot always work in sunshine. This restaurant exterior was shot for Chemcrest, a manufacturer of architectural moldings, during a brief break in the rain. A sepia grad plus an 81D filter added some color to the dull sky and warmed the overall rendition. Camera: Linhof Super Technika 23, lens: 75mm (moderate wide-angle), film: Fuji Provia RDP. Slight vertical rise was used.

64 Here is a preliminary 35mm test of Warren Carther's glass sculpture, *A Prairie Boy's Dream*, in the lobby of the Investors Group Building. It reveals some of the problems of color, exposure, and perspective that have been corrected in images 65–68.

65 This view was made with the camera clamped to the top of a 12ft ladder. Camera: Fuji GX680II, lens: 65mm (moderate wide-angle), film: Kodak Ektachrome EPP.

66 This image was made with the camera clamped to the top of a 12ft ladder. The security desk was included to add depth and scale. The glass towers were lit with electronic flash to make them appear more luminous. A .9ND soft grad was positioned horizontally to even out the left-to-right brightness gradiant.

67 This image was made from the second floor mezzanine balcony and clearly shows the serendipitous pattern of sunlight on the floor in front of the sculpture.

68 Also made from the top of the 12ft ladder, this horizontal view yields a more detailed, contextual look at the situation of **Carther's work.** Camera: Fuji GX680II, lens: (66, 67) 50mm (extreme wide-angle), (68) 100mm (moderate wide-angle) film: Kodak Ektachrome EPP.

69–72 Here are four exterior views of Arthur Erickson's Maggie Benston Student Services Centre at Simon Fraser University in Vancouver. All are shot from similar points of view, but under different conditions. Image 69 is a failed experiment—an inappropriate use of a sunset filter that resulted in a rather heavy-handed rendition. Image 70 was made about ten minutes after sunset, when the sky began to go magenta and the windows reflected the warm light lingering on the western horizon. A graduated sepia filter was used to darken the foreground, and a #2 blue grad was used to darken the sky. Image 71 was made in the early evening, when the sunlight was warmed by the absorption of blue light by dust and other atmospheric pollutants. No filtration was used here. Image 72 was made by the cool light of the high, late-morning sun, with no filtration. Camera: Fuji GX680II, lens: 65mm (moderate wide-angle), film: Fuji Velvia RVP (69, 70), Kodak Ektachrome EPP (71, 72).

73 This relative close up depicts a strong vertical view of Maggie Benston. Such an extreme upward view precludes absolute alignment of the vertical elements, but in this case perfect parallelism was not wanted. The convergence of the pillars fits with the angles inherent to the structure of the skylight. Some care with swing and camera angle created an "anchoring" 90° angle formed by the vertical shaft of vegetation in the right of the frame and the horizontal mullion at the top of the frame. A .9ND grad retained detail in the skylight, while a CC10M countered a slight green caste reflected from the foliage. Camera: Fuji GX680II, lens: 100mm (moderate wide-angle), film: Kodak Ektachrome EPP.

74 Here is an interior detail from Arthur Erickson's library at the University of British Colombia. The exaggerated perspective is satisfyingly anchored by the vertical shaft of the pillar in the center. The shadow of the floor and stairway above provide a dramatic frame. This image shows how the distortion of relative size caused by extreme wide-angle lenses can be used to advantage if camera position is carefully chosen. A .6ND grad equalized exposure from top to bottom, while a polarizer reduced some of the reflections on the multiple glass surfaces. Camera: Fuji GX680II, lens: 50mm (extreme wide-angle), film: Kodak Ektachrome EPP. Some vertical rise, some forward tilt for focus.

75, 76 These images of the new library complex at the University of British Columbia were made within a minute or two of each other under virtually identical conditions. The difference between them is filtration. Image 75 was altered with a #2 Lee sunset grad, while 76 was altered with a polarizer, increasing the transparency of some of the windows. Camera: Fuji GX680II, lens: 100mm (moderate wide-angle), film: Fuji Velvia RVP.

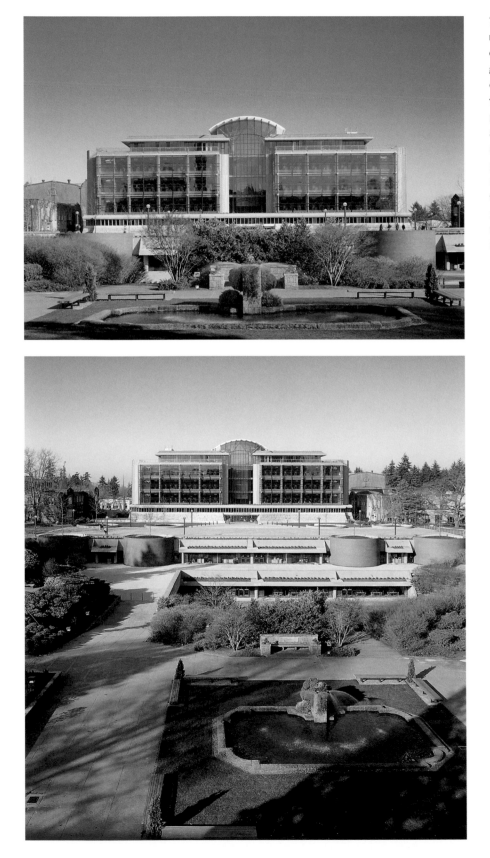

77, 78 What a difference fifty feet can make. Here are two early morning shots of the UBC library, **77** made from the ground level front steps of the adjacent old library, and **78** made from the roof of the old library. Image **77** is certainly pleasant, but the complexity of the mall and walkway beneath the new library is revealed only from the much higher viewpoint of image **78**. A #2 blue grad was used in both cases to enrich the color of the sky. Camera: Fuji GX680II, lens: 135mm (normal) (77), 65mm (moderate wide-angle) (78), film: Kodak Ektachrome EPP.

79, 80 Here are two almost identical images showing a stairwell at the British Colombia Institute of Technology. These images were made with the camera a few inches off the floor and pointing strait up. An 81A filter added some warmth, and a .9ND grad darkened the corner with a slice of window. The difference between the two shots is the multicolored flare evident in image 79. A narrow shaft of sunlight was projected at a raking angle across the front element of the lens. Only very precise positioning of a black card shaded the lens and eliminated the distracting flare without vignetting image **80.** Camera: Fuji GX680II, lens: 65mm (extreme wide-angle), film: Fuji Velvia RVP.

81, 82 Two different shots of the place where the BCIT stairway meets the adjacent window wall illustrate the effects of slight changes of perspective on rectilinearity. These pictures were made from the same camera position with the same lens and the same degree of correction, but image 81 shows what the camera saw when aligned almost level, while image 82 shows what the camera saw when it was pointed a little higher. The second image, because of the strongly converging verticals, is more dramatic. In addition, this view picks up more of the reflected light from the stainless steel surfaces beneath the higher stairs, adding another pleasing compositional element.
Camera: Fuji GX680II, lens: 100mm (moderate wide-angle), film: Kodak Ektachrome EPP.

83, 84 Here are two views of the upper atrium and stairwell in the new UBC library, one looking inward and one looking outward. Inside we clearly see the connection between the stacks of books and the office and arches above. Looking out, we see the laciness of the slender columns, the transparency of the walls and roof, and the pleasing expanse of buildings and mountains in the middle and far distance. Both views are made with the same wide-angle lens. (These images would have been stronger with a little more contrast. In hindsight, I regret not having used Fuji RVP instead of the Ektachrome EPP.) Camera: Fuji GX680II, lens: 50mm (extreme wide-angle).

CRITICAL FACTORS

THE TRUE NATURE OF INTERIOR PHOTOGRAPHY Exterior photography is concerned with context to some degree, but mostly it is concerned with form and texture. This is definitely not the case for interior photography, where texture and form take second place to context, which in the case of a room occupied by humans is entirely related to function. Most of the interior photography that I do is requested by people who are not architectural professionals. This is perfectly understandable, considering the diverse human activities and interests variously encompassed by four walls and a ceiling.

An interior space is almost always a locus for some manifestation of human life; therefore, interior photography is almost always a specialized form of photojournalism. We record the three-dimensional interplay between cultural artifacts assembled inside a room, and the result is a peculiarly precise and intimate cultural snapshot. This snapshot can be a crude likeness, or it can be an aesthetically elevated, technically faultless representation. It all depends on the mind set of the photographer and the array of tools that are brought to bear on the task.

COLOR BALANCE The previous chapter illustrated the range of technical choices available for interior photography in those situations where a space is predominately lit by daylight. But a great deal of interior work is necessarily done in rooms where artificial sources predominate. Black-and-white photography or very basic documentary photography can be undertaken without any particular concern for the spectral nature of man-made sources of illumination, but all other work demands close study of color temperature and often fairly sophisticated technical accommodations.

After-the-fact laboratory control of overall color balance is perhaps the most appealing feature of color negative technology, but it works best when only one type of artificial source is present. Most interior photography, regardless of format, takes place under mixed sources, so professional-looking results are possible only if color corrections are made at the time when the photographs are made. Most high-level interior work requires medium- or large-format color transparencies for reproduction, so on-site color balancing becomes even more critical. This involves the use of some or all of the following techniques: modification of the ambient light, filtration on the camera, and auxiliary photographic lighting, or complete replacement of ambient sources with photographic sources.

154

GEOMETRIC BALANCE Geometry is of critical importance in interior photography. Long lenses are used for shooting details indoors, but everything else requires wide-angle lenses, and, as discussed in Chapter 6, these lenses can introduce some visual anomalies in the shapes and relative sizes of objects. Since we cannot avoid using wide lenses, we must learn to minimize those effects that are distracting, and maximize those that enhance.

PHOTOGRAPHIC LIGHTING

SYNTHETIC SOURCES Acquiring an eclectic arsenal of lighting hardware is an unavoidable necessity for anyone interested in serious interior photography. There are four different methods of generating photographically useful artificial light:

1. A tiny coil of wire can be made to glow white-hot by an electrical current. Because tungsten has proven to be the best material for the glowing wire, these are called "tungsten" or "incandescent" lights. Quartz lights are tungsten lights that use a quartz envelope rather than glass—these lights are also called "halogen" lights because the quartz envelope is filled with inert halogen gas, which permits a longer operating life compared to that of a simple vacuum.

2. A small tube of gas can be excited to luminescence by a continuous electrical discharge. These can be sodium or mercury vapor or xenon discharge lights. Each of these glow at different color temperatures, according to the materials from which they are made.

3. Long glass tubes can be coated on their interior surfaces with a phosphorescent material that glows when stimulated by an electrical discharge—these are fluorescent lights.

4. A small tube of xenon gas can be excited to a bright, brief glow by an instantaneous electrical discharge. Since the xenon gas emits light for only the fraction of a second during which it is energized, this source is called "electronic flash" or "speed light."

Here are four interior views from Arthur Erickson's Maggie Benston Student Services Centre at Simon Fraser University. All are shot with a CC10M filter to counteract the greening caused by the foliage, the green tile and the window glass. This series illustrates "bracketing by position," that is, the creation of several significantly different views of a particular subject by making slight changes in camera position. The image in the upper left is made from one floor lower than that on the upper left. The image in the lower left is made from a position a few inches farther from the edge of the balcony rail than that on the lower right. Note how the two large vertical columns on the right are made to merge into one by moving the camera. Camera: Fuji GX680II, lens: 50mm (extreme wide-angle), film: Kodak Ektachrome EPP.

Electrical energy is stored in a capacitor, a device that works like a rechargeable battery, except faster. To fully charge the capacitor with electricity takes from one to thirty or more seconds depending on the characteristics of the particular flash unit. The stored energy is discharged rapidly through the flash tube when a small electrical signal called a trigger pulse is initiated by a switch built into the shutter mechanism of the camera. The flash must be synchronized with the shutter so that the pulse of light, which may be from 1/10,000 to 1/50 second in duration, occurs when the shutter is completely open.

CHARACTERISTICS OF VARIOUS LIGHTING SYSTEMS Tungsten light, vapor-discharge lamps, and electronic flash tubes are relatively small, so when they are used for photographic purposes without any sort of modification they are extremely hard light sources. All their other attributes are markedly dissimilar. Tungsten, vapor-discharge, and fluorescent light is continuous; as long as electricity flows light is produced. Electronic flash generates light only in very short, albeit bright, pulses.

A conventional glass tungsten lamp darkens and changes color with age as metal evaporating from the hot filament condenses on the inside of the bulb. Quartz and halogen tungsten lamps are filled with inert gas and operate at extremely high temperatures so that vaporized tungsten does not condense on the envelope but instead is redeposited on the filament in a continuous cycle. In terms of both color balance and brightness, quartz lights behave more consistently than conventional lamps. Their life expectancy ranges from fifty to a couple of hundred hours. Both types of tungsten lamps are delicate and will burn out if they are jarred while operating. Photographers put up with all the inconveniences of hot lights because the lighting effects may be easily judged and very finely controlled. The bright continuous light also makes focusing and framing easy. Some people feel that the warmer tungsten spectrum renders a more natural look than the cool light from an electronic flash.

The brevity of the xenon flash might seem at first to be a disadvantage, but it is actually a blessing in disguise. The pulse of light is so short that both subject motion and camera shake are not problems. Since the flash is very brief, it can be synchronized to fast shutter

156

This is one of my rather battered professional electronic flash powerpacks, a 2400ws unit. Switches and knobs on the top control power distribution to the connectors on the front panel. Several flash heads can be plugged in at once. A unit this size with two or three heads and umbrellas can illuminate most domestic interiors and moderate-sized office spaces.

This is a Lowel DP incandescent lamp, shown with its accessory barn doors. (One leaf of the barn door has been removed to show the mounting configuration and handle.) This lamp allows variable beam angle. Interchangeable reflectors, filters, snoots, grids, scrims, and a variety of other useful accessories are available.

An electronic flash head is shown with a small soft box. Beside it is a Lowel DP incandescent lamp with a silver umbrella. Both soft boxes and umbrellas come in a variety of sizes and materials. Umbrellas are fast to set up and cheap to buy. They are useful when broad light coverage is required. Soft boxes are more difficult to set up, but provide better control over the width and direction of the lighting.

speeds—all speeds with leaf shutters, up to 1/250 second for modern focal plane shutters, up to 1/60 second for older focal plane shutters—allowing precise control of the balance between ambient and flash lighting, a very handy characteristic for interior work. In order to preview the effects of the flash and to provide sufficient illumination for focusing, a small tungsten lamp (typically 100 to 250 watts), called a "modeling light," is mounted near the flash tube in professional studio flash units.

Due to the elaborate electronics involved, electronic flash equipment powerful enough for professional use is complicated, expensive, and heavy compared to tungsten lamps, which are simple in construction and very lightweight, making them appealing for location work. Unfortunately, they are not very energy efficient. A lamp rated at 1000 watts will use 200 watts of electricity to make light and as much as 800 watts to make heat. Because of this inherent characteristic, tungsten lights are a fire hazard and destructive to heat-sensitive subjects, so they can be awkward and sometimes dangerous.

QUANTIFYING COLOR The color of both artificial and natural light is described precisely by the Kelvin Color Temperature Scale. Daylight color films are balanced for 5500°K and intended to be used outdoors for exposures shorter than one second and for indoor exposures with electronic flash. Tungsten-balanced films are designed for exposure under 3200°K incandescent lights. Most small-format transparency films, such as Kodak Ektachrome EPP, are intended for short exposure times, while some large-format tungsten transparency films, such as Kodak Ektachrome 6118, are intended for long exposure times. Although absolute color fidelity cannot be guaranteed, in a pinch daylight-balanced and tungsten-balanced films may be interchanged, provided appropriate filters are used and the corresponding exposure corrections are made. Technical data sheets spelling out color balance and reciprocity corrections for specific professional films are available from their manufacturers.

A TUNGSTEN LIGHTING SYSTEM I generally rely on tungsten lights when the space I am shooting is already predominantly lit by tungsten or sodium vapor-discharge lamps. I chose the Lowel tungsten lighting system because it is versatile and durable as well as lightweight and compact. It was designed by a working photographer, and there are appropriate bits and pieces available to solve almost any lighting problem.

The Lowel DP light is the heart of the system. I am particularly fond of the DP's focusing ability. With a simple turn of a knob, the light beam can be varied with precision from 15° to 90° (this range can be extended with inexpensive snap-in reflectors). DP lights can handle up to 1000 watts each and typically use an FEL 50 hour/1000 watt lamp. However, I prefer the 200 hour/750 watt EHG bulb. These lamps have a slightly warmer color—3000°K instead of the usual 3200°K—that I find very pleasing, and they run a little cooler, temperature-wise.

Multi-leaf barn doors (hinged metal flaps used to attenuate the light beam) and a variety of different size flags (thin metal sheets of various shapes, positioned by flexible metal rods, also used to attenuate the light beam) can be easily attached. A simple but solid umbrella bracket and large, comfortably cool handles that allow the lights to be manipulated without burning fingers are available as well. A very clever system of clamps, adapters, and stands facilitates mounting the lights and accessories in all kinds of situations. Sensibly priced fitted cases allow the entire system to pack and travel well.

Although the Lowel system can be used in a hundred different ways, my favorite approach is to bounce the DP units off strategically positioned, light-colored walls or reflector cards of various sizes, using their focusing capability in combination with the barn doors to surgically tailor the pattern and intensity of the light. By adding a few little Photogenic focusing spots (sometimes called "needle lights'" or "inkies"), I add highlights and accents when required.

ELECTRONIC FLASH HARDWARE I use unfiltered electronic flash to complement or overpower available daylight, and filtered electronic flash to complement or overpower fluorescent or mercury vapor ambient sources.

Because the technology for generating electronic flash light is so complicated, the business end of these units, the flash head, must inevitably be less flexible than its incandescent counterpart. Nevertheless, several well-developed professional flash systems—such as Balcar, Speedotron, and Norman—offer a wide selection of reflectors, umbrellas, honeycomb grids

Here are three metal devices that are fitted directly to photographic lamps and flash heads for lighting control. The flat plate, or flag, is attached via a highly malleable metal rod and is positioned to limit beam spread. The honeycomb grid creates a directional beam of moderated width, while the snoot produces a very narrow beam for highlighting small areas or objects.

158

(metal screens, similar in construction to the metal or plastic grids often used with fluorescent ceiling fixtures, about 3/8in in depth—the smaller the holes, the tighter the light beam), snoots (metal tubes the same diameter as the light—the longer the tube, the tighter the beam), and soft boxes (tentlike, collapsible, nylon structures, black on the outside, silver on the inside, with a translucent diffusion material on the face opposite the light) to fine-tune the output of their flash heads. Flash heads bounced from umbrellas or through soft boxes will simulate the effect of indirect daylight transmitted through large windows, while grids, snoots, and parabolic reflectors create effects more like direct sunlight. For more flexibility, I have modified some of my heads to accept Lowel accessories.

In the world of flash, power is measured in watt-seconds (ws). A small unit might generate 100ws, while a really large pack might be capable of producing 4800ws. Twenty-four hundred watt-seconds is typical for a heavy-duty professional power pack. Many assignments can be handled with one big power pack and four flash heads.

"Recycle time" refers to how long the unit needs to recharge after each flash—thirty seconds is a long time to wait between shots, but two seconds or less is not. I think it is worth while to invest in a powerful and reliable system with a short recycle time. Big units draw heavy currents, up to twenty amperes, when recycling fast. It is wise to buy power packs that have a switch that permits slower recycling for those locations where the electrical supply is limited. I recommend you obtain a second pack as a backup against breakdown. I recommend that infrared or radio triggers be used in place of endlessly troublesome synch cords.

A WORD ABOUT SAFETY Quartz-halogen lights operate at extremely high temperatures. Always watch out for fire hazards and possible heat-induced damage to props or equipment. Use gloves when adjusting hot lights. Make sure that everyone involved in a shoot is well aware of the risk of contact or radiation burns from fixtures. Do not touch quartz bulbs with your fingers during installation—skin oils can cause uneven heating and may result in fractures or even explosions accompanied by dangerous flying fragments.

Never forget that professional electronic flash equipment operates at very high voltages and under some circumstances can be extremely dangerous. Check connectors and cables often and replace any that look worn. Make certain that stand-mounted heads are secure and that wires are safely taped to the floor when working on location. Never allow flash equipment to be operated by people unfamiliar with it. Do not use flash equipment in a wet environment or in the presence of flammable vapors. Extension cords for use with large flash generators should have sixteen gauge wire, or fourteen gauge for runs longer than fifty feet. Make certain that flash units are supplied by well-maintained grounded receptacles of adequate size. Always switch power packs off before connecting or disconnecting flash heads. Always leave flash units unplugged and discharged when unattended.

LIGHTING COMPOSITION Although composition and perspective are important, in the calculated world of commercial photography it is mainly through the intelligent and sensitive use of light that a photograph is infused with a style. Photographers need to know how to select and tastefully apply a multitude of lighting tools and techniques. It is absolutely essential to study the photographs that appear everywhere around you. Make it a habit and you will find that it becomes fairly easy to discern the size and placement of the lights. Clues about lighting configurations can be found by studying the position, the intensity, and the edges of reflections and shadows. Your own emotional responses to the images you study will teach you how lighting works to evoke an astounding range of moods.

SAMPLE SHOOTS—FROM THE SUBLIME TO THE NOT SO SUBLIME

INTRODUCTION Quantum physics teaches that the observer and the observed are linked, that the observed effect is, in some inextricably mysterious way, a result of the act of observation. Photographers who shoot interior spaces must chose how they will be linked to their subjects. The passive photographer observes, thinks, and then selects a point of view, film type, filtration, and exposure that results in a photographic record of an interior space. The active photographer also observes and thinks, but selects a point of view, film type, filtration, and exposure only after physically interacting with the subject—moving or removing objects, adding or subtracting light, creating rather than finding a place to put the camera— to make, rather than simply record, a photograph. As the following anecdotes reveal, advanced interior photography can be an athletic pursuit.

THE INVESTORS SYNDICATE LOBBY Warren Carther, a noted glass sculptor, invited me to his studio because he wanted to shoot some strong photographs of his work. He was competing for a commission to produce a large piece for the lobby of a new sixty-story office building in Hong Kong and would include the photographs with his proposal.

The piece I was to photograph dominates the lobby of the head office of an international financial services company, The Investors Group. At thirty-five feet, *A Prairie Boy's Dream* is the tallest freestanding glass sculpture in the world. Using curved panels of etched, stained, and iridescent dichroic glass, Carther incorporated highly stylized urban and rural prairie motifs into a pair of elegant towers supported by four 8x8in chromed steel posts.

The Investor's lobby is a three-story atriumlike space with an elevator lobby and narrow mezzanine on the north side and a full-height glass wall and entrance on the south side. East and west walls are fairly ordinary-looking office facades incorporating interior windows with horizontal metal blinds. The floor, structural walls, supporting pillars, and entrance archway are clad in a warm tone of polished granite.

Carther's Hong Kong commission would be much larger in scale, but similar in situation, so he needed at least a couple of photographs that would show off the intricacies of his glass work in the context of an urban interior.

The work had been unsuccessfully photographed by two other professional photographers. Carther showed me the earlier photographs and pointed out several problems.

1. In the previous photos his work looked like stone rather than glass.

2. None of the existing images captured a pleasing view of the lobby and a pleasing view of the sculpture at the same time.

3. All the images had color problems.

4. The images were not sharp enough to delineate the fine work on the glass.

5. None of the images immediately provided a sense of scale or proportion.

6. All the images had a certain heaviness about them that misrepresented the uplifting ambiance that the sculpture evoked in real life.

7. None of the existing images accomplished the subtle but vital task of guiding the viewer to subconsciously focus on a sophisticated sculpture enhanced by a handsome space, rather than a sophisticated space enhanced by a handsome sculpture.

The photographs that I was charged to replace were reasonably serviceable images in general terms, but they did not specifically meet Warren's needs. Since many tens of thousands of dollars in fees and a global reputation were at stake, something more needed to be done. The first step was to define the difficulties:

1. The glass looked like stone because it was too dark relative to the rest of the room. When viewed from the elevator lobby, the sculpture was gloriously backlit by the southern window wall. Viewed from the other side, the position from which the signature images would have to be shot, the sculpture looked much less luminous.

2. The lobby is a wide rectangle with the complex window wall along one long side and the sculpture positioned close to the middle. The most interesting elements are therefore separated by a relatively bleak open space that is terminated at its opposing ends with ordinary offices.

3. The admixture of ambient mercury vapor, incandescent, and daylight, plus the greenish-blue tint of the building's windows and the sea-green tint of the two-inch-thick glass from which the piece is fabricated, combined to yield an odd, blue-green overall color balance, with patches of strong green and strong red in places. The wrong film stock, the

wrong time of day, the wrong season, and the absence of filtration exacerbated the problem.

4. The apparent sharpness of an image has both technical and psychological aspects. In this case there were deficiencies in both areas. The dull light on the sculpture lowered the contrast between the various etched and tinted areas, which read as an apparent lack of sharpness. In addition, the first photographer used a poor quality wide-angle lens on his 4x5in view camera. The extreme degree of front rise necessary to properly frame the image resulted in a fuzzy rendition of the top of the sculpture. The second photographer used more modern equipment, but on a couple of critical images he neglected to properly set up swings and tilts to maximize edge-to-edge sharpness.

5. The sculpture is big, but it sits in a large space. Lacking an immediately recognizable visual reference to establish the actual proportions, the space photographed like a well-made scale model rather than something real and monumental.

6. A combination of insufficient lighting, an overall blue-green color caste, and an inappropriate point of view established an oppressive, rather than an optimistic, visual modality.

7. I decided that the attention of the viewer was misdirected mostly by unbalanced lighting. The window side of the room was too bright relative to the elevator side, and the sculpture was too dark relative to its immediate surroundings.

Here is what I did to correct the deficiencies listed above.

Here is one of the lighting stacks used to backlight Warren Carther's sculpture in the lobby of the Investors Group Building in Winnipeg. The three lights are supplied with energy through cables from the powerpacks on the floor. The stand to the left of the lights supports a long, vertical black "flag" that keeps stray light from going where it is not wanted.

160

1. Increasing the light coming through the glass on the sculpture would make the piece more luminous, and less like stone. Very powerful lights would be needed to compete with the very bright ambient daylight. I stacked three flash heads with sixteen-inch parabolic reflectors vertically, one above the other, on a tall stand. These lights were each connected to industrial strength (2400ws) power packs. The stand was tucked just inside the elevator lobby, and each of the lights was positioned to illuminate the three lower quarters of the sculpture. The top of the sculpture was lit by another flash head connected to another 2400ws power pack and secured to a stand positioned on the mezzanine balcony directly above the main floor elevator lobby. Two more tall stands supported long flags made of black foil; these were precisely positioned at each side of the three light stack to prevent light from spilling around the sculpture towers and reflecting too strongly off the chrome steel supports. The flash provided enough illumination for an aperture of f16 with ISO 100 film. A shutter speed was selected and tested with Polaroid to retain detail in the rest of the room while still rendering it a bit darker than the glass in the sculpture.

2. Finding an angle of view that pleasingly rendered both sculpture towers and the lobby was something of a challenge. My solution was to make several test pictures the day before from a variety of angles and study them together with the artist. We agreed to concentrate on fine-tuning two of them for the final presentation.

3. The bright available daylight was more than sufficient to light the lobby space. A little detective work quickly deter-

mined that the mercury vapor and tungsten lights could be switched off from the security desk, eliminating a big headache. The day before the shoot I tested three different films with a variety of filtrations, and determined that a combination of Ektachrome EPP and an 81D filter resulted in agreeably warm overall tonality. I covered the electronic flash heads with some light amber filters to warm up Carther's glass panels.

4. The additional lighting on the glass would heighten the apparent sharpness in those areas. The degree of perspective control required was within the range available on the Fuji GX680II. The optics for this camera are outstanding, and the super-bright Beattie screen, in combination with the right-angle finder, makes accurate focusing and framing easy. The aperture of f16 guaranteed sufficient depth of field.

5. Warren and I agreed on two views, both of which included the security desk, partly because a human figure could be included within the frame to effectively establish the scale of the room and the sculpture.

6. Some of the heaviness of the earlier photos would be elevated when the exposure and color balance was corrected, but inappropriate point of view was the main factor that had to be addressed. Shooting from the mezzanine balcony overemphasized the ceiling elements, the massive supporting columns, and the pattern in the stone floor while diminishing the sculpture. Shooting from ground level overemphasized the sculpture at the expense of the surrounding elements. My solution was a simple idea, but one that had eluded everyone else: I clamped the camera to the top of a twelve-foot ladder, a point of view that yielded just the right spatial balance.

7. Three techniques effectively balanced the light and thus properly directed the viewer's attention. Pumping extra light through the glass sculpture made Carther's work into an attractively radiant focal point, while a horizontally positioned .9ND soft grad evened out the left-to-right brightness gradient of the room as a whole. Last but not least, I was able to shoot at midday during the height of the summer—the high overhead sun projected a dazzling arch of warm light that exactly cradled the base of the curved sculpture.

Everything worked out and we ended up with more than the two excellent images for which we were aiming. You can take a look at the results in color plates 65–68.

A HOLIDAY INN BALLROOM A hotel owner had spared no effort to make his banquet hall into a lavishly decorated scene for his daughter's wedding reception, and he wanted a picture for her scrapbook and for the hotel brochure. The room was physically ugly, with a dark green, textured wall covering, tacky, strange-colored fluorescent chandeliers, incandescent wall sconces, and a very low ceiling. The head table was elevated a scant ten inches off the floor and it stretched the entire length of the room in an unbroken sixty-foot line. Five-hundred-dollar floral arrangements (all white roses) were deliriously impaled on plastic tubes that extended a full two feet above each individual table, effectively blocking the head table from view. To complicate matters, the proprietor, the florist, the catering staff, the chef, and an account executive from the hotel's advertising agency were all hovering about during my shoot, even though the reception was still four hours away.

Two serious technical issues had to be addressed: color and contrast. The chandeliers, comprised of hanging, sharpened plastic rods, looked alarmingly aggressive, even dangerous, when dark. Switched on they were a little more acceptable, but then they projected unevenly distributed pools of garish, green-tinged light across the multitude of tables. Some tables appeared like burning white disks on the initial Polaroid, while others, including the head table, receded into glowering shadow. The walls looked black, except for little pods of red around the sconces that were positioned about twelve feet apart at eye level.

These technical wrinkles created aesthetic complications, of course, but these were overshadowed by the forest of flowers. Taken together the sixty-odd arrangements created a nightmare scenario of white on white, plus they obscured every reasonable point of view. There was no way around it, some of those brutally expensive roses would have to be shifted. Some of the heavily laden tables would have to be moved, as well, to counterbalance the exaggerated perspective associated with the 50mm extreme wide-angle lens I would have to use on the Fuji GX680II. Finally, the camera would have to be positioned inconveniently above eye level in order to be able to see far enough into the room.

A full half-hour of intense diplomacy went into pre-shoot negotiations. I appealed to the owner's marketing savvy, I promised the florist free pictures, and I cajoled the catering staff with plenty of sweet talk. I had to convince the members of the band, who were rehearsing,

Here is the result of my efforts in the Holiday Inn banquet hall. The electronic flash and the available light have been carefully balanced to make the existing fixtures look alive, though subject modeling and detail is actually provided predominately by the flash. Camera: Fuji GX680II, lens: 50mm (extreme wide-angle), film: Kodak Ektachrome EPP.

to unplug their equipment so that I could plug in my own. I had to invent a method of safely supporting the two-foot flower-support rods away from their table-bound bases—we used buckets filled with ice. I had to contact building maintenance to positively identify the type of lamps in those awful fixtures and to replace a few missing tubes.

After testing the available light with color Polaroid, I decided that bright, filtered electronic flash was necessary to control both contrast and color. A CC30 magenta filter over the lens would bring the fluorescent chandeliers to neutral, and several strategically positioned flash units, each filtered with CC30 green to match the fluorescents, would bring the contrast under control.

I positioned four small 400ws units along the back wall behind the head table. In addition to the green filters, each head was covered with a diffuser to spread the beams and reduce hot spots. Two large parabolic flash heads, each powered by a 2400ws pack, were positioned to the far left of the camera and angled so that together they swept the entire room. This strong side light gave a satisfying three-dimensional look to the tablecloths and flower arrangements. I created a feeling of depth with some backlight provided by a third powerful flash unit positioned against the back wall to the extreme right of the camera.

The camera was positioned about two feet below the ceiling. I used front tilt and a touch of swing to bring all the tables into focus. Some shift allowed the camera to be oriented more perpendicular to the back wall, reducing the horizontal diminishing-perspective effect. Front fall reduced the expanse of ceiling that appeared in the frame while preserving vertical alignment. Finally, under the watchful eyes of all concerned, a few of the foreground tables and chairs were carefully repositioned to give a more balanced feel to the strong wide-angle view.

Three shots made from slightly different positions were successfully achieved in under two and one-half hours. There was no foul language from anyone, and the reception began on time.

ON YOUR OWN IN THE REAL WORLD Successful interior photography requires diplomacy, an analytical frame of mind, lots of equipment, and some hard physical work. But do not be discouraged. The work is more fun than it might sound here, mainly because clients on site quickly realize that something unusual is happening and pitch in to help.

This phenomenon is related to my earlier observation that a room is a sort of secular shrine dedicated to the human activities that take place within it. Shooting architectural interiors is essentially an exercise in social anthropology. When an effort is made to make a room look good, it is interpreted by those who have a personal interest in that room as an effort to make their lives or occupations look good, and they want to be involved.

INTRODUCTION

WHAT FILTERS DO Filters are to photography what adjectives are to language: their judicious use clarifies or enhances a simple statement that might otherwise be confusing, inaccurate, or just plain dull. This analogy can be taken a little further: consider the fact that both filters and adjectives can be misused and superfluous, and both can be used in atypical ways for extraordinary effects.

Filters work by altering the photographically significant characteristics of light. While many variables—lens selection, point-of-view, format, etc.—work together to determine the overall look of an image, filtration is the last technical refinement that can be made before the shutter is tripped and the image is recorded. The tremendous control offered by the filtration process sets up something of a creative paradox, since one can chose filters to produce either an extremely accurate or a wildly inaccurate photographic representation. And a very wide range of interesting possibilities exists between these two extremes.

ARCHITECTURAL IMPERATIVES Buildings and interiors are photographically demanding because they are mechanically obdurate. They cannot be manipulated in space, and so are subject to the exasperating vagaries of natural light, weather, and inconveniently positioned artificial sources of indeterminate color. Frequently size or situation renders them awkward, if not impossible, to light photographically. After selecting an appropriate film, filtration is the architectural photographer's only practical remedy for extreme color, contrast, brightness, or pictorial dreariness.

This detail from an elevator lobby required two ND grads and a CC30M together. A .9ND grad darkened what would otherwise have been a burnt-out area where a mercury vapor fixture brightly lit the top of the frame. The .6ND grad was used to slightly darken the bottom of the big structural *X*. A CC30M rendered a reasonably neutral overall color balance.
Camera: Fuji GX680II, lens: 50mm (extreme wide-angle), film: Kodak Ektachrome EPP.

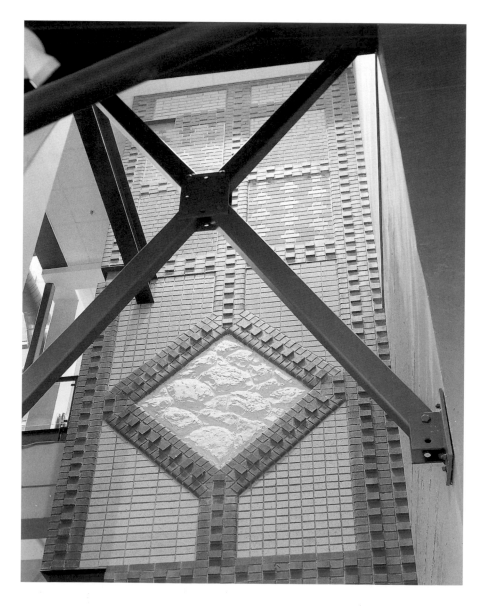

OPTOMECHANICAL CONSIDERATIONS

VARIABLES All filters are bits of glass, plastic, or gelatin that are interposed somewhere and somehow into the optical path between the subject and the film. There are a lot of methods for achieving this condition, and photographers who must make regular and efficient use of filters have to choose a system that will best achieve their purposes. We make judgments about all our photographic tools according to their cost, weight, durability, and precision of manufacture—filters are no exception.

The first choice for filter lovers is a tough one: glass, rigid acrylic resin, gelatin, or flexible polyester? Well-made glass filters are indisputably the best in optical terms—they can be made very flat, very clear, and very scratch resistant. Color effects are achieved by mixing dyes into the molten glass or by thin-film vacuum deposit of various exotic materials that possess very precise color reflection/transmission characteristics. All glass filters perform very well, although diachroic filters—those made by the latter technique—are universally considered to be the most accurate and the most stable. High-end glass filters are multicoated for reflection and flare control, just like lenses. (Multicoating also enhances scratch resistance.) Unfortunately, glass is heavy, fragile, expensive, and—for a surprising variety of filter types—hard to find. Still, high-end glass filters are preferred by well-moneyed perfectionists.

There are some alternatives for the rest of us. The best of the modern acrylic resin filters are reasonably equivalent to glass in flatness and clarity, and very close to glass in accuracy of color. Rigid plastic filters are offered in a dizzyingly wide array of sizes, effects, and mounting systems. Furthermore, plastic is significantly cheaper than glass, filter for filter. An acrylic resin filter will not shatter when dropped. Unfortunately plastic filters are not multicoated and are very scratch prone, so much so that even the most fastidious worker will be unable to avoid noticeable damage over time. I handle my acrylic resin filters carefully, but I find that I have to replace the ones I use most frequently every couple of years. I do not mind the scratching, but I do miss the multicoating, particularly in circumstances where light sources must be included within the frame.

Gelatin filters can be made in very thin, flawless sheets; consequently they are optically superior to plastic, but more delicate. They are highly susceptible to scratching and creasing—even a fingerprint can become a permanent insult. Plastic polyester filters are more robust than gelatin filters, but not as good optically. They are cheaper than gelatin, and easier to find in larger sizes.

FILTER SYSTEMS Whether made of glass, plastic, gelatin, or polyester, all filters must be mechanically mounted to a lens in order to function. Some extreme wide-angle and telephoto lenses with exceptionally large front elements provide small rear-mounted or internal pockets for filters cut to size from sheets of gelatin or plastic polyester, but all other lenses require filters to be attached ahead of the front element.

The traditional filter system consists of a glass disk mounted in a metal or plastic ring that has been threaded on its outside diameter to fit a matching thread on the front end of the lens barrel. This is an excellent system optically because it provides good centering, a solid mechanical mount, and precise vertical alignment. But this is an expensive system, not only because the filter element is glass, but because a different size of filter is required for each different sized lens. This is also an inconvenient system, since a variety of mounted glass filters of different sizes are heavy, bulky, and delicate, and because attaching and detaching screw-in filters is a time-consuming activity. Furthermore, the fine threads are easily damaged and will cause the filters to bind with the lenses when dirty, misaligned, or over tightened.

There is a practical alternative to the traditional filter system. Tiffen, Lee, Kodak, Hitech, Lindahl, Optiflex, Cokin, and other manufacturers offer a variety of glass, gelatin, and polyester or acrylic resin plastic filters in 75mm, 100mm, and 150mm squares. These filters fit into the manufacturer's universal filter holder, which typically consists of a slotted plastic or metal frame that accepts a series of different-sized threaded adapters to fit all sorts of lenses. The slots are lightly spring loaded so that the square filters can be quickly and safely inserted or removed.

Architectural photographers working in medium or large format are dependent on wide-angle lenses, which tend to have large front elements—the widest in my collection is 96mm.

These Lee filter holders connect together via a tandem adapter, allowing even more filters in front of the lens. The holders can be rotated independently to achieve the optimum filter effect. Photo courtesy Lee Filters.

A typical 96mm glass filter in a threaded metal mount might cost well over $150, while a 100mm square acrylic equivalent that can be easily fitted via a $20 adapter to any lens I own costs $40 to $60. Extrapolated over a range of sizes and applications, the square-cut filter/holder/adapter technology makes a lot of sense. I have standardized on the Lee filter system because it offers a very useful range of 100mm filters backed up with clever, durable, and easy-to-use holders and lens adapters. Of very special interest are the Lee wide-angle adapters, which are carefully configured to position filters as close as is mechanically possible to the front lens element in order to eliminate vignetting.

SELECTING A FILTER SIZE The very large 150mm filter format is needed by cinematographers and by photographers who specialize in wide-angle work with 8x10in or larger cameras. Many medium- and small-format users will be well served by 75mm filters, normally priced at less than half of what the 100mm versions cost. Nevertheless, an investment in a 100mm filter system will pay off in ease of use with wide-angle lenses, in fewer vignetting problems in any format, and when upgrading to larger diameter lenses.

EXPOSURE CORRECTIONS Virtually all filters absorb some light and thus require an increase in exposure to compensate. The darker the filter, the greater the necessary increase. Behind-the-lens light meters will allow automatic exposure accommodations, but for all other applications a mathematical calculation has to be made. Filter manufacturers provide a recommended filter factor that indicates the required increase in exposure for a given filter. For example, a typical polarizer has a filter factor of 4. If the measured exposure is f11 at 1/250th of a second, the proper exposure with the filter in place would by f11 at 1/250 x 4, or about 1/60th of a second (that is, 2 stops). A filter factor of 2 would require a 1-stop increase, a filter factor of 8 would require a 3-stop increase, and so on.

Precise filter factors are hard to determine, since they vary with film response and the color of ambient light. Testing with Polaroid is recommended, as is bracketing. Keep track of your results so that you can build up a personal filter-factor list for the films and filters you use most often.

FILTER TYPES

OVERVIEW Filter effects range from the sublime to the ridiculous, but all filters fit into a few general categories. Color contrast filters are used to increase or decrease the intensity of one particular color. Color conversion filters are designed to allow fairly accurate color rendition when films are used with inappropriate light sources. Color balancing filters are used to regain neutral color rendition under ambient conditions that vary noticeably toward warm or cool tonalities. Color compensating (CC) filters are used to make fine incremental adjustments of color balance. Neutral density (ND) filters diminish overall brightness. Polarizing filters are used to reduce reflections and increase color saturation. There are also a host of special-purpose filters to accentuate, modify, or create distinctive optical effects.

COLOR CONTRAST FILTERS When used with black-and-white films these filters alter the tonal response of the film to light of different wavelengths. The rule of thumb is simple: use a colored filter to lighten the appearance of that color in the photograph, or to darken its complement. The deeper the color, the stronger the effect. In black-and-white architectural work the most useful filters are as follows:

1. To enhance the texture of architectural wood, stone, or concrete under sunlight: mild effect 8 yellow, stronger effect 15 yellow or 25 red

2. To darken blue skies and enhance cloud contrast: mild 8 yellow, medium effect 15 yellow, dramatic 25 red, night effect 29 red (a polarizer can be added for additional control)

3. To enhance sunset effects: mild 8 yellow, dramatic 25 red

4. To lighten foliage: mild 58 green, dramatic 25 red

5. To enhance/sharpen a distant skyline: mild 25 yellow, strong 25 red

6. To increase haze effects: 47 blue

I carry with me a 25 red, 15 yellow, and a 58 green on black-and-white architectural assignments. When used with color film, these filters impart a strong overall monochromatic hue, so their use is limited to special effects.

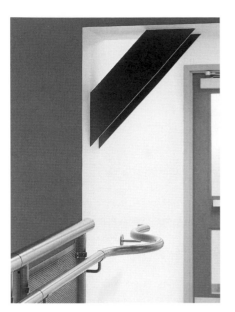

I was asked specifically to provide an image that showed how this handrail "bump-out" was employed to guide pedestrians away from a structural steel component that unavoidably occurred where a new building joined a preexisting one. One fluorescent fixture lit the short hallway, so a CC30M was required for neutral color. A .9ND grad darkened the right hand side of the frame. A large white reflector card was positioned on the right, close to the camera, to provide additional highlights on the railing. Extreme swing preserved the focus. Camera: Fuji GX680II, lens: 135mm (normal), film: Kodak Ektachrome EPP.

COLOR CONVERSION FILTERS These filters allow the use of otherwise mismatched color films and light sources. They are approximations at best, but in many cases their correction will be close enough to be pleasing.

1. For daylight film under tungsten light conditions: 80A (blue)
2. For tungsten film under daylight conditions: 85B (orange)

COLOR BALANCING FILTERS These filters make color temperature either warmer or cooler. They are used to achieve a neutral effect whenever ambient conditions vary from nominal 5500°K daylight. Here are Kodak's recommendations for Ektachrome films:

1. Sunrise/sunset: 80B or 80C (blue)
2. Two hours after sunset or before sunrise: 80D (blue)
3. Noontime sun: None
4. Overcast sky: 81A or 81B (amber)
5. Open shade: 81B or 81C (amber)
6. Electronic flash: 81A (amber)

I have never actually needed any of the blue 80 series filters, but I carry with me 81B and 81D amber filters. The Ektachrome film I prefer tends to be a little cool, so for general daylight shooting and with electronic flash I warm things up with the 81B. I use the 81D under overcast skies or when shooting interiors that are indirectly lit by daylight (that is, no direct sunlight coming through the windows).

COLOR COMPENSATING FILTERS These filters facilitate very fine control of color balance. They are available in various densities (.025 or CC025, .05 or CC05, .10 or CC10, .20 or CC20, .30 or CC30, .40 or CC40, .50 or CC50) and in various colors (red or R, green or G, blue or B, cyan or C, yellow or Y, magenta or M).

Precise determination of correct CC values for a particular circumstance is difficult, so I recommend color Polaroids and preshoot testing with conventional materials. A color temperature meter, a hand-held instrument that measures color rather than brightness, is a useful tool for making a fast analysis of unfamiliar light. However, the filtration recommendation by even the most accurate instrument—Minolta offers a very good one for about $1000—should be confirmed by tests for absolute security.

Color compensating filters can also be used to fine-tune the performance of particular color emulsions. Even films designated "professional" vary slightly in performance from batch to batch, so manufacturers often recommend a small filtration (usually no greater than CC05) that will return color response to normal. If the filtration is not indicated on the film package, it must be determined experimentally. (I rarely worry about this particular variable—I find modern films to be extremely consistent.) Some photographers like a certain tonal bias in all their work, and consequently customize various films with a personally determined filter pack. Similarly, some photographers have favorite lenses or lighting systems that add a particular tonality that must be counterbalanced by filtration in order to

achieve results consistent to those obtained with the rest of their equipment. Here are some of Kodak's recommendations for CC filtrations with daylight Ektachrome films and a variety of light sources:

1. Cool fluorescent: 05C + 30M (+1 stop)
2. Warm fluorescent: 10Y + 40M (+1 stop)
3. Daylight fluorescent: 50R (+1 stop)
4. Sodium vapor: 80B + 20C (+2 1/3 stop)
5. Mercury vapor: 30R + 30M (+1 1/3 stop)

The only CC filters I regularly use are a CC10M, a CC20M, and a CC30M. I use the 10M and the 20M for interiors lit by a mixture of fluorescents and bright daylight or interiors lit entirely by daylight coming through heavy plate-glass windows. The 30M is my universal correction for interiors lit exclusively by fluorescent or mercury vapor light; experience has proved that this works reasonably well in most office and factory situations with the Ektachrome films I favor.

NEUTRAL DENSITY FILTERS Neutral density filters work by reducing the intensity of all colors of light by the same measured degree at once. This is useful when wide apertures are desired for shallow depth-of-field effects, or under bright light conditions when a grainy, high-speed film is needed for stylistic purposes. Neutral density filters are readily available in one stop increments: minus 1 stop (.3ND, filter factor 2), minus 2 stop (.6ND, filter factor 4), minus 3 stops (.9ND, filter factor 8).

POLARIZING FILTERS Light travels along a straight path but also vibrates perpendicularly relative to that path. Light that is vibrating in a single plane as it travels along a path is said to be polarized. A polarizing filter is a sort of gate made up of parallel rows of microscopic crystals embedded in a glass or plastic substrate. Light that is vibrating parallel to the orientation of the crystalline rows can pass through the filter, but light that is vibrating perpendicular to those rows is blocked.

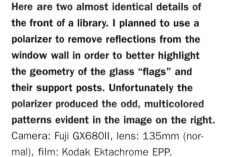

Here are two almost identical details of the front of a library. I planned to use a polarizer to remove reflections from the window wall in order to better highlight the geometry of the glass "flags" and their support posts. Unfortunately the polarizer produced the odd, multicolored patterns evident in the image on the right. Camera: Fuji GX680II, lens: 135mm (normal), film: Kodak Ektachrome EPP.

Randomly vibrating, nonpolarized light can become polarized when reflected off certain surfaces, such as glass or water. Light passing through the atmosphere is also polarized to some degree. By rotating the polarizing filter, the axis of polarization can be oriented to block certain reflections or darken parts of the sky. A polarizer can be used to enhance color saturation in architectural photographs by reducing or eliminating reflections from the surfaces of leaves and grass, tile, concrete, masonry, and even finished wood.

Both glass and plastic polarizers are available, but this is one case where glass is preferred, regardless of cost. Polarizers interact intensely with certain image elements to create remarkably dynamic visual effects—plastic polarizers scratch easily and are often flawed or irregular in performance, conditions that add unpleasantly uneven tonalities to critical images. My Lee 100mm glass polarizer costs over $200.

BOUNDARY HOPPING The forgoing recommendations are intended to assist in maintaining a neutral or natural look under varying conditions—this is the bread and butter work of color control. Of course, creative photographers will sometimes choose not to correct to neutral or will make alternative corrections that move color balance even further away from neutral for aesthetic effect. The very same filters, applied differently, can be used to achieve a fantastic range of artistic goals.

SPECIAL-PURPOSE FILTERS

GRADUATED NEUTRAL DENSITY FILTERS Of all the special purpose-filters available, graduated ND's are my favorite, simply because they are so useful. These filters really help architectural photographers who are working under time and budgetary pressures and who are required to cope with extreme lighting conditions.

Graduated neutral density filters are clear on one end and dark on the other. Filters are available with varying degrees of neutral density on the dark end (.3ND, .6ND, .9ND) and with quick (hard) or slow (soft) transitions from light to dark. The transition point can be shifted around by rotating or sliding the filter within the holder.

These filters can be used to balance a streetscape that is sunlit on one side and deeply shadowed on the other, to selectively darken an interior floor that is too brilliantly illuminated by a shaft of sunlight, or to add some tonal contour to a featureless foreground. These situations can be further adjusted with the use of color grads—graduated density filters in which the dark area is colored rather than neutral. A green graduated filter will make a brownish, scraggly lawn look lush and fresh, while a graduated blue will turn an overcast sky into something much more cheerful. Filter holders with two slots allow the use of two graduated filters at once, so you can have your emerald green grass and your azure blue sky both at the same time on the same dull day.

The flexibility and control provided by the whole family of graduated filters cannot adequately be described in words. I always pack .3ND, .6ND, and .9ND hard and soft neutral density grads, as well as several blue, green, and sepia grads.

STRIPES AND SUNSETS These filters are subsets of the graduated filter category just described. Striped filters feature a soft-edged line of color that runs edge-to-edge across the middle. These are more specialized in application than regular grads, and are usually used to accentuate or de-emphasize narrow areas within a composition, such as the land forms, vegetation, or cloud formations positioned immediately adjacent to the horizon.

Sunset filters are single-filter grad and stripe combinations, typically graduated red or magenta on one end, graduated yellow on the other, with an orange/gold stripe in between. These filters simulate a sunset or sunrise effect and are offered in a range of densities. Each manufacturer has developed its own unique combination of colors. I have three different sunset grads. I use them sparingly, but for certain subjects these clever tools are spectacularly effective.

COLOR ENHANCEMENT FILTERS AND COLOR POLARIZERS Color enhancement filters modify the visual spectrum in a nonlinear fashion—they accentuate or attenuate several different specific colors at once, like a visual designer drug. Each manufacturer's enhancer is peculiar and distinctive, and each is useful for special subjects under special conditions, particularly in those markets where photographers are expected to regularly render

unusual or exotic images. Most enhancing filters are designed to enhance red and gold colors in foliage, so buildings photographed during the summertime might appear as if the image were made in the autumn and so those photographed in the autumn can take on an extraordinarily rich luminosity. Some experimentation will be required to familiarize oneself with the way these filters render different building materials and window treatments.

Color polarizers are available that attenuate reflections of one color or a combination of colors. These are essentially variable color contrast filters, and their application is likewise limited to dramatic special effects.

DIFFUSION, FOG, MIST, AND STARS These no-color filters degrade optical performance in a systematic, controlled way in order to achieve a variety of softening and diffraction effects. Diffusion filters are available in incremental strengths that progressively reduce sharpness for a romantic, pictorial look with gently glowing highlights and luminous shadows. Fog and mist filters are graduated or striped diffusers that are used to soften selected areas to render an effect that mimics natural foggy or misty conditions. Star filters generate four, six, eight, or more radiating white lines around hard highlights.

Most of these effects are tiresome and hopelessly sentimental, but two clever variations are useful to architectural photographers. Tiffen offers a specialized diffuser designed originally for cinematography (it actually won an Academy Award). The diffusion in this case is implemented in such a subtle and technically sophisticated way that it is undetectable visually, yet it has the very desirable effect of compressing a scene of extreme contrast into a photographically recordable tonal range. Lee makes a pair of unique star filters that locate the star effect in either a corner or a small spot so that an individual highlight or a small group of highlights can be separately embellished, leaving the rest of the image unaltered. Once in a while this is a desirable option.

A RATIONALE FOR IN-HOUSE PROCESSING

THE TRUTH WILL SET YOU FREE Photography is concerned not only with the aesthetic exercise of *taking* pictures, but also with the chemical exercise of *making* pictures. To do the job right it is necessary to maintain control over all aspects of the technology, but this is difficult if the last few operations are surrendered to others. I realize that darkroom work will not appeal to everyone, but I offer the following information in an effort to explode some limiting mythology and to demonstrate that complete photographic control is a practical, possible, and profitable option. The basic, undeniable truth is that darkroom procedures are simple and the benefits are inevitable. A fully functional darkroom can be set up and equipped for well under $2000.

A final thought: even if you choose not to set up a darkroom and make your own images, understanding what is actually involved in processing will make your relationship with the local lab much more fruitful. You will have a more precise notion of how long photographic procedures take and what adjustments and alterations can be made in the darkroom.

TIME AND TIMING After investing in a darkroom and learning the skills, anyone can produce quality results faster than a professional lab. This in itself is an incentive to taking over processing, but another characteristic of architectural photography makes relative timing, as well as duration, a significant factor.

Most architectural photography takes place during odd hours, at least as far as the business cycle is concerned. Before and after sunrise and before and after sunset—especially on weekends and holidays—are preferred for exterior architectural work because these periods are characterized by low traffic and sweet light. On a typical summer Sunday, I start preparations and packing at 4:30A.M., travel puts me on ground zero at 5:30A.M., and shooting lasts until 8:30A.M., at which time I find myself standing in a deserted street or parking lot with several rolls of exposed film in hand, my head buzzing from the beauty of yet another sunrise, the sweet morning air, and the intensity of the work.

At such a moment my understanding and appreciation of the assignment is at a peak, while my patience is at an absolute low. I want to see results right away, to evaluate my creative and technical choices, to learn what I did wrong, and to revel in what I did right. I head straight for the darkroom. If my judgment was faulty, I have, if the weather holds, early Monday to try again. If things are good, I will know by noon and can spend the rest of the day in perfect contentment.

THE NEGATIVE ADVANTAGE In Chapter 3 I listed the valuable properties of a handmade print, and in Chapter 6 I listed what a good printer can do. In your own darkroom you can learn to produce your own handmade prints and be a good printer. Here is a summary of the benefits:

1. Fast turn around (minutes, instead of days)
2. Low cost (pennies, instead of dollars, per image)
3. Direct communication between photographer and printer
4. Prints of decent color balance regardless of original light source
5. Complete control over cropping and image size
6. In color prints, moderate but significant contrast control via paper selection
7. Color transparencies can be pushed to increase contrast or pulled to decrease contrast
8. Extreme black-and-white contrast control via paper selection, enlarger filtration, and development
9. Complete control over local and overall density (print exposure, burning, and dodging)
10. Excellent black-and-white conversions from color originals
11. Quick, constant, and memorable feedback on all technical matters
12. Painless access to experimental special effects
13. Professional and artistic satisfaction.

PSYCHOLOGICAL BENEFITS If the aesthetic, technical, and financial arguments are not sufficiently persuasive, consider the psychological advantage. A darkroom of one's own can be a much needed refuge from the frantic intensity of business deals and complex assignments. Under the amber glow of the safelights, the distractions of the outer world fade and are replaced by simpler satisfactions. After more than thirty years in the profession I am

This photo shows my processing setup for making quick and inexpensive color prints. The three trays in the left foreground are sitting in a shallow "sink-within-a-sink" made of one-half-inch plastic. Tempered water flows under the trays from the temperature controller just visible on the floor (bottom left). Tray processing color prints is unconventional, but very efficient for low-volume work.

This photo shows my insulated, temperature-controlled sink for color film processing. The rectangular shapes are 1.75-gallon stainless steel tanks with plastic lids. The three tanks in the foreground are for color negatives. The seven tanks in the background hold chemicals necessary for color transparencies.

still amazed by the subtle, inevitable, chemical reactions that transform virgin film and paper into real images.

OVERVIEW OF DARKROOM SETUP A darkroom is divided into wet and dry areas. Wet procedures include mixing solutions, washing equipment and containers, and processing film and prints with chemicals. Dry procedures are mounting slides, sleeving film, trimming and mounting prints, loading exposed film into reels or hangars for development, and enlarging prints from photographic negatives on an enlarger.

Conventional wisdom dictates that wet and dry areas should be several feet apart, or even in different rooms, so that liquids and chemical powders cannot contaminate dry-side materials. Kodak publishes some excellent books on conventional darkroom layout. They include several detailed floor plans, and are well worth reading.

1. *Basic Developing, Printing, and Enlarging in Color* (Kodak product #AE-13)
2. *Basic Developing and Printing in Black-and-White* (AJ-2)
3. *Black-and-White Darkroom Techniques* (KW-15)
4. *Building a Home Darkroom* (KW-14)
5. *Photolab Design for Professionals* (K-13)
6. *Conservation of Photographs* (F-40)
7. *Kodak Black-and-White Darkroom Dataguide* (R-20)
8. *Kodak Color Darkroom Dataguide* (R-19)

BLACK-AND-WHITE DARKROOM PROCEDURES

BLACK-AND-WHITE FILM PROCESSING Black-and-white processing is a straightforward affair that takes only a few minutes and costs only pennies per roll. Here is the process, step by step: film is loaded onto hangars or reels, submerged in a container full of developer for a certain time, briefly rinsed, submerged in a container of hypo (also called fixer; it dissolves away those parts of the emulsion that will not be part of the final image), then washed, dried, and sleeved.

Time, temperature, and agitation determine density and contrast, the main technical attributes of image quality. Density is the measure of blackening, the combined result of development and illumination. Contrast describes the relative densities of the lightest and darkest tones of a print or negative.

Agitation—moving the film around while it is submerged in developer—is extremely important, in fact critically important, because it determines the degree of development as well as the uniformity of development. Film that has been improperly agitated during development may be mottled, streaked, or stained, and consequently difficult or impossible to print.

A GOOD BLACK-AND-WHITE NEGATIVE In the section "Consideration for Black-and-White" on pages 35–36, I introduced the densitometer, previsualization, the Zone System, and other tools for evaluating negatives. Here I will expand on this.

Manufacturing parameters, as well as exposure and development, work together to establish the density and contrast of the final negative. A scientifically minded lab manager or photographer would describe a good black-and-white negative quantitatively with the aid of a densitometer. Although this is certainly the ultimate in precision, other more intuitive judgments can be made through experience. In general terms, a negative is too thin when shadow areas appear clear and devoid of any detail, and a negative is too heavy when highlight areas are completely black or blocked up (it should be just possible to read newsprint through the darkest part of the negative).

Black-and-white negative film will record texture over a range of five or six f-stops, between 64:1 and 128:1, and a subject brightness range of 512:1. Black-and-white printing papers, however, produce a reflection density or brightness range of about only 100:1. Since neither the response of the film nor the paper is linear, there will inevitably be considerable compression in both the shadows and the highlights with some subjects.

An incident light meter, the kind with a little white diffuser dome over the sensor (as pictured on page 62 top center) measures the brightness of light falling on a scene and recommends an exposure to put an "average" subject, such as an 18% gray card, right in the middle of the useful density range on the negative. A reflected light meter (page 62 top left) would give the same reading under the same light provided that the reading was taken with

the meter pointed directly at the 18% gray card. The gray card is a manufactured object, a standard target that is used for testing photographic film and equipment. But objects from real life exhibit a wide range of reflectivity. If the subject brightness range exceeds the nominal 128:1 capability of the film, it is said to be a high-contrast subject. If the subject brightness range is substantially less than 128:1, it is referred to as low-contrast.

If exposure of the film is always based on an average reading, and if development and printing are normal, prints made from both high-contrast and low-contrast negatives look unnatural. Within certain limits the contrast range of such negatives can be expanded or contracted by selecting a different grade of paper, but outside these limits the remedy for both excessive and insufficient contrast is based on manipulation of the relationship between exposure, development, and density.

When film development is extended, density continues to build up significantly, however the density of the highlight areas builds up faster than the density in the shadow areas. This allows contrast to be controlled photochemically. The credo of Zone System aficionados is, expose for the shadows, develop for the highlights. In other words, a high-contrast subject can be compressed by over-exposure and under-development of the negative, while a low-contrast subject can be expanded by under-exposure and over-development.

This stainless steel rack is used to process roll film. It is shown here with nine empty reels sized for 120 film; the same rack will hold fifteen 35mm reels. For processing, film is loaded onto the reels, the reels are stacked in the rack, and the rack is lowered by hand into the 3.5 gallon tanks that sit in a tempered water bath in my darkroom sink.

PRINTMAKING IN BRIEF The chemistry of black-and-white printmaking is basically the same as that for film, although the hardware is different. Developer and fixer are set out in trays rather than tanks. Unlike film, which is processed in absolute darkness and never touched while wet, prints are moved from tray to tray by hand under the surprising bright illumination of red or orange safelights.

Here are the basic steps. A piece of photographic printing paper is removed from a light-tight container under safelight conditions, placed under the enlarger, and then exposed for some appropriate time, usually between five and thirty seconds. Using tongs, the paper is immersed in a tray of developer and agitated to ensure uniform development. Because the whole operation is done under safelights, it is possible to actually see the image appear on the blank paper.

Development takes about a minute, and then the paper is transferred to the stopbath, a dilute solution of acetic acid, which immediately halts the process of development. The print is moved to a tray of fixer after thirty seconds of continuous agitation in the stop bath. Following a short time in the fixer, the white lights may be turned on and the wet print can be evaluated. If it is satisfactory, the paper is then washed and dried. It takes hardly any more time to make a print than it does to read this short description.

A RATIONALE FOR TRAY PROCESSING Developing prints in trays is a technique that is as old as photography itself. It may seem anachronistic at a time when small but sophisticated mechanical processors are readily available. The fastest black-and-white machines use the stabilization process to make a print in about 3.5 minutes. But there are several disad-

vantages to this method. The print quality is inferior to that of tray processing. The developing image is hidden inside the machine, so early evaluation is not possible. The prints are not normally washed and so will fade in a few weeks; they will contaminate clean prints if they are stored with them. Multiple prints must be made sequentially. Rollers, chemical troughs, and fittings are difficult to keep clean. Chemical and paper costs for machine processing are higher than those used for manual methods.

Automatic machines that use conventional chemicals take up to several minutes per print, dry to dry, and require meticulous cleaning and maintenance. The machines are, of course, expensive to buy, but have small operating costs for mass production of very large prints or continuous processing of long rolls. For low-volume work, however, they are slow and inefficient.

I have chosen to use trays because this is far and away the fastest and most efficient method of producing the quantities of prints I need. The advantage of trays flows mainly from the fact that an image is visible almost immediately after the print has been immersed in the developer solution. Under safelight illumination an experienced printer can make a judgment and discard an unsatisfactory print without waiting for the rest of the processing to finish. Even taken to completion through stopbath and fixer the whole process requires only 2.5 minutes. Including time for a couple of tests, I typically produce a final print in six minutes at a cost of about fifty cents. When multiple prints are required, I use rubber gloves to process fifteen or twenty prints at the same time. Tray maintenance is limited to a quick rinse in running water after discarding used chemicals.

A GOOD BLACK-AND-WHITE PRINT Producing a negative is a process that begins in the camera but is completed in the darkroom. Producing a print is a process that takes place entirely within the darkroom and is consequently very easy to control. Making an acceptable black-and-white print takes only minutes once the basic technology is understood. Making a superb print takes a little longer. The key to perfection in printmaking is the ability to recognize an outstanding print when you see one.

Good prints have a wide tonal range plus a wealth of detail in both highlight and shadow areas. Blacks should be rich, whites should be clean, and gray areas should look smooth. A good print appears natural and unforced and creates an illusion of three-dimensionality. The full realization of these subtle qualities depends on the specific choice of chemicals, the selection of the correct contrast paper grade and exposure time, and proper development.

Proper development is easy to achieve. Three elements are necessary: an ample supply of fresh chemicals diluted to the manufacturer's specifications, gentle but constant agitation to ensure a good flow of liquid over the surface of the print, and sufficient time to let the developer do its work. If a print has been overexposed, it will darken too quickly in the developer. The natural response is to yank it out and slap it into the stopbath right away. The inevitable result is a mottled, streaked, and flat-looking print. It is true that extended development will add some density in highlight areas, but errors of overexposure cannot be fixed by shortening development times.

SPECIAL SKILLS Contrast and exposure adjustments are not the only variables that the skilled printmaker must manage. Very often the local density of certain areas within a photograph needs special attention. If a highlight is lacking in detail, it can be darkened, or burned-in, by giving extra exposure in that location. A tool for this purpose is made by cutting a hole of the approximate size and shape of the area to be darkened in a piece of thin but opaque cardboard. After the initial exposure, an additional exposure is made with the cardboard held in place an inch or two above the surface of the easel. The cardboard must be moved about slightly in a random pattern so that the extra density at the edges of the burned-in area are feathered, or graduated, in a natural-looking way (*see samples on page 38*). I use cardboard tools for burning-in very tiny or irregularly shaped areas, but most often I can quickly arrange my hands into a suitable mask.

Reducing local density is called dodging, or holding back. It should be obvious from a test print which areas need this treatment. For part of the time during the basic exposure one's own hands or a specially formed cardboard tool taped to a piece of stiff wire can be used to prevent light from striking those areas of the print that are too dense, such as deep shadows. The idea is to preserve some realistic tonal modulation in areas that would otherwise look unnaturally heavy and featureless.

Many of the skills in photography are interlocking. Refinement of one particular ability leads to or requires advancement in other related areas. For example, someone who regularly makes black-and-white prints inevitably acquires a thorough understanding of what constitutes a good black-and-white negative because bad negatives are extremely difficult to print. What is not present in the negative to begin with cannot be added in the darkroom.

COLOR DARKROOM PROCEDURES

THE MYTHOLOGY The technical simplicity of color processing is obscured by some commonly held misconceptions, but in reality the complexity of color theory and the difficulty of preserving the correct color balance has been greatly exaggerated. This negative bias evolved because the technology employed by large-scale processors is complex, expensive, and often temperamental. Equally significant is the fact that commercial processors have a vested interest in maintaining an intimidating illusion in order to preserve their position in the market. But the theoretical foundation of the technology is not as impenetrable as all the elaborate machinery it has engendered, and a much simpler production approach is possible for small-scale operations.

C-41 PROCESSING FOR COLOR NEGATIVES Kodak's C-41 chemistry for color negative processing, the industry standard, has six steps: develop for 3.25 minutes, bleach for 6 minutes, wash for 1 minute, fix for 6 minutes, wash for 10 minutes, then dry. White lights may be switched on after the film has been in the bleach for 2 minutes. Aside from the time required to load reels or hangars, the entire process takes only 25 minutes dry to dry.

Color negative films consists of three separate black-and-white emulsions layered one on top of another. Each layer is cleverly designed to react to only one of three colors: red, blue, and green. The developer in the C-41 process works on the three black-and-white emulsions and causes color dyes, incorporated in the film at the time of manufacture, to couple with the silver images in proportion to the density of the silver. The red-sensitive layer accumulates cyan dye, the blue-sensitive layer accumulates yellow dye, and the green-sensitive layer accumulates magenta dye.

The bleach removes unused dye and the developed silver image. The fixer dissolves away all undeveloped parts of the black-and-white emulsions. What is left is a color negative made of organic cyan, yellow, and magenta dyes. When printed these layers transmit light disproportionately, so an overall corrective red/orange caste that equalizes the color densities is built into the plastic film base.

E-6 FOR COLOR TRANSPARENCIES The Kodak E-6 process for color transparencies, also the industry standard, is more complicated chemically than C-41 because the final image must be a positive rather than negative, hence the term reversal film.

The first developer requires approximately 6.5 minutes with normal agitation. (Development time for E-6 films can be increased or decreased—pushed or pulled—to increase or decrease effective film speed.) Next comes a 2-minute wash in running water followed by 2 minutes in the reversal bath. After 30 seconds in the reversal bath the room lights may be turned on. From the reversal bath the film goes to the color (second) developer for 6 minutes, followed by 2 minutes in the conditioner, then 6 minutes in bleach, 6 minutes in fixer, and finally 10 minutes wash in running water.

The E-6 first and color developers perform the same functions in two steps as the C-41 developer does in one, but here the tasks of black-and-white development and color coupling are divided so that in between the reversal bath can change the way the film and the dyes will interact. Thus, in reversal films the color builds up in inverse proportion to the density of the developed silver image, resulting in a positive. Because transparencies are primarily intended for direct viewing, slide film has an untinted film base.

COLOR PRINTING THE SIMPLE WAY Low-tech solutions might appear outdated to those people who have succumbed to micro-processor fever, but I prefer a simple and direct approach whenever possible. The logic that justifies black-and-white printing in trays applies equally well to color work—trays are fast, easy to maintain, and inexpensive to operate. Moreover, there is a powerful technical advantage to trays over machines that is unique to color processing for the low-volume lab.

Consider the following. In black-and-white printing the main variables are contrast and density. When making enlargements in color these factors remain important, but they are significant only after the correct color balance has been achieved. Unless intentionally altered to achieve some special effect, the correct color balance is a specific state in which familiar objects appear natural. There are several color markers that all of us look for unconsciously—for example, sky blue, leaf green, and normal skin tone.

The venerable 18% gray card can be used to quantify the process of evaluating color balance. After having been photographed and reproduced, the color of the original and the color of the print can be compared using a densitometer equipped with sharp cut-off red, green, and blue filters. (A sharp cut-off filter transmits only a very narrowly delineated bandwidth; in other words, it filters out everything except the color of interest.) If the gray card and its photographic copy are shown through accurate measurement of the primary colors to be identical, then the film, the paper, and the processing can be said to have worked together to produce a perfect result.

Commercial labs use fancy equipment and rigorous testing to make certain that the various chemical parameters affecting color balance never change. Machines are relatively slow, but, because they operate continuously, large numbers of prints can be put through per hour. Professional printers expose test strips or test prints from many negatives, run them through the processor, evaluate them, and then come back to process final prints after another hour (or two or three) of work in the darkroom. The machine must be consistent so that adjustments based on the test results still apply at the time the final prints are run.

In trays a test can be processed and evaluated in under 3 minutes, and a final print can be achieved after a test or two. With feedback this fast the exact state of the chemicals at any given time is unimportant. Changes sufficiently gross to alter the appearance of a print simply do not occur in 10 or 12 minutes. In one stroke this ultra-low-maintenance method reduces processing time by 80% and completely eliminates the need for chemical monitoring. These economies also apply to batch processing of multiple color prints.

NEW VARIABLES Black-and-white film processing allows a tremendous degree of control over contrast, but the contrast of color negative materials are predetermined when they are manufactured. This limitation has been imposed as a consequence of the chemical complexity of color materials in general. It is just too difficult technically to guarantee that color film will react to all colors in a linear way whenever contrast is adjusted. Happily, Kodak has introduced Ektacolor RA papers in three contrast ranges: Portra is lowest, Supra is normal, Ultra is highest. These papers are powerful new tools.

Density is an important consideration in color printing, just as in black-and-white work. Beyond the lightness or darkness of the image, variations in density have a noticeable second-order effect on color balance. With Kodak Ektacolor papers, building density by longer exposures tends to move color balance toward yellow. This can be problematic when burning-in a highlight, for example. To minimize the uncertainties some people rely on an electronic device called a "color analyzer," a highly evolved color-sensitive light meter. But because tray processing is so fast, my method of choice is the test strip/test print.

THE COLOR ENLARGER All color enlargers must have some means of changing the color of the light they project, because this is the only way to adjust the color balance of the print. Two different systems of manipulating photographic color have evolved out of the basic physical properties of light. The simplest to understand is the additive system, which uses combinations of the primary colors to generate all other colors. Enlargers that use the additive system, such as those made by Phillips, Nord, and Minolta, combine light from individually controlled red, blue, and green sources in a mixing chamber. Perfectionists say that this approach produces the purist and most saturated color, however the attendant optical and mechanical complexity adds considerable expense.

The subtractive system, almost universally accepted as the most practical solution, requires only one white light source—usually a low-voltage quartz-halogen lamp with a built-in reflector—modified by highly efficient cyan, yellow, and magenta dichroic filters. (Dichroic filters work by reflecting, rather than absorbing, unwanted colors. They are much more efficient and their characteristics are more stable over time than cheaper dyed-glass filters.) All enlargers based on the subtractive system, such as those made by Omega, Besseler, and Durst, have some precise mechanical means of controlling the degree to which

the filters intersect the path of the light beam so that the projected color can be carefully fine-tuned.

SELECTING THE CORRECT COLOR BALANCE

Before learning what corrections to make when color printing, it is necessary to understand how changes in the color of the light from the enlarger affect the print.

In the negative, colors from real life are represented by their complimentary colors: red objects result in a cyan image, blue objects appear yellow, and green objects are magenta. In the print, these values are again flopped, so that things look natural once more.

To determine what needs to be changed in an off-color print, first decide in which direction the colors are skewed. Is the print too red, blue, green, cyan, yellow, or magenta? Even for experienced printers it helps to have on hand several properly balanced prints for comparison. The trick is to remember that to reduce a color cast in the print, either increase the color in the filtration or carefully reduce the complement.

Cyan light from the enlarger induces red in the print.

If the print is too cyan, increase the cyan filtration.

Yellow light form the enlarger induces blue in the print.

If a print is too yellow, increase the yellow filtration.

Magenta light from the enlarger induces green in the print.

If a print is too magenta, increase the magenta filtration.

My Super Chromega enlarger accepts negatives up to 4x5in in size and uses the subtractive system of color control. Not unlike a view camera, the enlarger uses a bellows and monorail-like focusing system. The white knob is for fine focussing, while the black knob behind it is for coarse focusing. The crank at the back of the machine raises and lowers the whole apparatus on the heavy aluminum I-beam that is attached to the darkroom wall at the top and the counter at the bottom. Three lenses of different focal length (each for a different size negative) are mounted on a rotating turret below the bellows. Hanging on the pegboard in the background are various negative holders.

Only two of the three subtractive filters should be used at one time. The third will only add neutral density. Additional exposure is required as filtration increases.

Learning how to balance color is like learning to run a personal computer. At first it seems absolutely bizarre, but after some hard work the underlying simplicity becomes apparent. Take heart in the thought that filtration varies relatively little between negatives made on the same type of film exposed under similar conditions. After exposure and color balance are determined with test strips, test prints can be used to ascertain exactly where and how to burn and dodge.

RESULTS

I recently received a phone call from a designer client who had incorporated some of my prints in a brochure. She told me that while creating the layout she had automatically opened up Photoshop on her computer to perform remedial work on scans made from the photos I had supplied, when she suddenly realized "nothing at all needed to be done to your images. You produce beautiful prints that are a pleasure to work with."

Good processing and printing extends the value of good photography, and many important adjustments and photographic effects can be achieved more easily inside the darkroom than inside a computer.

DARKROOM TECHNIQUES FOR ENHANCING ARCHITECTURAL PHOTOGRAPHY

SUPERIMPOSING NEGATIVES Dedicated and patient darkroom workers can use several processing techniques to repair, improve, or enhance architectural photos. For example, an image that includes an overcast sky that registers as light gray or white on a color or black-and-white print can be reanimated by printing a second negative of an interesting sky directly onto the blank area of the print. Some experimentation is required to balance color and density and to create a believable, graduated boundary between the two superimposed images.

Similarly, quick and dirty mockups that show how a proposed building will look in a real skyline can be created by carefully gluing a close-cut image of a model (shot to the appropriate size and perspective) onto a print of the existing landscape; rephotographing and reprinting the composite will add to the credibility of the final result. (This technique works best for models with simple geometric forms. An experienced retoucher can do wonders with this technique in more complicated configurations.)

CORRECTING FOR HIGH OR LOW CONTRAST Architectural photography in direct daylight or heavily overcast skies can result in unacceptably high- or low-contrast negatives and prints. Unsatisfactory images can be moderated with several photo-mechanical interventions; none of these are particularly convenient, but from time to time in professional work situations arise where heroic efforts are required. One powerful remedy is a method of post-exposure contrast control called "silver masking" or "contrast masking." When printing a negative that is too hard the tonal scale may be compressed by masking with a thin black-and-white positive made by contact printing the original. The areas of maximum density in the mask coincide with the areas of least density in the negative, thus reducing the exposure in those areas when the two are printed in register as a "sandwich" using a glass negative carrier; the reverse is true for soft negatives printed together with a negative black-and-white mask. The same techniques work when printing excessively high- or low-contrast transparencies except that the masking values are inverted. Skillful masking can produce prints of exceptional quality, especially with color print material, the contrast-handling capabilities of which are inherently limited.

Some overexposed or underexposed black-and-white negatives can be salvaged by chemical agents called "reducers" and "intensifiers," which dissolve away or build up density. The action of these chemicals in remedial applications is rather crude, so do not expect miracles. Well-exposed and properly printed black-and-white images can be subtly enhanced by gentler applications of these same chemicals to local areas with a retouching brush, cotton swab, or fingertip—a chemical form of burning and dodging that is useful for altering small areas or intricate details. There are chemical reducers for transparencies that will lighten overall density or even specific colors (useful for slides made without filtration or with incorrect filtration under artificial sources).

As a last resort, a less-than-perfect negative or slide can be printed, then retouched and carefully copied.

NEW WAYS OF WORKING

The initial hoopla surrounding digital imaging coincided with the onset of a major and prolonged recession, and for a year or two the implications of the latter were mistaken for the implications of the former. I for one was certain that financial ruin was just around the corner. Business was shrinking, and those who were not on the digital imaging bandwagon were assumed to be doomed. Happily, this gloomy scenario has not materialized, except for many unfortunate dot-com/e-business speculators. Electronic photography is coming right along, technically speaking, but today and for at least the near future, film is still a highly viable and desirable recording medium. In fact, developments over the last few years in computer-aided-design (CAD) and computer-aided-manufacturing (CAM) have positively impacted the traditional photo industry, as demonstrated by a plethora of purpose-built cameras, lenses, films, and accessories highlighted in Chapters 9, 10, and 11.

I still shoot a lot of film, but now my business is successfully interfaced with the electronic revolution. This chapter, and those that follow it, examine the tools, methods, and implications of recent advances in digital imaging.

THE DIGITAL IMAGE

CONVENTIONAL VERSUS DIGITAL PHOTOGRAPHY A conventional black-and-white image is composed of tiny particles of metallic silver suspended in a gelatin emulsion spread on a paper or plastic base. A conventional color image is composed of tiny particles of organic dye suspended in several emulsion layers superimposed on a paper or plastic base. In both cases, the image-forming components are so small as to be nearly invisible to the naked eye, yet together they permit every conventional image to exist as a physical object, a collectivity of real particles, that can be seen and touched.

A digital image does not exist in the same way as a conventional image in that it cannot be seen or touched without some sort of physical interface. The dictionary Webster defines interface as "a surface defining a common boundary of two bodies, spaces, or phases…a place at which independent systems meet." We can see and touch an interface surface, be it an inkjet or dye-sublimation printout, a cathode ray tube, or a solid-state display screen, but we cannot see or touch the digital image it represents. A digital image exists only as a mathematically coded series of electrical or magnetic potentials inside an electronic device.

A computer encompasses and manipulates digital images in somewhat the same way that the brain encompasses and manipulates thoughts. Inside our biological computers consciousness is supported by a massively interconnected network of neurons—no brain, no thoughts. Inside a computer, digital images are supported by a somewhat less sophisticated network of electronic switches and magnetic or optical storage devices—no hardware, no image.

Thoughts are plastic and subject to all sorts of influences. We test drive possibilities on a mental plane, taking action on the physical plane after having arrived at an appropriate conclusion. Digital images, like thoughts, are also plastic. Ensconced inside their electronic environment, they can be juggled and teased and mutated at will.

HOW AN IMAGE IS DIGITIZED A digital image comes into being through an electronic system of image recording or digital capture. Fundamental to this endeavor is a solid-state optical sensor, called a charged-coupled device (CCD), that converts light to electrical energy. CCDs are the basic elements in most electronic imaging hardware, from video camcorders to high-end large-format still cameras.

An electronic camera uses many CCD sensors grouped together to transform an image into a grid of picture elements, or pixels. Each pixel is assigned a value that corresponds to the average of all the brightness or color levels within the pixel's area. This value is encoded as a sequence of zeros and ones. In computer terminology, each zero and each one is a bit and eight bits is one byte. The black-and-white data for one pixel occupies one byte of memory. For a color image, one byte per primary color component is required for each color pixel, hence the term 24-bit color. All the bytes from all the pixels of a complete image are stored as a data block, or file. The file size for color image storage is necessarily three times that of a comparable black-and-white image.

We know from conventional photographic practice that the finer the grain and/or the larger the piece of film, the higher the resolution. The same is true for digital imaging, except the key variable is the number of pixels rather than the number of grain particles.

. The images are (in most digital cameras) stored on CF (compact flash) memory cards. A CF memory card is a small removable mass storage device. A typical unit weighs half an ounce and is slightly smaller than a matchbook. A CF card is like a reusable roll of film for a digital camera, and they are available in 8mb through 512mb configurations. Because these devices are entirely solid-state, they are extremely durable. Costs range from about $25 for the smallest card, up to $500 to $600 for the largest. IBM makes a tiny 1gb hard drive ($500, approx.) that will fit in some CF slots. The extra storage is welcome, but because they incorporate moving parts, micro-drives are much more susceptible to mechanical damage.

FILE FORMATS AND IMAGE RESOLUTION Different file formats have different characteristics. Some software programs and digital cameras dictate the kind of files that must be used, but typically, there is some leeway.

The required file size is determined by image resolution, which is in turn determined by the choice of image output. For on-screen use, it is only necessary to match the resolution of the monitor (typically 72dpi), which is listed as part of the technical specifications in your user's manual. To determine resolution for a printer, divide the printer's resolution by 3, for example a 360dpi color inkjet printer will be able to faithfully render an image scanned to a maximum of 120dpi. To compare dpi with pixels, multiply the dimensions of the image with the scanning resolution. For example, a 5x7in image scanned at 120dpi would measure 600x840 pixels, or about 1.5mb.

GIF (Graphic Interchange Format) is useful for images that are to be posted online (that is, on the web), because its relatively small file size allows rapid uploading and downloading. GIF files are not practical for other applications, however, because they will handle only 256 colors, so their detail and color quality are relatively primitive, and are therefore limited to images with solid color fills and/or text.

JPEG (Joint Photographic Experts Group) files are more commonly used to display photographs online and use a variety of compression techniques to create minimally detailed images. Unlike GIF and TIFF, JPEG is a "lossy" compression scheme, which makes it less desirable for print work. (*See Chapter 19 for more about file compression and file transfer.*)

TIFF (Tagged Image File Format) files provide high-resolution and high-quality color and black-and-white for printing applications and high-quality on-screen display. TIFF files can be compressed in ways that reduce file size while retaining full image quality (LWZ compression).

35MM DIGITAL CAMERAS

INTRODUCTION Film is fast and flexible and can be digitized relatively cheaply, but entirely filmless photography has some appealing advantages, especially when the images are intended to be directly incorporated into a desktop-created document, a computer-animated presentation, or an Internet-based web page. In these and other no-print-required situations, an appropriate digital camera provides a direct, chemical-free link between subject and end use.

Not so long ago the digital camera was an intriguing novelty that was only slowly evolving into a moderately useful working tool for those interested in documenting architectural projects. As this is being written, the novelty has not diminished and today's 35mm digital cameras are becoming significantly more useful than their antecedents of only a few months ago.

The biggest change has been the introduction of larger sensors; a year or so ago a range of 1 to 2 megapixels was the rule, now 3 or more megapixels is standard on most models. Sales of these cameras are increasing rapidly as image quality and the utility of the camera/computer/printer interface improves. Fully automatic point-and-shoot models can now provide image files that look great on a screen and translate into excellent quality 8x10in prints. More advanced 35mm single-reflex (SLR) models with 3 to 7

The Nikon Coolpix 885 is the slightly less expensive, slightly less sophisticated version of the Coolpix 995 described in the text. Image courtesy of Nikon Canada.

Canon's entry-level interchangeable lens SLR, D30, features 3.25-megapixel resolution, sturdy construction, and, at approximately $2500, reasonable cost. Shown here fitted with a 24–85mm zoom lens. Photo courtesy of Canon Canada.

megapixel sensors integrate well with existing upscale professional lenses and accessories from traditional high-end manufacturers like Canon and Nikon. Following are some interesting cameras currently available.

POINT-AND-SHOOT CAMERAS The Canon Powershot G1 is a 3.3-megapixel device equipped with an f2–f2.5 3x 8-element aspheric optical zoom lens (equivalent to 34–102mm) that focuses to a very close 2.3 inches, perfect for recording details in architectural models or of mechanical structures. A flip-out LCD screen yields instantaneous image previews, useful when manipulating the contrast, saturation, and sharpness controls built into the camera. The G1 incorporates an unusual feature for a point-and-shoot camera —full manual control is a selectable option. Image files are saved to CF memory cards at three user-selectable resolutions and three compression modes. The unit costs approximately $800.

The Nikon Coolpix 995 replicates the popular twist-body design of the venerable Coolpix 990, but with a 3.34-megapixel sensor, a new pop-up flash, 4x optical zoom (38–152mm equivalent), 2cm macro close-up capability, and 123-step auto-focus. The 25-element matrix auto-exposure system provides both exposure and white-balance bracketing capability. Another unusual feature of this camera is a flash synch terminal for an accessory flash, helpful for lighting large interiors. The retail price is around $900.

Manufacturers are breaking the old molds, and almost every point-and-shoot digital camera sports some unique features that separate it from its competition. In this spirit, Polaroid has provided its Polaroid Photomax PDC640 Modem with a built-in 56k modem, which permits uploading of images to the web without a laptop computer. Just plug in a standard phone cord and push a button to connect to polaroiddigital.com, a secure service that provides easy uploading and downloading plus storage for your images at $5 per month; certainly a convenient way to get those quick-and-dirty progress photos back to the office. At only $200, this machine also saves its VGA quality to CF cards. (VGA stands for video graphics array, the most common of several technical conventions describing the color gamut and resolution characteristics for video monitors used on personal computers. Other, newer standards, such as SVGA [super VGA], provide for a wider range of colors and higher resolutions.)

The Sony Mavica MVC-CD300 is a 3.34-megapixel camera that makes it easy to store up to forty maximum-quality JPEG images with a built-in digital mini-disc recorder. Using 3in 156mb CD-R or CD-RW media that will work in a typical computer's CD-ROM drive without any modification, this, albeit slightly slow, recording method costs only about 3 cents per megabyte and eliminates interface cables and software entirely. The typical retail price is about $1000.

Another route to high-capacity storage has been taken by Sanyo. The 1.5-megapixel Sanyo IDC-1000Z iDshot offers an amazing 730mb. A built-in drive works with a $35 (about 5 cents per megabyte) 2in-square removable magneto-optical disk to provide more capacity than a regular full-sized CD. A firewire connection turns the camera into a high-speed hard drive, which means that TIFF or JPEG images or QuickTime video can be viewed and edited without having to download the files to the computer. Costs are around $1200.

SINGLE-LENS REFLEX CAMERAS At $2500, the Canon EOS D30 with its 3.25-megapixel SLR body has shattered the $5000+ threshold for a professional-level camera. Fully integrated into an extensive system of lenses and accessories, the D30 offers 3-point auto-focus, 3-frames-per-second drive speed, eleven shooting modes, twelve custom functions, 35-zone evaluative metering, and a built-in E-TTL flash system. Dye-sublimation 8x10in prints made from 48bit TIFFs converted from the 18mb 24bit raw files this camera produces are superior to regular 8x10in photographic prints made from 100 ISO 35mm color negatives. Type I/II CF cards are used for storage, and a USB connection is provided for tethered downloads. The body will feel very familiar to anyone used to current top-of-the-line Canons.

Also fully integrated into a comprehensive modular system, is the professional-level Nikon D1x. The D1 SLR body doubles the previous 2.7-megapixel capability of its predecessor to 5.47 megapixels and yields impressive 18mb 8bit TIFF files, nearly as large as a high-res scan from 35mm film. With an effective sensitivity range of 200–1600 ISO and

up to five frames per second for forty consecutive shots at shutter speeds as high as 1/16,000sec, this camera has become a favorite of sports photographers and photojournalists. It is priced close to $5500. The similar but slightly slower D1h is available for $4500.

Fuji claims that its proprietary technology coaxes performance equivalent to that of a 6.1-megapixel device from the 3.4-megapixel Super-CCD chip in the Fujifilm Finepix S1 PRO. Apparently they are on to something, because the camera's full-resolution 10mb TIFF files produce outstanding enlargements. Another advantage of the highly tweaked sensor is increased sensitivity, rated at an equivalent to 320–1600 ISO. The camera uses Nikon interchangeable lenses, and at about $2700, it is a good value.

At around $2000, there is no better bargain for a fully featured SLR than the 5.24-megapixel Minolta Dimage 7. This camera does not have interchangeable lenses, but

Here is the Minolta Dimage 7 digital camera. A formidable machine, featuring a 5.2-megapixel sensor, and 7x zoom lens. Image courtesy of Minolta Canada.

the high-performance apochromatic 28–200mm built-in zoom is no slouch, sporting sixteen elements in thirteen groups with two aspheric components, and a maximum f2.8 aperture. The lens is augmented by a 2x digital zoom feature and focuses as close as 5.1in (13cm). A 4x digital magnification function enhances focusing accuracy significantly. Exposure, contrast, and color saturation are fully adjustable and can be bracketed automatically. Variations may be easily evaluated even under bright daylight on the 122-megapixel 1.8in LCD display. Three-point auto-focus, 300-segment metering, auto-white balance, and video capability make this an impressive, economical digital solution.

After having perused an array of $700 to $2000 consumer-oriented digital cameras at the local camera store, a $5000–$20,000 professional Nikon, Fuji, or Kodak digital SLR system certainly looks like a premium electronic imaging product. And, as far as small format goes, these digital 35mm clones are, in fact, top of the line. Sporting sensors of up to 6 megapixels, such cameras will generate extrapolated files that render excellent 8x10in prints. Because of this ability they are finding a lot of use among sports photographers, photojournalists, and even wedding photographers. Commercial photographers, too, are using this class of camera to produce images eminently suitable for reproduction at small sizes in newspaper advertisements, brochures, and such. Since they accept interchangeable lenses—including the extreme wide-angle and perspective-control varieties—we can use these SLRs very effectively for architectural photography intended for desktop publishing, the web, or proposals and competition entries.

HIGH-END DIGITAL CAPTURE

But even expensive 35mm film and 35mm clone digital cameras cannot produce images of impeccable image quality in every situation for every application. In earlier chapters we learned that with film-based photography there is an image-quality advantage associated with larger formats, so it is not surprising to learn that in the digital world too, bigger can often be better. Nevertheless, I must qualify this statement, because just as in conventional photography, medium- and large-format digital work introduces technical problems as well as technical gifts. This section will investigate the realities of high-end digital capture.

There are two approaches to medium- and large-format digital imaging, both of which depend upon existing conventional camera technologies by substituting electronic devices for the interchangeable film backs and/or film holders normally used with professional-level medium- and large-format cameras. The first approach uses a large sensor (as this is being written 16 megapixels is the upper limit) to mimic the one-shot capabilities of film

at a normal range of shutter speeds. This approach is convenient, since shooting methods need not be significantly modified, and moving subjects present no special difficulties. The ultimate image quality, though, is limited by the size of the sensor, and since big sensors are difficult to construct, they are expensive.

Certainly, 16 megapixels is significantly more than the 3–7 megapixels provided by smaller cameras, but it is no match for a 100–200-megapixel file produced by high-end digital option number two—the scanning back. Scanning backs are miniaturized, ultra-high-precision versions of the desktop flatbed scanner. They attach like film backs, but the similarity ends there. Scanning backs have no one-shot capability at all: An image file is constructed by adding together the thousands of consecutive stripes of data created incrementally as a linear array consisting of tiny red-, green-, and blue-sensitive sensors travels slowly across the film plane. A scan time measured in minutes (1–10 minutes, depending on scan parameters) is typically required to make a high-resolution file. Naturally, these units are not at all suitable for moving subjects, but in the appropriate situations the image output is exceptional, in fact, more than equivalent to a high-resolution scan made from a well-exposed medium- or large-format film image.

Architectural photographers often record a mix of moving and none-moving subjects—we have flags, clouds, foliage, water, people, and vehicles to contend with—but many interior views and some exterior views made on windless days include no moving objects whatsoever. So those interested in producing premium work can employ both single-shot and scanning-based capture systems according to subject matter, time, and budget conditions. On your behalf, I have investigated these conditions, working on various location shoots with both a high-performance scanning back and a high-end one-shot back.

A Better Light scan back and its controller box. Image courtesy of Better Light Inc.

This is the Better Light portability option, which includes a rigid case, lead-acid dryfit battery, controller box, and scan back. The case provides space for storing a laptop (not included in the portability package). Image courtesy of Better Light Inc.

THE SCAN-BACK APPROACH The scanning back I tested was provided by Better Light Inc. (www.betterlight.com). I had the use of their Model 6000 Digital Camera System, which came with a 48 (6000x8000) megapixel scan back, camera and image management software, a controller box with built-in hard drive, a rechargeable battery, and several proprietary cables, all of which added up to a retail value of $16,000. Everything, including my Macintosh G3 Powerbook, slotted nicely into a padded, fitted case 8x10x16in in size that weighed about 15lbs when packed to travel. This ensemble completely eliminates the need for conventional roll or sheet film, Polaroid test film, and regular film backs. For a big shoot, traditional materials and equipment might approach the weight and bulk of this digital replacement package, but generally it will not; there can be no argument that the new hardware demands a formidable physical investment. Of course, digital equipment permits on-site image evaluation and evaporates the costs, hassles, and vagaries of chemical processing.

SCAN-BACK TECHNOLOGY AND HARDWARE The scanning back, controller, battery, and laptop need to be linked together for every exposure by multi-conductor computer-cables with thumb-screw connectors, which means time and effort must repeatedly be expended on assembly, disassembly, and shifting the gear from one shooting location to the next, even if the locations are separated by only a few feet. And we have all learned by hard experience that everything in the computer world is physically delicate and susceptible to contamination by dirt, dust, and moisture. The required extra measure of environmental mindfulness adds still more work-related tension: The sensible remedy is charging an assistant with lugging the equipment from place to place and maintaining a watchful eye while the primary shooter is occupied by camera placement and set-up.

Upon receiving the equipment from Better Light, I erased all unnecessary files from my laptop hard drive to make room for the bulky image files I would be making shortly, and then copied the camera management software from the CD provided. The software is comprehensive, offering a wide variety of controls over color, density, effective ISO speed, contrast, brightness, and cropping. Professional users of these digital backs quite effectively use the Better Light program to optimize their raw RGB files before importing them into Photoshop™ for retouching. The CD sensors used in the scan back are capable of generating a tremendous wealth of image data over an 11-stop range of luminosity, so some user-defined limitations must be made in order to end up with images that fit into the much narrower reproduction range of print or video display. Several predetermined

The Better Light system (portability option) on location. Image courtesy of Better Light Inc.

characteristic curves are selectable via pop-up menus; these include curves that mimic the response of conventional transparency films, a curve for copy work, a low-contrast curve, even a "raw" 16bit (i.e. unmodified data) curve, for those who really do wish to finesse their work in Photoshop™.

The software provides for fast preview scans that appear in a scalable window on screen. The effect of any of the software controls can be quickly evaluated in real time as the necessary image parameters are adjusted for an appropriate final scan. The preview scan might take anywhere from 10–90 seconds, depending on frame size and image resolution, as well as effective ISO. A very precise qualitative focus function can be accessed by selecting the "focus" tab. After a cross-hair indicator is positioned on the preview display, numerical and graphical readouts indicate the optimal focus point in real time as the lens is slowly racked in or out manually.

Once exact focus and other necessary image values have been determined, a mouse click on the "scan" button initiates recording, which can take anywhere from 30 seconds to several minutes. The process can be accelerated somewhat by writing the image file directly to RAM (a selectable software option), rather than to the hard drive in the controller box, if the host laptop has sufficient memory resources. RAM capability of at least 1.25x the largest image size is required for this approach to work effectively. The image files are big and lots of RAM is definitely much better than just enough.

SCAN-BACK SHOOTING IN THE REAL WORLD　　How does the process fare in the real world of location architectural photography? Surprisingly well! Once one becomes used to the mechanical aspects of handling the equipment, digital photography is a breeze. My learning curve was steep but quick, and it is exciting to record technically exquisite digital images right at the scene.

I began by making a few test images inside my home. Less than 15 minutes was required to hook up and start the equipment the first time. The initial image was very odd-looking, washed out and off-color, because I had forgotten the glass infra-red cutoff filter that came with the digital kit: The CCD sensors are sensitive well into the infra-red range, and there are two filters provided, one for day light and one for tungsten light. 3x3in and 4x4in filters are available, at approximately $175 and $545, respectively. Better Light recommends securing the filter behind the lens, which is a good solution for roomy view cameras but does not work for the Fuji because of the reflex mirror—I inserted the 4in filter into my regular Lee Filters adapter.

A few minutes after this problem was sorted out, I was literally astounded by the digital image I had made of my kitchen. The wide-angle view of the whole room in available light was so detailed that I could easily read the fine print on the label of a spice bottle at 25x magnification on my PowerBook screen. Color fidelity was shockingly pure, and the dynamic range of highlight-to-shadow luminosity was outstanding. I was looking at digital image files completely free of dust and scratches right out of the camera—scans from conventional films always need to be cleaned up, either with Digital Ice or manually in Photoshop™, both of which are time-consuming operations.

SHOOTING ON ASSIGNMENT WITH THE SCAN BACK　　The first field test of the outfit occurred on a trip to Chicago, Illinois, where I photographed new retail additions to both Midway and O'Hare airports for the Vancouver architectural firm responsible for the design work. At the request of my publisher, three additional days were added to shoot an image for the cover of this book.

Both airports were swarming with people, even at 5 A.M., when the retail concourses opened up, so the inability of the scan back to properly record moving subjects precluded its use at these locations: Moving objects leave behind obvious vertical bands or stripes, sometimes with chromatic fringing, depending on relative luminosity. Small things like flags or a leaf or two can be quickly dealt with in Photoshop™, but the multi-colored digital evidence of larger, more complicated entities such as people or vehicles are very hard to eliminate, particularly if they have tracked slowly through the foreground. I shot with 400 ISO color negative film, and put off the scan-back test until I could work outside with stationary buildings.

I was eager to put the equipment to use, so at dawn the morning after, I was standing on a deserted construction site across the river from the famous Mies van der Rohe IBM Plaza tower. Normally, I would have brought only a camera bag and a tripod to make a

These images show the famous "corncob" apartment towers (left) in Chicago with the Mies van der Rohe IBM Tower (right) in different light and sky conditions. Note that there are no moving objects in these shots, an ideal condition for scan-back photography. The best camera position available was so close to the tall subjects that the range of perspective control on the camera (Fuji 680 III) was inadequate for full correction (see images below). The image to the right was corrected for rectilinear perspective using the "Transform/ Distort" tools in Photoshop™.

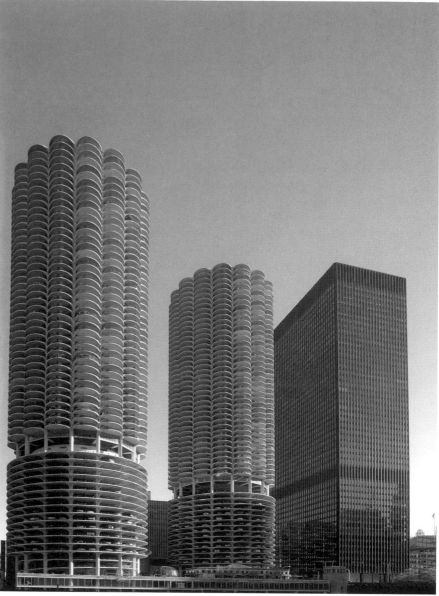

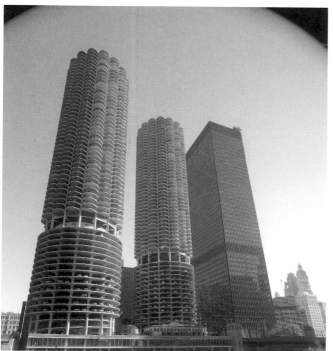

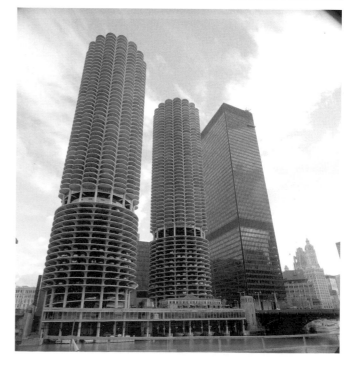

shot like this. Now I was carrying an extra case with the digital gear and computer, which necessitated the use of a two-wheel cart and some tricky maneuvering as I scrambled over chunks of broken concrete and other debris.

Once in position, the early hour and the secluded locale afforded a peaceful working environment. Without too much mechanical confusion I was set up and ready as the sun rose between two office towers on my side of the river. On the first exposure I repeated my earlier error of shooting without the infra-red filter, but subsequent images were made quickly and smoothly. However, as the sun rose higher and the day got brighter, it became more and more difficult to view the computer screen, and I had to make adjustments for exposure and color based on the only slightly more visible preview histograms. For the next day, I fashioned a collapsible sunshade out of cardboard and masking tape. A more elegant nylon and velcro solution for this problem is available from Hoodman (hoodmanusa.com) for about $40.

SCAN-BACK DIFFICULTIES Every digital shot was also recorded on color negative film, and two problems became apparent as I switched back and forth between media:

First, the digital back captures a wider field of view than the 6x8cm film aperture on the dedicated Fuji backs. It is nice to have the extra image area, but taking full advantage of this attribute as I was doing in this situation, meant that the film backup image was inevitably cropped tighter than the digital image. Some discipline in setting the electronic framing on the digital preview would negate this anomaly, but I find that for most wide-angle photography involving perspective control, every extra millimeter of coverage is irresistible.

Second, the mechanical procedure of switching backs was awkward and time-consuming since the Fuji adapter for the Better Light unit is quite large and will not rotate to come off the camera with the angle-finder in place. The finder and the back must be removed and placed somewhere stable and clean, the camera shutter must be closed (I used a locking cable release to hold the shutter open during the relatively long digital scan times, typically 2 minutes at 100 ISO with an aperture of f22 in full sunlight), and the multiple exposure control reset to normal sequential function. I usually tested with Polaroid before making a conventional exposure, as well.

The whole procedure had to be repeated in reverse to refit the digital back, and then another prescan had to be made if any shooting conditions had changed during the interval. All this took up a minimum of 5 or 6 minutes per sequence and I missed opportunities for specific shots at certain critical sun angles in both formats as I fumbled with the equipment. Nevertheless, at this early stage making a conventional backup was in my view worthwhile, since the digital file sometimes turns out to be unsatisfactory and, of course, there is always the possibility of catastrophic hard-disk failure.

When I took a close look at the files in Photoshop™ later that day, I was very pleased with the results. The day had been windy and some cumulous clouds were tracking across the sky, but since the preview scans looked OK, I ignored the movement and shot anyway. A close examination of the files revealed that no objectionable banding or color fringing had occurred, presumably because the clouds were white, bright objects moving in front of a relatively dark monochromatic (blue) background. And again, the incredible image resolution capability of the Better Light technology took my breath away. I had brought along a portable CD writer with me and transcribed the raw files onto disk for security and to clear off the hard drive to receive the next day's work.

TWO CLOSE CALLS WITH THE SCAN BACK My digital confidence was growing. In fact, I was getting cocky and a little careless—so the very next morning I had a problem. Architectural photography in big cities is an exercise that involves extremely precise timing. As the sun swings across the sky over deep urban canyons, so do the shadows of huge buildings. The desired light conditions at subject structures might last only 5 to 10 minutes, so one must be ready and waiting at predetermined locations and predetermined times to capture the perfect effect. And there I was at 9:10 A.M. with my camera secured to the precisely positioned tripod and the computer, digital back, and conventional back all loaded and close at hand, on the sidewalk across the river from the Wrigley Building. Unfortunately, the battery powering the digital setup died just as I fired up the controller box. Figuring furiously, I guessed that if I quickly packed up the equipment, raced

These images show the Wrigley Building in Chicago under a variety of sky and light conditions. All were shot from the exact same camera position, over a period of less than an hour. Moving objects like flags and people, exhibit color banding that need attention in Photoshop™. The cutoff at the upper corners indicate that maximum coverage of the shooting lens was being exceeded for maximum perspective correction. These areas can be filled in with Photoshop™ controls.

These details highlight differences between the non-digital and scan back images made under dim available-light conditions. The images to the right show a magnified view (compare thumbnail image below for scale) of a dark area of the frame. Shot at an effective ISO of 1600, we see the "noise" that is the digital equivalent of film grain on the left image. (If this image had been made with an effective ISO closer to the native ISO 100 sensitivity of the CCD sensors in the Better Light back, the noise would have been almost completely undetectable.) The comparable film detail (right image) is much smoother. My non-digital ICE[3] scanner, however, records a lot of dust spots that would need extensive clean-up in Photoshop™.

The details above show how digital image noise quickly disappears as light levels rise, even at an effective ISO of 1600. The digital image to the left is hardly distinguishable from the film image to the right.

back to the car (a block away in a parking lot), and quickly fabricated an electrical connection between the Better Light battery and the car battery, I could briefly charge the former with the latter, and still get back to the location in time to set up for the sun's imminent arrival. This in fact I was able to do. I was back in time to set up and shoot what was needed, both digitally and on film.

My next commercial application for the scan back was not quite so successful, again because of a careless error:

Back home in Winnipeg, I was asked to photograph a bedroom suite in a newly renovated hotel. The digital approach seemed perfect for this job—a single shot, no moving objects, constant lighting conditions. Just to be sure, however, I brought a conventional back and some color negative film with me, and I was ultimately very glad I did.

After preparing the room for the shoot, the camera was carefully positioned and the computer and Better Light hardware were set up on a nearby end table.

The preview indicated that at f22 and an effective 200 ISO the final scan time would be over 11 minutes. At this point, my own impatience led to an error of judgment: Eleven minutes just seemed too long to wait, so I selected a higher effective ISO, which in turn yielded a much shorter scan time of 3 minutes. I confirmed the exposure with another prescan, made some subtle color adjustments, and then finished off with two scans. By simple reflex, I took a couple of backup exposures on color negative film before putting the camera away.

Back at the studio, a close look at the final scans revealed two deficiencies I had overlooked at the location, one of which was caused by selecting too fast a scan time, and the other caused by selecting too long a scan time.

Error number one had to do with image quality. The native sensitivity of the CCD sensors in the Better Light back is approximately 100 ISO. Any higher effective ISO is

achieved by the software through amplification of the analogue signal generated by the CCDs, which in turn amplifies the noise (non-signal information) inevitably present in any electronic system. The higher the effective ISO, the lower the signal-to-noise ratio, which after analogue-to-digital conversion, manifests as a degradation of image quality that looks, ironically, much like the grain associated with high-speed films. The higher the ISO, the worse the digital "grain." My impatience made me select an effective ISO of over 800, which resulted in an image of unacceptable "graininess" for the application.

I should have stuck with the 11-minute scan. But even the 3 minutes were too long in relation to another potential variable I failed to properly consider: the ambient daylight. My error was assuming that the exterior daylight was constant. Because I did not check the conditions outside, I did not notice that subtle streaks of high cirrus clouds were drifting across the sun. This was recorded in the 3-minute scans as undulating bands of about ±10% nominal density most visible in the ceiling portion of the image: Fixable with Photoshop™ of course, but an annoying oversight, nonetheless. The backup color negative, which I had made more or less on autopilot, saved me from the professional embarrassment of having to reshoot.

My overall experience with the Better Light 6000 high-end scan back was strongly positive. Their hardware and software is sophisticated and certainly capable of producing exquisitely accurate digital imagery so long as it is used properly in the appropriate circumstances. For someone with a special interest in recording highly detailed and chromatically faithful architectural interiors without people, this device is the most perfect electronic tool available today. As we have seen, for exterior work where movement or changing light is not a significant component, the Better Light unit also performs more than admirably. This is, however, a relatively new technology, and there is room for improvement.

AVAILABLE SCANNING BACKS High-performance scanning backs are available from other manufacturers, but, as one might expect, the field is limited.

One of the early entries, Dicomed, succumbed in 1999 to financial difficulties despite the fact that their equipment was highly respected. However, if a used back from this manufacturer is offered at a reasonable price, Better Light is offering parts and service for these units. The early Dicomed backs are slightly less-refined versions of the current Better Light units, which now include 53mb and 549mb models. Better Light's latest, the 309mb super 6K-2 ($19,000) incorporates a new Kodak CCD with a native sensitivity of ISO 200—a great development for those who shoot a lot of interiors.

The Jobo Proscan 10500 is an ultra-high-performance back that covers 4x5in at a native resolution of 10,500x13,100 pixels. It is capable of generating 395mb 24bit RGB files. Proprietary digital-noise-reduction software yields clean, pure color with comprehensive image management controls. Special circuitry synchronizes the capture process with the 60Hz 120VAC powerline in order to ensure minimum banding due to supply fluctuations. The suggested retail price is about $25,000. The slightly less sophisticated Jobo ImageScan 8000 provides 8000x10,500-pixel resolution for 240mb 24bit scans with the same software for a little less cash: about $19,995. Both units use an scsi interface.

The precision PowerPhase scanning backs from Phase One are designed to work specifically with Mamiya, Hasselblad, Bronica, Rollei, and Fuji medium-format cameras as well as 4x5 large-format cameras. Users of the PowerPhase can expect ultra-high-resolution images of up to 144mb at 8bit RGB and 288mb at 16bit RGB output. Working up to the equivalent of ISO 1600, PowerPhase captures images directly to the computer hard drive via an scsi cable connection. It costs about $25,000.

Also from Phase One is the PowerPhase FX. This large-format 4x5in back will create the largest image file in its class, a whopping 760mb. This unit is specifically for photographers who need to enlarge their still-life images to huge sizes with better-than-film quality. The PowerPhase FX software tracks RGB values over the duration of the exposure, making real-time adjustments for lighting fluctuations created by changes in the electrical supply. The result are digital scans with no banding and accurate, consistent color. Offering the world's highest resolution at 10,500x12,600 pixels, it is capable of scan times of 240mb per minute through a firewire cable of up to 200ft in length. Typical file sizes are 380mb (8bit RGB) and 760mb (16bit RGB). Approximately $35,000.

The principal power of the scan back resides in its ability to create data-rich image files, and the principal liability is the fact that such files are necessarily huge. At present, it is the creation and storage of huge files that dictates slow operation and mechanical bulk. I expect that advances in storage methodology will shrink or eliminate the controller altogether. In the near future I hope we will see some sort of wireless link between the back and the controller and/or the computer. Further advances in storage media will make on-board storage a possibility, and together with an on-board microprocessor and color LCD preview screen, the scan back will eventually become a tether-free, self-contained unit. This is all speculation, of course, but when this technology does finally arrive, the demise of film seems certain.

HIGH-END ONE SHOT BACKS A functional approximation of the perfect digital system exists right now. Those who want to transcend the technical capabilities of the digital 35mm clones while avoiding the speed-of-operation limitations associated with scanning technology can choose from a surprisingly wide range of one-shot digital backs. Built to attach much like conventional film backs to medium- and large-format systems and to specialized smaller-format bodies, these devices are used just like film, with a normal range of shutter speeds under available light and with electronic flash or tungsten photographic lighting. One unit, the Kodak DCS Pro Back conforms to most of our wish list in that it is entirely self-contained, with built-in storage and preview viewer. Others, like the Phase One H2O and LightPhase backs, need to be tethered to a computer. At up to 16 megapixels (dimensional resolution), these units fall short of the absolute high-end of the scan-back approach, but for many practical purposes, they will do most jobs that film can do, and often do them better.

TESTING A ONE-SHOT SOLUTION The prominent Canadian photographic supplier Vistek (vistek.ca) kindly arranged for a loan of the LightPhase back, together with a Horseman Digiflex body, altogether a $30,000 retail value. My original request included an adapter plate for the Fuji 680, but this arrangement would have limited wide-angle photography because of the small physical size (24x36mm, identical to a normal 35mm frame) of the CCD sensor in the LightPhase back. There are only two sensors in current use across the one-shot world. The unit inside the LightPhase is made by Phillips. Pixel dimensions are 3056x2030, and it can generate 18mb raw files when used in conjunction with the proprietary LightPhase image-processing software. The newer Phase One H2O back and the Kodak Pro Back both use the larger Kodak 37x37mm sensor. This 4080x4080pixel CCD does provide an advantage when the full square is used for image making, yielding interpolated files of up to 48mb.

The Digiflex is a simple but well-constructed reflex body that comes configured to accept the Hasselblad version of the LightPhase back together with Nikon 35mm interchangeable lenses. The unit I worked with was fitted with a Nikkor 28mm PC lens. The Digiflex body has two electrical connectors that are linked to the LightPhase back with short cables. A unique feature of the Phase One technology allows the back's sensor to be switched on and off by the flash synch switch inside the camera body just before and just after an image is captured. Such an approach saves battery power (the back takes energy from the computer through a firewire connection) and also allows cooler operation, which in turn reduces the creation of artifacts (non-image-related data) in the output files.

As reflex cameras go, the Digiflex is fairly primitive, with no auto-diaphragm function and an awkwardly dark Kepler telescopic viewfinder that straddles the significant depth of the LightPhase back by extending out from the camera body about 3 inches. These hindrances notwithstanding, I found this package to be light, compact, and easy to use. The equipment must be tethered to a laptop on location, but the firewire connection provides for hot-swapping, which makes moving around much less complicated compared to the thumb-screw scsi connection used by Better Light and several other manufacturers.

ON ASSIGNMENT WITH THE LIGHTPHASE My intention for this evaluation was to simultaneously shoot both color negative and digital images while on assignment in Vancouver. I had three buildings to photograph, inside and out. I got underway and took a fast look at the first few digital images with the LightPhase software's preview and contact sheet functions (A 1mb preview image pops up within a few seconds after each exposure) followed by a closer look in Photoshop™.

Shown here is the Kodak Pro Back, the only high-end one-shot digital camera back with built-in LCD preview screen and image storage capability. Image courtesy of Kodak Canada.

This is the Horeseman Digiflex II, a newer version of the unit I used for the LightPhase test. It is fitted with a Nikon zoom lens and one-shot digital back. A compact, powerful setup. Image courtesy of Horseman USA.

Here are four interior images from the Contemporary Art Gallery in Vancouver (Architectura), all made with the LightPhase one-shot digital back with the Digiflex body and Nikkor 28mm PC lens. All were originally in color.

Top left: This interior view of a small exhibition space clearly demonstrates the extremely wide tonal latitude possible with high-end digital capture technology. Both the bright, sunlit window areas and the interior walls and ceiling are rich with detail.

Top right: This image shows a larger gallery space and also displays rich detail at both ends of the tonal scale, even in and around the fluorescent fixtures.

Bottom left: This extremely wide view is actually a composite of two images made from the same camera position . . . one image was made with the 28mm PC lens set to maximum rise, and the second with the lens set to maximum fall. This scene was illuminated by a mixture of daylight and tungsten sources. The calm color response of the digital hardware yielded a final view that is very natural in appearance.

Bottom right: This image is a detail from the same stairway. The light coming out from under the stairs was from a fluorescent source, the light from above was a mixture of daylight and tungsten. The original color image encompassed this chromic potpourri very satisfactorily without filtration.

The very first digital files were just lovely; very detailed, with wide tonal rendition and what can only be described as calm color reproduction, even under mixed light sources. I soon established a relaxed working rhythm, and moved very efficiently from shot to shot, indoors and out. I never did shoot a color negative during the entire four days, and simply left the heavy Fuji kit locked in the rental car trunk.

I worked exclusively with the Nikkor 28mm PC lens, and when it did not provide wide enough coverage, I shot two images from a fixed camera position using maximum left/right or up/down shift and later knitted them together in Photoshop™. The Digiflex was definitely difficult to focus, particularly in dimly lit interior spaces, and occasionally I wished for greater effective ISO. The LightPhase native sensitivity is equivalent to 50 ISO and at small apertures exposures did grow inconveniently long, but at 30 seconds or so, they were still shorter than what a scan back would have required.

FOCUS AND FRAMING WITH THE LIGHTPHASE There are in fact other one-shot-capable camera options that offer easier focusing. If wide-angle photography is not necessary, adapters will connect the LightPhase or any of several other backs to medium-format SLR systems or even 4x5in cameras, all of which have bright and sophisticated viewfinder systems as normal features. Perhaps the best option, concerning viewfinding, when wide-angle digital photography is the order of the day, is a clever device called the TrueWide (truewide.com). This machine uses a precision sliding-back arrangement in combination with a permanently mounted leaf shutter fitted with a special adapter that accepts Nikon, Canon, or Olympus lenses. Sliding back mounts are available for Hasselblad, Contax 645, and Mamiya 645 configurations. All mounts can easily and quickly be rotated, and the Copal #3 shutter offers low vibration and excellent reliability. Specially designed Beattie Intenscreen Plus focusing screens are used in conjunction with a proprietary fresnel lens and Hasselblad or Sinar reflex focus hoods for a very bright viewfinder image, even with wide-angle lenses in fully articulated PC mounts. Having to open and close the shutter and shifting back and forth between the ground glass and the capture back is admittedly less convenient than the simplicity of the SLR approach, but this is the only solution for those high-end digital wide-angle photographers who are hesitant to trust a dark ground-glass image for critical framing and focusing.

ELECTRONIC DEVELOPMENT Focusing considerations notwithstanding, my work with the Digiflex/LightPhase combination proceeded smoothly and electronic photos accumulated at a rapid rate. At night in the hotel I processed the raw image captures into TIFF files using the comprehensive LightPhase image management software. Phase One calls this procedure "developing"; parameters such as output dimensions and image resolution are entered via a straightforward control panel. The development process takes 2 or 3 minutes per image, and yields beautifully interpolated 8 or 16bit TIFF files. Photoshop™ manipulations can then be made in the normal way.

ONE-SHOT DIFFICULTIES The only real hitch in the whole process was not directly related to the digital imaging hardware, but was, perhaps, an ironic twist on the digital imaging paradigm in general: My portable CD writer quit, and as a result I ran out of room on my Macintosh Powerbook's 6gb hard drive. Each image capture file is approximately 13mb, and developed files can be literally as big as one wants. My only option on location was to erase unused applications and archival material from the drive, but even that was not sufficient: On the last day of shooting I had to network my machine to a desktop Mac G4 at a friend's house, and use his CD writer to clear some electronic real estate on my overextended hard drive. Image files are big!

The next day I returned once more to the borrowed desktop with thirty final, fully Photoshopped images, and burned a CD for my client. I made the presentation on my laptop in their office a little later in the afternoon and received rave reviews.

My overall experience with high-end one-shot capture was extremely positive. The workflow was smooth, the equipment is easy to handle, and the results were excellent. There is no question that the LightPhase back and software perform as advertised, and of course, the proof of the pudding was a happy client: There is no question that scan-back technology delivers a superior image, but a perfect 25mb file yields one heck of a good looking 8x10in photo-real print, and is more than adequate for most commercial applications.

AVAILABLE DIGITAL ONE-SHOT BACKS Several other manufacturers offer digital backs of similar resolution to the LightPhase unit I tested.

Unique in that it has a 6.6-megapixel CMOS sensor chip rather than a CCD array, the Leaf C-MOST unit outputs 16bit 39mb files via its firewire connection. It is capable of shooting at a burst rate of three frames per second, which is unusual for this kind of device. CMOS technology is rapidly approaching existing resolution standards associated with CCDs with the added advantage of 75% lower power requirements, making for longer shooting times when dependent on battery power. It costs approximately $10,000.

The Kodak DCS ProBack is very attractive, simply because it is the only high-resolution one-shot that is completely self-contained, with built-in LCD color preview screen and CF card image storage on board. Capable of making an image every 2 seconds, the back and accessory cables can be fitted to a wide variety of medium-format and specialty bodies. The latest version produces 48–128mb interpolated TIFF files from its 16-megapixel sensor. About $20,000.

Well-known for its line of high-end film scanners, Imacon has produced a truly unusual back in its Imacon Flexframe 3020, which is actually something of a one-shot/scan-back hybrid. In single-shot mode the unit will make 16bit 36mb RGB files. Higher resolutions for non-moving subjects are available in 3-shot mode, wherein the CCD sensor is mechanically shifted one pixel at a time for separate red, green, and blue exposures. This approach yields 36bit non-interpolated files with extreme color accuracy. In micro-stepping mode, sixteen consecutive precision shifts of the sensor produce non-interpolated 16bit files of up to 144mb. Very impressive performance for about $20,000.

The Fovion II one-shot solution is not really a camera back, but an almost self-contained one-shot camera; a laptop is required for viewfinding, however. A prism is used to split the image three ways for simultaneous red, green, and blue capture on three separate 4-megapixel CMOS sensors. Software perfectly stitches the images together to make 12-megapixel captures with unsurpassed color fidelity and the absolute absence of color aliasing, a moiré-like color fringing that sometimes occurs with conventional single-sensor systems. The unit takes Canon lenses, and costs around $24,000.

This is a significant magnification of a detail from an original file shot digitally with the Better Light scan back. (The entire image appears on the cover of this book.) The resolution of the image is impressive; it certainly equals or exceeds the capabilities of film, but even high-end digital images can be improved through Photoshop™ manipulation.

ELECTRONIC IMAGE ENHANCEMENT

INTRODUCTION Most of this book is intended to educate and support those who need to acquire technical and aesthetic control over the production and use of architectural photographs. I believe that it is advantageous to first master the skills necessary for good work using traditional materials and hardware, before moving into the digital world, simply because digital imaging, particularly those electronic procedures that take place after the shutter closes, is not photography in the literal sense of the word. But nowadays, photographers working at the cutting edge need to adapt traditional procedures to a new paradigm, one in which photography intersects with design, pre-press, and computer-based image control. The preceding section on high-end digital capture introduced some of the pleasures and difficulties that manifest when an electronic sensing device is substituted for film. This next section examines the details of electronic image processing and output.

COMPUTERS FOR GRAPHIC ARTS WORK Digital image manipulation is not photography, because the images that are being manipulated do not exist in the real world. In traditional photography we are always able to hold and view an actual negative, transparency, or print, but a digital image is an electronic phantom that resides only inside a silicone lattice as an ordered series of electric charges in RAM (random access memory, the computer's real-time data bank account), as patterns of magnetized iron oxide on a disk or tape, or as a collection of optical perturbations on a compact disc. We cannot see these images, only representations of them on a screen or a printout. To alter, adjust, or manipulate them we cannot turn to lenses, filters, or chemicals—the only option is a computer. Photoshop™ is the software that is almost universally employed for this work, but before we take a close look at what Photoshop™ can do, we need to understand more about the computers that are used in the graphic arts industry.

Computers come in two flavors, IBM (also called PC, for personal computer) and Macintosh, or MAC. I began my electronic odyssey with IBM clones, but shortly after making the leap into digital imaging I switched to MAC hardware. These two platforms are slowly converging, but as this is being written—and for the near future at least—the MAC is the standard system for virtually all graphic professionals. MACs are smarter, present a more user-friendly interface, and they are faster and more stable than Bill Gates's offspring.

Imaging programs are getting bigger, and photo-real image files can be huge. Photoshop™ itself is memory- and disk-space hungry—for maximum processing speed, the recommended allocation of RAM is at least four times the size of the largest image that might be handled. I therefore recommend the fastest Macintosh you can afford and I recommend that you equip it with the largest and fastest hard drive, the fastest CD writer, and the most RAM your budget will allow.

Costs are substantial for cutting-edge hardware in MAC-land. But anyone with modest dollars willing to invest some time can significantly speed up older machines with economical processor upgrades, more memory, and a new hard drive. Relatively easy "upgradeability" is one of MAC's endearing qualities. I took this route myself and was pleased with the results: I installed a Sonnet G4 central processing unit (CPU), 440mb of RAM, and a new 36G ultra-scsi hard drive into a 5-year-old Power Computing MAC clone. Lack of expertise or lack of time can be addressed with the assistance of the right geek. Just ask around.

PHOTOSHOP™ People who should know say that Photoshop™ is the best software application ever written. Certainly anyone working with digital images will find within the program scores of different ways to implement any imaginable graphic enhancement, modification, or manipulation. Photoshop™ towers over the digital landscape, and by extension, the world of digitized architectural photography. Where the fashion world has wrinkles, pimples, and sagging appendages, we have utility poles, oil stains, and uneven blinds. Where the advertising world has melting ice-cream, flat beer, and gray meat, we have gray skies, recalcitrant delivery vehicles, and brown grass. Where the political world has yellow teeth, skewed hairpieces, and sweat-stained Armani suits, we have cracked masonry, crooked light standards, and graffiti. There is quite literally no visual defect or deficiency that cannot be remedied with Photoshop™ and a little good taste.

Of course, error correction is only one small aspect of Photoshop's purview. The program functions as a quasi-organic interface that intelligently interconnects cameras, scanners, computers, printers, monitors, film, paper, and the Internet. Photoshop™ is the most senior standard application in the whole of cyberspace, and it is a durable standard because of its enormous scope and flexibility, deftly encompassing the mysteries of file format, file compression, RGB and CMYK color, image resolution, image scaling, and much more, together with thousands of special effects. There are of course competing products and less accomplished siblings like Photoshop LE or Photoshop Effects. But for professional-level work, the $700 investment for the real deal is an expenditure that I confidently and cheerfully endorse.

For many years I relied on the skills of expert airbrush artist Ray Phillips (wjrp@total.net) to fix what needed fixing in my carefully made black-and-white and color prints. Ray is the third generation of airbrush artists in his family. He acquired his skills from his father and his grandfather and then refined them at the University of Manitoba Faculty of Fine Arts. Today however, airbrush retouching is essentially extinct, and Ray has reconfigured himself as a Photoshop specialist. It is a great blessing to have access to an expert like Ray when confronted by thorny visual problems or when deadlines are tight, but as even he reluctantly admits, almost anyone can learn the rudiments of Photoshop™. Ray and I collaborated to produce the series of step-by-step examples that appear in this book (*see color plates 85–102 and pages 201–202*).

Photoshop™ is a very rich and versatile software tool. There are many ways to achieve the effects and corrections needed for image control, and even veteran users will tell you that there are surprises and discoveries to be made around every cyber-corner while navigating the many menus.

Nevertheless, there is no reason not to plunge right into Photoshop™ and begin to do your own work. The program comes packaged with help screens and tutorials that will lead you through the various options and menus. Familiarize yourself with the illustrated procedures provided in this chapter, and expand your knowledge by trial-and-error experimentation supported with any one of the dozens of Photoshop™ manuals available at bookstores. To help you start I have described a few favorite techniques and tools.

MY FAVORITE PHOTOSHOP™ TOOLS The Photoshop™ desktop presents a palette of icons representing mouse-operated tools on a vertical strip along the left-hand side. Along the top is a bar of drop-down menu items that list various operations and filters. A number of windows that display refinements, adjustments, and options for all of these items appear along the right-hand side of the screen. On first glance, the range and number of possible combinations and permutations can be quite intimidating. The following are my favorite Photoshop™ tools, operations, and filters, ranked roughly according to how often I use them.

The rubber stamp tool, found in the left-hand tools palette, is used to replicate samples of existing textures and tones. It is the tool I use the most for such operations as removing dust and scratches and for retouching out unwanted details. The virtual "rubber stamp" can be made large or small, opaque or translucent, and hard or soft around the edges.

Also found in the tools palette, the lasso tool can be used as a free form or as a geometric outline comprised of a series of straight lines. Its function is to specify an area within which various other Photoshop™ operations can be performed. The "Grow" option, located under the "Select" item in the upper menu bar, will increase the selected area by increments. From the same menu, "Invert" will select everything outside of the original selection.

"Unsharp Masking," found under the "Filter" segment of the upper menu bar, is an oddly backward description of the Photoshop™ filter that increases the apparent sharpness of an image by enhancing the contrast at the edges of areas of different tonal values. The tool is highly adjustable and the sharpening effect is easily taken too far, so go lightly. This procedure should be done as the last operation on a file, after all other operations are complete.

"Transform-Distort" or "Transform-Perspective" is found under the "Edit" section of the upper menu bar. These are very powerful tools for correcting perspective distortion. This is a very slow operation, however, without a fast cpu (central processing unit, the computer's "brain") and lots of memory.

Under the "Image" heading in the upper menu bar we find "Adjust," which provides a submenu with a number of options. "Hue/Saturation" or "Levels" will tweak overall image color or in areas selected with the lasso tool. These adjustments can be very mild and subtle, or they can be extremely bold.

"Shift" and "option" are keyboard controls that constrain the behavior of most tools, making it easier to control them for finer movements. If you are using the lasso tool, for example, and intermittently hit the option key while moving the tool, you can select areas with much greater accuracy and smoothness.

Under the "Edit" drop-down menu, we find "Undo," which will reverse the effects of the last implemented Photoshop™ operation. Under the same menu item, "Step Backward" allows multiple undos. "Step Forward" incrementally reverses "Step Backward" commands.

To retouch large similar areas, use the lasso tool to select the area that you want everything to look like, "Feather" it (under "Select" drop-down menu—note that the amount of feathering is a controllable option) for smoother blending. Grab the selected area using the hand tool (left-hand tool palette) and the option key, drag it to the area you want to change, and drop it there. Touch up with rubber stamp if there are any hard edges.

"Command" plus "option" are keyboard commands that will clone and position a mouse-selectable area, useful when expanding areas of foliage blue sky, or other textures and patterns.

In the drop-down "View" menu we find "New View," which will keep a picture (any size you like) of the original file on screen while you process the file in another window—this allows you to see how what you are doing is affecting the original while you work.

The above items are only a minuscule sampling of the multitude of Photoshop™ controls that can be accessed by a skilled operator.

LAYERS Working with layers is like working with a stack of transparencies, one on top of the other. One can choose when to make a new layer, when to delete a layer, when to change a layer, and when to melt all the layers together. If each Photoshop™ modification or enhancement that you make to an image is implemented in a separate layer, it will be much easier for you to change your mind about elements you like or don't like without having to erase and rubber stamp and hope you have got your history saved. You can also play with the opacity of the layers, i.e. the degree to which an individual layer can be seen through other layers. You can "link" layers with the eternity loop symbol in the "Layers" window, and you can jump from layer to layer by clicking on the bar in the "Layers" window. To add a new layer, hit the page symbol with the folded-down corner. When you are satisfied with your work and want to save the result or print out, go up to "Layers" in the top menu bar and "Flatten" them. This compresses all the layers together (you cannot reverse this) to make a smaller file that is easier to print and store.

SCANNING

INTRODUCTION Some sample images for practicing purposes are supplied with Photoshop™, but it is much more satisfying to Photoshop (yes, Photoshop is a verb in the graphic arts universe!) your own pictures. Nowadays there are many highly serviceable digital cameras available for under $1000 (*see Chapter 17*), and the photographs they produce may be loaded into your computer via cable, magnetic or optical disk, or memory cards. Photoshop™ enhancement will certainly improve the modest-resolution images derived from consumer-level equipment, but large image files provide the richest grist for the digital imaging practitioner's manipulation mill. If you have not invested in high-end digital photo gear, your main source of high-resolution images will be the slides, prints, or negatives created with film cameras. Whether they are historical relics or pictures shot just today, film-based images are chock full of detail—detail that is usually best displayed and appreciated after some electronic refinement. The interface between film materials and the digital world is a process called scanning. To enjoy the benefits of Photoshop™ one needs a practical understanding of scanning soft- and hardware.

The following images track the evolution of the image that is reproduced on the cover of this book. I did the Photoshop™ work myself. Above is the raw, unmanipulated Better Light file, exactly as exported to the laptop computer at the time of shooting. Although downsized for reproduction, the original file was 95mb. Reproduced here without any Photoshop™ enhancements, it appears very flat, and noticeably off-color. Some manipulation of the Better Light software at the shoot could have optimized the file for reproduction, but I preferred to capture the scene using the full 11-stop range that the back is capable of recording. Color balance was easily fine-tuned later.

Here the raw file has been color and density corrected. Now the weathered steel with which the building and sculpture are fabricated appears naturally robust in texture and tonality.

Detail 1: A significant amount of Photoshop™ work is needed to produce a final image for reproduction. The detail above shows the clutter in the lower left-hand corner of the building that will have to be simplified.

Detail 4: This detail from the lower right-hand corner of the frame shows the multi-colored ghost-like images of two people who were walking through the shot when the exposure was made.

Detail 2: A further blow-up from inside this detail shows color fringing around the flag and moving people.

Detail 3: This detail shows the distractingly dark shadow across the corner structural column at the base of the building.

Top left: The Image was cropped to fit the cover dimensions. The sky was darkened and contrast increased, and the pedestrians in the foreground were removed with the rubber stamp.

Top right: The people in the lower left were replaced with cloned bushes. The woman seated on the sculpture base was removed, and the picnic tables and umbrellas were simplified. The tonal separation between the building and the sculpture was increased (using levels and contrast controls) and some stains and shadows on the sculpture were removed (with the rubber stamp tool).

Bottom left: The color fringing on the flags was removed. To reduce visual clutter, windows blinds were removed with the polygonal lasso and rubber stamp tools.

Bottom right: As a final touch, the windows were darkened to make the steel building look more dramatic.

FLATBED SCANNERS Before investigating the process of scanning, we need to take a look at the available hardware:

Any computer vendor will happily sell the uncritical customer a $99 flatbed scanner. This device is constructed like a small, desktop photocopier, and at first glance, appears to function in the same way. A closer look reveals that the flatbed scanner shares the glass platen, hinged lid, and traveling internal light source of a photocopier, but the similarity ends there. The photocopier uses lasers and electrostatic ink to capture an image of whatever is placed on the glass, while the scanner relies on a thin array of photoelectric sensors that move in precisely governed increments along a motorized track to record a digital image of printed materials. The resulting data file is transmitted through a cable to the computer.

Ninety-nine dollars does not seem like a lot of money, and the question arises whether such an inexpensive unit is worth considering. As even the most humble of flatbed scanners will typically produce a digital file from an 8x10in color photograph that might be twenty times larger (and bigger is usually better) than a file from a $1000 digital camera, this gives us a clear illustration of the utility of scanning for image acquisition: a big data bang for a modest digital buck.

However, mostly for mechanical reasons I do not recommend the purchase of a $99 flatbed scanner; they do not stand up to heavy service. (There are related image quality concerns as well, but these are diminishing faster than the durability issue.) I do, however, heartily recommend the purchase of a $500 or $1000 unit. Bear in mind also that a refurbished upper-middle-class scanner that originally sold for $1000 a year and a half ago might sell for $500 today and would still be a very useful tool. Obsessive-compulsives pull their hair trying to keep up with constantly evolving hardware, but anyone with a bit of humility and patience will find that even the not-quite-latest toy is often quite capable of doing journeyman's service.

FILM SCANNERS Some flatbeds can be outfitted with a transparency adapter that allows the scanning of slides and negatives. Often priced close to the original cost of the scanner itself, these accessories do add functionality, but I believe they are not a good value. A dedicated film scanner is a better choice. The main consideration here is image resolution. Any decent flatbed can reliably resolve 1200 dpi over an 8.5x11in surface, but slides and negatives are much smaller and consequently must be magnified several times over for reproduction, requiring significantly greater resolving power at the scanning stage. Dedicated film scanners are capable of consistently resolving from 2800 to 4000 dpi and they come equipped with convenient and reliable holders to position film firmly and precisely. Several very fine scanners for use with 35mm film are available at prices ranging from $600 to $2000. Excellent medium-format film scanners of similar design are available for $3000 to $5000.

DRUM SCANNERS Although I have made a distinction between desktop flatbed scanners and dedicated film scanners, all scanners that are priced below the $5000 mark share one characteristic: the material being scanned is held as flat as possible and the scan is made with an array of photosensitive receptors and a fluorescent light source. Such technology, no matter how carefully realized, is limited to approximately 4000dpi. The ultra-high-end is serviced by drum scanners; here, film or reflective materials are temporarily fixed with optical adhesives or precision clamps to cylinders spinning several thousand rotations per minute, and then microscopically examined with laser-governed sensors. Resolutions of 10,000–20,000dpi and higher are routinely achieved using this method, but these units cost from $15,000 up into the millions. Perfection is an expensive proposition, nevertheless there are many image-making and image-using professionals who have made the investment. The $15,000 Imacon Flextight Precision III, which is capable of 6300dpi, is a popular entry-level choice.

CLEAN CAPTURE Regardless of what scanning technology is employed, all high-resolution scans of small pieces of film accentuate problems that are not so bothersome when scanning big pieces of reflective material: These include surface dust, scratches, fingerprints, crease marks, grain, tape marks, watermarks, and faded or distorted color. Meticulous cleanliness (i.e. pre-scan dusting with compressed air, clean, lint-free cotton

At approximately $600, the Canon D2400 flatbed scanner is capable of extremely high resolution output—4800dpi, interpolated, according to the manufacturer. Includes an adapter for scanning transparencies and negatives. Photo courtesy of Canon Canada.

This is the Minolta Elite 35mm film scanner, which comes equipped with Digital ICE[3] image enhancement technology. Image courtesy of Minolta Canada.

Top left: The Multipro is the current high-end medium-format film scanner from Minolta. Capable of handling negatives and transparancies up to 6x9cm. Incorporates Digital ICE³ technology. Image courtesy of Minolta Canada.

Top right: This is the Nikon Super Coolscan 8000 ED, a 4000dpi Digital ICE³–equipped medium-format film scanner. Image courtesy of Nikon Canada.

gloves, etc.) and careful storage practices will reduce these problems somewhat, but ultimately they can never be addressed completely by special handling or by special hardware alone. Photoshop™ provides a myriad of retouching tools to remedy all these deficiencies, the necessary operations, however, are laborious and extremely time-consuming.

Happily, there are other clever software approaches to this problem, and in my view the best are provided by Applied Science Fiction Technologies (asf.com). ASF's Digital ICE³™ is a suite of applications including Digital ICE (image correction and enhancement), Digital GEM (grain equalization and management), and Digital ROC (reconstruction of color) that come bundled with high-end Nikon, Minolta, and Acer scanners. Sophisticated proprietary algorithms that govern dedicated hardware modifications allow these programs to make active interventions in the film scanning process at the machine level.

Digital ICE uses an additional scanning pass to record surface details from the film; this information is then subtracted from the final scan resulting in a much cleaner file with no reduction in sharpness. (Other software, even Photoshop's "Dust and Scratches Filter," purposely degrade image sharpness to hide—rather than eliminate—optical noise.) Digital GEM analyses grain patterns and textures picked up during scanning, and then uses this information to create a grain-free final image without loss of image detail. Digital ROC compares the ideal characteristics of the color layers in the film with the actual characteristics determined during scanning and then restores optimal values in the output file.

Applied Science Fiction's latest software product, the Digital SHO™plug-in for Photoshop™, compliments their ICE³™ package. As the manufacturer describes it, ASF's Digital SHO™ plug-in software "automatically adjusts the contrast in digital image files so that all detail in the images is visible and the overall brightness is visually pleasing. The result is to reveal the details in shadows and darker areas of an image. Typically, details in some portions of an image have to be sacrificed to provide adequate contrast in other areas during photo processing. Examples of the failure to correctly balance contrast are common in photography, such as pictures where the subject looks dark in front of a bright background, where important areas of a picture are in shadow, or where the flash illuminates people closer to the camera but people farther away are too dark. Digital SHO™ automatically detects scene-contrast imbalance and presents the user an image that is visually pleasing."

Unfortunately, these programs all require substantial memory and processing times. They perform as advertised in terms of image correction, but they are slow even on the fastest machines, and painfully slow on medium-speed units. On my hardware, for example, a 75mb scan from a medium-format negative takes about 45 minutes to complete when all ICE³™ functions are in effect. Even so, I know that those of you out there in possession of cabinets full of less than pristine archival images will come to love this software.

THE RAW SCAN All scanners come with dedicated software that provides a user interface for management of the scanning process from the computer keyboard. Different software packages offer different levels of sophistication, but each one will provide controls that determine color balance, brightness and contrast, image cropping, image size, and

These two images illustrate the utility of the latest image enhancement software from Applied Science Fiction. The top image is an unmanipulated scan of my original transparency, a fairly high-contrast shot of a hotel room with bright highlight detail and overly dark shadows. The image below shows how ASF's Digital SHO™ software automatically created a new scan with a more reproducible tonal range.

This pair of images dramatically illustrates the efficaciousness of Applied Science Fiction's ICE³ ROC™ color restoration software. Images courtesy of Applied Science Fiction.

image resolution. The skilled scanner operator will use these controls carefully to render the most useful raw scan (an image file that has not yet been manipulated in Photoshop™, or any other image management program other than the software managing the scanner) that the scanner is capable of producing. A raw scan, no matter how well made, is used directly for reproduction only very rarely: Some Photoshop™ work is always required to refine a raw scan into a file that is a serviceable fit with the ultimate reproduction medium, be it plain paper in an electrostatic color photocopy machine, premium photo paper in a desktop inkjet printer, archival velum for high-resolution lithography, or a computer screen linked to the Internet. A good raw scan is thus an image file that has encoded within it all the data necessary for successful reproduction via the media of choice, once the appropriate Photoshop™ adjustments and enhancements are complete. The key to mastering the art of scanning is a clear understanding of what the words "all the data necessary" encompass.

How important a good raw scan is becomes clear when you consider that even Photoshop™, graphic titan that it is, cannot really fix a bad raw scan. Any graphic designer or electronic pre-press professional will tell you that tremendous time and effort are required to re-engineer a shoddy raw scan into something halfway useful. Proper scanning saves tremendous grief in the future. Happily, all that is necessary is some understanding of how scanner software controls affect output, together with a little restraint.

A raw scan is a mathematical description of the original image, a digital map that encodes the brightness, contrast, color, and resolution of the original image. Because of variations in the materials to be scanned, all these variables need to be adjusted to some degree before reproduction in some other medium. But to what degree and with what method?

HOW TO MAKE A GOOD RAW SCAN At the scanning stage all choices about adjustment will be made by comparing the original material with the image on a computer screen. All scanner software provide a "preview" function by making a fast, low-resolution scan that yields enough detail to form a reasonably clear image on the screen that can be evaluated. Scanning parameters can then be altered appropriately. Obviously, the state of the computer monitor is an important variable in this operation. Calibrating a monitor for exact standardized tone and color reproduction is time-consuming and expensive, because the work involves proprietary hardware and software and a lot of testing (*see pages 210–211 for more information on color management*), but a workable calibration can be obtained using the adjustments available in the Adobe Gamma program that comes with Photoshop™. This visual exercise takes only a few minutes and results in a better-than-in-the-ballpark baseline for getting started. Once a flow of work has been established, final results can be compared with the image on your screen, and additional tweaking done.

BRIGHTNESS AND CONTRAST Brightness and contrast adjustments when scanning can be made with the brightness and contrast controls available as part of any scanner software program. However, I strongly advise against this approach, because ordinary brightness and contrast controls alter the image file in a way that discards data necessary for proper reproduction later in the process. Simple tonal controls work in a linear fashion—if an image is made brighter or darker, every point in the image is made uniformly lighter or darker at once, and tonal values that exceed the system's recording ability disappear unceremoniously and irretrievably. Generally speaking, information about the brightest points in the image is lost when it is made uniformly lighter and information about the darkest points in the image is lost when it is made uniformly darker. If the contrast of an image is increased, information about both highlight and shadow detail is lost in one stroke. Exercise restraint by avoiding the easy solution.

Happily, a more sophisticated approach is available with only a little more effort. "Levels" and "Curves" are the names of the non-linear tonal controls supplied with most scanner software and with Photoshop™. Nonlinear controls lose some data as well, but not in such a devastating way as linear controls. Levels work by first fixing the maximum highlight values and the minimum shadow values to the maximum and minimum recordable values for the hardware, and then allow smooth alteration of in-between grayscale values to make dark areas lighter or light areas darker, as required. This is accomplished by moving a virtual slider along a histogram—a horizontal graphical depiction of tonal

value distribution—while observing the changes in the program's preview window. Contrast adjustments, which are not recommended at the scanning stage in any event, are rarely required once this operation is properly done.

Curve controls work in a similar way, except the tonal map is presented as a two-dimensional graph, and adjustments are made by moving virtual points on the tonal curve. I rarely use curve controls for scanning, although they are useful at the Photoshop™ stage.

COLOR CONTROL Color control is best achieved with the levels or curves approach as well. The goal at the scanning stage is to get all of the useable color information in the original image into electronic form. Level and curves controls are typically available for the individual red, blue, and green color channels that the scanner records. A color caste (a.k.a. color bias or color shift) can be corrected while preserving the maximum tonal range with a minimum of data loss.

RESOLUTION Resolution is the next consideration when producing a raw scan, and for best results one has to think ahead before reaching for the controls. The scanning process digitally deconstructs a continuous tone image into an electronic file that assigns numerical gray-scale and color values to a network of virtual dots positioned on a virtual grid. The finer the grid, the more dots. The more dots and the more information available about the dots, the more accurate the virtual description of the image can be. The characteristics of the virtual grid and the virtual dots are determined during scanning, altered with Photoshop™, and then made real when the image is printed out as an ordered array of ink dots on paper or glowing dots of phosphorescence displayed on a screen.

The amount of detail recorded during the scan is described qualitatively by the term "resolution," but resolution is quantified in different ways for different media. The dots on the grid pattern employed by an inkjet printer are actually called dots, so resolution is described in terms of dots per inch, or dpi. The dots associated with a digital camera or a computer screen are called pixels (picture elements), and resolution for such devices is described by pixels per inch, or ppi. The dots associated with the scanning process are properly called samples, and scanner resolution should be described as samples per inch, or spi. The popular convention uses dpi, rather than spi for scanner and scan specifications, however, even though common sense tells us that there can be no such thing as a dot in cyberspace. (Virtual dots in cyberspace are described in terms of bits and bytes.) I will from now on use spi to describe the scanning resolution and dpi to describe output image resolution: As you will see, scanning resolution and output resolution for a particular image are often represented by different numbers.

THE RIGHT RESOLUTION The trick for good scanning is to think backwards: start by figuring out what output you want at the end of the process, do not just scan at whatever default is set. To do this, it is necessary to know the characteristics of your output device (printer, screen, disk, etc.) and then determine what file size and resolution you need for a particular size of image.

We tend to think automatically that more is better, but this is not true for scanning and scaling—the process of creating appropriately sized image files for reproduction purposes. For many common uses, the sampling capability of most scanners far exceeds the requirements of the reproduction techniques being used. That is to say, if scans of a very high resolution are created, the digital information can overwhelm the computer or the printer farther down the line, leading to computer crashes, very slow throughput times, and very slow downloads from the net. The capabilities of the scanner must, in almost every case, be limited to match the final reproduction medium. Low-resolution images, say from a digital camera, provide more than enough information to be posted to the Internet, for example: only 1mb is required to create a sharp-looking 4x5in image on a monitor screen. This same logic holds true when scanning and scaling high-quality photographic prints that are to be reproduced at the same size or smaller.

Say, for example, an 8x10in photograph is to be scanned on a flatbed scanner, manipulated in Photoshop™, and then printed out to one half its original size with a photo-real inkjet printer. If the scanner is capable of 2400 spi, a scan at maximum resolution will create a file of 2400spix10in x 2400spix8in = 446.8mb. That is a lot of data. As Photoshop™, to

Here are several versions of the same image, scanned in a flatbed scanner at different resolutions. The 72ppi scan (top) would look normal on newsprint where large half-tone dots are used to avoid spreading of ink. Printed here with a relatively fine half-tone screen the 72ppi scan looks very crude compared to the 300ppi (middle) or 600ppi (bottom) scan.

XVIII

run efficiently, needs at least four times the amount of RAM as the file size being manipulated, you would need 446.8Mx4 = 1,843mb. My computer is currently equipped with only 440mb of RAM, so my machine would be swamped and a routine filter application in Photoshop™ would require several minutes to complete. A Photoshop™ session with lots of successive operations would take a couple of hours or more. Not fun.

Now let's look at it the other way, from the perspective of the final printout. A good inkjet is capable of printing 1440dpix720dpi, so a 5x8in picture printed out at maximum resolution would require 1440dpix8in x 720dpix5in = 41.47mb. This is only 1/10th the image size we calculated earlier—a substantial difference. And there is another consideration—at normal viewing distances the naked eye cannot distinguish any significant difference between an image printed at 300dpi and an image printed at 720dpi, let alone 1440dpi.

So, even though our printer is capable of printing a 41.47mb file at 5x8in, our eyes cannot discern much improvement in detail beyond that provided by a 300dpix8in x 300dpix5in= 3.6mb file. This is less than 1/100th of the image size resulting from the maximum scanner resolution.

Generally, it works better to scan the original at twice the resolution required by the output device, and then scale it down to the final size. At the scanning stage, therefore, we should set up the software to scan the original 8x10in print at 300spi, which will result in a 7.2mb virtual image (8inx300spi x 10inx300spi). This we will scale down in Photoshop™ to 3.6mb (5x8in at 300dpi) for printout. 7.2mb is a relatively small, and consequently easy-to-process file, compared to the nearly half-gigabyte (1g = 1000mb) file that the scanner would have produced at maximum resolution.

SCALING DOWN Scaling down results in a proportionally smaller print with the same resolution as a larger print produced from the original, unscaled file. Scaling down maintains final image integrity by eliminating data that is unnecessary for printing: Fewer dots are required to make a smaller print. Going up in scale is an entirely different matter: Image integrity is not preserved when a file is scaled up. In this instance the new data required to cover the increased image area are created by software interpolation—by filling the space between the original dots. Generally speaking, the invented dots are assigned color and density values by averaging the values of the existing dots around them. The resulting print is smooth in tone, but will contain no more (and often somewhat less) detail than the original unscaled file. Image resolution goes down whenever a file is scaled up, and scaling up by any more than a few percentage points is always a technically unsatisfactory process. The remedy—larger scans—will slow down the system, therefore the calculation of minimum file size for a given output is a very important operation.

RULES FOR EFFECTIVE SCANNING

1. Store and handle original materials carefully.

2. Maintain meticulous cleanliness: Use a lint-free cotton cloth slightly dampened with glass cleaner for the glass platen and/or film holders. Dust materials to be scanned with compressed air. Clean scans digitally with ICE[3].

3. Avoid linear tonal and color controls in favor of non-linear controls.

4. Calculate minimum file sizes carefully.

Observe these simple rules, and the resulting raw scans will be a pleasure to work with at the next stage in the process.

AN AFFORDABLE COMMERCIAL ALTERNATIVE Kodak's ubiquitous Photo CD system is promoted as an economical compromise between in-house flatbed scanning and service-bureau drum scanning, and sometimes it is. Professional Photo CDs provide five file sizes corresponding to five levels of resolution for as many as 100 originals up to 4x5in. The scans are delivered on a CD, together with a thumbnail printout for each scanned photo. The file sizes range from 25k to 25mb, which means that, theoretically at least, some very good results are possible. Unfortunately, not all providers are sufficiently expert to operate the Kodak Photo CD workstation at maximum efficiency. Here are some guidelines to help you extract decent scans from both Photo CD and service bureau suppliers:

Solicit word-of-mouth advice and shop around for quality work.

Tell the provider in advance that the scans should match your originals.

Tell the provider that the scans are intended for photomechanical reproduction.

In the case of a Photo CD, do not accept a disc that is delivered with bad thumbnail proofs: the thumbnails are indicative of the quality of the scans.

PRINTING

INTRODUCTION A beautiful architectural image can hold its own as a piece of art on an office wall or it can inform and support a technical, aesthetic, or business-related discussion. But for any of this to actually happen, the original film or digital image must be printed to a size and quality suitable for display.

In traditional photography, a color negative or transparency is transformed into a print by optical and chemical processes in a darkroom. The finished product is a piece of photographic paper that has been exposed to light using an enlarger and then chemically processed. In the digital world, an optical image is converted into a digital file by a digital camera or by a scanner, manipulated in Photoshop™ or some other image management software, and then electronically delivered to a printer that outputs to paper. This sounds simple (and it can be), but there are some important variables to keep in mind.

First, one must choose a printer, and there are lots to choose from. For what has come to be called "photo-real" quality (i.e. very much like a real photographic print from a high-quality negative) we have two cost-effective choices: Inkjet printers are certainly the most ubiquitous and the most economical, while dye-sublimation printers are capable of better results but at a greater cost.

The Epson Stylus Photo 1280 is a very popular inkjet printer with photographers involved in digital imaging. Photo courtesy of Epson Canada.

INKJET PRINTERS Inkjet printers deliver tiny drops (as small as 3 picoliters) of cyan, magenta, yellow, and black inks from separate nozzles onto specially formulated papers. Significant variables when selecting an inkjet printer include durability, printing speed, paper size, drop size, resolution, ink quality, image stability, cost-per-print, and software. There are hundreds of printers to choose from, but for a useful blend of quality and economy, at approximately $600, the Epson Stylus Photo 1280 is a very good choice. This 11x14in unit uses a black ink cartridge in combination with a five-compartment color cartridge that carries regular-density yellow, cyan, and magenta inks, plus light-density magenta and cyan inks. This approach allows for accurate full-color reproduction of detail in both very deep and very light tonal ranges, making attractive and accurate photographic-like reproduction possible. It takes 4–5 minutes to make an 8.5x11in print. Resolution is a very respectable 1440dpi. A wide variety of paper media is available; I find heavy-weight Epson Premium Glossy Photo Paper to be the most attractive. Print longevity is a decade or two and rising. Cost-per-print is approximately $1.25 for each 8.5x11in.

Canon, Hewlett Packard, and others all manufacture competing products that have respectable followings. The best method for making a choice among them is to eyeball printed samples made by the machines you are considering. This process is made more efficient by providing the hardware supplier with an image of your own on disk so that a direct comparison can be made of the various outputs.

The Epson Stylus Photo 2000 inkjetprinter is designed for high performance and uses special archival-quality inks. Photo courtesy of Epson Canada.

The Epson Stylus Photo 2000P, at around twice the price of the 1280, is an 11x14in, 2440dpi inkjet designed to use special archival pigments that incorporate acrylic-polymer resins for prints of a longevity of a century or more. Other specifications are similar to the 1280, but print costs are about double.

DYE-SUBLIMATION PRINTERS Dye-sublimation printing uses heat to transfer archival-quality color from pigment-impregnated transfer sheets in a dotless process that looks more like a continuous tone photograph than even an ultra-high resolution inkjet. Typically, these units print at resolutions similar to their inkjet cousins, but because they do not use discrete dots of ink to formulate an image, their output has a silkier appearance. Olympus makes an affordable (approx $1000) 8.5x11in version, the Camedia P400. Prints from this unit are superior to those produced by the best inkjets by a small, but noticeable margin. Perhaps its bigger advantage is speed: about 3 minutes per full color print, a little more than twice the rate of the closest competing inkjet. Ink and paper costs for dye-sub printers run at about $3.00 per print.

The Fuji Pictrography 3000 and 4000 high-performance thermal/hybrid color printers. These machines use a thermal development and transfer printing technology that requires no chemicals or toner. Their laser-diode exposure process guarantees ultra-high-quality output onto photographic paper and transparency material. Very high-speed operation. Photo courtesy of Fuji Canada.

Kodak's upscale dye-sub printer, the Digital Science 8650, is extremely fast, about 70 seconds per letter-size print. At $8000, this is a production machine that operates at a 24bit color depth and 300dpi (equivalent to inkjet 1440 dpi) for rich, permanent prints, the durability of which are enhanced by the built-in anti-uv/anti-scratch lamination process.

Top-of-class printing for the perfectionist is available with the Pictrography color printers from Fuji. This series uses a combination thermal transfer and photographic-based chemical process to create ultra-smooth 400dpi prints on a variety of media in as little as 40 seconds for multiple prints. The Model 3500 ($9500) prints up to 8.5x11in, while the Model 4000 ($15,000) prints up to 11x14in.

COLOR MANAGEMENT

INTRODUCTION Achieving true photo-real output can be as simple as pushing a button and letting the printer do the rest, but to achieve this optimum condition some preparatory communication between operator and hardware is necessary. The correct hardware and software operating parameters must be determined for the particular combination equipment being used, but once things are properly balanced, the digital printing process can be implacably accurate and repeatable. Setting those parameters involves some insight and experimentation.

The main concern is color. Describing color subjectively and describing it scientifically are entirely different processes. There is a professional cult of color management built around the seemingly impenetrable theoretical structure that describes the spectral responses of digital systems. A close look at this problem reveals that the intricacies of absolute color control are quite difficult to master completely, but not so difficult as to prevent an enthusiastic beginner from setting up a workable system.

COLOR SPACE The 8, 12, 24, or 36bit images from your digital camera, scanner, or digital back quantitatively describe the red, green, and blue brightness levels for every individual pixel. The greater the bit depth, i.e. the greater the amount of data associated with each color pixel, the more accurately a given color value can be specified. The physics of light tells us that the hue, saturation, and brightness of any color in the visible spectrum can be described as a particular combination of red, green, and blue values. How much red, green, and blue are required to reproduce a particular color is a function of how pure red, pure green, and pure blue are defined.

But what frequency or wavelength of light describes a pure, primary color? How are electronically specified colors translated into visible colors on a screen or on paper? These are only a couple of the many questions that must be answered before precise color control in the digital realm is possible. Every printer, every ink, every monitor, film, electronic sensor, and every paper have different spectral characteristics, so standardization is, to put it bluntly, something of a headache.

Monitor manufacturers, for example, try diligently to select phosphors—the red-, green-, and blue-producing chemical elements coated on the inside face of cathode ray

tubes—that will generate a broad, bright, and accurate color spectrum. But this is a very tricky exercise, and different manufacturers make different choices. Printer manufacturers have an analogous problem with inks, and scanner and digital camera manufacturers have similar problems with sensors and the mathematical algorithms that are used to interpret the data created by them. Similarly, paper manufacturers are concerned with mechanical absorption and the dry-down characteristics of inks and dyes, and with the reflectivity and light-scattering qualities of paper surfaces.

The first step towards standardization involves selecting a color space within which all color-related operations are undertaken. A color space is a geometric representation that describes mathematically what constitutes a primary color, what constitutes a pure white and a pure black, and what range of composite colors is included in the overall palette available to the reproduction equipment.

Naturally, a number of different color spaces have been developed, each of which is optimized for different reproduction processes. Photoshop™, printers, and monitors provide a number of choices for color space in their setup menus. For consistency, all must be set to the same choice. The sRGB standard, developed jointly by Microsoft and Hewlett Packard, has been widely accepted for the Internet and for desktop applications. The "s" stands for single or standard; sRGB is meant to be a device-independent color space, a uniform system of color definitions that manufacturers can implement in a way that permits a variety of hardware to synchronize to the same color space.

ICC PROFILES A standardized way of comparing color response is required in order to obtain accurate reproduction when several different devices are interconnected. ICC (International Color Consortium) profiles were developed to do just that. An ICC profile describes how combinations of the primary colors map to an independent color standard for a particular device or process. Thus ICC profiling helps in predicting exactly what final "color" will result for a given set of red, green and blue digital inputs. But "exactly" is a potent word. ICC profiling is a software-based method of color management, and consequently, its relation to the real world is a mixture of wishful thinking and good intentions.

Even though ICC profiling is not perfect, it is useful. These days, every imaging device is provided by its manufacturer with an electronic "tag" in the form of a unique ICC profile, and happily, we can employ this information to get fairly accurate reproduction. ICC profiles are automatically loaded into your computer when new hardware is installed using the disk provided by the manufacturer of the device, or when updated device drivers are downloaded from the manufacturer's website. By ensuring that these profiles are properly selected in your monitor, scanner, and printer setup menus (as well as in Photoshop™) there is a good chance that your color processes will be fairly predictable and stable.

CALIBRATING Truly perfect color control, however, cannot be achieved by software alone. The ultimate hardware solution involves a physical analysis of monitor and printed output with calibrated sensors that feedback color information into the color management software, thus creating a closed loop that zeroes in on color perfection.

Soft- and hardware implementations of this sort of color management are available from a number of sources. Three that cost less than $1000 are the Monitor Spyder with OptiCal software from ColorVision (www.colorcal.com), the Monaco Sensor with MonacoView software from Monaco Systems (www.monacosys.com), and the Monitor Optimizer with ColorShop software from X-Rite (www.x-rite.com). All three devices attach to the monitor screen using suction cups, and then create custom monitor profiles. Standard image files and print samples are provided to help calibrate your system. It is recommended that monitors be re-calibrated weekly, since electrical and phosphor characteristics vary over time.

DESIGN OF THE PRINTED PAGE

This book is of course concerned mainly with photographic control, but as you will see in the next chapter (*see pages 213–227*), the utility of photographic images has been extended dramatically through integration into well-designed websites. And just as the Internet has evolved, the printed page too has increased in effectiveness as a communication medium with the evolution of sophisticated page-layout software that does for print on paper what Photoshop™ does for photos.

Quark Express, Adobe's InDesign, and the somewhat less sophisticated Adobe Pagemaker provide, via Photoshop-like interfaces, an array of graphical and page-layout tools that make a pencil, a ruler, and a drafting table look like stone-age implements. Regular word-processing programs come with some graphic capabilities and layout tools, but these professionally oriented programs are in an entirely different class. I have only a rudimentary knowledge of these complex tools, but I have access to an expert—my son, the designer. Those who are not related to a graphic-arts talent but who want to present their architectural photographs as contextual elements within effective, sophisticated, and attractive printed materials should familiarize themselves with electronic design and page-layout in a workshop or a continuing-education course.

Training and hands-on practice will eventually provide the confidence to take over the job oneself, however, these programs are formidable tools, and cannot be mastered overnight. For the duration of the training interval, it is a good idea to engage the services of a professional designer rather than compromise one's professional image with unskilled design choice.

The following images show, in stages, Photoshop™ enhancements implemented by professional retouch artist Ray Phillips to four original transparencies.

To the left (85) is an early morning image of a restored heritage building, part of the Asper Jewish Community Campus, Winnipeg (restoration by Akman + Sons, WPU). Although this is a perfectly reproducible image as it is, a number of unavoidable deficiencies make this a candidate for Photoshop™ enhancement. Shot with the Fuji 680II, on color negative film.

86 Ray's first operation in Photoshop™ involves color balance and contrast. Using the curves control panel and histogram information, Ray sets the white and black points, raising the image contrast. In the levels control panel, Ray subtly shifts color balance toward a more neutral setting. The overall brightness of the lower half of the image was also raised to give a more open feel to this area.

87 This image illustrates how Ray will use the rubber stamp tool to eliminate the distracting white lamp standard in the left foreground.

Above: 88 The lamp standard has been removed.

Right: 89 Using cut and paste from the edit menu, together with the rubber stamp tool, Ray has removed the trash can and bicycle stand from the lower right-hand corner.

90 This daylit original image, shot with the Fuji 680II and 50mm extreme wide-angle lens, was made on daylight transparency film and polarizer filter to enrich the colors and control reflections from the windows. (Canwest Global Performing Arts Centre, Prairie Partnership, Architects.)

91 Using the distort tool (above) and the perspective tool (middle, left image), Ray straightens up the perspective distortion of the original image. Perspective control available on the camera was not sufficient to achieve a fully rectilinear effect in the transparency.

Above: 92, 93 The use of polarizer filters in ultra-wide-angle shots often introduces an uneven density distribution in an otherwise clear blue sky. In this operation, Ray used the polygonal lasso tool to isolate the sky area, which was then evened out using a combination of Gaussian blur and levels controls.

Left: 94 A final touch... Ray smoothes the course texture of the red stucco above the building entrance. This distracting roughness is the result of a poor job of stucco application harshly highlighted by the glancing angle of the direct sunlight. Ray selected this area, smoothed it with Gaussian blur, then introduced a more even texture using the noise control under the filter menu.

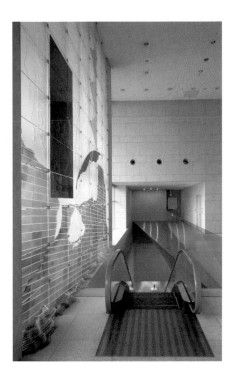

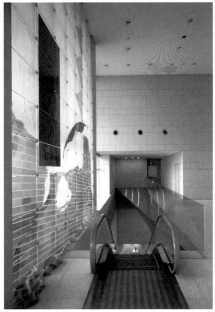

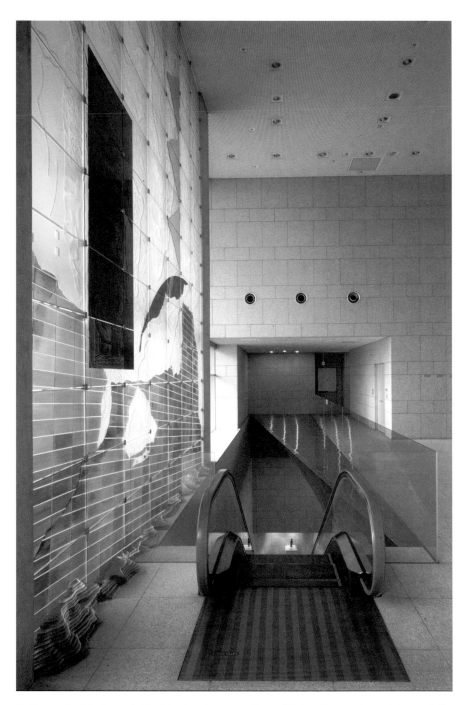

Top: 95 This is an unretouched interior view of the Canadian Embassy in Tokyo, Japan, shot for Winnipeg sculptor Warren Carther, who created the exotic glass wall on the left of the frame. Shot with a Linhof Technikarden 4x5 view camera fitted with a 9x12cm Horeseman film back on daylight transparency film.

Bottom, left: 96 Ray sets the black and white points and overall luminosity levels, raising the apparent contrast and saturation. This operation accentuates the color discrepancy between the generally daylit areas, the center area illuminated by fluorescent fixtures, and the area at the bottom of the escalator lit by tungsten lamps.

Above: 97 Starting with careful use of the polygonal lasso tool, Ray worked on the areas of out-of-neutral color balance. With the level control panel, he brought the color closer to a normal range, while leaving enough of a difference in these areas to retain a rich sense of the ambiance of the space.

98 This image was made while traveling to several locations for Wilmar Windows, a Winnipeg manufacturer. I was working on a tight budget, so no time was available to wait for the perfect weather, hence the overcast sky. Shot originally on Fuji Velvia transparancy material, this photo actually records the details of wood and windows in rich color and detail, but because of the dreary sky, it lacks a certain zing.

99, 100 The first step was to create a separate background layer consisting of a stock image of a blue sky with puffy clouds. Using the lasso tool and cut and paste tools, Ray replaced the dull sky with the brilliant blue background. Edges of contact between the two images were carefully filled in with the rubber stamp, effecting a seamless match at every adjoining edge.

101 Using similar select/cut/paste techniques Ray livened-up the windows. Ray flipped the images of sky and incorporated some blur in order to assure a natural look to the artificial reflections.

Opposite:
102 The final touch...a tighter crop snaps the windows into greater prominence.

103 (top left), 104 (top right), 105 (middle left), 106 (middle right) depict aspects of the Scotiabank Dance Centre in Vancouver, Arther Erickson/Architectura, Architects. All four images show how subtle tonal graduations and film-unfriendly color balance are handled with aplomb by digital recording technology. Image 103 shows a theater space being prepared for a performance. We see bright video test-patterns on hanging screens reproduced just as clearly as the dark, dark details in the black-painted ceiling and walls. Image 104, a student's lounge, is illuminated by a mixture of daylight from the window and tungsten ceiling pots—everything, including the buildings across the street, is rendered clearly and naturally. Images 105 and 106 are views of the Dance Centre lobby/entrance. Here we have very subtle color and tone in both dark and light areas—something that would severely tax conventional film—rendered smoothly and accurately.

107 (top) and 108 (right) The Liu Centre for Global Issues, UBC, (Arthur Erickson/ Architectura) is my first published project that entirely bypassed conventional film technology (see *Canadian Architect*, Jan, 2002). Image 107 shows how well the LightPhase rendered a mix of daylight and fluorescent lighting. Image 108, actually two images knit together in Photoshop™ for an extreme wide-angle view, is a reasonable rendering of a tricky daylight, fluorescent, and tungsten combo.

MARKETING THROUGH THE WORLD WIDE WEB

INTRODUCTION For a time it looked like good architectural photography was losing ground in a fuzzy, color photocopied world papered by quick, cheap snapshots. But as we have seen in the preceding chapters on digital imaging techniques and equipment, the technologies that initially threatened the value of carefully made images of buildings and interiors, namely desktop publishing, digital imaging, and Internet communications, have matured well past the "quick-and-dirty" stage, and are becoming sophisticated marketing tools for architectural professionals. The consequence of this development is an increasing need for both professional-looking architectural photographs and highly useable websites in which to insert them.

My son, Leo Kopelow, specializes in user-centered interaction design at IDEO, one of the world's most innovative design companies. His work has received awards from *ID Magazine*, The Industrial Designers Society of America (IDSA), and *Graphis*, among others, and has been featured in the *New York Times* and *Business Week*. I collaborated with Leo to shape this chapter.

The Pugh + Scarpa Architecture website (pugh-scarpa.com) is effective, despite being based in Macromedia Flash, which can cause compatibility problems. The layout of the site makes good use of images that are small enough to download quickly but large enough to see. Reproduced with the permission of pugh-scarpa.com.

A PURPOSE FOR YOUR WEBSITE The Internet has many functions, and its effective use as a marketing tool depends on a clear identification of what your site is intended to do. A marketing website cannot be expected to be a stand-alone generator of new business, but it can effectively supplement your current efforts to gain new business. At least three functions are crucial: First, a website must be interesting enough to attract attention. Next, the site must be sufficiently information-rich and easy to use. It should instill confidence in the key audiences that refer to it. Finally, it must be appropriate in style and aesthetically pleasing so that professional publications as well as awards committees and juries will trust it as a resource when your work is being reviewed.

THOSE WHO WILL BENEFIT FROM THIS CHAPTER The ultimate purpose of a good website can be described in a few words, but it takes an impressive amount of skill and experience to make it happen. It is certainly common to seek out an individual or firm that specializes in this work, but readers of this book are likely sufficiently adventurous to investigate the nuts and bolts before engaging the help of an expert. In my view this is a wise approach, if only because *caveat emptor* is just as true in the twenty-first century as it was in the first.

Most of you will identify with one of the following scenarios: You might be a student, an individual practitioner, or a partner in a small firm that wants to create or update an existing site—your budget for this work might be anything from $500 to $10,000. A big or mid-sized firm likely already has a site up and running, in which case expansion, improvement, or a total revamp is the order of the day, and the price tag could be $10,000 to $50,000 at the lower end of the spectrum and perhaps $50,000 to $500,000 or more at the high end. Quite a range of costs, expectations, and possibilities. Regardless of budget, though, the fundamental characteristics of a highly functional website are universal—only the scope of the project will vary.

CHARACTERISTICS OF AN ACTIVE EFFECTIVE SITE The following functions are critical for any effective website:

1. It should be a functional extension of your marketing strategy.

2. It should serve the needs of the intended audience with appropriate, compelling content.

3. The interface should be intuitive and easy to use.

4. It should be technically appropriate, i.e. quick to download and not dependent on non-standard technologies.

5. It should be aesthetically appropriate and integrate seamlessly with the existing corporate identity.

First and foremost, a website must be an accessible source of current information about you and your work. This most fundamental function is achieved through a variety of techniques, applications, and structures. Intranets and extranets, for example, bring an additional layer of functionality to your website, but with them come higher design, development, and administrative costs. An intranet is a section of your website that is

My website (gkphoto.net) started with research and a review of business goals. The result, designed by Leo Kopelow, is a simple yet targeted site that has already helped secure a number of contracts.

accessible only to members of your firm, allowing the proprietary intellectual assets that need to continually flow between working colleagues to be conveniently organized, updated, and disseminated. An extranet is a section of your website that is accessible only to specific external individuals or organizations, a place where you can share digital assets with your clients, such as progress photos of current projects. This shared workspace can foster collaboration and improve project efficiency, especially if you are separated by physical distance.

PHOTO NOTES As we have seen, a website can consist of public and private areas, with photographic portfolios being significant components in each. To put images of your work online you must organize and scan (*see chapter 18*) existing paper or film archival images for insertion into the new electronic archive. This initial kernel must be supplemented regularly, perhaps four times a year or more, to keep the site up to date. There are some technical considerations governing this process that are best sorted out early on.

Most likely, existing photography will have been produced using a variety of formats and reproduced in a variety of sizes. A video monitor is significantly less accurate than a photographic print or transparency, but nevertheless, images from different sources will inevitably look inconsistent and/or uneven when reproduced side by side on-screen. Manipulating color, density, and contrast with a program like Adobe Photoshop™ (*see chapter 18*) will certainly help, but it makes sense at the beginning to decide upon a format for future photographs intended for web use. This could be image files from digital cameras, 35mm slides, 8x10in prints, or even 4x6in prints. If shooting format is an uncontrollable variable in your situation, a web designer should be consulted to determine a scanning standard for output size and resolution.

COPYRIGHT ISSUES The web has become very sophisticated, and so have the corporate lawyers on the look-out for copyright infringements. The world of professional photography has been repeatedly rocked by acrimonious legal proceedings and substantial settlements (some beyond six figures) in cases of misappropriation of copyright-protected images. Magazines have been particularly active in guarding their hegemony over published material, both photographic and text-based. This means simply that it is illegal to scan and reproduce previously published material on your website without permission, even if you or your firm happens to be the subject of the purloined items.

Contact the source publications directly for the appropriate waivers, some of which may require the payment of a reproduction fee or the addition of a credit line ("reproduced with permission from…").

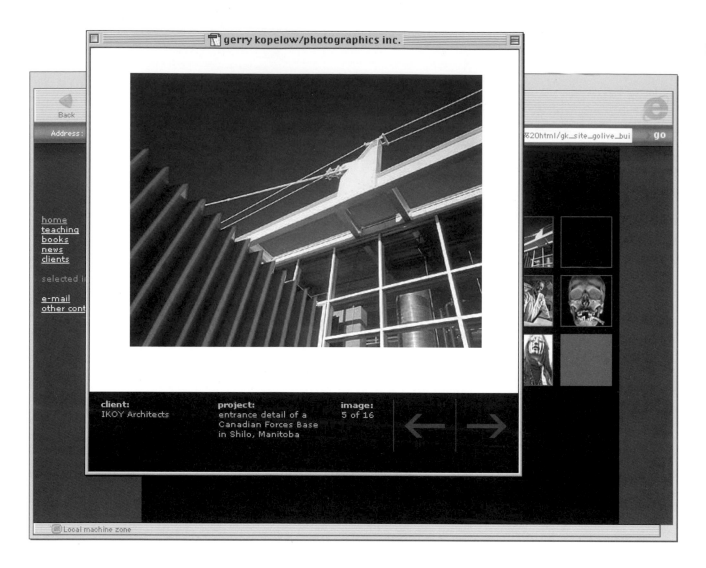

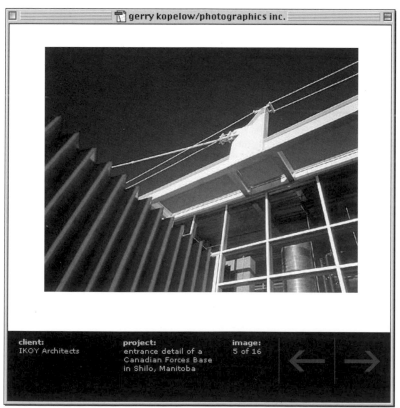

Two screen captures of my online portfolio—the top image is the pop-up window over the main window, below is the pop-up window only. For the portfolio section of my site we had to balance image quality with download speed.

SPECIFICS OF WEBSITE DESIGN

A LARGE SITE IN DETAIL Where do large, highly produced websites come from and what are their critical characteristics? Usually, but not always, a large site is the progeny of a very big firm with a substantial marketing budget. As this is being written, the dot-com frenzy has subsided, and we are seeing a less fevered attitude on the part of big corporations towards e-commerce in general and the significance of establishing and maintaining a towering presence on the web in particular. Nevertheless, the move into cyber-marketing has been made in some form by virtually every business entity in North America. As a result of this broad electronic thrust, the current stock of large commercial websites is huge and extremely uneven in quality.

Elaborate sites have sprung from the collective minds of marketing managers and public relations departments by way of advertising agencies, public-relations firms, design firms, individual designers, and a motley collection of computer-savvy programmers, geeks, and nerds. For two or three years during the boom, dedicated web-design firms or departments flourished to service the tsunami-like wave of web-driven demand, and the best of these, or at least the most resilient, survive today.

Naturally, every website is launched into the electronic universe along with the very best of intentions, but lack of timely maintenance is typically the Achilles heel for most large sites, if only because this is an age of short attention spans and informational greed. Those that do not faithfully update promptly degenerate. The necessary constant attention might be provided by a marketing person/department charged with the responsibility of gathering new images as well as graphic and text-based content, together with an internal webmaster or technical group who implements the changes. Alternately, an outside web-design firm or specialist contractor could be engaged to handle the work, but whichever agencies or individuals end up with the job will inevitably require monitoring and updating as well.

Our special interest is of course photography, and putting new, clearly captioned pictures into suitable electronic portfolios is perhaps the most regular upgrade that any architecture-related site will require. The rise of Internet marketing has generated a new need for good architectural imagery, and good architectural imagery is generally what is to be found on the big sites.

Large firms use or should be using photographs produced by professional photographers or highly skilled in-house photographers. Whereas the web is a wonderfully effective disseminator of low-resolution facsimiles, it demands at the same time to be fed a continuous stream of high-resolution originals.

An 8x10in digitally produced image requires at least 25mb (millions of bytes) of information in order to preserve a "photo-real" appearance when printed out on dedicated photo paper, but to ensure a conveniently quick download a web page should ideally be smaller than 25kb. 45–75kb is noticeably slower, but hard to avoid when photos are involved (Smaller is better!). 100k can be painfully slow and should be avoided. It makes sense, therefore, to produce original imagery of the highest quality possible, and then scan and retouch at the highest resolution possible, with a view to preserving quality for multiple uses so the final image can be used in print as well as on the web. The webmaster or in-house graphics person will compress and re-size photos appropriately for online use.

INTRANET NOTES The intranet component of a big site will include confidential snapshots of work in progress showing both deficient and successfully executed construction elements. Businesses may also want to provide inspiring historical and archival images and perhaps a representative range of excellent as well as less-than-excellent work by competitors. Photographs and brief biographical sketches of principals and employees will find a place here, together with working documents and drawings, memos, suppliers' particulars, specifications, directives, internal billboards, schedules, and discussion forums.

EXTRANET NOTES In addition to public areas open to all, a rich site could include extranet features accessible to selected clients and suppliers through passwords and dedicated pages. Projects in progress can be examined here via relatively informal location photos; documentary-level digital images work well for this application, provided standards of clarity, content, and reproducibility are maintained as described earlier in Chapter 7 (*see page 92*).

IDEO design's intranet is used for sharing knowledge, tools, design methodologies, project updates, and marketing assets across a number of the design consultancy's international offices. Reproduced with the permission of IDEO design.

A laptop computer equipped with a wireless modem will allow updates by the project manager right from the construction site.

Slightly more sophisticated images and another set of dedicated pages should be provided for the legal proofs that insurers and banks and other funding agencies require as critical phases of construction are reached.

A SMALL SITE IN DETAIL Small can be beautiful. In the current business environment not having a web presence is like not having a business card, yet even a quick look at the big sites could well be intimidating to anyone considering an Internet launch of modest proportions. It is true that all those high-performance features are costly and complicated to assemble, but it is also true that intelligent design can make a small site memorable and effective. Even a low-budget site allows instant communication of your message to clients or would-be clients. Specialized architectural services are identifiable by keyword through a search engine, and of course, it is often smaller firms that focus on particular specialties. Strategically distributed direct-mail promotional pieces can point prospective clients to your site where much more information than can economically be included on printed material can conveniently be browsed.

ARO (aro.net) is a small New York–based architecture firm. The layout of their site is crisp and appealing, a great example of how less can be more. The interface uses non-standard scrolling arrows, which could potentially confuse inexperienced web users. Reproduced with the permission of aro.net.

Your URL should appear on every piece of printed material that leaves the office—business cards, stationary, labels, proposals, specifications, invoices, etc. Research will yield lists of Internet sites that might be frequented by prospective clients and could be hot-linked to your site after some negotiation (school boards, for example, likely look at sites that feature school supplies or textbooks, while hospital boards likely look at sites that feature medical equipment).

Magazines, journals, and newspapers that feature your work will normally be quite happy to include your web address with their stories. (*Revisit the section on publication, public relations, and press releases in Chapter 8.*)

CONTENT In Chapter 3, I put forward the proposition that a skilled amateur relying on 35mm equipment and professionally made prints from color negative film could expect to produce work of very useable quality. My thesis is fully vindicated by the world of web marketing: Well-executed 35mm photography and Internet-related technologies are an excellent match in terms of resolution, flexibility, and economy of use. Furthermore, high-end digital cameras that share lenses, accessories, and mechanical configurations with the classic 35mm systems upon which they are based extend the usefulness of the small-format approach even farther.

Photographs will provide the primary visual foundation for all architecture-related sites, both small and large, but beyond photography, the manager of a small site can successfully exploit many additional resources for content without breaking the bank. For example, it does not cost much to enter work in competitions or to submit ideas to publications: If one does this often and succeeds even rarely, durable materials to feature on the web will inevitably accumulate. In fact, entry materials themselves constitute useable content: Those carefully crafted work-ups that do not win awards or do not end up in publications can be relabeled as in-house creative exercises and electronically displayed to good advantage.

The press-release gambit should be pursued frequently, since all resulting articles or reviews relating to your work in any local, regional, national, or international newspapers and magazines can become valuable content for your website, once the appropriate permissions have been obtained. Even seemingly mundane data like company information, a staff directory, and a map with directions to the office can be put up on the net clearly and imaginatively in order to help visitors develop an upbeat impression about your business and the people connected to it.

A final suggestion: the "poor man's extranet" is a scaled-down version of the password-accessible extranet features common to the larger sites. If the project assets are confidential, you can post them on "hidden" pages to which your public pages do not link. You can then e-mail the address of the hidden pages to selected clients.

ARCHITECTURAL PHOTOGRAPHS AND VIRTUAL REALITY The content of your site need not be limited to text and conventional still pictures. There are a number of exciting ways to enhance and animate regular photographic imagery that can increase viewer interest and deliver more information at the same time.

One very literal way of expanding the role of still photography is to create composites made of several photos skillfully melded together into a continuous panorama. This process is called stitching, and several software programs are available to do the intricate work of matching color, density, and perspective for images that are to be conjoined. Stitcher 3.0, for example, from Realviz (realviz.com) is a $500 package that will make planar, cylindrical, or spherical panoramic presentations.

Planar panoramas are flat, ultra-wide-angle perspective-controlled images that could not exist without stitching technology. Such images are positioned and viewed just like regular photos, although they are extremely horizontal or extremely vertical in shape. Cylindrical panoramas are created from ordinary images taken in a 360° horizontal arc from a particular point of view at 30° increments, and then stitched together to form a cylindrical image around a center point. Spherical panoramas are cylindrical panoramas that have been extended ±180° above and below the center point. These specialized panoramas are experienced as user-navigable virtual reality presentations, generally requiring specialized software like QuickTimeVR or MacroMedia Shockwave 3D for implementation on the web.

Virtual reality web presentations need not be based on actual photographs only. Those of you familiar with the ongoing computerization of architectural design will know that programs such as ArchiCAD and AutoCAD are used almost universally to create renderings and working drawings. You may also know that structures that do not yet exist in reality can be modeled in three dimensions using conventional computer-aided-design (CAD) technology in conjunction with software developed initially for the film industry and for automobile manufacturers; floor plans and perspectives are the starting points in the creation of geometric armatures that can be embellished by electronically generated textures and light effects to make simulated interior spaces and exterior forms that can be examined from any angle at the flick of a mouse.

Steven Spielberg's *Jurassic Park* marked a watershed for computer animation. Certainly, special effects had appeared in movies before, but here, for the first time, was a truly seamless melding of reality and virtual reality, convincing enough to make extinct dinosaurs into flesh-hacking terrors whose artificial nature was so deeply disguised as to be undetectable.

Anyone with a $20,000 Silicon Graphics workstation can make their buildings come to life in almost the same way. Alias Wavefront's Power Animator is the $30,000 software program behind *Jurassic Park, The Terminator*, and *Toy Story*. It makes three-dimensional

These images are from the photo-real video presentation prepared for sculptor Warren Carther by Rescom Interactive in Winnipeg.

XIX

219

modeling an almost biological activity. I learned about Power Animator from Eric Santiago, a three-dimensional digital video specialist at Rescom Interactive in Winnipeg.

I met Santiago through Warren Carther, my sculptor client that I introduced to you in Chapter 14. Carther was preparing a photo-real video clip for presentation to his Hong Kong clients. An animated electronic tour of the buildings in which his three proposed pieces were to be placed would demonstrate how they would actually look. My photographs of existing Carther sculptures, including those from the Investors Group lobby (*see color plates 65, 66, 67, 68*), were being scanned to harvest authentic surface textures for mapping onto the Power Animator virtual sculptures inside the Power Animator virtual building that Santiago had created from drawings, plans, and elevations provided by Carther and the developers in Hong Kong. (Warren Carther made his presentation on location in Hong Kong and actually won the prestigious commission. He told me afterwards that his virtual reality video clip played a significant role in the process.)

Architects who regularly need to pitch projects to clients bedazzled by Hollywood voodoo technology are using outside consultants like Rescom Interactive in conjunction with in-house specialists to create their own animated three-dimensional video simulations. These activities require images made with digital cameras, or scanned conventional images, as the raw material necessary for the generation of photo-realistic renderings of new or existing surfaces, interior spaces, building exteriors, or even entire streets and communities.

As with all powerful visual tools (i.e. fish-eye lenses, high-contrast or posterized graphics, extreme film grain, or blurry focus), photo-real VR are best used in moderation. Loading and navigating such complicated graphics take up a lot of computer time and resources; moderation is the key to effectiveness.

THE WORK OF SITE CREATION Constructing a site is a sophisticated undertaking, regardless of the scale of the finished product. In preparation for the actual building of its Internet appearance, any future Internet marketer requires a business strategy supported by research into the needs of the target audience. This need not be an expensive or unwieldy procedure: Simply make a list of six to ten individuals or companies that you would like to attract through the web and politely solicit their views and expectations. (*See page 227 for a sample questionnaire.*)

A preliminary structure for the site must be mapped out to address these needs once they are identified. A process for site maintenance and updating must be established, a domain name registered, and a hosting company be hired. All this can be done with or without the benefit of pricey specialists, according to the resources available.

Once the necessary practical requirements are in place, the work of site creation can start. Nuts-and-bolts operations include the determination of the detailed architecture of the site, interface design, graphic design, content generation, and, finally the programming that makes everything happen. Except for perhaps content generation, all this work is best left to specialists.

Expertise is most reliably found within a firm that specializes in web design, and not so reliably within an advertising agency, public-relations firm, or print-design studio that sports an add-on web-design department. Of course, an outstanding multimedia student at a technical college or design school can make a good shot at creating a useful site, and with extremely tight budgets, this might be the best way to go. All things considered, though, if money is available to get up and running it is best to spend it on the real thing.

HOW TO CHOOSE A WEB DESIGN FIRM When selecting a web design firm avoid Internet service providers (ISPs) and firms that are primarily involved in web hosting, advertising, public relations (PR), or print design. Non-specialized shops whose main expertise is in print or advertising design typically create a visual concept in-house and then hand off the technical work of programming to a subcontractor, usually underemphasizing or missing entirely critical cognitive and human-usability factors.

It is best to retain a firm with deep expertise. The development of a first-rate site requires a wide range of aesthetic, technical, and intuitive talents, and is best attended to by the collegial efforts of a team of fully engaged individuals. The right group might have from three to one hundred people on staff, including a visual/graphic designer, specialists in usability, information, and interface design, and one or more programmers with expert

ID Magazine Interactive Media Design Review (idonline.com) can be a starting point when trying to locate a company to help create your website. Reproduced with the permission of idonline.com.

knowledge of HTML, DHTML, java-script, and other current programming technologies. They should be able to demonstrate their experience with examples of press coverage of their work in respected publications, case studies on how their work positively impacted their clients' businesses, and a respectable number of significant awards. Firms of the required caliber can be found through references in web-related journals and magazines, through referrals from satisfied clients, through professional associations, and even through press coverage in the popular media.

Perhaps the best way to evaluate a short list of likely candidates is to visit some of the sites they created for others. Navigation should be intuitive, one's location inside the sites should always be obvious, and the sites should work flawlessly regardless of which browser platform, operating system, or hardware configuration is in use.

Costs for web-design services vary widely. The largest consultancies may require a minimum commitment of $100,000 to $1,000,000, but there is no real upper limit. The search for the right mix of skill and economy may take some time and effort, but ultimately it will be worthwhile.

ABOUT USABILITY "The content of the site should be interesting. The site's interface should not. In fact, it should be so predictable nobody thinks twice about how to use it."

Even in cyber-space common sense should prevail, and the wise web-wanna-be must occasionally intervene to temper the passions of the overly creative when "cool design" threatens to make the site less than user-friendly. Site structure and interface should be designed around the user's needs in a way that is immediately understandable to them, and not necessarily in a way that caters to you, your colleagues, or your designers.

All menus should use real words, not professional jargon. If an icon or symbol is used it must be instantly recognizable. Terminology should be simple and descriptive (e.g. "portfolio," not "work.") Choose small, fast-loading files over super-high image quality. It is best to adopt standard rather than exotic features and controls. A logo-click should take the user "home," links should be underlined, menus should not change location from screen to screen. Avoid the use of "frames," which can interfere with other browser functions such as "back" and "forward" buttons. Always clearly highlight the user's location in the current menu and provide a simple "how you got here" indicator. Never put obstacles between users and information, such as showy splash screens with an "enter site here" button, or an animated introduction with a "skip intro" button.

HOW TO REGISTER A DOMAIN NAME It is easy and fun to select and secure one's own domain name. There are a number of domain registration services, the oldest being Network Solutions. To search for and register available domain names, simply log onto networksolutions.com and follow the instructions. Current registration fees are about $35 for one year.

Here is some information about the most common domain names:

.com and .net are the most widely recognized domains for businesses. (.com is the domain originally intended for "commercial" entities, .net is the domain originally intended for Internet-related entities.)

Left: Google (google.com) is an example of usability at its best. They have put a lot of effort into building a search engine that works extremely well, and an equal amount of effort into keeping the interface brilliantly simple. Reproduced with the permission of google.com.

Right: This community resource site scores very high on the usability scale. No graphics, no distractions—just high-quality contents and an interface that allows easy access. Reproduced with the permission of craigslist.com.

.edu is designated for four-year, degree-granting colleges and universities.

.org is the domain designated for non-profit organizations that do not fit under any of the other top-level domains.

.gov is the domain for agencies and branches of the U.S. Federal Government.

.mil is the domain designated for United States military entities.

One last suggestion: a useful complement to a professional presence on the web is a 1-800/1-888 toll-free number (available through your telecom provider).

This is the schedule Leo Kopelow devised to keep us on track as we worked to create the gkphoto.net website. It proved to be a reasonable timeline, despite the many details that had to be attended to.

DELIVERY OF PHOTOS IN THE NEW DIGITAL MARKETPLACE

INTRODUCTION In many markets the standard method of moving images from creator to user is Federal Express or one of their competitors. In fact, at this very moment many thousands of plastic-sleeved 35mm, medium-format, and large-format transparencies are zipping through the skies, comfortably ensconced between slabs of corrugated cardboard. But editorial standards and needs are changing, and magazines and journals are working to tighter and tighter deadlines. Right now the flow of physical images may be substantial, but it is certainly declining as electronic image delivery becomes cheaper, faster, and more reliable.

ELECTRONIC STANDARDS FOR MAGAZINE SUBMISSIONS With a view to determining what the publishing world wants to receive from photographers, I recently polled editors and art directors at several publications, including *Architecture Magazine, Canadian Architect, Architectural Record,* and *Architectural Digest,* all of which depend upon an endless stream of architectural images for their existence. Although each had one or two particular idiosyncratic requirements, they all agreed on several critical points.

Every publication wants to see a brief, informal written query before any images of any sort are shipped; this might be a letter sent by snail mail, an email, or a fax.

(Addresses and numbers can be found in the publication's masthead, usually found in the first few pages of the magazine.) Once the magazine has indicated an interest, a submission can be forwarded. Included in the package should be a printed list with brief descriptions, regardless whether you submit conventional photos or electronic files. The photos themselves can be documentary-level scouting images in the form of 4x6in or larger prints, duplicate slides or transparencies, ink-jet prints, or a low-res Zip, Jazz, or Compact Disk. Those making a preliminary submission of this sort should not expect their materials to be returned, unless arrangements are made beforehand and sufficient postage and packing materials are supplied with the images.

Once a project is accepted and if original photography is not to be commissioned, images for reproduction can be submitted in a variety of formats. It is interesting to note that real photographs, in the form of excellent original 4x5in, medium-format transparencies, or very well made 8x10in photographic prints are the first choice of most art directors. 35mm slides of exceptional quality may be deemed suitable as well. A sign of the times, though, is the fact that electronic image files are universally accepted in lieu of real photographs, but only if superior technical specifications are maintained.

Magazines typically want TIFF or Photoshop™ EPS files created in MAC format at an absolute minimum of 300dpi resolution scaled to 8.5x11in size output. All magazines will accept these files on a CD, and many will take Zip or Jazz disks as well. The files must be made on a high-end digital capture device or from first-class original photographic images digitized with a professional-level scanner operated by a skilled technician. One might keep in mind that if a publication really wants to publish a particular project and deadlines are tight, these criteria might be relaxed somewhat. Photoshop™ is a powerful tool, and more often then editors and art directors like to let on, pretty sorry-looking originals will be buffed up sufficiently by an image enhancement expert to make it into print. In most cases, though, the better the image the better your chances of engaging the magazine's interest.

MOVING BIG FILES THROUGH THE WORLD WIDE WEB Like the law, the web is a powerful but very blunt instrument. The Internet is a graphical broadcasting medium, a device for reaching a lot of people with a lot of information. Happily, however, the electronic infrastructure that supports it can be used for pinpoint delivery of specific materials to specific individuals, institutions, or businesses. Email is one of a suite of applications that move electronic files from one place to another, and it works for low-resolution image files just as well as for ordinary text files.

In this section, however, we are specifically concerned with the electronic transfer of high-resolution electronic image files—images suitable for reproduction. Compared to text files, hi-res files are awkward and time-consuming to transmit via ordinary email. We have all experienced difficulties like odiously long upload and download times, file-corrupting server fowl-ups during transmission or reception, and of course, general system crashes.

Just a couple of weeks before this was written, I shot an assignment for *Time* magazine that had to be executed and delivered in a big hurry. I got the call at 2:30 P.M., made the shot on location one hour later with a digital camera, and, as directed, attached the file (a modest 1.5mb JPEG that would ultimately be reproduced about 2in square) to an email sent to *Time* magazine's AOL address. My work required less than two hours to complete, but it took another two hours for the file to make it through *Time*'s elaborate electronic firewall and virus-protection protocols. It finally arrived, but with posterized highlights. The whole procedure had to be repeated with a different email provider.

Complications like these are show-stoppers when design professionals need to electronically submit images suitable for high-quality reproduction—25–100mb in size—to magazines, journals, or to potential clients in real time. A faster and more reliable system than email is required.

FILE-HANDLING MEDIA There are several approaches to this problem, but there is always some kind of trade-off between speed and reliability. Data transmission via removable media like floppy disks, Zip disks, Jazz disks, and compact disks, is slow but widely accepted by editors and art directors. These systems allow anything from several megabytes to several gigabytes of data to be recorded at the desktop, and then the disks can be physically shipped to their destination. The utility of this method depends upon

This image shows an array of data storage media. Image courtesy of Iomega Inc.

This is a CD-RW disk, 650mb capacity. Image courtesy of Iomega Inc.

This is the Iomega 250mb Zip disk. Image courtesy of Iomega Inc.

the reliability of overnight couriers and the existence of suitable disk readers and software at the receiving end.

Ironically, we encounter at this point an unspoken but critical shortcoming of rapid technical evolution, which I call the media gap. Data-recording modalities have changed and continue to change as this is being written: I have clients who have managed to acquire, more or less by osmosis, a working knowledge of 1.4mb floppies but who still think that CD-Roms are nasty and annoying because they will not play on their stereo turntable. Only a couple of years ago Zip and Jazz disks were the data transfer medium of choice for the graphic arts industry, but now they seem rather expensive. The recordable CD is the present standard, but the DVD and all kinds of unique solid-state USB and firewire memory modules are rapidly overtaking it in popularity. Nevertheless, any computer recently purchased or upgraded will have a CD reader and more than likely a CD recorder and recording management software as well, so for the near future at least, CDs rule.

Even as this is being written, however, the culture continues to accelerate, and marketing and publishing professionals have become addicted to speed, just like the rest of us. These days we all make light of the postal service, and lately even overnight couriers have begun to seem annoyingly slow. Digitized images can be electronically distributed in real time virtually anywhere in the world, but special arrangements must be made for large files.

FILE COMPRESSION The first step toward real-time electronic file transfer is a technology called compression, a form of mathematical manipulation that uses special algorithms to analyze and encode raw files in a way that permits image data to be recorded in a compacted form; electronic shorthand, if you will.

Some compression schemes, like LZW (Limpel-Ziv-Welch) compression, are entirely lossless, which means that a raw TIFF (Tagged Image File Format) file can be reduced in size by about 50% and then decompressed into the absolutely identical raw tiff form at a later time. LZW compression works by identifying repetitive patterns or "phrases" in the file and assigns simpler symbols to represent them.

Other, more aggressive types of compression, like the ubiquitous JPEG (Joint Photographic Experts Group) format, are lossy, which means that this type of compression can reduce a file by up to 90%, but only at the expense of some real data. This scheme works because information about luminosity is more important to the human eye than information about hue and saturation, so some of the latter can be discarded without inordinately degenerating the visible image. In extreme JPEG compression some image detail is permanently tossed out with the extra color information as well. This means that a decompressed JPEG will inevitably be only a partial representation of the original file. Exactly how partial it actually is will depend on the degree of compression selected through software controls, and this choice is made according to the final use of the decompressed file. With the LZW scheme an image can be compressed and decompressed repeatedly without any degeneration, but with JPEG compression repeated applications quickly render the image unrecognizable.

ELECTRONIC FILE TRANSFER Using file compression we can squeeze more data onto recordable media or push more information through a regular phone line using an email account, but the time will come when this becomes both unwieldy and too slow—image files are getting bigger as digital cameras and scanners improve, and editors, clients and colleagues are getting more and more impatient as the pace of business accelerates.

The first step to speeding up the transfer process is to get a high-speed (also called broadband) Internet hook-up. This might be in the form of a cable modem provided by a local cable TV company, a DSL (Dedicated Single Line) connection provided by a local telecom, or an ISDN (Integrated Services Digital Network) line provided by a local telecom or Internet service. Any of these three approaches can increase the rate of data transfer by one to two orders of magnitude.

DSL and ISDN are not yet available in all markets, but broadband cable can be had wherever cable TV is available. A cable connection is usually cheaper, about $25–$40 per month, as compared to $50–$200 per month for DSL or ISDN, but performance will slow

down depending upon how many other subscribers are using your segment of the line at any given moment. I have a cable modem, and slow speed is rarely a problem in my area, but it is prudent to make some inquiries before committing to a contract. Remote locations without access to wire-based high-speed technology can be serviced anywhere in North America using satellite-based digital broadband.

Any high-speed connection will greatly enhance the speed with which files can be attached and transmitted via email. But this will not circumvent the limitation of the number of files and what size of files your email provider will accommodate. For serious throughput one must use an FTP (File Transfer Protocol) service. Similar to other Internet applications, FTP uses the client-server approach to access a remote computer, which acts as a host for the local computer. Files of any size are uploaded to what is in effect a temporary website. This can be accessed by the target computer which downloads the files as required. Your broadband supplier will supply the technical information necessary to set up this capability, usually at no additional charge.

Sample Website Planning Questionnaire

Questions for You
— What do you want to do with the website?
— To achieve this, with whom must you communicate?
(Once you know who your target audience(s) are, you can move on to the next section and ask the following questions of them)

Part I: Contact
— How do you usually contact architects/designers?
— How do you prefer to be contacted by architects/ designers?
— Have you ever searched for architects/designers on the web? How?
— What path led to the architects/designers you hired?
— What are some mistakes that architects/designers make when contacting you?

Part II: Decision Making
— Describe the decision-making process once you find some architects/designers. How is the "winner" selected?
— What are the top five characteristics you look for in an architect/designer?
— What is the essential information the architect/designer's website needs to contain in order for you to proceed to contact them or pass the URL along to other decision makers?
— Are the following features important? (rank each from 1—10)
 • portfolio
 • mailing list
 • bio
 • articles by the architects/designers
 • credentials
 • online photos of jobs
 • other features that are important?
— Is an architect/designer's "house style" important, or is versatility important for your projects?
— Rank the following decision-making factors from 1—6, with 6 being critical and 1 being unimportant:
 • credentials (please specify which of the following are especially important to you: publications, teaching, years of experience, education, equipment, impressive client list, number of employees, any other credentials)
 • experience (give details: What kind of experience? What level of detail do you need when the experience is described in the architect/designer's portfolio?)
 • portfolio quality (give details: What qualities are important in a portfolio? How many photos do you like to see in a portfolio?)
 • price
 • location (give details: Are you more likely to hire someone local? What would it take to make you opt for a non-local architects/designers?)
 • client testimonials
— What would it take for you to use me/my firm?

ABERRATION An imperfection in lens performance. All lenses only approximate the ideal.

ALGORITHM The specific process in a computer program used to solve a particular problem.

ANGLE OF ACCEPTANCE The angle that describes the width of the field encompassed by a particular lens. A wide-angle lens has a relatively wide angle of acceptance while a telephoto lens has a relatively narrow angle of acceptance. Also called "field of view."

ANGLE OF REFLECTANCE The angle at which light bounces off a surface. For perfectly flat surfaces the angle of reflectance is always equal to the angle of incidence.

APOCHROMATIC (APO) LENS A photographic lens in which all aberrations have been carefully minimized so that performance is very nearly perfect.

ARTIFACT An undesirable element or degradation of an electronic image. Can occur during image capture, manipulation, or output.

AUTOMATIC DIAPHRAGM A diaphragm (typically in the lens of an SLR camera) that automatically closes to a preset size just before an exposure is made, then automatically opens to its maximum size immediately after the exposure. Sometimes "automatic diaphragm" is used to refer to the entire actuating mechanism of springs and levers in both camera body and lens.

AUTOMATIC FOCUS The process during which a modern electro-mechanically governed camera measures the distance between the camera and a photographic subject.

AXIS OF POLARIZATION The orientation of the light-blocking "slots" or "gates" or a polarization filter. Photographic polarizers are mounted on special rings so that the axis of polarization may be rotated to achieve the most desirable affect.

BACK SWING The rotation about a vertical axis of the back standard of a view camera.

BACK TILT The rotation about a horizontal axis of the back standard of a view camera.

BAG BELLOWS An extra-flexible bellows required whenever short focal length (wide-angle) lenses are used with a view camera.

BALL-AND-SOCKET HEAD A mechanism used to attach a camera to a tripod. The camera is connected to a metal ball by means of a short metal stem. The ball is secured inside a metal cup, which is slightly larger than the ball. A clamp is used to lock the ball in position within the cup at an appropriate camera position.

BARREL DISTORTION A type of aberration often associated with extreme wide-angle prime lenses and wide-angle zoom lenses in which vertical and horizontal lines appear curved or bowed away from the center of the image.

BATTERY-POWERED PORTABLE FLASH A compact, self-contained electrical device, energized by a battery, which produces a brief but bright burst of light (flash) in synchronization with the opening of a camera shutter. The smallest verions of these devices are mounted directly on the camera while larger versions include a "power pack" carried in a case with a shoulder strap and a "flash-head" which is mounted on the camera and connected to the power pack with an electrical cable. Portable flash units are used to illuminate a photographic subject under conditions that would otherwise be too dark to conveniently make a hand-held exposure.

BELLOWS The very flexible accordion-like light-proof box that joins the front and back standard of a view camera. The bellows allos the necessary technical contortions of the view camera while completely blocking all non-image-forming light.

BEHIND-THE-LENS (BTL) METER Also known as "through-the-lens (TTL) meter." An electrical or electro-mechanical device built into the body of an SLR camera. Such a meter measures the light reflected by the subject and transmitted by the lens in order to determine, automatically or mechanically, the correct shutter speed and diaphragm opening required for the proper exposure of a particular subject/film combination.

BLACK-AND-WHITEE NEGATIVE FILM A type of photographic film that records a monochromatic image in reverse tones: what is bright in the subject is rendered dark on the film, and vice versa.

BOUNCE LIGHT A photographic technique in which light from an artificial source (such as an electronic flash or photo floodlight) is bounced off a reflective surface (a white card or a light-colored wall). This technique transforms a source of "hard" light into a source of "soft" light.

BRACKETING The technique of exposing a series of frames of film at slightly under- and slightly over the measured exposure. This technique is sometimes necessary in order to accommodate the many variations of light, subject reflectance, and film responses that make predetermining a single, exact exposure setting difficult.

BRIGHTNESS RANGE The subject brightness range; the range of luminance in the subject.

BRIGHTNESS RATIO Brightness range expressed mathematically, i.e., 128:1.

BTL METER See "behind-the-lens meter."

BURN-IN A technique of photographic printing in which a darkroom worker darkens certain specific areas of a photograph.

CABLE RELEASE A very flexible remote-control trigger (usually six to twenty-four inches in length) used to trip a shutter in order to prevent the vibration that might otherwise be induced by direct physical contact between a photographer and tripod-mounted camera.

CALIBRATION The act of adjusting the color response of one digital device relative to another, such as a monitor to a printer, a scanner to a film recorder. Also the process of adjusting the color response of a digital device to conform to an established standard.

CCD—CHARGED COUPLED DEVICE Such a device converts light into a proportional (analog) electrical signal. Linear CCD's are used in film and print scanners and photographic scanning backs. CCD area arrays are used in cameras and one-shot digital backs for photography.

CENTER-WEIGHTED NEUTRAL-DENSITY FILTER An optical device that is mounted in front of a photographic lens (usually an extreme wide-angle lens) in order to reduce the amount of light transmitted through the center of the lens. Permits an even exposure from edge to edge with those lenses that exhibit a fall-off in light transmission at the outer extremes of their image field.

CHARACTERISTIC CURVE A diagram of the effect on the film of every degree of exposure and a particular developer.

CMOS—COMPLIMENTARY METAL OXIDE SEMICONDUCTOR CMOS devises are light sensors that perform the same funcion as CCD's, but with lower power requirements.

CMYK—CYAN, MAGENTA, YELLOW, BLACK The system used by printers for producing a full color image on paper based on the subtractive primary colors.

COATERLESS Refers to those Polaroid instant print films that retain a permanent image without the necessity of applying a chemical coating.

COLOR COMPENSATING/COLOR BALANCING FILTER An optical device that is placed in front of a photographic lens in order to adjust the overall color balance (e.g., a 30M [30 magenta] filter for cool fluorescent lighting and daylight-balanced color film). Such filters work by reflecting or absorbing light of specific wavelengths.

COLOR CONVERSION FILTER A filter, stronger than a light-balancing filter, designed to allow daylight film to be used under tungsten and vice versa.

COLOR FIDELITY The degree to which a photograph mimics the exact color of a real object or scene.

COLOR NEGATIVE FILM A type of photographic film which records a full color image in reverse tones. Specific colors are represented by their complements: i.e., red is reproduced as green, blue as yellow, etc. The colors are reversed again to their normal values when the color negative is printed on appropriate photographic paper.

COLOR POSITIVE FILM A type of photographic film that records a full spectrum image in actual (rather than reversed), natural tone.

COLOR PRINT FILM A special type of color negative film for making color transparencies directly from original color negatives.

COMPACT FLASH An erasable storage device used in digital cameras to temporarily store electronic images for transfer to a computer or other mass storage device.

COMPRESSION The elimination or encoding of digital data to reduce file size.

CONTRAST-CONTROL MASKING A sophisticated darkroom technique that allows negatives and transparencies with unsuitable density ranges to be successfully printed.

CONTROLLED-FLARE A photographic technique that permits the brightness range of a photograph to be reduced by the introduction of non-image-forming light into the optical system.

COPY-SLIDE A 35mm transparency made by photographic text, a drawing, or another photographic image.

COUPLED RANGE FINDER A range finder mechanically linked to the focusing mechanism of the camera's lens.

CPU—CENTRAL PROCESSING UNIT The main integrated circuit chip in a computer. Handles virtually all computational functions .

CURVILINEAR DISTORTION A type of distortion introduced by a lens that renders straight lines as curved. See pincushion and barrel distortion.

DARK CLOTH An opaque cloth that is used to block extraneous light from striking the ground glass of a view camera.

DAYLIGHT BLUE FILTER GEL A tough, temperature-resistant, blue filter that is placed in front of a tungsten photographic light in order to change the spectrum radiated by the light to one more closely matched to normal daylight.

DEGREE OF REFLECTIVITY The amount of light reflected from a particular surface as compared to the amount of light that strikes that surface—usually expressed as a percentage.

DENSITOMETER An electrical device that measures the degree of reflectivity or transmittance of photographs, negatives, or transparencies.

DEPTH-OF-FIELD The range around a particular point of focus that is rendered as acceptably sharp in a photograph. For example, if a lens is focused at ten feet but objects at eight feet and twelve feet appear clearly rendered in the photograph, then the depth-of-field is said to be four feet. Depth-of-field varies with the f-stop.

DIAPHRAGM An aperture of variable size that changes the intensity or brightness of light passing through a lens.

DIFFRACTION The change of direction (bending) that is induced whenever a ray of light passes a sharp edge. This effect is responsible for a degree of photographic image degradation when the lens is set to a very small diaphragm opening.

DOCUMENTARY PHOTOGRAPHY A type of photography that attempts to make a very realistic (true-to-life) representation of a particular subject.

DODGE A technique of photographic printing in which a particular area in a photograph is lightened.

DPI—DOTS PER INCH The measure of resolution for a printer.

DYE SUBLIMATION A high resolution, continuous tone method for colour printing in which dyes are vaporized and diffused across a small gap to paper or transparency for output.

EDGE CUTOFF The outer limit of the image projected by a photographic lens.

EDGE FALLOFF An optical property of lenses that renders the outer edges of the projected image as darker than the center.

EFFECTIVE FILM SPEED A measure of the sensitivity of photographic film dependent on, and varying with, processing lens aperture, filter factor, and shutter speed.

EFFECTIVE ISO The electronic analogue to film speed for digital imaging sensors.

EXPOSURE The process of allowing a controlled quantity of image-forming light to strike a piece of photographic film.

EXPOSURE CONTROL Refers to the process of determining the optimum camera settings for a particular combination of film sensitivity and subject brightness.

EXPOSURE (LIGHT) METER An electrical or electro-mechanical device that measures the brightness of light reflected by a scene or object.

EXTENSION TUBE A light-tight cylinder of specific length that is interposed between the lens and body of an SLR camera, allowing the making of photographs at a closer distance than normal.

FIELD OF VIEW See "angle of acceptance."

FIREWIRE A method of interconnecting digital devices that allows fast data transfer and hotswapping.

FLATBED CAMERA/FIELD CAMERA A type of large-format view camera that does not use a monorail but instead uses a hinged platform (bed) to support the lens; usually folds up to a relatively compact size when not in use.

FLATBED SCANNER An optical scanner in which the origianl image remains stationary while the sensors pass over or under it.

FILM BACK A device for holding photographic film in proper position on view cameras or modular style, medium-format cameras.

FILM HOLDER A light-tight device for handling photographic sheet film.

FILM SPEED A quantitative measure of the sensitivity of photographic film to light. Film is assigned a number that represents its relative sensitivity to light so that proper exposure can be determined with the aid of a light meter.

FILTERS Optical devices that modify various qualities of light such as color, polarization, and intensity.

FOCAL LENGTH The distance (usually expressed in millimeters) from the rear principal focus or point of intersection of a lens and the film plane when the lens is focused on a very distant object.

FRAME LINES Bright lines within an optical viewfinder that indicate the approximate image area encompassed by a particular camera/lens combination.

FRESNEL LENS A lens made up of a concentric series of simple lens sections, this construction permits a thin lens to have a short focal length and large diameter.

FRONT FALL The downward movement of the front standard of a view camera.

FRONT RISE The upward movement of the front standard of a view camera.

FRONT SHIFT The rotation of the front standard of a view camera about a horizontal axis.

F-STOP The number that expresses the size of the lens opening relative to focal length.

FTP—FILE TRANSFER PROTOCOL The universal format for transferring files from one computer to another over the Internet.

GIGABYTE—GB A measure of computer memory or disk space consisting of about one million bytes or one thousand megabytes. The actual value is 1,073,741,824 bytes (1024 megabytes).

GRADUATED GRAY SCALE A strip of cardboard on which is printed a series of neutral gray patches of increasing density; used to determine correct exposure and effective film speed.

HALFTONE An image reproduced through a special screen made up of dots of various sizes to simulate shades of gray in a photograph.

HISTOGRAM A bar graph that identifies contrast and dynamic tonal range in an electronic image.

HOT SPOT A small (but photographically significant) spot of abnormal brightness in a photograph, in a scene, or on the surface of an object.

HOTSWAPPING A technology that permits the connection and disconnection of digital hardware without having to power-down the devices.

IMAGE DENSITY The quantitative measure of reflectance or transmittance in a photographic print, negative, or transparency.

INCIDENT LIGHT METER A light meter that measures the intensity of the ambient light impining on a particular area.

INTERNEGATIVE A copy negative made from a slide, required when a print from a slide is to be made on photographic paper intended for use with color negatives.

KELVIN COLOR TEMPERATURE SCALE A method for describing the quality of light according to color. Normal daylight is 5500°K.

LARGE-FORMAT CAMERA Any camera that is intended for use with film 4x5in or larger.

LENS SHADE A device that is mounted on the front of a photographic lens in order to block any extraneous non-image forming light from reaching the front surface of the lens.

LIGHT-BALANCING FILTER Photometric filter designed to raise or lower, by small increments, the color temperature of the image forming light.

LIGHT METER A device for measuring illumination.

LIGHT TABLE A table or counter with a translucent, illuminated top intended for viewing photographic negatives and transparencies.

LOCK A device for rendering immovable the adjustable parts of a view camera or a tripod.

LOUPE A high-quality magnifier used to evaluate photographic materials or to assist in setting precise focus for a view camera.

LPI—LINES PER INCH The freaquency of horizontal and vertical lines in a halftone screen.

LOSSLESS COMPRESSION A compression method in which the reconstructed data is identical to the original source.

LOSSY COMPRESSION A method of reducing file size that involves the throwing away of some data. This method allows significant compression but inevitably results in a proportional degradation of the original file.

MASKS A specially prepared black-and-white negative or positive transparency which is sandwiched in perfect registration together with an original negative or transparency for the purpose of contrast control in photographic printing.

MAXIMUM EXPOSURE LEVEL Properly called D-max, the maximum obtainable film or paper density.

MINIMUM LEVEL OF SENSITIVITY The exposure threshold of film or paper.

MONORAIL A rigid tube of square or round cross-section that supports the front and back standards of a view camera.

NEUTRAL DENSITY FILTER An optical device that is fitted in front of a photographic lens in order to reduce light transmission by a known amount without changing the color of the transmitted light.

OPTICAL VIEWFINDER A device (usually built into a non-SLR camera) consisting of a simple optical system used to give a close approximation of the field of view encompassed by a particular lens.

OUTTAKE Any photographs or slides eliminated or discarded during the editing process.

PAINTING WITH LIGHT A technique that allows a large scene to be illuminated by smoothly sweeping the beam of a photographic light during a long exposure.

PC LENS See "perspective control lens."

PERSPECTIVE CONTROL (PC) LENS A specially designed lens that mimics view camera perspective-control movements, intended for use with SLR cameras.

PERSPECTIVE DISTORTION The unnatural appearance of objects in photographs made without the use of perspective controls.

PHOTOCELL A device for changing light energy into electrical energy.

PHOTONS A quantum of radiant energy. The smallest "package" of light found in nature.

PICTORIAL PHOTOGRAPHY Nineteenth-century phrase that describes a romantic, highly stylized type of landscape photography. The term also refers to any photography that is not documentary in nature.

PINCUSHION DISTORTION An optical aberration of photographic lenses (usually zoom lenses) in which vertical and horizontal lines are rendered as curving inward toward the center of the image.

PIXEL—PICTURE ELEMENT The smallest element of a digitized image or a CCD or CMOS electronic image sensor. Also, the tiny points of light that make up an image on a computer monitor.

PLANE OF FOCUS A plane that describes a sharply focused image of a flat photographic subject.

POLARIZATION A process of modifying the orientation of the plane of vibration of light waves, a photographically significant property of light. Useful in controlling reflected light from certain surfaces without altering color.

POLARIZING FILTER An optical device that causes light to be polarized. Allows the axis of polarization to be varied.

PREVISUALIZATION A term, coined by photographer Ansel Adams, that describes the process of intellectually predetermining the properties of a photographic image before an exposure is made.

PROCESS LENS An apochromatic lens used in various non-photographic printing processes.

PULLING A darkroom technique for reducing film speed and/or reducing contrast by removing film from the developer before normal processing time has elapsed.

PUSHING A darkroom technique for increasing film speed and/or increasing contrast by allowing the film to remain in the developer longer than normal processing time.

RAM—RANDOM ACCESS MEMORY RAM is fast but volatile memory which exists only so long as the computer is powered up. When the machine is turned off, loses power, or crashes this memory is lost.

RANGE FINDER A device that measures camera-to-subject distance by means of triangulation.

REAR FALL The downward movement of the back standard on a view camera.

REAR RISE The upward movement of the back standard on a view camera.

REAR SHIFT The sideways movement of the back standard of a view camera.

REAR TILT The rotation about a horizontal axis of the back standard of a view camera.

REAR SWING The rotation about a vertical axis of the back standard of a view camera.

RECIPROCITY EFFECT More correctly, reciprocity failure. The loss of film speed and contrast that occurs at a long exposure time under low levels of illumination.

REFLECTION DENSITOMETER A densitometer that measures the light reflected from photographic print material.

RELATIVE BRIGHTNESS Describes the difference of brightness of two areas or objects within a scene. See "brightness range" and "brightness ratio."

RELATIVE COLOR Describes the difference in color balance between scenes illuminated by sources of different color or the difference in color balance between two photographs of the same scene made with different filtration.

RESOLUTION The number of pixels per unit length of an electronic image.

RETROFOCUS LENS A specially designed lens that allows a wider displacement between the lens and the film plane than would be required by a lens of conventional design. This innovation allows enough room for the incorporation of a swinging mirror behind the lens in SLR cameras.

REVERSAL FILM A photographic film (either color or black-and-white) that records an image in which dark areas of the subject are rendered as dark on the film, and light areas of the subject are rendered as light on the film. See "slide film."

RGB Short for Red, Green, and Blue, the primary colors used to simulate natural color on a computer screen.

SCSI—SMALL COMPUTER SYSTEM INTERFACE A method of connecting digital devices to a computer, often used in electronic imaging applications because of its high speed of data transfer.

SHUTTER A mechanical or electro-mechanical device that opens and closes a light-tight barrier for a predetermined length of time to allow controlled exposure of light-sensitive materials in a camera.

SINGLE-LENS REFLEX (SLR) CAMERA A camera design, incorporating a mirror and a prism, that allows the photographer to see in the viewfinder whatever the taking lens sees.

SLIDE FILE A system of organizing and storing 35mm color transparencies; usually involves 8x11in polyethylene sheets with twenty 2x2in pockets.

SLIDE FILM Reversal film; generally used to describe 35mm transparency film.

SLR CAMERA See "single-lens reflex camera."

SMALL-FORMAT CAMERA Any camera that uses 35mm film.

SPECIAL EFFECTS FILTER An optical device placed in front of a photographic lens in order to modify the image in an unusual way (e.g. diffusion, multiple image).

SPECULARITY Describes the relative size of a light source. Only a point source is truly specular. All other sources are diffuse or semi-diffuse.

STANDARD A mechanical device for securing a lens or a film back to a view camera monorail. A well-designed and constructed standard allows the precise movements of rise, fall, shift, and tilt.

TECHNICAL CAMERA See "view camera."

TELEPHOTO LENS A lens of longer-than-normal focal length with a relatively short physical length. Not all long lenses are of tele design.

THROUGH-THE-LENS (TTL) METER See "behind-the-lens (BTL) meter."

TONALITIES The various densities recorded on a photographic print or transparencies.

TRANSPARENCY FILM See "reversal film."

TRANSMISSION DENSITOMETER A densitometer that measures the light transmitted through photographic negatives of transparencies

TRIPOD A rigid, three-legged device of adjustable height for securing a camera in position during long exposures.

TRIPOD HEAD A device for securing a camera to a tripod. Allows control of the horizontal and vertical orientation of the camera.

TTL METER See "through-the-lens meter."

ULTRAVIOLET FILTER An optical device that blocks ultraviolet radiation from entering a photographic lens.

VIEW CAMERA A camera design that allows the photographer to manipulate various optical parameters by altering the relative orientation of a film back and a lens linked together by a flexible lighttight bellows. The image is viewed on a ground glass screen in the film back.

WIDE-ANGLE DISTORTION The unnatural appearance of foreground objects in a photograph made with a wide-angle lens.

WIDE-ANGLE LENS A photographic lens with a wide field of view.

WIDE-ANGLE PROJECTION LENS A wide-angle lens specifically designed to allow a shorter-than-normal distance between a slide projector and screen.